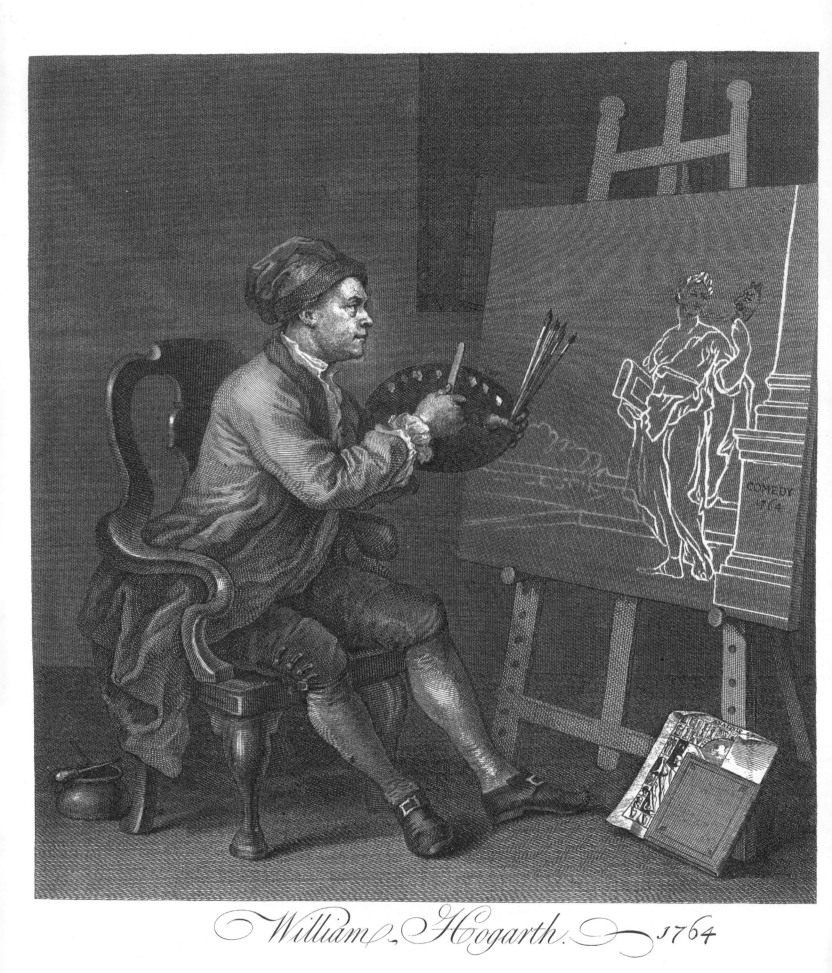

William Hogarth. 1764

See commentary on p. iv.

Engravings by
HOGARTH

101 PRINTS

Edited by Sean Shesgreen

Department of English
Northern Illinois University

Dover Publications, Inc., New York

Engravings by Hogarth: 101 Prints is a new work, first
published by Dover Publications, Inc., in 1973.

Library of Congress Catalog Card Number: 72-96411

International Standard Book Number

ISBN-13: 978-0-486-22479-4
ISBN-10: 0-486-22479-1

Manufactured in the United States by LSC Communications
22479120 2018
www.doverpublications.com

COMMENTARY ON THE FRONTISPIECE

WILLIAM HOGARTH PAINTING THE COMIC MUSE.

ETCHED AND ENGRAVED FROM A PAINTING. SEVENTH STATE. MARCH 1758. $14\frac{9}{16} \times 13\frac{3}{8}$.

This print was first issued to celebrate the artist's appointment as Sergeant-Painter to George II. Early states show a smiling, almost jovial, Hogarth working on a study of the muse gazing at her comic mask. In later states Hogarth's face is made stern and serious, the face of the muse is filled in and her mask becomes that of a satyr. The publication line "Wm Hogarth Sergeant-Painter to His Majesty" is reduced to "William Hogarth. 1764" and he identifies, not with his position, but with his comic painting and his writing (represented by the muse and his *Analysis of Beauty*).

The print depicts a keen-eyed, serious-minded painter, alert and stable in character, whose devotion to his art is complete.

For Pamela Jane Richards

Preface

In the past decade Hogarth's engravings have delighted and intrigued growing audiences. Thanks to the scholarship and labors of such men as Frederick Antal, Ronald Paulson, Joseph Burke and Colin Caldwell, the engraver's work is available in most libraries today, and his ideas are more accessible than before. Unfortunately Paulson's volumes are priced beyond the means of most individuals, and even the Burke and Caldwell edition is a relatively expensive book. An inexpensive popular edition of Hogarth's most important engravings now seems in order. Hogarth himself designed many of his prints for wide distribution and was often at pains to see that other engravings of his or inexpensive copies of them were sold at prices that made them available to the less affluent. It is in this spirit that this book has been conceived.

I am happy to acknowledge the assistance and cooperation of my friends and colleagues in my work. Jean Hagstrum first introduced me to Hogarth's engravings when I was a graduate student at Northwestern. Ronald Paulson's works guided me at every step of the project; without his scholarship this volume could not have been realized. Anne McKenzie, Ian Watt and Sam Kinser provided helpful suggestions for the introduction; my departmental colleagues Sue Doederlein, Jim Kennedy and Marthe Wolfe offered many valuable comments on the manuscript. Through Mr. Ken Soderland the University of Chicago Library provided me with most of the prints reproduced in this volume. To these and to the many other people who encouraged and assisted me in my work, not least among them the irrepressible undergraduate students in my Hogarth class, I am grateful.

SEAN SHESGREEN

English Department
Northern Illinois University
DeKalb, Illinois
March 18, 1973

Contents

List of Plates

Introduction

THE MILIEU

With the rise of parliamentary rule over royal power and influence in the late seventeenth and early eighteenth centuries, aristocratic patronage of the arts waned in England. During the reigns of George I (1714–1727) and George II (1727–1760), it declined steadily. Native Germans and foreigners to English culture, George I never learned to speak English, and George II took only a limited interest in the arts. John Ireland records a humorous instance of his philistinism in his reaction to Hogarth's picture, *The March to Finchley*. When the work was brought to him for his approval he asked, "Pray, who is this Hogarth?" "A painter, my liege." "I hate *bainting* and *boetry* too! neither the one nor the other ever did any good! Does the fellow mean to laugh at my guards?" "The picture, an please your Majesty, must undoubtedly be considered as burlesque." "What! a *bainter* burlesque a soldier? he deserves to be picketed for his insolence! Take his trumpery out of my sight." Though not a patron, it is true that George II was something of a collector and Queen Caroline was a patroness; still this and similar well-known utterances on native poets and painters had a chilling effect on the relationship between artists and aristocracy.

Samuel Johnson's letter to Lord Chesterfield in 1755, toward the end of George II's reign, spurning that nobleman's patronage of his popular dictionary is often taken as formally marking the end of patronage in Britain. During this period, sometimes called "the age of the common man," the number and wealth of shopkeepers, artisans, tradesmen, clerks and entrepreneurs grew, and their unique culture took form and stabilized itself. The growth of middle-class culture had quickened with the political ascendence of the mercantile classes first under Cromwell in the second half of the seventeenth century and later under William and Mary—Hogarth, incidentally, was named after William II. It was established first in the City of London, one of the trade centers of the world where members of the new middle classes were self-conscious, literate, anxious for knowledge and moderately leisured. Anxious too for the status afforded by literature and the arts, they formed a stable, powerful audience that could help pay Alexander Pope £9,000 (over $150,000 in today's money) for his translations of the *Iliad* and *Odyssey*. It was to this broad middle stratum of the population that artists and writers looked for their support as their direct dependencies on the court and aristocracy were gradually reduced.

The tastes of the English mercantile classes were substantially different from the tastes of the class to which previous art and literature had been addressed. Traditionally the arts reflected codes, values and life styles which were largely irrelevant to the bourgeoisie: martial heroism, courtly love, chivalry. Art and literature from the Restoration to near the end of the seventeenth century had been particularly scornful of and at odds with middle-class culture. Under Charles II (whose undiscriminating importation of certain aspects of continental court life had earned him the half-humorous title "Patron of Bawdy-houses"), the arts embodied aristocratic values like cosmopolitanism, cynicism (especially in matters of religion), sexual freedom and love of leisure and amusement. Hogarth's *A Rake's Progress* is a frank summary of these values from a middle-class viewpoint; Tom Rakewell affects taste, conspicuously neglects religion, drinks, gambles, seduces women and marries for money rather than love. Such values were directly opposed to the qualities of character which were necessary to the survival of the bourgeoisie as a class and which, as a result, they fervently espoused. Their commitment was to such concepts as thrift, work, temperance (especially in matters of sex and alcohol), sentimentalism, religion, nationalism (i.e. hatred of the French) and humanitarianism.

As members of the mercantile classes felt their own power and

defined their interests, they looked for sympathetic reflections of their world in what they saw and read. In the art and literature which they acquired, they sought direct, straightforward accounts of their everyday lives presented in a manner that was unadorned and lucid. Even more importantly, they looked to the arts for compelling statements of the moral values which were uniquely theirs. As a result a number of art forms, forms congenial to expressing matters of social record, grew up around the interests and values of the middle classes, patronized, sustained and, in many cases, created by members of those very classes. Newspapers representing bourgeois viewpoints and reporting news of special interest to the middle classes sprang up and flourished. The first successful daily paper, *The Daily Courant* (1702–1735), was a commercial sheet of Whig tendencies. Indeed the influence of Whig papers was so powerful in 1712 that the Tory government taxed each copy a halfpenny to crush them.* Periodicals of similar persuasion thrived, bringing culture and education to the bourgeoisie, and providing them with the rules of conduct and good taste that they eagerly sought. Addison and Steele published the most influential of these, their didactic *Tatler* and *Spectator*, aiming to teach to an extended public the practice of morality, or, as they put it, to "enliven morality with wit, and to temper wit with morality." Daniel Defoe, Samuel Richardson and Henry Fielding wrote the first English novels describing the successes and failures in the day-to-day lives of the ordinary people of England—servants, parsons, prostitutes, soldiers, adventurers, middle-class and sometimes upper-class men and women. Moved by the same forces as these men and liberated by the absence of a strong native pictorial tradition (religious hostility during the Reformation had snuffed out most creativity and interest in the representational arts in England), William Hogarth invented, executed and sold in his own shop his realistic engravings of popular subjects, the visual equivalents of these new literary art forms.

Writing about his novels in his letters, Samuel Richardson spoke of attempting something which might "introduce a new species of writing, that might possibly turn young people into a course of reading different from the pomp and parade of romance-writing, and dismissing the improbable and marvellous, with which novels generally abound, might tend to promote the cause of religion and virtue"; and Henry Fielding described his comic prose epic in *Joseph Andrews* (1742) as a "kind of Writing, which I do not remember to have seen hitherto attempted in our Language." Like his fellow artists Richardson and Fielding, Hogarth was also keenly aware of the original nature of his art. In his *Autobiographical Notes* he speaks of his work as an "intermediate species of subjects for painting between the sublime and the grotesque" which writers and painters never mention and again as "a more new way of proceeding, viz painting and Engraving modern moral Subjects, a Field unbroke up in any Country or any age." Subscription tickets (small engravings issued as receipts for advance payment or partial payment for larger works) were the manifestoes of Hogarth's "uncommon way of painting" with its unique emphasis on contemporary subjects. In "Boys Peeping at Nature," the ticket for his first progress, he speaks again about the newness of his art form. Drawing an inquisitive satyr looking up the dress of a many-breasted statue of Nature, he explains the meaning of the plate with a quotation from Horace reading, "Abstruse matter must be presented in novel terms . . . license is granted if it is used modestly." The quotation and the engraving suggest that Hogarth sees himself as an innovator exploring contemporary reality, a reality that is both novel and in the eyes of many, indecent or low;† consequently he must invent new and different means to achieve what he set out to do.‡ And if his work is more frank than it is flattering, it is only because he is more empirical than traditional artists who, in Sir Joshua Reynolds' words, drew idealized beauties or "an abstract idea of their forms more perfect than any one original."§

Hogarth's formal means of presenting his "modern moral Subjects" are related not only to economic and social trends in the neoclassical milieu but also to a concurrent, new philosophical movement which is associated with the rise of the novel and other related art forms. Modern philosophical realism, first formulated in England by John Locke (1632–1704), was a component of considerable significance in the intellectual and artistic climate of the eighteenth century. The quality of Locke's realism was critical, innovative and anti-traditional.¶ Its basic premise was that truth came to the individual from the external world through the senses. In method it was empirical; the unbiased eyewitness scrutinized the particulars of his unique experience. The same empirical approach to experience in art was ideally suited to the commonplace material drawn from everyday, middle-class existence with its implicit realism. It was also well suited to the anti-authoritarian, individualistic spirit and the utilitarian outlook of the middle classes with their secular, highly rational vision of things. As a result modern empiricism in its aesthetic manifestations is a critical element in the emergence of bourgeois art and is reflected in the characteristic ways that its artists mirror their world in art. It was the independent spirit of this new realism that Hogarth expressed when he spoke in his *Autobiographical Notes* of failing to engage "such as have been brought up to the old religion of pictures, who love to delight in antiquity and the marvellous and what they do not understand" and succeeding with "such as dare think for themselves and can believe their own Eyes."

* George Sherburn and Donald F. Bond, *The Restoration and the Eighteenth Century* (New York: Appleton-Century-Crofts, 1967), 847–848.

† Hogarth's novel work appeared low and vulgar to Sir Joshua Reynolds, the classical portraitist, whom the aristocrats and the wealthy sat to during the eighteenth century. "The painters who have applied themselves more particularly to low and vulgar characters, and who express with precision the various shades of passion, as they are exhibited by vulgar minds, (such as we see in the works of Hogarth,) deserve great praise; but as their genius has been employed on low and confined subjects, the praise we give must be as limited as its object," says Reynolds in Discourse III. All quotations from Reynolds are taken from *Discourses on Art,* ed. by Robert R. Wark, (San Marino: Huntington Library, 1959).

‡ Paulson, *Hogarth's Graphic Works,* 1:141.

§ Discourse III.

¶ The approach to Hogarth's work used here and throughout this introduction has been adapted from Ian Watt's *The Rise of the Novel* (Berkeley: University of California Press, 1965).

PLOT

Traditionally the touchstone of reality in art was conformity to the past as it had been summarized and codified by its writers and painters. In Discourse I, Reynolds told his students "that those models, which have passed through the approbation of ages, should be considered by them as perfect and infallible guides; as subjects for their imitation, not their criticism." In Hogarth's engravings, by contrast, reality is all that is novel, contemporary and local in eighteenth-century life. His pictures are overwhelmingly literal, direct and unrhetorical; they make use of few formal conventions from previous art and usually do not rely on comparison with or understanding of previous artistic models or genres to make their statements. "Hogarth had no model to follow and improve upon. He created his art," wrote the engraver's contemporary, art critic Horace Walpole. "He drew all his stores from nature and the force of his own genius," he adds in the same essay in his *Anecdotes of Painting*, "and was indebted neither to models nor books for his style, thoughts or hints" Perhaps the innovative characteristic that stands out most in Hogarth's work is his frequent use of plot; he was the first major European artist to use the technique of narration in the visual arts in a skillful manner. Moral tales with simple plots told in pictures did exist in Italy before Hogarth's time,* but there is little relationship between these crude religious moralities with their Bunyan-like stereotypes and the engraver's worldly progresses. Hogarth's use of plot is not as novel as is his use of new plots instead of traditional stories. The subject matter in classical and many contemporary works of art—both pictorial and literary—were drawn from sources already familiar to most audiences: the Bible, mythology, history and legend. To his students at the Royal Academy, Reynolds recommended as subjects (in Discourse IV) "the great events of Greek and Roman fable and history, which early education, and the usual course of reading, have made familiar and interesting to all Europe, without being degraded by the vulgarism of ordinary life in any country. Such too are the capital subjects of scripture history, which, besides their general notoriety, become venerable by their connection with our religion." The interest in these well-known sources reflected a belief in human experience as unchanging and permanent.

Hogarth's contrasting attitude toward his material is aptly illustrated in the signature to his work, where he self-consciously describes himself not merely as a painter and engraver, but above all as an inventor; as the publication line in so many of his progresses, his signature to *A Rake's Progress* announces, "Invented Painted Engrav'd & Publish'd by Wm. Hogarth." Departing from customary practice, he created his own narratives around the individual, everyday experience of English people, emphasizing the particular in the commonplace lives of ordinary people. Some of his plots he invented by himself; others he derived from actual events of the time; still others may have been suggested to him by contemporary newspapers, essays and bourgeois plays. His depiction of the events surrounding a visit to France in "O the Roast Beef of Old England" and the fascinating parallels between his career and Francis Goodchild's in *Industry*

and Idleness suggest that he even used his own life as a source for his art.

For his new material Hogarth turned confidently to the lives of the British working classes and middle classes, examining a broad range of representative experience hitherto unexplored in English art. In "Beer Street" and "Gin Lane" and *The Four Stages of Cruelty* (two of which were issued inexpensively as bold, stark woodcuts), aimed, like much of Defoe's work, at working people, the engraver dealt with the concerns of servants, coachmen, butlers, apprentices and laborers as well as with the lives of victimized social outcasts and debilitated rejects in the lowest social class. In *A Harlot's Progress* and *A Rake's Progress* he treated, as Richardson did in his novels, the affairs of the more prosperous and mobile middle classes; the similarities and differences between Moll and Pamela, Rakewell and Lovelace are obvious.

In *Industry and Idleness* Hogarth touched on both classes just mentioned. That series, which begins in a working-class setting, follows the fate of one of its characters to an ignominious execution at Tyburn and the fortune of the other to the Lord Mayorship of London in a ceremony in which the former apprentice is the central attraction and the Prince of Wales and court mere spectators. Faithful to the essentially democratic and iconoclastic nature of his art form, Hogarth never really treated the affairs of the aristocracy by themselves or directed his engravings primarily to them. In *Marriage à la Mode* and *Four Prints of An Election*, executed by or with the assistance of professional French engravers and aimed, like Fielding's novels, at the upper middle class and obliquely at the aristocracy, Hogarth scrutinizes the upper reaches of society, the wealthy merchants, money-lenders and politicians. It is true that in these works he does examine the lives of the bankrupt, improvident aristocracy and the manipulative ruling class; but he examines them only as they relate to and exploit the classes below them.†

If none of these social classes, high or low, was beyond Hogarth's interest, neither were the everyday, mundane aspects of their members' lives. Because the entertainments of the middle and and lower classes were often at odds with their interests and sometimes a threat to their very existences, the engraver treated the common amusements of the citizens of London extensively. In such representative scenes as curiosity-seeking fairgoers in Southwark early in September, a London dyer passing an oppressive evening with his family at Sadlers Wells, an orgy in a London tavern, frenzied gamblers at a cockfight and the hopeless and destitute dying by gin, Hogarth's plots illustrate the destructive nature of popular amusements. The engraver also treated labor extensively and with predictable seriousness, for work held a sacred place in bourgeois existence. There is much delight and contentment—compelling or not—in Hogarth's pictures of labor. In two of his self-portraits, he shows himself laboring earnestly and intently at his art, his face radiant with satisfaction and fulfillment. All but two of the plates in which Francis Goodchild

* Hilda Kurtz, "Italian Models of Hogarth's Picture Stories," *Journal of the Warburg and Courtauld Institutes*, 15 (1952):136-168.

† For a more elaborate discussion of Hogarth's audience, see Antal, *Hogarth and His Place in European Art*, p. 57. I am indebted to Antal's writing here and throughout this introduction. Indeed, there are few points on which my thinking about Hogarth has not been sophisticated by Antal's scholarship.

appears show him at work; none deal with family or personal life. A good bourgeois who denounced the immorality of the lower as well as the upper classes, Hogarth was also a democratically minded man of the people who showed the evils that commoners fell prey to or embraced, the religions they followed and the political system that cheated them, and who celebrated in his plots the tragic and the comic in the lives of the ordinary people of England, whose basic aspirations he shared.

In dealing with these concerns in his plots, Hogarth dwelled on problematic, "low" aspects of ordinary people's lives. This bias against normative experience is most interestingly revealed in the fact that after he had completed *Marriage à la Mode*, the engraver attempted a contrasting series entitled *The Happy Marriage* but apparently found the topic uncongenial. He never finished it. His vision was habitually critical and negative, and he was seldom more persuasive than when he examined the darker side of his characters' lives. Few students of his work will find Francis Goodchild's rise to fame as compelling as they will Tom Idle's fall. No other eighteenth-century artist portrayed so well the exploitation of women by men (Moll, Sarah, Rakewell's wife) and by society (all but one of Moll's prison mates are female), the oppressed condition of the poor, the moral and spiritual bankruptcy of the nobility and the folly of the middle classes who aspired to the decadence of their "betters." Despite his consistently satiric posture, however, Hogarth was no misanthrope. Each work, no matter how negative, implies some positive value or standard from the artist's own culture, whether or not this standard is attainable by the characters in the progresses. If *A Rake's Progress* describes the vicious nature of aristocratic life, it implies to its audience the sufficiency of bourgeois existence; if *Marriage à la Mode* condemns unions of convenience, it proposes marriages based on love and sentiment; if "A Midnight Modern Conversation" exposes the folly of drunkenness, it advocates temperance.

A final characteristic of Hogarth's plots merits attention. Prior to the eighteenth century many plots were narratives of events based on coincidence and mistaken identity.* In Hogarth's art, by way of contrast, the operation of cause and effect moves the narrative. In works like *A Harlot's Progress, Industry and Idleness* and *The Four Stages of Cruelty*, the artist gives us not a collection of picaresque episodes arranged in arbitrary order, but a series of closely knit events in which each follows almost deterministically from the other. Every item in the series represents a dramatic moment chosen for its consequential nature; taken together, all the scenes portray with considerable elaboration the operations of a rigorous social and individual causality in human life. The causality which Hogarth makes use of has its own distinctive nature and employs its own set of conventions. Best described as a moral logic or moral causality, it depicts patterns of individual ethical choice (often circumscribed by social factors like environment or family) and consequence which, despite their rigor, sometimes strain the reader's sense of the probable in their ultimate conclusions. It was within the confines of a plot based on such conventions that the engraver could best represent the system of rewards and punishments that he attached to the fulfillment and transgression of middle-class codes of behavior. Henry Fielding, who knew Hogarth and his work extremely well, wrote (in the *Champion*), "In his excellent works you see the delusive scene exposed with all the force of humour, and, on casting your eyes on another picture you behold the dreadful and fatal consequences."

What has been said of Hogarth's progresses is also largely true of his other engravings. Most are self-contained narratives which spell out stories in their teeming, rich detail. "Evening," for example, tells an amusing psychological tale about the relationship between the dyer, his wife and their children; the plate may justly be called a narrative because it relates the past (the wife's cuckoldry) to the present (her continuing domination of her spouse) and even to the future (through her pregnancy). Nor does Hogarth confine the illustration of cause and effect to his progresses. In single engravings and in series without plots he often portrays the consequences of folly in the carefully differentiated conditions of the figures in his scenes. The man vomiting in "A Midnight Modern Conversation" and the fellow suspended in a basket from the roof in "Pit Ticket: The Cockpit" are compelling illustrations of the dire effects of drunkenness and gambling. Predictably enough, the most obvious differences between the engravings of this class and the progresses is that the former include a large quantity of prints that are topical and reportorial in nature; in this they resemble the popular newspapers and periodicals in much the same way the progresses do the neoclassical novels. Engravings like "An Emblematical Print on the South Sea Scheme," "O the Roast Beef of Old England," *The Invasion* and *The Times* plates are tied to the most important political events of the century. Others, like "Simon Lord Lovat" and "John Wilkes Esqr.," have sensational, journalistic qualities to them. Still others, works like the *Four Groups of Heads*, "Characters Caricaturas," "Time Smoking a Picture" and Hogarth's essays in the grand style issued as engravings ("Paul before Felix," "Moses Brought to Pharaoh's Daughter" and others), together with his *Analysis of Beauty*, are attempts to provide an aesthetic as opposed to a moral education for the middle classes in the important artistic issues of the period.

CHARACTER

If the traditional conception of plot and its proper subject matter was inadequate to the task of expressing Hogarth's vision of reality as commonplace, individual and intelligible, so was the received notion of character. Character had been commonly understood as referring to qualities and clusters of qualities which belonged not to individuals, but to all human beings. In terms of

* Fielding's novels continue to employ these devices in their plots.

portraiture this emphasis on the typical and universal meant that the artist avoided the minute and the particular and represented the ideal and the general. "The excellence of Portrait-Painting, and we may add even the likeness, the character, and countenance, as I have observed in another place," says Reynolds in Discourse XI, "depend more upon the general effect produced by the painter, than on the exact expression of the peculiarities, or minute discrimination of the parts." Summing up the received aesthetic

wisdom as it pertained to characterization in Discourse IV, he says, "Even in portraits, the grace, and, we may add, the likeness, consists more in taking the general air, than in observing the exact similitude of every feature."

Hogarth disagreed sharply with this viewpoint. His attitude toward Reynolds' *beau idéal* he expressed in his late versions or states of "Boys Peeping at Nature." There the putto idealizing nature stands with his back to her statue, ignoring her presence entirely. Hogarth is to be identified with the empirical-minded faun whose curiosity exceeds his inhibition. The characters he portrayed were not heroic figures from a mythic past but English cook maids and other "originals" from everyday life which could best be described in particular terms. "The perpetual fluctuations in the manners of the times," he says, "enabled me to introduce new characters, which, being drawn from the passing day had a chance of more originality and less insipidity than those which are repeated again, and again and again from old stories." *

Hogarth's interest in original characters is manifested in a number of ways. It appears in the central nature of character in the artist's work; Pope's statement "the proper study of Mankind is Man" is strikingly true of Hogarth's plates. Novel characters of all kinds dominate his engravings—only a handful of very minor and less memorable works depict objects rather than people —and even influence or dictate the direction in which his plots unfold. In a formal sense Hogarth's interest appears in his creation of visual biographies (for this is what the artist's progresses amount to) which single out individual figures and chronicle their lives.

Perhaps his concern to reveal individual identity appears most clearly in his characters' names and appearances, because these two distinguishing characteristics are the critical verbal and visual means by which the identity of a person is established in real life. Hogarth's innovation in nomenclature is that he christens the majority of his fictional people (even minor figures), assigning them given names and surnames or, in their place, initials. His given names, most of which are purposefully common and middle-class, suggest individuals from ordinary life: Tom (used for three major characters), Francis, Richard, Tim, Moll, Sarah, Ann.

The same is true of the family names of a number of his minor figures; names like West, Cogg, Gill and Young are common and lifelike. The surnames of the engraver's principal characters like Hackabout, Rakewell, Goodchild, Idle, Nero, Silvertongue and Squanderfield suggest the moral or psychological nature of the figures they identify; still they are not as overtly taxonomic as names like Christian, Prudence, Piety, Patience and Despair from John Bunyan's *The Pilgrim's Progress* (1678). Like the names of the characters in the novels of Henry Fielding, they are type names that have been modified in a realistic direction so that they have at least a plausible resemblance to names in real life.

Finally, in a supremely realistic stroke, the engraver gives the names of contemporary people to some of his characters; in "Morning" Dr. Rock advertises and sells quack medicines bearing his name; Mr. Fawkes juggles in "Southwark Fair" in front of a showcloth with his picture and name on it; the boxer James Field's skeleton seems to oversee the dissection of Tom Nero. By juxtaposing the names of living people with those of his fictional

* Quoted by Antal, *Hogarth and His Place in European Art*, p. 16.

people the engraver extends to all the historicity and the particularity of the actual.

In the visual arts the naming of characters is not as valuable an index to the artist's particularizing intention as the degree to which, in his treatment of his figures' appearance, he follows or departs from Reynolds' imperative to idealize his subjects. Hogarth's practice in this matter is best discussed in terms of his characters' countenances or heads, for it was on physiognomies that the engraver's principal effort was expended. Even in prints like *Marriage à la Mode*, for example, where he employed the assistance of other engravers in the production of his work, he usually reserved to himself all work on the faces of his characters. Hogarth speaks of himself as being interested in depicting his figures' characters and emotions through their faces. As we might expect from his interest in "originality" and "new character," the physiognomies he draws are individualized character portraits and unique social stereotypes—even though he portrays a number of identical types (how many quack doctors must there be in the artist's corpus?), no two figures of his resemble each other.

Hogarth's overriding concern in his prints was to depict the passions in his subjects' faces, and this is certainly the most successful aspect of his characterization. Most of his figures' countenances are unique but intelligible interpretations of general human passions, thoughts and emotions. Unlike previous studies of the effects of passion on the human face, the expressions Hogarth pictures are more particularized than idealized, more common than heroic and simpler and more natural than they are posed and monumental. Surprise, indifference, lust, anger, pride, every imaginable expression is present in the common faces of the figures that people his work. A number of his engravings are devoted entirely to the presentation of contrasting expressions. In "A Midnight Modern Conversation" and "Pit Ticket: The Cockpit," for example, where characters are crowded around a central unifying action, the face and posture of each record his emotional reaction to what is taking place. By itself the action in these scenes is relatively unimportant in comparison to the sea of expressions, each carefully differentiated from and contrasted to the others. The lively faces, contrived to represent a spectrum of responses in exactly modulated variations, are both comic and instructive in their fundamentally realistic effect.

This is especially true of many of the physiognomies in his early works devoted exclusively to heads. In "The Company of Undertakers" and "Scholars at a Lecture," the engraver mocks dull-witted pedants and quack doctors by distorting their appearances; expressions are exaggerated, faces become mere personifications of emotions, and features are crude and unnatural. Moles, blood marks, wounds, oddly shaped noses, bulging, crossed and missing eyes, and ominous beauty spots twist appearances and overemphasize simple expressions to the point of grotesqueness. Because the progresses usually picture complex, highly charged events involving only a handful of characters, the expressions of their major figures are less artificially differentiated and less of set-pieces. Constructed with care and art, the commonplace faces are lively, striking, fully expressive and, without being excessively staged, are dramatic. The passions Hogarth pictures in these physiognomies are completely individualized, and revealed with a subtlety and reportorial accuracy unequaled in his other engravings. In addition to depicting different emotions in a single face,

the engraver further sophisticates his portraits by marking in his subjects' appearances the toll which age, disease, want and dissipation take over a lifetime. Despite the generally high level of characterization in the progresses, there is a marked tendency toward caricature in the portraits of the minor figures in works like the *Harlot* and *Rake* and the major figures in progresses executed for popular audiences like *The Four Stages of Cruelty*. Moll's noseless servant, Rakewell's one-eyed bride and Nero's corpse, with their deformed countenances and crude, overstated expressions, resemble figures from the artist's *Four Groups of Heads*.

In some of Hogarth's other works the appearance of his characters moves beyond realism of expression in the logical direction of caricature. This is so despite the artist's implicit claim in "Characters Caricaturas" (reaffirming not his own, but Henry Fielding's statement) that he was not a "burlesque" painter. Coming at a time when he was still wooing upper-class audiences ("Characters Caricaturas" is the subscription ticket to *Marriage à la Mode*), this statement should be seen not as a dispassionate description of his art, but rather as an attempt to give it a status which he felt it lacked. Just as Fielding gave importance to *Joseph Andrews* by calling it a comic prose epic, Hogarth, in this ticket and in "The Bench" (done during the last days of his life), claims similar status for his comic history painting. The evidence of the engraver's work is at odds with his theoretical pronouncements; he sometimes did caricature the expressions he depicted.

Jonathan Swift was very much taken with Hogarth's work, particularly with his character-revealing physiognomies. In his poem "The Legion Club," he writes:

> How I want thee, humorous *Hogart*?
> Thou I hear, a pleasant Rogue art;
> Were but you and I acquainted,
> Every Monster should be painted;
> You should try your graving Tools
> On this odious Group of Fools;
> Draw the Beasts as I describe 'em,
> Form their Features, while I gibe them;
> Draw them like, for I assure you,
> You will need no *Car'catura*;
> Draw them so, that we may trace
> All the Soul in every Face.

The faithful psychological delineation of character praised here by Swift appears in many of Hogarth's portraits of historical figures. Among these his most striking psychological sketches are, perhaps, his portraits of radicals and criminals. In these works Hogarth summarizes the ruling passions of his subjects in their features. The calculating nature of Lord Lovat's character is revealed in his pursed brow and cocked head. In Hogarth's portraits of such people, who in real or imaginary ways threatened the order he clung to, there are again elements of caricature. The most naked example of this appears in the engraver's "John Wilkes Esqr.," where the victim's wig is artfully arranged to give him demonic horns, while his leering mouth and fugitive eyes suggest a posturing that cynically mocks the standard of liberty he bears. Hogarth's engravings of himself and Martin Folkes, and his oils of people like Captain Coram and Bishop Hoadly, stand in contrast to these studies of political activists and actual criminals. Enshrining qualities of character like benevolence, industry, stability and sobriety, these portraits lionize the unassuming middle-class character as the backbone of the English nation. Finally, while many of the portraits in the progresses are studies of emotions and passions, some (and this is particularly true of the portraits in progresses done for sophisticated audiences) are sketches of moral natures and complex psychological dispositions. In the haughty, bloated face of Lord Squanderfield, in the vain self-absorption of his son's expression, in the shallow, placid countenance of Commodity Taxem, the corrupt or the vacuous nature of each figure is exposed.

Though these characters have universal aspects to them, all, even the stereotypes, are executed with a conspicuous degree of uniqueness or individuality; in Hogarth's portraits the type exists in and through the individual. Many of the minor figures in his crowds, mere stock bystanders to the principal scene, are recognizable butchers, paviors, carpenters, postboys, bootblacks and lawyers. In his major works not even his mobs are anonymous. Moreover, many of these minor figures and some of the artist's major figures were recognized by his contemporaries as bearing the unmistakable likeness of people they knew. The story is told that when *A Harlot's Progress* first appeared, it was brought to a meeting of the Board of Treasury. The lords present were so delighted with the likeness of Sir John Gonson in his harlot-hunting role (Plate III) that they each went to Hogarth's house and purchased copies and, according to the clerk of the Treasury who told the story, the result was that "Hogarth rose completely into fame."

In *A Harlot's Progress* alone there are at least four figures who have been identified with real people, and the engraver's works—both his single plates and his progresses—from that time forward are filled with notorious bawds, depraved noblemen, deceitful lawyers, quack doctors, gluttonous clergymen and scheming politicians whose identities have been preserved down to the present. The very fact that so many of the artist's characters were identified with real people suggests that they are not idealized in his plates. The words of contemporary commentators give credit to the testimony of our eyes. John Ireland referred to these highly individualized likenesses not as burlesques or idealizations but as "representations," "portraits" and "representatives" of people.

TIME

Art and literature prior to the Renaissance exhibit little concern for mechanical time schemas or external, circumstantial chronologies. With the growth of a scientific interest in temporal process and a renewed interest in secular history, in men's deeds and worldly achievements, time came to be represented as a determining factor in people's lives. Furthermore, the new importance of

secular as opposed to religious time emphasized minute divisions of existence rather than larger unities such as a person's lifetime or the eternity he or she was thought to spend in heaven or hell following death. Temporal focuses or concentrations also grew up around centers of interest like class movements, moral issues and character development. The middle classes in developing bourgeois cultures like eighteenth-century England were sensitive to time in another perspective.

With the rise of a money economy time and timekeeping took on a new value in people's lives. For the mercantile classes time was money, in the words of a catch-phrase which seems to have been conceived in the bustling cities of the thirteenth century. Hard work was necessary to guarantee their success as individuals and as a class. Futuristically oriented, they saw themselves as asserting their uniqueness and individuality economically through their careful use of time. The new interest in time and its central place in bourgeois life was first recognized by the middle-class novelists of the eighteenth century and expressed in their works. Daniel Defoe's novels are the first to chronicle life as a real, historical and economic phenomenon, and Samuel Richardson locates the events of his stories in an unprecedentedly detailed time-scheme.*

On the most superficial level a sense of time permeates Hogarth's art; it is, beyond question, one of the most prominent realities in his work. A number of his engravings deal exclusively with time and its effect in human affairs. In *The Four Times of the Day*, "Time Smoking a Picture" and "Tail Piece: The Bathos," it is variously seen as a force that is hostile, destructive, fleeting and judgmental, yet capable of being relished and enjoyed, even if it is somewhat elusive. In most of Hogarth's works where time itself is not the subject of the engraving, it is just there, obsessively present and inescapable. Its minutes and hours are marked in the watches his characters wear, in the clocks in their rooms and on their buildings, on their sundials, in the light and shadows on their walls, on their liquor bottles and in the activities they perform. The window's reflection on the gin bottle in "A Midnight Modern Conversation" announces the sunrise; the shifting shadows in *Before and After* mark the progress of the evening. In these prints the indications of time seem to serve two functions; as well as providing minutely specified temporal settings, they offer implicit moral comments on the contents of Hogarth's scenes.

In addition to these discriminations, the engraver, by a variety of devices, marks time by date, month and year. The oak leaves on the barber-surgeon's pole in "Night" indicate that it is May 29, Restoration Day; the leek in the Welshman's hat (*A Rake's Progress*, Plate IV) marks the day as March 1, St. David's Day. Sometimes the plates are dated in still more specific detail. Part of the Licensing Act which received royal assent on June 21, 1737, appears in "Strolling Actresses"; in "Beer Street" the king's address to Parliament "On Tuesday ye 29 Day of November 1748" lies on the table beside the butcher. In other plates dates are an even more integral part of the engravings in that they fix overtly the central action. In the final plate of the *Harlot* the following inscription appears on Moll's coffin, "M. Hackabout Died Sept 2d 1731 Aged 23." In the final state of *A Rake's Progress*, Plate VIII, the year "1763" is inscribed under the figure of

* Watt, *The Rise of the Novel*, p. 24.

Britannia gone mad. And in "An Election Entertainment" Abel Squat reads a note dated "April 1 1754." By so grounding his work in temporal settings, Hogarth provides for his actions particularized, historical milieus that are richly circumstantial and authenticating.

An essential part of the role time plays in Hogarth's work is the attitudes the artist's characters take toward it and the uses they make of it. In this context it is an economic reality, an instrument and a reflection of financial, social and political power. One of the most prominent decorations on the wall of the rich merchant's home in *Marriage à la Mode* is his calendar or "Almanack." Francis Goodchild is successful because he uses time to assure his economic "progress"; like the figure of Youth or Industry on his "London Almanack," he has seized time by the forelock. So committed to work is he that he even manages to make his recreational and devotional acts a part of his occupational life. He attends church with his master's daughter, marries her and a partnership in the business; similarly his presence at the sheriff's banquet and the procession of the Lord Mayor are official acts of office rather than entertainments. Several figures stand in contrast to Goodchild. Tom Idle squanders time by sleeping when he should work; no doubt he has been up late the night before, drinking in Spittle Fields; Moll Hackabout spends her mornings lying in bed, rising only to eat just before noon. And Tom Rakewell wastes his late nights and early mornings drinking and whoring; he is still at both when daylight shines through the windows of the Rose Tavern.

But there is still a more fundamental way in which Hogarth's work reflects the new cultural sense of time's importance. In contrast to literature, which is primarily a temporal art form, the visual arts have generally been considered spatial forms. Hogarth's art, however, succeeds in incorporating temporal flux and the concepts associated with it, causality and individual identity through time. Indeed the engraver's progresses and a number of his other works can accurately be described as spatial realizations of temporal categories. The progresses are rigously chronological, of course, and even the individual scenes within them are rooted in temporal reality. Tom Rakewell is arrested at 1:40 P.M. on March 1; Countess Squanderfield expires at 11:10 on the day of Silvertongue's execution. More important, from the chronological flow of the stories in which events are bound together in cause-effect relationships, we derive a sense of individual lives being lived out at particular times in particular places. The scenes are joined together by the identity of the principal characters who determine the course or movement of the action and are, at the same time, themselves determined by it. In *Marriage à la Mode* Squanderfield and his bride are trapped together by their fathers. The progress chronicles the changes in the young people's characters which occur over a period of years in response to their predicament. The coherence of the work derives from the sense it provides of individual personalities developing in increasingly extreme directions (particularly in the case of the girl) in desperate, fatalistic attempts to free themselves from their oppressive bondage.

Hogarth's causal presentation of time is not confined to the relationship between the plates of his progresses; it also appears within many of the works where events representing different times are all present in one scene, usually represented by different

groupings and their respective positions within the scene. The present is frequently embodied in the principals of the story who appear in the foreground; the past and the future are represented by either characters or objects (pictures, bottles, letters) which are set in the background and which, therefore, are seen after the main action of the work.*

In *A Rake's Progress*, Plate I, for example, Rakewell's past is depicted in the symbols of his deceased father's life style which appear in the background. The present is represented in the foreground by the scene's principal group, in which the rake callously attempts to buy off Sarah Young; and the future, again in the background, appears in the motto "Beware" from the funeral escutcheon, in the lawyer who steals Tom's money and in the tailor who exploits his fashionable aspirations. By these techniques Hogarth visualizes time in a spatial form and literally illustrates its effects in human life.

SETTING

The concepts of time and space are closely associated in most contexts. As equally essential factors in the individuation of any person or object, they are inseparable. Predictably enough, Hogarth's treatment of place follows much the same pattern as his handling of time; his single-perspective rather than panoramic portrayal of space parallels his concentrated view of time. Reynolds' imperative in Discourse III is representative of much of received opinion on the treatment of localizing details of both time and place in art up to and through the eighteenth century. The artist, Reynolds held, "must divest himself of all prejudices in favour of his age or country; he must disregard all local and temporary ornaments, and look only on those general habits which are every where and always the same." According to him, "the whole beauty and grandeur of the art consists, in my opinion, in being able to get above all singular forms, local customs, particularities, and details of every kind."

Hogarth viewed his art in a different light from Reynolds. Expressing an awareness of the important role environment plays in human life, he rooted his art inextricably in the circumstances of eighteenth-century England. Affirming his method in his *Autobiographical Notes,* he speaks of giving some account of his prints because "it may be instructive and amusing in future times, when the customs, manners, fasheons, Characters and humours of the present age in this country may be alter'd and perhaps in some respects be otherwise unknown to posterity, both at home and abroad."

For Hogarth, then, fully specified settings, like minute temporal details and individualized characters, were integral to his work. More varied, less uniform and more particularized than even Dutch settings, his scenes are filled with details of all kinds. Unlike such highly particularized pictures as Jan van Eyck's *Arnolfini Wedding,* where everything is a symbol as well as a circumstance, Hogarth's details are usually just a part of the setting and only occasionally symbols. His typical interior is crammed with pictures, prints, drapery, liquor bottles, letters, jars of ointment, dishes and broken glasses. Exteriors teem with dogs, cats, street urchins, butchers, bailiffs, sedan chairs and hackney coaches, all hurrying before London's infamous coffeehouses, notorious taverns, popular brothels and churches. The importance of setting in Hogarth's work is suggested by the fact that he names a number of his works after locations in which they are set. "Southwark Fair" reproduces the topography around the Church of St. George the Martyr, though the scene is somewhat generalized. "O the Roast Beef of Old England: The Gate of Calais" depicts the fortifications of Calais with the town in the background. "The March to Finchley" is set at the intersection of Hampstead and Euston Streets; the village of Highgate is visible in the distance.

There is no more authentic picture than Hogarth's of eighteenth-century London with its narrow, cobbled streets, its open sewers, its descriptive signboards and its steeple-topped skylines. Full and detailed, the engraver's delineations of the great middle-class capital city's inns, squares, streets and suburbs are also historically accurate and faithful, though sometimes a scene may be generalized or a detail modified. Even Hogarth's fictive progresses are usually set in historical London streets and public places. Almost every scene in *A Rake's Progress* has been associated with some location in the city. Tom Rakewell's orgy takes place in the Rose Tavern in Drury Lane, as the inscription on the posture woman's performing platter makes clear. He is arrested for debt in St. James's Street just in front of St. James's Palace; he is married in Mary-le-bone Old Church, gambles away his wife's fortune at a place resembling White's, is imprisoned in the Fleet and ends his days in Bethlehem Hospital.

In choosing his setting Hogarth is careful not to reproduce a milieu which is authentic in merely external ways; rather, the artist's choice of setting is determined by the nature of the action he describes. Mary-le-bone Old Church, the site of Rakewell's wedding, was a notorious church for quick marriages. Sadlers Wells, which the dyer and his wife visit, was one of the places of entertainment most popular with the middle classes. The night cellar in which Idle is betrayed by his whore is known as "The Blood Bowl House"; located in Blood Bowl Alley near Fleet Street, it was an infamous hideout for criminals during the eighteenth century. Thus the particular character of each of Hogarth's scenes, in addition to being historically precise, is an instructive complement to the actions and themes the works treat.

Like his exteriors, Hogarth's interiors are fastidiously authentic; a number are actually based upon rooms in well-known eighteenth-century houses. The interior of young Squanderfield's salon is believed to be a copy of the drawing room of 24 Arlington Street, where Horace Walpole once lived, and the doctor's office in the same series is said to belong to Dr. Misaubin, 96 St. Martin's Lane, Westminster. But again Hogarth's elaborately detailed interiors are more than "the history of the manners of the age"

* Ronald Paulson, "The *Harlot's Progress* and the Tradition of History Painting," *Eighteenth-Century Studies* 1 (1967):75.

(Walpole's words); they are an integral part of his didacticism. The dreary room in which Moll dies is as much a part of the wretched consequences of her fatal harlotry as Rakewell's cell in Bedlam. Hogarth's settings are also extensions of and commentaries on the characters or natures of his personages. The dilapidated garret of Tom Idle and his whore mirrors their low moral condition and Idle's fear-filled psychological state. "The very furniture of his rooms," as Horace Walpole remarked, "describe the characters of the persons to whom they belong."

The furniture also describes the social and economic status of his figures. Merchants own heavy, functional furniture, pewter mugs, earthenware, Dutch paintings; aristocrats possess sublime history paintings of mythological topics purchased abroad, and their places are fitted out with carpets, tapestries, elaborate mirrors, china and delicately wrought tables and chairs, all watched over by servants. Moll's apartment and its appointments become proportionately more drab and grim as she falls from her position as mistress to that of prostitute. As the businessman's mistress she resides in elegant surroundings decorated with finely made furniture and large, framed pictures; she dies a common whore in a crude, uncomfortable, underfurnished hovel.

What is true of the more general aspects of setting is also true of its specific components. Many natural details, in addition to contributing to the authenticity of the scene they are a part of, make especially pointed observations on Hogarth's characters, their actions and situations. The cats, dogs, monkeys and rats which are so frequently a part of the engraver's scene provide their own commentaries by cutting through outward appearances and pretensions and reducing things to an instinctual or animalistic level, the moral level on which the characters are operating. The dignity of the church wedding ceremony and the pretentiousness of the rake and the rich old woman he marries are made ludicrous by the naked lust of the aggressive male dog and the one-eyed bitch he approaches. Two dogs also represent the bride and groom in *Marriage à la Mode*; the Earl's proprietary coronet which appears on one of the animals underlines the fact that both young people are no more than pieces of disposable property in their callous fathers' eyes. The iron shackles binding the animals so impossibly close point up the inhuman nature of the genteel, businesslike transaction taking place in the scene.

Hogarth's animals play another role in his prints. They serve as visual models by which he caricatures the appearance of his personages. The coarse, distorted faces of the women in "O the

Roast Beef of Old England: The Gate of Calais" resemble that of the skate they hold; the grinning women are comic figures because they laugh at the half-human, half-animal appearance of the fish while remaining blind to their own likeness to the grotesque face they mock. The face and posture of Moll's keeper come from the frightened little ape that flees before the crashing dishes. His caricatured, simian appearance cuts through his ostentatious dress and fashionable aspirations and reduces him to a symbol of lust. In all of this Hogarth seems to suggest that man, despite his pretensions, is too often governed by the same instincts as brutes.

Pictures also constitute an important part of Hogarth's interiors. Like his animals, they contribute to the authenticity of the interiors they adorn. They also reflect the taste—usually the bad taste—of their owners. The ridiculous portrait of the Earl done in the sublime manner which appears in the opening scene of *Marriage à la Mode* expresses his naked vanity and his blind acceptance of the works of this genre. The picture behind the rake, an amateurish rendering of *The Judgment of Paris*, suggests that the gullible fellow, in his hasty attempt to appear an art connoisseur, has had a "dark Master" passed off on him. Pictures also provide predictions—usually of a fatal nature—and commentaries on the actions of the plates. In *A Harlot's Progress*, Plate II, the pictures express Old Testament themes of retribution, and forecast Moll's ultimate fate. The cheap prints of Macheath and Sacheverell in the scene following reveal the depraved types of people she identifies with and, by association, her own corruption. Similarly the violence and death in the art from the first plate of *Marriage à la Mode* warn of the murder, hanging and suicide implicit in the events transpiring in the scene.

Hogarth's works, then, give us accurate, natural pictures of everyday life that are primarily literal in content but occasionally symbolic as well. His pictures are of particular people, common middle-class citizens for the most part, in specific situations and places and in real, historical time. These pictures present full, authentic reports on human experience. Their qualities are explicitness, readability, clarity and simplicity. They are devoid of rhetorical and conventional embellishment, exaggerated, overblown design and decorative matter. Immediate and lucid, they are more direct than stylized, more concerned with full, exhaustive description (even to the point of cataloging) than with elegant selection and concentration.

TRADITIONAL DIMENSIONS

Artistic

But if there are novel aspects to Hogarth's work, there are also important dimensions to it which derive from previous art and its traditions. A popular art existed in England prior to Hogarth's time, and he was unquestionably familiar with it. In medieval times this tradition found expression in manuscript illuminations and in ornamental carvings and sculptures on furniture and buildings such as the graphic *Tedium of Academe* on the Bell Tower of New College, Oxford. With the advent of printing this popular art appeared in woodcuts, chapbooks, icon books and broadsheets. On the Continent Hieronymus Bosch, Peter Bruegel the Elder and Jacques Callot created an influential, popular art that was moralistic, allegorical, grotesque and sometimes realistic.*

Hogarth's work shares many qualities with these British and Continental artists and genres; among the characteristics which many such models have in common—their frequent realism, their

* F. D. Klingender, *Hogarth and English Caricature*, pp. iii–iv.

middle-class subject matter and their use of grotesque and fantastic imagery—most striking is perhaps their use of similar didacticizing forms and techniques. Such, for example, are the engraver's allegorical figures and motifs. The figures of Good Luck, Industry and National Credit in "The Lottery" are clearly middle-class derivations of allegorical characters in the English and Continental art which Hogarth drew upon.

The legends, moralizing verses and biblical quotations which accompany so many of Hogarth's pictures belong to the same category of techniques. Appearing as "explanations" in those prints directed toward the lower classes, they may even derive from the same popular iconographies (like Cesare Ripa's *Iconologia*), which were among the best-known sources of allegorical characters at the beginning of the century. In a related class are the emblematic images which appear (often incongruously when Hogarth's moral sense seems to overwhelm his sense of decorum) in his most realistic works. The lightning which strikes White's gambling house purposefully (*A Rake's Progress*, Plate IV) is a retributive bolt, not from the skies, but from Heaven. The figure of Britannia gone mad appears in an emblem on the wall of Bedlam; she appears in "The Polling" as a distressed lady whose carriage, neglected by its gambling coachmen, is in peril.

From the same traditions too come the bizarre images which give Hogarth's prints the grotesque tone they frequently have. The masks which lie around Countess Squanderfield's and Moll's apartments like live severed heads are both comic disguises for masquerades and eerie death masks. The grinning pig's head on the merchant's dinner table, the chandelier in the shape of a monster's face in the fanatics' meetinghouse, the human head with its bulging eyes and a pill between its teeth, the two-headed hermaphrodite—all these resemble grotesque, unattached, living gargoyles, and all seem to point to an irrational chaotic world, hostile and threatening, which lies just beyond the boundaries of everyday middle-class existence.

Theatrical

The contemporary stage and its drama constitute literary influences of some importance on Hogarth's work. "Subjects I consider'd as writers do," Hogarth wrote in his *Autobiographical Notes*, "my Picture was my Stage and men and women my actors who were, by Means of certain Actions and expressions, to Exhibit a dumb shew." Bourgeois theater, growing rapidly in popularity, had a melodramatic tendency to it. It was also heavily moralistic and, as the naturalistic "Mr. Garrick in the Character of Richard the Third" plainly shows, plays then staged were being presented with increasing realism in England.

For these reasons drama was an art form congenial to Hogarth's moral and aesthetic prejudices. Most of his scenes are viewed head-on as an audience views a stage. Almost all have a boxed or framed quality to them. Sometimes this frame resembles a proscenium as in *Industry and Idleness*; usually the stagelike appearance of his work is established implicitly by the rectangular shape and the carefully defined boundaries of the plate. Sometimes the action takes place on a stage or a platform resembling one; the main action in Plate IV of *Industry and Idleness* takes place on a small platform which heightens the significance of what transpires there and literally sets the principals above the other people in the scene. Hogarth's progresses have special stage qualities to them. The

dramatic moment is the basic unit of meaning, and each work is built from so many climactic scenes. Characters relate directly to each other by gesture and expression. Movement, not stasis, is the subject of Hogarth's art. Action is arrested, and theatrical instants are captured whose implications reach forward to what is to come and back to what has passed.

Moral

Like artists in all ages the engraver believed that his work should fulfill the time-honored purposes of pleasing and instructing. In his *Autobiographical Notes* he wrote, "Subjects of most consequence are those that most entertain and Improve the mind and are of public utility." The emphasis on the didactic function of art in both social and personal matters reveals accurately Hogarth's overriding concern with his work as a moral-cultural force. Like Defoe and Richardson, Addison and Steele, Hogarth sought out and codified the individual and larger social concerns of the middle classes, the benevolence, humanitarianism, honesty, respectability and efficiency that were critical to their economic success and social acceptance.

In his presentation of these ideas the engraver was more intensely and consistently moralistic than any of his contemporaries. Violations of the middle-class ethic result, in Hogarth's work, in sanctions that are absolute or fatalistic. Secular rather than religious in nature, these sanctions are imposed either by society or by nature. The harlot dies of venereal disease, the rake goes mad, Squanderfield is killed by his wife's lover, his wife commits suicide and Silvertongue is hanged. Hogarth's positive sanctions are also strong and worldly, though not as powerful as the negative ones and less compelling—on the few occasions he chooses to present them. The industrious apprentice gains wealth, prestige and political power; the inhabitants of Beer Street live happy, dignified lives devoid of need and full of conviviality. Despite the rigors of the artist's didacticism, by and large, Hogarth's moral vision is comic, egalitarian and rational. Concerned to expose and reform, not destroy, this common-sense viewpoint is more critical than it is cynical and misanthropic.

As his statement on subject matter indicates, Hogarth was interested in two different types of didacticism; the first dealt primarily with individual or personal morality, with what he calls matters that "improve the mind"; the second treated subjects of social concern or "public utility." In his early work the engraver's main concern was with matters of personal morality. The people in "A Midnight Modern Conversation" injure only themselves. The protagonists in *A Rake's Progress* and *A Harlot's Progress* are likewise themselves the primary objects of their own folly and their world's hostility.

Even in these early prints, however, the artist's works are full of social commentary. The follies of the harlot and the rake extend beyond them; both have children, and the rake seems to ruin the lives of two women. The worlds they all live in are filled with hostile forces of overwhelming power, embodying the values of selfish gain and indiscriminate lust. At least in the case of the harlot, these forces are aggressive. They descend on her uninvited in the persons of Mother Needham and Colonel Charteris and, by means of a minor weakness, overwhelm her. In Rakewell's case the same hostile forces await anxiously the opportunity to destroy him which his vanity duly provides. Against

these antagonistic forces (which frequently have the power of wealth and influence behind them) the individual has little defense. In the final plate of *A Harlot's Progress* Moll's friends continue in their profession because they can do nothing else; trapped by their lack of power, they have no other possible way of life open to them but the fatal one they have been seduced into.

In Hogarth's later works his concern with social commentary predominates. "Beer Street" and "Gin Lane" were published in support of the Tippling Act, a legislative measure curbing the unlimited sale of gin. Tom Nero's and Tom Idle's acts are crimes against society, and it is against these—cruelty to animals, robbery, murder—that Hogarth moralizes. It is revealing that while the harlot and the rake are punished by their own natures which they somehow helped violate, it is society and its laws which punish Idle, Nero and Silvertongue.

Nor does Hogarth confine himself to depicting these symptoms of social ills. In Plates I and IV of *Industry and Idleness*, he sketches the grim, alienating working conditions of a primitive industrial society where employment for women and men is already impersonal and uniform and where the need for escapist activities like drinking and gambling is plausible. From these conditions he shows only one man escaping, and that man's rise is assured only through marriage to his wealthy master's daughter. In "Gin Lane" he reveals the poverty of the working classes and the insufferable conditions in which they live, which are not only effects but also causes of gin drinking. Conscious also of the influence of those in position of economic and political power, he outlines in *Marriage à la Mode* the dreadful outcome of the black arts of those who play with human lives for economic gain and social advancement.

Hogarth's didactic intention has been questioned because so much of the behavior he dealt with was obscene, nefarious and criminal. His attention to the details of the lives of harlots, rakes, drunkards and murderers has been construed as an indication of his repressed interest in and identification with the lewd and vicious that belies his overt didacticism. Does he not use didacticism merely as a justification for dealing in the fascinations of venereal and criminal matters, as some charge Defoe and Richardson do in *Moll Flanders* and *Pamela*?

While Hogarth's fundamental moral purpose and its consistency cannot be doubted, it is true that the nature of his moral vision did change in intensity and direction over the course of his career. In his very early works, for example, he combatted such threats to middle-class morality as gambling ("The Lottery"), sexual licence and affected foreign tastes ("A Just View of the British Stage").

At the same time he engraved a number of playful subjects in morally neutral styles. "Southwark Fair," *The Four Times of the Day* and "Strolling Actresses" ("for wit and imagination, without any other end," says Horace Walpole in his *Anecdotes of Painting* of this print, "I think the best of all his works") are light, comic engravings devoid of overt moral purpose. *Before and After* with its humorous, amoral treatment of sex, belongs to the same class of engravings. The decadent aristocratic culture of the Restoration which was still felt when Hogarth was a youth had a powerful effect on him, and it is aspects of this culture that he expresses in these early prints. However, as he grew older, his interest in didacticism and in serious subject matter increased. In

early works like *A Harlot's Progress* and *A Rake's Progress* the matter is salacious. In later works Hogarth avoided lewd topics entirely; indeed, in a number of his revisions ("Boys Peeping at Nature," for example) he removed or toned down references to sexual matters which had been part of his original design. In place of these topics he treated, with increasing pessimism, subjects of high seriousness like religion, his own art, death and partisan politics.

Comic

Though the artist's didacticism may be less than congenial to twentieth-century audiences, the pleasing or comic aspects of Hogarth's art delight and entertain today with the same power as they did when his prints first appeared. The sources of the engraver's comedy are various. He makes some interesting uses of visual puns, for example, playing wittily with several meanings of words or objects in his scene. The players who tumble earthward in their regal costumes in "Southwark Fair" with such utter loss of dignity have been performing *The Fall of Bajazet*. Tom Rakewell's miserly father has cut the sole of his shoe out of the Bible just before his death. In "Evening," the horns of the animal are so placed as to appear to belong to the little dyer, who apparently has been cuckolded by his vain, oppressive wife. In "Time Smoking a Picture," an anthropomorphic Time sits beside a painting, blowing smoke on its surface from his pipe. Hogarth's grim "Tail Piece: The Bathos," is filled with puns on "end" and "last"; in the foreground of that print, for example, a cobbler's waxed end is wrapped around a last.

The engraver also makes humorous use of attitudes (usually very solemn, dignified attitudes) from classical works of art by recreating comic variations of them in his own contemporary settings. Such motifs invite comparison between an idealized past in which conflict is generated around abstract, heroic issues and an earthy, robust present where motives are frankly sexual and economic but by no means always debased or low. Imaginative reinterpretations of the sublime *Hercules at the Crossroads* occur frequently in the engraver's plates. The smiling farmer in "Canvassing for Votes" is solicited by archetypally similar political henchmen; he seems to incline his ear to the one with the most money. In the foreground of "The March to Finchley," two women of opposite political parties vie for a soldier. The dejected fellow seems interested in neither. In "An Election Entertainment" a Puritan saint resists the threats of his wife and the seductions of a party hack to barter his vote. A similar burlesque structure appears in "A Midnight Modern Conversation" and "Pit Ticket: The Cockpit." There Hogarth ridicules the characters and their actions by describing low scenes of gambling and drinking in terms of Leonardo da Vinci's sublime *Last Supper*.

Hogarth's characters are also an important part of his comedy. Though most of his figures are highly individualized, in many of his characters comic types emerge from his individuals. Doctors and clergymen are among the engraver's favorite and most accurately hit satiric targets. Almost all of Hogarth's doctors are charlatans. The two physicians (identified as Dr. Rock and Dr. Misaubin) consumed by a petty quarrel while Moll dies before their eyes are timeless examples of shameless, money-grabbing quacks. His clergymen, who are more often portrayed at table or beside a punch bowl than at their religious duties, are libertines.

The Fleet clergyman who presides at Moll's wake is a humorous example of the alcoholic, lecherous parson. But Hogarth is not partial to these professions only; few occupations and classes escape his satire. Soldiers are thieves, not protectors; lawyers are robbers; politicians are confidence men; professors are bores. The poor are drunkards and petty tyrants; the rich are shiftless adventurers; the middle classes are composed of misguided social climbers.

In drawing his characters the artist was particularly sensitive to the contrasts and juxtapositions that he could establish between them. For him these contrasts and incongruities were a rich source of comic insight. The wizened faces of the two scheming Jacobites in "The March to Finchley" are laughable because set next to them is the bright, innocent face of a child. The same comic incongruity exists between the burly female and the effeminate politician she kisses in "An Election Entertainment," and between the undertaker in heat and the detached, thieving object of his consuming passion in the last plate of *A Harlot's Progress*. The comic and tragic intermingle freely in Hogarth's art and this same device of contrast is also a powerful source of the tragic in his works. The unsuspecting faces of the children are to be contrasted to the death pallors on their mothers' faces in *A Harlot's Progress* and *Marriage à la Mode*.

Like Fielding, Hogarth saw the comic and the moral as bound up together. "Great Vices are the proper Objects of our Detestation, smaller Faults of our Pity: but Affectation appears to me the only true Source of the Ridiculous," wrote the novelist in the Preface to *Joseph Andrews*. Hogarth agreed with him completely. In his works this type of humor sometimes grows out of the situations he sets his characters in. Moll is a comic figure in the Bridewell scene because her elegant dress is incongruous to one in her incarcerated state; she, of course, is too affected and distressed to see this, though the two old hags to the right are anxious to point it out. The pretentious politicians in the *Election* series attempt to pass off their manipulative celebration as an "entertainment"; in reality, it is a combination of brawl, orgy and bacchanalia. The formal escutcheon framing "The Company of Undertakers" contrasts with the sour faces of the quacks absorbed in their urine-inspecting ritual.

Sometimes the affectation is a product of character. Much of the wit in "Strolling Actresses" results from the seriousness with which the low characters take the sublime roles they are to play. Hogarth believed in the sufficiency of middle-class culture and the vicious nature of aristocratic life styles, and was particularly sensitive to the perverse, fruitless and often comic attempts of the lower and middle classes to become part of the aristocracy and ape their manners. As a result a great part of the engraver's comedy is based on the affectation of social climbers. The sweep who takes snuff so preciously in "Pit Ticket: The Cockpit" is ridiculous because he is mimicking the manners of a class utterly remote from him.

The same type of affectation, interestingly enough, is at the source of much of both the comedy and tragedy in *A Rake's Progress, A Harlot's Progress* and even *Marriage à la Mode*. In all of these works, the efforts of lower and middle-class people to improve their lots result in comic incongruities like the attractive, youthful Rakewell's marriage to a wizened old hag, and the beautiful young Hackabout's alliance with the ugly middle-aged businessman. Ultimately, however, this affectation brings about death or insanity for all the protagonists, none of whom survive beyond the prime of their youth.

CONCLUSION

William Hogarth not only felt the pulse of his age, he quickened it. For this reason his work is of critical importance to students of the eighteenth century. But Hogarth's vision probes deeper than the manners of his own age. He recorded with verve and energy in a lasting reportorial style the fortunes of the English middle and lower classes in their efforts to establish themselves in a world dominated by an older order often hostile to them and their values. He pictured too the subtle and overt violence inflicted by a mercenary urban society upon its special prey: the poor, children, women. And he recorded also the perennial vanity, cruelty, folly and self-delusion people practice on themselves and on each other, both in their grim and in their comic manifestations. For these reasons Hogarth's work is delightful and instructive in ways which his commentators can never adequately explicate or measure, and which time, despite his fear of it in the "Tail Piece: The Bathos," can only enhance.

A Chronology of the Life of William Hogarth

The text of this biography is based largely on Hogarth's own *Autobiographical Notes*, which, written toward the conclusion of his life, offer the most instructive approach presently available to the artist and his work. Only to a minimal degree have punctuation, spelling and capitalization been emended and words inserted or omitted from his rough draft to clarify the artist's sense. As a result much of Hogarth's notoriously irregular spelling and awkward phrasing has been retained.

Included at various points in the chronology are George Vertue's informative but often hostile comments on Hogarth's career. Vertue, a contemporary of the artist, was himself an engraver, and his *Note Books* provide valuable first-hand information about Hogarth's professional life. Vertue's remarks have been edited in the same manner as the quotations from Hogarth's *Autobiographical Notes*.

1697

William Hogarth, according to the parish register at Great St. Bartholomew's Church, was born "next doore to Mr. Downinge's the Printer's, November ye 10th," in Bartholomew Close, an old middle-class section of London. Father, Richard Hogarth, a schoolmaster, literary hack and classical scholar of considerable ability.

1703–1711

Educated by his father and in grammar school. Of this period he says in retrospect: "I had naturally a good eye; shews of all sort gave me uncommon pleasure when an Infant; and mimickry, common to all children, was remarkable in me. An early access to a neighbouring Painter drew my attention from play; every oppertunity was employd in attempt at drawing. I pickt up acquaintances of the same turn. When at school my exercises were more remarkable for the ornaments which adorn'd them than for the Exercise itself. I found Blockheads with better memories beat me in the former, but I was particularly distinguished for the latter."

1712

"Taken early from school and served a long apprenticeship to a Silver plate Engraver," one Ellis Gamble, at the Golden Angel in Leicester Fields.

c 1717

Found engraving on silver "too limited in every respect. Engraving on copper was at twenty his utmost ambition." These reasons and the inspiration derived from the art in Greenwich Hospital and St. Paul's done by Sir James Thornhill, a baroque artist of ability, and the architect Sir Christopher Wren, determined Hogarth to keep to "this Engraving no longer than necessity obliged me to it."

1718

Father died in May of "Illness occationd by partly the useage he met with from this set of people [grasping booksellers] and partly by disapointments from great mens Promises."

1720

Attended John Vanderbank's drawing school and trained memory to make available certain common set-pieces which would enable him to become proficient in painting and engraving. "For want of beginning early with the Burin on copper Plates as well as that care and patience I dispaired of at so late as twenty of having the full command of the graver—for on these two virtues the Beauty and delicacy of the stroke of graving cheifly depends—it was much more unlikely, if I pursued the common methods of copying and drawing, I should ever be able to make my own designs as I was ambitious of doing. I therefore endeavoured a habit of retaining what ever I saw in such a manner as by the repeating in my mind the parts of which objects were composed, I could by degrees put them down with my pencil so that when I was about my Pleasure or amusement I was at the same time upon my studies."

April, issued own shop card establishing himself as independent engraver working for booksellers, goldsmiths, merchants and families.

1720–1727

Designed coats of arms, shop cards, funeral and benefit tickets, illustrations for books and some satirical engravings.

"An Emblematical Print on the South Sea Scheme (1721) and "The Lottery" (1721), first topical satiric prints.

Other prints from this period: "A Just View of the British Stage" (1724) and the illustrations for *Hudibras* (1725/6), Hogarth's most important work from this period. "Another work appeard which was well enough accepted," Vertue relates, "being undertook by printsellers, the several Stories of Hudibrass, designd in a burlesque manner humoring very naturally the Ideas of that famous poem. These designes were the Invention of Wm. Hogarth, a young Man of facile and ready Invention, who, from a perfect natural genius improvd by some study in the Accademy under the direction of Cheron and Vanderbank, has producd several charactures in print; if not so well gravd, yet still the humours are well represented, whereby he gain'd reputation. From being bred up to small gravings of plate work and watch workes, he has so far excelld that by the strength of his genius and drawing, and now applying himself to painting of small conversation peices, he meets with good encouragement according to his Meritt."

At publication of the engraving "Masquerade Ticket" (perhaps because of it) became acquainted with Sir James Thornhill, Serjeant Painter to the King. Thornhill responsible for a number of frescoes on historical and mythological subjects in the grand or sublime manner, a style Hogarth never ceased to aspire to. Attended Thornhill's Covent-Garden Academy.

1728–1732

Shift in emphasis from engraving to painting in Hogarth's career. "Then maried [Sir James Thornhill's only daughter Jane, secretly, March 25, 1729, at Old Paddington Church] and turned Painter of Portraits in small conversation Peices [i.e. small, full-length group portraits ten to fifteen inches high of figures in informal poses and settings] and great success, but that manner of Painting was not sufficiently paid to do every thing my family requird."

"Mr Hogarths paintings," Vertue observes around 1730, "gain every day so many admirers that happy are they that can get a picture of his painting. A small peice of several figures representing a Christening being lately sold at a public sale for a good price got him much reputation. Also another peice representing the Gentlemen of the Committee of the House of Commons in the jails setting upon the examination of those malefactors was well painted and their likeness is observd truely. Many other family peices and conversations consisting of many figures done with great spirit, a lively invention and an universal agreeableness."

1732

A Harlot's Progress engraved from six pictures painted c 1731. Issued in April to twelve hundred subscribers.

May 27, set forth from Bedford Arms Tavern on famous "peregrination" with four comrades: John Thornhill, brother-in-law, William Tothall, draper, Samuel Scott, landscape painter, Ebenezer Forrest, lawyer. Group spent five convivial days wandering around Kent in carefree spirits. The lark immortalized in journal of tour written by Forrest and illustrated by Scott and Hogarth.

1733

Took up residence in a house in Leicester Field at the sign of the Golden Head; lived there for the remainder of his life.

1734

"Saturday night May 4. Died Sr. J. Thornhill Knt, the greatest History painter this Kingdom has produced," writes Vertue. "Witness his elaborate workes in that noble Structure of Greenwhich Hospital, the Cupola of St. Pauls Cathedral, the Altar peices in the Chappel of All Souls college, Oxford and in the Church of Weymouth, the place of his Nativity.

"He left a son, Mr. J. Thornhill, who by the interest of Sr. James got to be Sergeant Painter and painter to the Navy Royal. An only daughter married Mr. Wm. Hogarth painter and Engraver, admired for his curious conversations and paintings, as well serious as humourous. Sr. James has left a great Collection of pictures and other Curiosities."

Hogarth inherited furniture and equipment from his father-in-law's school; used this to set up cooperative academy with other artists in St. Martin's Lane. School survived till founding of Royal Academy.

1735

Mother died.

"After having had my first plates Pirated in all sides and manner, I applied to parliament for redress which not only has so effectualy done my business but has made prints a considerable article and trade in this country, there being more business of that kind done in this Town than in Paris or any where else." This act of Parliament, Hogarth's Act, giving engravers and designers exclusive rights to their work for fourteen years, received Royal Assent May 15.

A Rake's Progress, engraved from paintings completed in 1734. Issued June 25, day after Hogarth's Act became law. This progress secured his reputation with his contemporaries.

1736–1744

Hogarth again more interested in painting life-size portraits and oils in the sublime style than engraving.

"The puffing in books about the grand stile of history painting put him upon trying how that might take. So, without haveing a stroke of this grand business before him, imediatly, from family pictures in smal, he painted a great stair case at Bartholomews Hospital with two scripture-stories, the Pool of Bethesday [1735–1736] and the Good Samaritan [1736], figures 7 foot high. This present to the charity he gave. By the pother made about the grand stile, thought they might serve as a specimen to shew that, were there any inclination in England for Historical painting, such a first essay would Proove it more easily attainable than is imagined. But religion, the great promoter of this stile in other countries, in this rejected it."

Visited Paris in 1743 with the intent, in Vertue's opinion, "to cultivate knowledge or improve his Stock of Assurance."

Chief portraits in oil for this period: *Peg Woffington* (1740), *Lavinia Fenton* (1740), *Captain Coram* (1740), *Graham Children* (1742), *Mrs. Salter* (1744).

Principal engravings of this time: *Before and After* (1736), "The Distrest Poet" (1736/7), *The Four Times of the Day* (1738), "Strolling Actresses" (1738), "The Enraged Musician" (1741).

1745

Marriage à la Mode appeared in June after pictures completed by Hogarth c 1743. For the prints "Hogarth employd 3 French Engravers; finisht the first of June, 1745—to the obscuration of my reputation," Vertue remarks despairingly.

c 1745

Only at this late date did Hogarth seem to recognize his ability as engraver and commit himself to that "intermediate species of subject ... between the sublime and the grotesque." And this probably because he considered the first auction of his comic history paintings to have failed miserably (he sold twenty for £450).

Vertue provides an interesting summary of Hogarth's career up to this point and recounts the artist's curious and unsuccessful attempt to sell his paintings. "As all things have their spring from nature, time and cultivation, so Arts have their bloom and Fruite as well in other places as in this Kingdom. On this observation at present a true English Genius in the Art of Painting has sprung and by natural strength of himself chiefly, begun with little and low-shrubb instructions, rose to a surprizing hight in the publick esteem and opinion. This remarkable circumstance is of Mr. Hogarth whose first practice was as an aprentice to a mean sort of Engraver of coats of arms which he left and applying to painting and study drew and painted humorous conversations in time with wonderful succes. From thence to portrait painting at large and attempted History thro' all of which with strong and powerfull pursuits and studyes. By the boldness of his Genious (in opposition to all other professors of Painting) he got into great Reputation and esteem of the Lovers of Art, Nobles of the greatest consideration in the Nation and by his undaunted spirit, despisd and under-valud all other present and preceedent painters such as Kneller, Lilly, Vandyke, English painters of the highest Reputation. Such reasonings or envious detractions he made the subject of his conversations and Observations to Gentlemen and Lovers of Art. Such invidious reflections he would argue and maintain with all sorts of Artists, painters and sculptors.

"But to carry a point higher, he proposed to sell his paintings, 6 of the *Harlots progress*, those of the *Rakes progress* and others of the 4 Times of the day and the Strolling Actresses, by a new manner of sale which was by Engravd printed tickets his own doing deliverd to Gentlemen, Noblemen and Lovers of Arts only (no painters nor Artists to be admitted to his sale). By this Letter and a day affixd to meet at his house the pictures were put up to sale to bid Gold only by a Clock set purposely by the minute hand—5 minutes each lott—so that by this means he coud raise them to the most value and no barr of Criticks' Judgement nor cost of Auctioneers. By this subtle means he sold about 20 pictures of his own paintings for near 450 pounds in an hour.

"Admitting that the Temper of the people loves humourous, spritely diverting subjects in painting, yet surely *the Foxes tale* was of great use to him. As Hudibrass expresseth:

> yet He! that hath but Impudence,
> to all things, has a Fair pretence."

Attempt in the grand manner failing, Hogarth tells us in his own account of this period, "I therefore recomend those who come to me for portraits to other Painters, and turn my thoughts to still a more new way of proceeding, viz painting and Engraving modern moral Subjects, a Field unbroke up in any Country or any age Dealing with the public in general I found was the most likely to work. provided I could strike the passions and by small sums from many, by means of prints which I could Engrav from my Pictures myself, I could secure my Property to myself." This decision resulted in Hogarth's redirecting his art toward the lower and lower-middle classes.

1746

Mr. Garrick in the Character of Richard the Third (both painting and engraving) and popular "Simon Lord Lovat" appeared.

Religious history painting, *Moses Brought to Pharaoh's Daughter,* done for Foundling Hospital.

1747

Industry and Idleness appeared in October, etched and engraved from preliminary drawings.

1748

Only public commission for a history painting, *Paul before Felix,* "done for to be placed in Lincoln's Inn chappel," Vertue tells, "but there being no propper room for it, it is placed in Lincoln's Inn hall over the Seat where the Lord chancellor sits. It is a great work and shows the greatness and magnificence of Mr Hogarths genius. It is placed too high and not so well to the light as it shoud be, but appears great and noble. These two pieces [the second piece is *Moses Brought to Pharaoh's Daughter*] he has proposed to put out in prints. This very piece in Lincoln's Inn hall procurd him by means of his Friends and their interest, being paid £200 left by will of chancellor Wyndham of Ireland and other monies for the picture and frame altogether. This really is a great work and of much honor so that it raises the character of that little man—tho not his person—whose additional cunning and skill and a good stock of assurance every way of the acutest kind possible causes him to be well paid beyond most others of the same profession."

1748–1749

Visit to France with artist friends occasioned *O the Roast Beef of Old England: The Gate of Calais* (painting completed in 1748). "The first time any one goes from hence to france by way of Calais, he cannot avoid

being struck with the Extreem different face things appear with at so little a distance from Dover. A farcical pomp of war, parade of religion and Bustle with very little business, in short, poverty, slavery and Insolence (with an affectation of politeness) give you even here the first specimen of the whole country. Nor are the figures less opposite to those of dover than the two shores. Fish women have faces of leather, and soldiers are ragged and lean. I was seiz by one of them and carried to the governor as a spy as I was sauntering about and observing them and the gate, which it seems, was build by the English when the place was in our possession—there is a fair appearance still of the arms of England upon it. As I conceild none of the memorandum I had privately taken and they being found to be only those of a painter for own use, it was Judged necessary only to confine me to my lodging till the wind changed for our coming away to England where I no sooner arived but set about the Picture wherein I introduced a poor highlander fled thither on account of the Rebelion brozing on scanty french fare in sight of a Surloin of Beef, a present from England which is opposed to the Kettle of soup meager. My own figure, in the corner with the soldier's hand upon my shoulder, is said to be tolerably like."

"O the Roast Beef of Old England: The Gate of Calais" and "Gulielmus Hogarth" engraved March 1748/9.

1750/1

"The March to Finchley" published. Exasperated and intrigued by Hogarth's ever-present business sense, Vertue gives a detailed account of his shrewd method of retailing the engraving. "Mr Hogarth proposed to publish a print the march to finchly of the army raisd in 1745, a drolle humorous, ridiculous print from a painting he had done, the print to be subscribed at 7s 6 each. Those that woud pay half a guinea should be entitled to a chance of Lottery for the painting also so that every person rather subscribed half a guinea than 3 half Crowns, by which means he gatherd about 1800 for Ticketts subscription before hand. Thus cunning and skill joynd together. For here in this case he valud the painting at 200 pounds its said (a great, unbounded price); however, by this means, he has raisd 900 pounds and still has the Engraved plate to dispose of prints at half guineas more. Therefore it may well be said, say well is good but do well is better. Such fortunate successes are the effect of cunning, artfull contrivances which men of much greater merritt coud never Get or expect. Of this picture it is said, having 200 Tickets unsubscribed on *the day*, 30 April, 1750, the Lot was to be drawn, he gave them to the Governors for the Hospitals of the Foundlings for their benefit whereby they became, by the Lot being drawn in one of their numbers, the possessors of the painted picture and all the rest went without it."

Beer Street and Gin Lane and *The Four Stages of Cruelty* appeared, etched and engraved from drawings.

1751

Hogarth's bizarre auction of the pictures for *Marriage à la Mode* a humiliating failure. "Mr Hogart, who is often projecting scheems to promote his business in some extraordinary manner, having some time ago made 6 pictures of marriage a la mode (from whence he had printed and published prints and sold very well to a large subscription) lately has a new scheem proposed in all the news papers to sell them by a new way of drawing lots. Persons who would buy them shoud write down the summ they woud give for them and leave that written paper for

others to make advances still more and more as they pleased till a certain day and hour; then the drawer to be openned and the highest bidder to be the proprietor of these pictures. As he thought the public was so very fond of his works and had showd often such great forwardness to pay him very high prices, he puffd this in news papers for a long time before hand. But alass when the time came to open this mighty secret, he found himself neglected. For instead of 500 or 600 pounds he expected, there was but one person he had got to bid without any advance the sum of 120 pounds, by which he saw the publick regard they had for his works. This so mortified his high spirits and ambition that it threw him into a rage and he cursd and damned the public and swore that they had all combind together to oppose him."

1753

The Analysis of Beauty, Hogarth's important statement on art theory, appeared December 1. Not well received by art critics and connoisseurs in England because of his status as a popular artist.

1755–1758

Four Prints of An Election etched and engraved from pictures painted c 1754.

1757

June 6, "obtained after my brothers Death, by means of my friend Mr. Manning and Duke of devonshire, the place of serjent painter which might have been one hundred a year to me for trouble and attendance but from two portraits of more than 80 pounds each, the last occationed by His present majesty's accession. In five years I have had at least one way or other £200."

c 1758

"An amiable nobleman prest before I entirely quitted the pencil, to paint him a pickture, leaving the subject to me, and any price I askd I was to have as my payment when the Picture was finished, the subject of which was a virtuous, married lady that has lost all at cards to a young officer wavering at his suit whether she should part with her Honour or no to regain the Loss which was offered her." Work entitled *The Lady's Last Stake.*

c 1759

Painted *Sigismunda*, a large oil in the Bolognese manner. Hogarth embittered by refusal of its commissioner to purchase it.

"A Gent^lm, now a noble man, seeing this Picture [*The Lady's Last Stake*], being infinitely Rich, Prest me with more vehimence to do what subject I would, upon the same terms much against my inclination. I began on a subject I once wished to paint. I had been ever flattered as to expression; my whole aim was to fetch Tears from the Spectator; my figure was the actor that was to do it: Sigismunda grieving over her lovers heart

"My price for it was what had been at that time bid for a picture of that Subject painted by a french master falsely said to be corregio. As I had spent more time and anxiety upon it than would have got me double the money in any of my other ways and not half what a common

face painter got in the time I ask four hundred. [Sir Richard Grosvenor refused to purchase the work.] I kept my Picture; he kept his money."

1762

"Credulity, Superstition and Fanaticism" appeared in April.

"The turmoil which attended this affair [the rejection of *Sigismunda*] coming at a time when perhaps nature rather wants a more quiet life and something to cheer, brought on an Illness which continued a year which a horse cheifly (when I got well enough to ride) recovered me of, but the loss of so much time and the inattention to Prints, occationd by the wars abroad and contentions at home, made it necessary to do some timed thing that would stop a gap in my income; produced the Print call the Times, the subject of which tended to Peace [i.e. the Peace of Paris which ended the Seven Years' War] and unanimity and so put the opposers of this humane purpose in a light which gave offence to the Fomenters of distruction in the minds of the people. One of the most notorious of whom till now my friend, a flatterer [John Wilkes, flamboyant and courageous Opposition leader, aroused by the artist's propagandizing for George III against the interests of the middle class] attacked me in a North Briton in so infamous a manner that he himself, when pushd by even his best friend, would not stand it, and was driven to so poor an excuse as to say he was drunk when he wrote. Being at my work in a kind of slow fever, it could not but hurt."

1763

"My best was to return the complement and turn it to some advantage. His Portrait ['John Wilkes Esqr.'], done as like as I could as to feature and at the same time some indication of his mind, fully answerd my purpose. The ridiculous was apparent to every Eye, a Brutus, a saviour of his country with such an aspect was an arrant Joke that, tho it set every body else a laughing, gauld him and his adherents to death.

"At length Churchill [Charles Churchill, Wilkes' ally in the affair] toadeater, put the North Briton attack into verse in an Epistle to me. But as the abuse was the same except a little poetical heighting which always goes for nothing, it not only made no impression but in some measure effaced the Black stroke of the North Briton. However having an old plate by me with some parts ready such as the Back ground and a dog, I thought how I could turn so much work laid aside to account. So patch up a print of Mr. Churchill in the character of a Bear ['The Bruiser'].

"The satisfaction and pecuniary advantage I receivd from these two prints together with constant Riding on horse back restored me as much health as can be expected at my time of life. What may follow god knows. Finis."

1764

"Tailpiece: The Bathos" appeared in April.

October 26, William Hogarth died. Buried in Chiswick Churchyard, where in 1771 friends erected tombstone to him bearing an epitaph by his old friend David Garrick, the actor:

> Farewel, great Painter of Mankind!
> Who reach'd the noblest point of Art
> Whose *pictur'd Morals* charm the Mind,
> And through the Eye correct the Heart.
>
> If *Genius* fire thee, Reader, stay:
> If *Nature* touch thee, drop a tear;
> If neither move thee, turn away,
> For Hogarth's honour'd dust lies here.

Bibliography

BASIC CATALOGUES AND COLLECTIONS

Beckett, R. B. *Hogarth*. London: Routledge and Kegan Paul, 1949.

 A complete catalogue raisonné of Hogarth's paintings, most of which are reproduced, together with an essay on the artist as a painter.

Burke, Joseph, and Colin Caldwell. *Hogarth The Complete Engravings*. New York: Harry N. Abrams, 1968.

 This complete edition of Hogarth's prints provides a briefer commentary than Paulson's work. It reproduces some of the preliminary sketches and paintings not in Paulson's volume. It also includes a great many full-size details from the engravings.

Hogarth, William. *The Analysis of Beauty*. Edited by Joseph Burke. Oxford: The Clarendon Press, 1955.

 The definitive edition of the artist's *Analysis*; also includes Hogarth's *Autobiographical Notes*.

Mitchell, Charles, ed. *Hogarth's Peregrination*. Oxford: The Clarendon Press, 1952.

 Includes Ebenezer Forrest's prose account and William Gostling's Hudibrastic narrative of a trip through Kent made by Hogarth and his friends; reproduces Hogarth's and Scott's illustrations to the account.

Oppé, A. P. *The Drawings of William Hogarth*. London: Phaidon Press, 1948.

 An illustrated catalogue of Hogarth's drawings with an analysis of his art and method as a draughtsman.

Paulson, Ronald. *Hogarth's Graphic Works*. 2 vols. New Haven: Yale University Press, 2nd edition, 1970.

 The definitive edition of Hogarth's graphic works.

BIOGRAPHIES, COMMENTARIES AND CRITICAL STUDIES

THE EIGHTEENTH CENTURY

Gilpin, William. *An Essay on Prints*. London: R. Blamire, 1781.

 A somewhat negative evaluation of Hogarth's technical abilities as an artist and engraver.

Ireland, John. *Hogarth Illustrated*. 2 vols. London: J & J. Boydell, 1790.

 An illuminating commentary on Hogarth's individual prints.

————. *A Supplement to Hogarth Illustrated: Compiled from his Original Manuscripts in the Possession of John Ireland*. London, 1798.

 Prints a "methodized" version of some Hogarth manuscripts obtained by Ireland after the artist's death. Includes a version of the *Autobiographical Notes*.

Ireland, Samuel. *Graphic Illustrations of Hogarth from Pictures, Drawings and Scarce Prints in the Possession of Samuel Ireland*. London: R. Faulder, 1776.

Includes copies of "a number of curious productions from the pencil of our artist; and such as either have not been communicated to them [the public], or at least have not been authenticated as his." Not all these miscellaneous prints are his.

Nichols, John, and George Steevens. *The Genuine Works of William Hogarth: Illustrated with Biographical Anecdotes, a Chronological Catalogue, and Commentary.* 2 vols. London: Longman, Hurst, Rees and Orme, 1808–1810.

The Genuine Works of William Hogarth; with Biographical Anecdotes. 3 vols. Vol. 3. London: Nichols, Son and Bently, 1817.

A more elaborate biography and a fuller account of the Hogarth canon than Nichols, Steevens and Reed provide. Includes an edition of *The Analysis of Beauty* and other Hogarthiana.

[Nichols, John; George Steevens; Isaac Reed; et al.] *Biographical Anecdotes of William Hogarth; and a Catalogue of his Works Chronologically Arranged; with Occasional Remarks.* London: J. Nichols, 1781.

A short, anecdotal account of Hogarth's life and a commentary on his works (guided by Walpole's essay in his *Anecdotes*) to which is added a bibliography of his engravings.

[Rouquet, Jean] *Lettres de Monsieur *** à un de ses Amis à Paris, pour lui Expliquer des Estampes de Monsieur Hogarth.* London: R. Dodsley and M. Cooper, 1746.

An important "official" commentary on the *Harlot, Rake* and *Marriage* written at Hogarth's instigation to accompany his prints sent to the Continent.

Trusler, John. *Hogarth Moralized. Being a Complete Edition of Hogarth's Works. Containing near Fourscore Copper-Plates, Most Elegantly Engraved. With an Explanation, Pointing out the Many Beauties that May have Hitherto Escaped Notice; and a Comment on their Moral Tendency. Calculated to Improve the Minds of Youth, and, Convey Instruction, under the Mask of Entertainment.* London: S. Hooper, 1768.

"While I moralized, I studied to explain; and while I explained," says Trusler, "I studied to moralize." The result, in the words of John Nichols, is "a very dull and languid though very moral commentary."

Vertue, George. *The Walpole Society, Vertue Note Books.* Vols. 3 and 6. Oxford: The University Press, 1934 and 1955.

An important source of information on Hogarth's career by a contemporary member of his own profession.

Walpole, Horace. *Anecdotes of Painting in England.* Vol. 4. London: J. Dodsley, 1781.

Insightful essay on Hogarth's prints by a contemporary who knew him; reductive analysis of his paintings.

THE NINETEENTH CENTURY

Hazlitt, William. "Lectures on the Comic Writers on the Works of Hogarth." *The Complete Works of William Hazlitt,* edited by P. P. Howe, vol. 6. London and Toronto: J. M. Dent, 1931.

An appreciation of Hogarth's work primarily in terms of the grand and the familiar styles of painting.

Lamb, Charles. "On the Genius and Character of Hogarth." *The Works of Charles and Mary Lamb,* edited by E. V. Lucas, vol. 1. London: Methuen, 1903.

An appreciation of Hogarth combating his reputation as a mere comic painter inferior (particularly in moral purpose) to men like Reynolds and Poussin.

Lichtenberg, G. C. *Lichtenberg's Commentaries on Hogarth's Engravings.* Translated by Innes and Gustav Herdan. London: The Cresset Press, 1966.

A stimulating but at times tediously discursive interpretation of some of Hogarth's major engravings.

Smith, J. Y. *Nollekens and his Times: Comprehending a Life of that Celebrated Sculptor; and Memories of Several Contemporary Artists from the Time of Roubiliac, Hogarth, and Reynolds, to that of Fuseli, Flaxman, and Blake.* 2 vols. New York: John Lane, 1917.

Contains a brief anecdotal memoir of Hogarth.

Hogarth on High Life. The Marriage à la Mode Series from George Christoph Lichtenberg's Commentaries. Translated and edited by Arthur A. Wensinger with W. B. Coley. Middletown: Wesleyan University Press, 1970.

An elaborate edition of Lichtenberg's description of *Marriage.* Reproduces the paintings, the original prints and the German version of them Lichtenberg knew. Includes extracts from Lichtenberg's letters, Rouquet's "Explanation" of the series and a rare English poetic commentary on the work.

Stephens, F. G. *Catalogue of Prints and Drawings in the British Museum. Division 1, Political and Personal Satires.* Vols. 2, 3 and 4. London: Chiswick Press, 1873–1883.

The fullest, most detailed historical and factual description of and commentary on Hogarth's plates and their background.

THE TWENTIETH CENTURY

Antal, F. *Hogarth and His Place in European Art.* New York: Basic Books, 1962.

A superb study on Hogarth in his aesthetic, social and intellectual milieu.

Bowen, Marjorie. *William Hogarth, The Cockney's Mirror.* New York: Appleton Century, 1936.

An account of the milieu of Hogarth's life and art with a discussion of his career, character and attitude toward his genius. Analyzes his principal pictures and prints and describes his work from an aesthetic viewpoint. Vivid but uneven. Contains some interesting remarks on the position of women in Hogarth's art and society.

Klingender, F. D. *Hogarth and English Caricature.* London: Pilot Press, 1944.

"A picture book about popular art in England during the eighteenth and early nineteenth centuries."

Moore, Robert E. *Hogarth's Literary Relationships.* Minneapolis: University of Minnesota Press, 1948.

An attempt to characterize the relationship between Hogarth and Smollett, Fielding and some Grub Street writers. For a challenging response to this book, and an excellent discussion of the relationship between Hogarth and Fielding, see Antal's "The Moral Purpose of Hogarth's Art," *Journal of the Warburg and Courtauld Institutes* 15 (1952):169–197.

Paulson, Ronald. "The *Harlot's Progress* and the Tradition of History Painting." *Eighteenth-Century Studies* 1 (1967):69–92.

A case for *A Harlot's Progress* as a new form of history painting.

———. *Hogarth: His Life, Art, and Times.* 2 vols., New Haven: Yale University Press, 1971.

The definitive biography of Hogarth.

Quennell, Peter. *Hogarth's Progress.* New York: Viking Press, 1955.

A lively, readable introduction to Hogarth and his works most useful to the general reader.

Read, Stanley E. *A Bibliography of Hogarth Books and Studies, 1900–1940.* Chicago: De Paul University, 1941.

An annotated bibliography of Hogarth studies with an introductory essay tracing his reputation from 1764 to 1940.

Wheatley, Henry B. *Hogarth's London.* New York: Dutton, 1909.

"Hogarth as a delineator of manners and an illustrator of London topography."

The Plates

AN EMBLEMATICAL PRINT ON THE SOUTH SEA SCHEME

ETCHED AND ENGRAVED. FIRST STATE. 1721. $10\frac{5}{16} \times 12\frac{7}{8}$*

This print, executed in the tradition of the topical political caricature, was prompted by the mania for political speculation begun around 1711 and concluding nine years later in general financial chaos and ruin. In return for assuming a portion (later all) of the national debt, the South Sea Company was granted a monopoly on trade between South America, the Pacific Islands and England. The resources of these then exotic, unknown lands were considered rich and limitless.

Initially, the company prospered and advanced more ambitious schemes. A swarm of other companies grew up in imitation of the South Sea Company, proposing such undertakings as the invention of a wheel for perpetual motion, one even proposing a "design which will hearafter be promulgated." Speculation raged through England and soon shares had increased in price beyond the remotest possibility of profitable return. In 1720 the South Sea Company stock rose from £128 per share in January to £330 in March to £550 in May to £1,000 in July. Panic resulted. By the end of 1720 the stock market had collapsed, the South Sea "bubble" had burst and thousands of naïve speculators were ruined.

This bluntly allegorical work depicts a populace consumed by speculation of all kinds to the point where they have forsaken their middle-class concerns for trade, industry, religion, honor and honesty. In the center of the carnival-like scene, which is filled with violence and chaos, there stands a merry-go-round operated by South Sea Company projectors. Mounted on it are a bizarre variety of figures: a terrified Scots noble (he wears a "blue garter"), a gleeful, witch-like hag, an idle bootblack and a clergyman in dalliance with a prostitute. Atop this wheel of fortune stands a goat, the symbol of desire, set between the horns of cuckoldry on the house where women choose husbands by lot and the distant cross on the pointedly remote St. Paul's.

To the left, the Guildhall (identified by the statue of Magog) has been possessed by a devil (he is also a Father Time figure—he stands with a scythe beneath a clock) who butchers Fortune and throws her flesh to the mob, who scuffle for it. A schoolmaster in the crowd is being robbed. In the corner three other "teachers" of differing faiths play hustlecap in attitudes which, as Antal points out, suggest "Playing at Dice for Christ's Mantle." In the foreground "Honesty" is broken on the wheel attended only by an impassive clergyman.

Under the London Fire Monument, which is now adorned with foxes, "Honour" is scourged by "Vilany," who prepares to murder his victim; the mask has fallen from the victimizer's face. His assistant is an ape who takes the shirt from the Christ-like "Honour's" back. In the shadows, "Trade" languishes alone on the ground.

* The dimensions are given in inches, height before width.

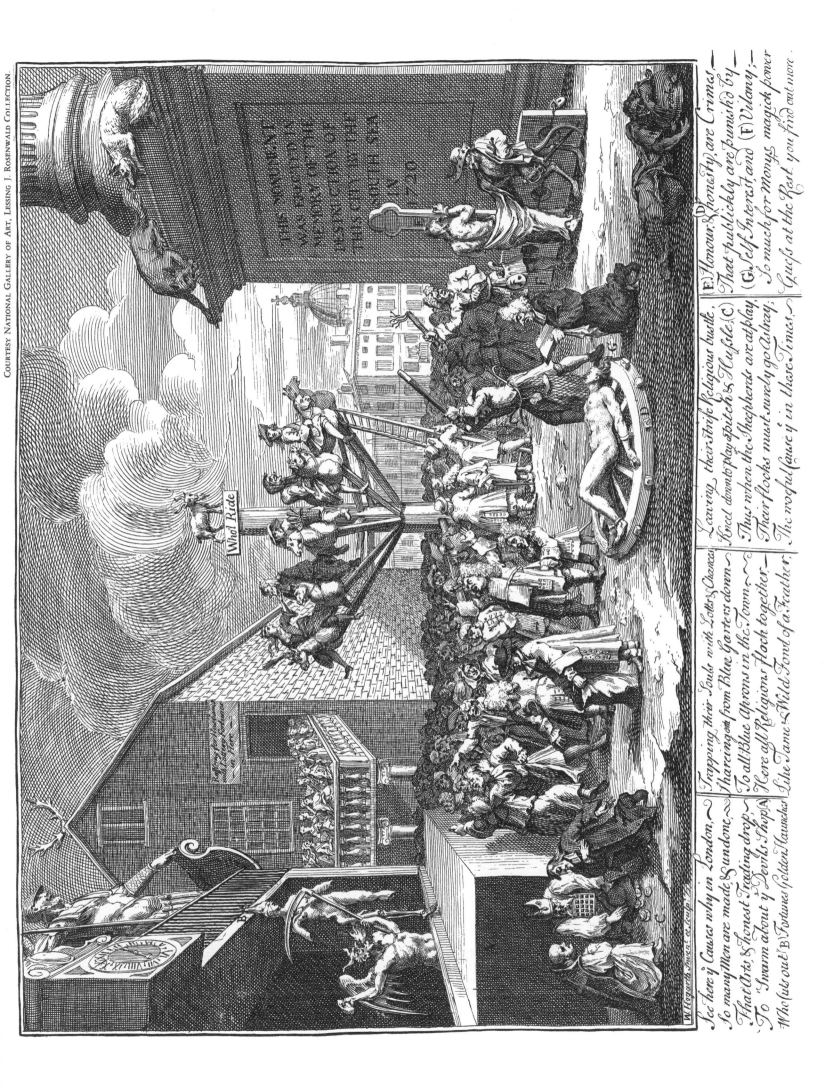

THE LOTTERY

ETCHED AND ENGRAVED. FOURTH STATE. 1721. $10\frac{1}{4} \times 12\frac{15}{16}$

This companion work to the "South Sea Scheme" is an exposé of the evil effects of lotteries which were used by the state to raise money in the seventeenth and eighteenth centuries. Didactic in purpose and middle-class in values, it reveals well how early Hogarth's interests and bias were formed.

The scene, which is given a dramatic, stage-like effect by its drapery, contains a number of allegorized bourgeois virtues and vices arranged in balance and antithesis. Following the practice common in such prints, the commentary is full and explicit.

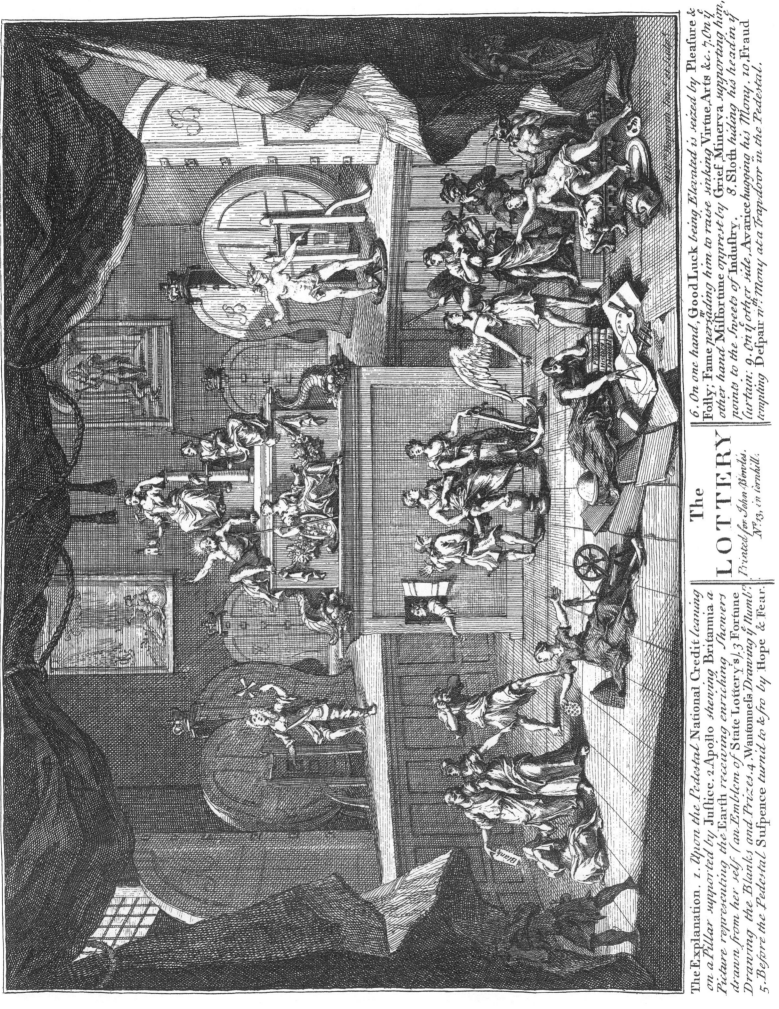

The Explanation. 1. Upon the Pedestal. National Credit leaning on a Pillar supported by Justice. 2. Apollo shewing Britannia a Picture representing the Earth receiving enriching Showers drawn from her self (an Emblem of State Lottery's) 3. Fortune Drawing the Blanks and Prizes. 4. Wantonness Drawing y' Numb'. 5. Before the Pedestal Suspence turn'd to &fro by Hope & Fear. || 6. On one hand, GoodLuck being Elevated is seized by Pleasure & Folly; Fame persuading him to raise sinking Virtue.Arts &c. 7. On y' other hand Misfortune oppress'd by Grief, Minerva supporting him. 8. Sloth hiding his head in y' curtain. 9. On y' other side, Avaricehugging his Mony, 10.Fraud tempting Despair n'. Mony at a Trap-door in the Pedestal.

The
LOTTERY
Printed for John Bowles,
N'. 13, in Cornhill.

3

SOME OF THE PRINCIPAL INHABITANTS OF YE MOON: ROYALTY, EPISCOPACY AND LAW

ETCHED AND ENGRAVED. 1724. $7\frac{5}{16} \times 7$

This iconoclastic emblem, executed in a surrealistic style, is a daring attack upon the English ruling class from a middle-class point of view. Playing on the worldly operations of these celestial (and lunar) figures, it depicts kings, bishops and lawyers as empty, mechanical forms having the power to manipulate but being composed only of the symbols with which they are decorated.

The circular form of the print is designed to suggest the field of vision offered by a telescope. On an elevated structure sits a king bearing a scepter and orb; he has a coin for a head. A bishop is resting his limbs on a luxurious pile of cushions; his head, a Jew's harp, operates a money-making machine by means of a prayerbook tied to its crank.

The machine, shaped like a church steeple, is topped by a weather vane, which like the moons on the king's orb and scepter, is a symbol of inconstancy. This device pours money into a chest bearing a coat of arms that reveals the hierarchy's preoccupation with food.

The overdressed lawyer, whose might resides in his gigantic sword and dagger, has a mallet as a head. The lawyer is flanked by two symbols of a dilettantish, aristocratic society; the woman has a teapot as a head, a glass as a neck and a fan as a torso. Her effeminate companion has a coat of arms for a head and two decorated fan sticks for legs. The king is flanked by his courtiers, who have mirrors as bodies and money as heads, and by his army.

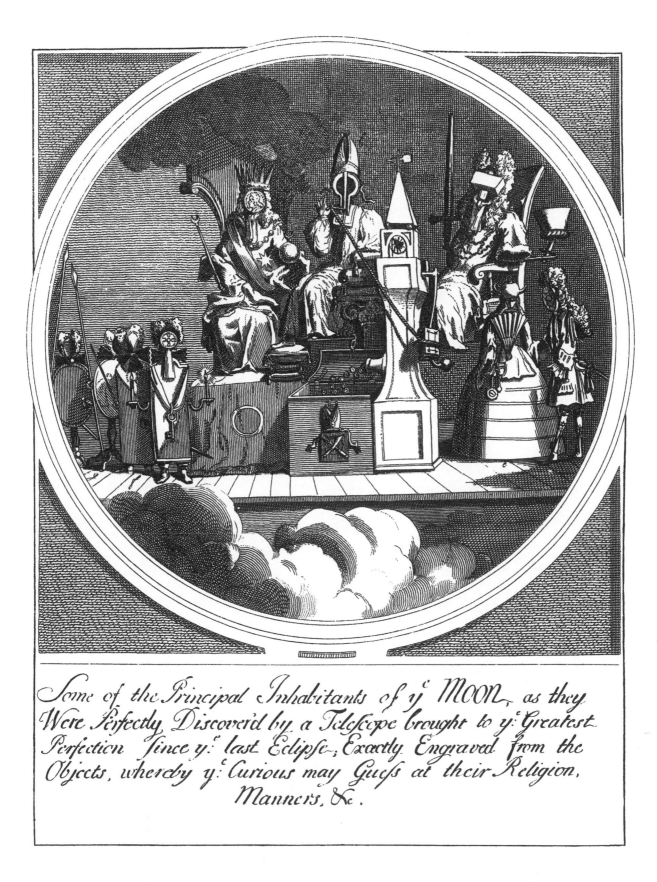

Some of the Principal Inhabitants of y.ͤ MOON, as they
Were Perfectly Discover'd by a Telescope brought to y.ͤ Greatest
Perfection Since y.ͤ last Eclipse; Exactly Engraved from the
Objects, whereby y.ͤ Curious may Guess at their Religion,
Manners, &c.

4

A JUST VIEW OF THE BRITISH STAGE

ETCHED. SECOND STATE. DECEMBER 1724. $7\frac{1}{8} \times 8\frac{3}{8}$

The artistic companion to "An Emblematical Print on the South Sea Scheme" and "The Lottery," this print was prompted by the popularity of exotic, irrational and often foreign amusements which caused a decline in the traditional native theater. (The toilet paper for the privies is inscribed "Hamlet," "[Mac]beth," "[Juli]us Ceas[ar]" and "[The] Way of ye World.") It attacks the frenzy for such extravaganzas as the pantomimes, farces and virtual circuses staged by John Rich at Lincoln's Inn Fields.

In this scene the managers of Drury Lane (Robert Wilks, Colley Cibber, Barton Booth) rehearse a production designed to out-do Rich.

The room is cluttered with every stock device imaginable in a farce; there is a ghost, a trapdoor, a flying monster, a dog; there are puppets (the managers themselves are puppet-like figures too with strings just above their heads), pulleys and ropes. The level of the subject matter is suggested by the pantomime's setting and by the emphasis on defecation and urination to which tragedy and comedy have been reduced. In the foreground statues of tragedy and comedy are obscured by advertisements for the pantomimes to be performed.

A picture in the grand manner of "The Muses," the supposed inspiration of the scene below, adorns the roof.

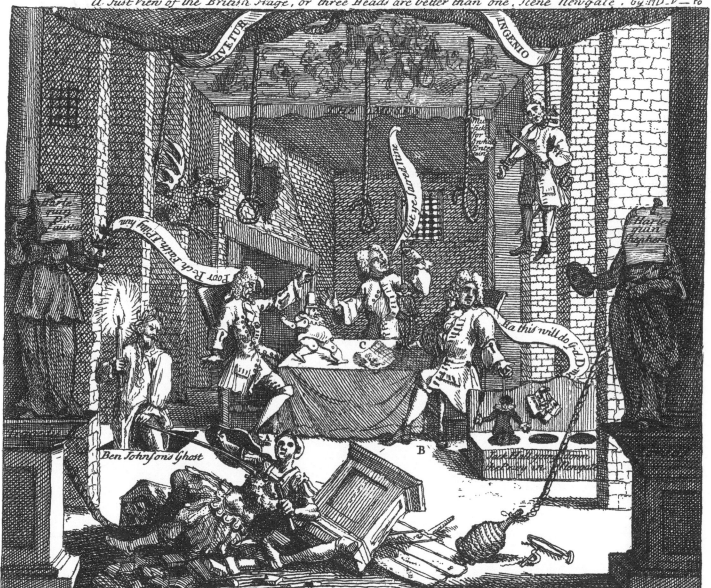

A Just View of the British Stage, or three Heads are better than one. Scene Newgate. by MD_V_to

This Print Represents the Rehearsing a new Farce that will Include ÿ two famous Entertainments D.ʳ Faustus & Harlequin Shepherd to w.ᵗʰ will be added Scaramouch Jack Hall the Chimney Sweeper's Escape from Newgate through ÿ Privy, with ÿ comical Humours of Ben Johnsons Ghost, Concluding with the Hay-Dance Perform'd in ÿ Air by ÿ Figures A.B.C. Assisted by Ropes from ÿ Muses. Note, there are no Conjurors concern'd in it as ÿ ignorant imagine ⸭ The Bricks, Rubbish &c. will be real, but the Excrements upon Jack Hall will be made of Chew'd Gingerbread to prevent Offence. Vivat Rex. price six pence.

Twelve large illustrations for Samuel Butler's "Hudibras"

ETCHED AND ENGRAVED FROM DRAWINGS. FEBRUARY 1725/6*

These prints, engraved as works of visual art in their own right, were sold by subscription to about 200 buyers. Butler's satiric bent and his religious, political and popular subject matter must have been attractive to Hogarth. The narrative method too, which is an integral part of book illustration, was well suited to his talent and gave an impetus to the development of his progresses.

* In 1752 the English Parliament replaced the Julian Calendar ("Old Style") with the Gregorian ("New Style"). Eleven days were dropped from the year (thus the banner "Give us our Eleven Days" in Hogarth's "Election Entertainment")—September 2 was followed by September 14—and the beginning of the new year was changed from March 25 (called "Lady Day" and commemorating, nine months before Christmas, the conception of Christ) to January 1.

Dates (from January through March) in this text prior to 1752 are expressed in terms of both calendars in the following fashion: February 1725/6—indicating that the year was 1725 under the Julian Calendar and 1726 under the currently used Gregorian Calendar.

FRONTISPIECE
FOURTH STATE. $9\frac{1}{2} \times 13\frac{5}{8}$

On the monument Butler's spirit (associated with the concept of justice) in the form of a satyr lashes the two-faced Hypocrisy, who, with armed Rebellion, leads Ignorance by the hands. The figures around the monument seem to refer to the productions of the visual arts. On the left a putto carves out the details of the pedestal from a copy of *Hudibras* held open for him by another satyr. On the right the pleased figure of Britannia admires her undistorted image in a mirror held up to her by an infant satyr. In the background Time bows reverently before Butler's tomb.

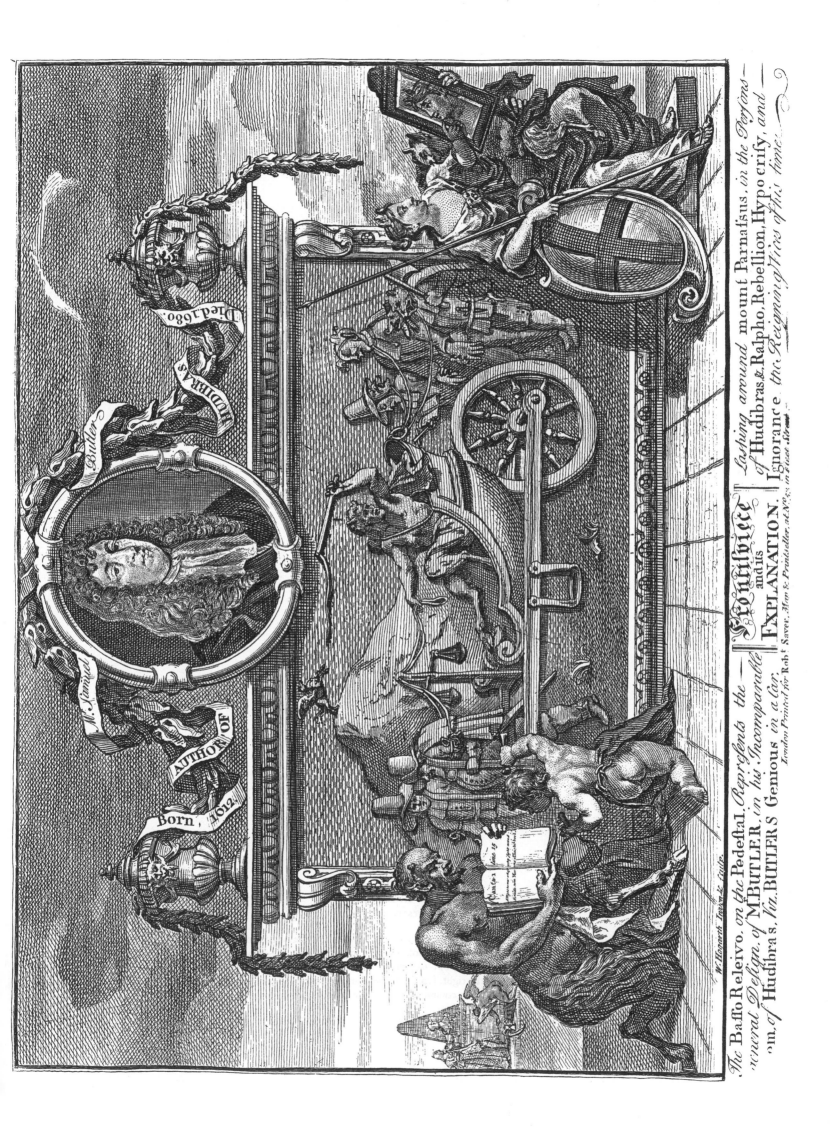

W. Hogarth Invon & Sculp.

The Baſſo Releivo, on the Pedeſtal, Repreſents the —— || ‖Frontiſpiece‖ and‖ Laſhing around mount Parnaſsus, in the Perſons
veral Deſign, of M. BUTLER, in his Incomparable ‖ ——————— ‖ of Hudibras & Ralpho, Rebellion, Hypocriſy, and ——
——m, of Hudibras. Viz. BUTLERS Genious in a Car. ‖ EXPLANATION. ‖ Ignorance, the Reigning Vices of this time.

London Printed for Robt Sayer, Map & Printseller, at No 53. in Fleet Street.

Dₒ Died 1680.

HUDIBRAS

Butler

M. Samuel

AUTHOR OF

Born, 1612

6

Illustrations for Samuel Butler's "Hudibras"
PLATE II
SR. HUDIBRAS
THIRD STATE. $9\frac{13}{16} \times 13\frac{1}{4}$

The engraved title of this plate comes from ll. 1–2 of the Argument to
the First Part, Canto I; the quotations are to be found in ll. 1–2, 9–14,
451–452, 459–460 and 621–624 of the Wilders edition of *Hudibras*.*
The incident at the right, typical of the dramatic action Hogarth por-
trayed so well and so complexly in his later work, is not in the poem.

 * All references are to Samuel Butler, *Hudibras*, ed. John Wilders (Oxford:
The Clarendon Press, 1967).

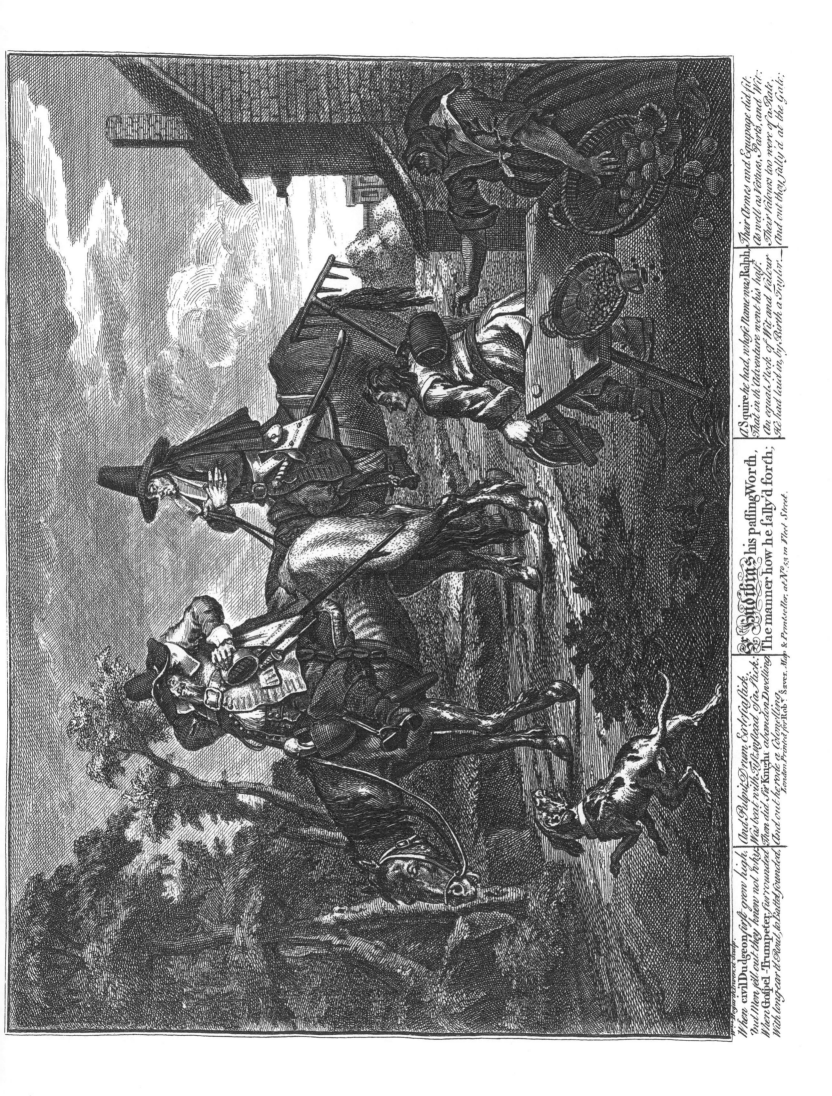

When civil Dudgeon first grew high,
And Men fell out they knew not why;
Where Gospel-Trumpeter, surrounded
With long-ear'd Rout, to Battel sounded,

And Pulpit Drum Ecclesiastick,
Was beat with fist, instead of a Stick;
Then did Sr Knight abandon Dwelling,
And out he rode a Colonelling.

Sr Hudibras his passing Worth,
The manner how he sally'd forth;

A Squire he had, whose name was Ralph,
That in th'adventure went his half:
As well as Fortues, Parts, and Wit;
An equal stock of Wit and valour
Their values too were of a-Rate:
He had laid in, by Birth a Taylor.—
And out they sally'd at the Gate.

Fair Armes and Equipage did fit:

London Printed for Rob.t Sayer, Map & Printseller, at N.o 53 in Fleet Street.

7

Illustrations for Samuel Butler's "Hudibras"
PLATE III
HUDIBRAS' FIRST ADVENTURE
FIFTH STATE. 9¾ × 13⅛

The quotation is the Argument to the First Part, Canto II. The leader of
"this Warlike Rabble" is Crowdero, the fiddler; with him are Orsin,
"Marshall to the Champion Bear," and Talgol ("He many a Bore and
huge *Dun Cow*/ Did, like another *Guy*, o'rethrow"). The woman is
Trulla, "A bold *Virago*, stout and tall/ As *Joan* of *France*, or *English*
Mall."

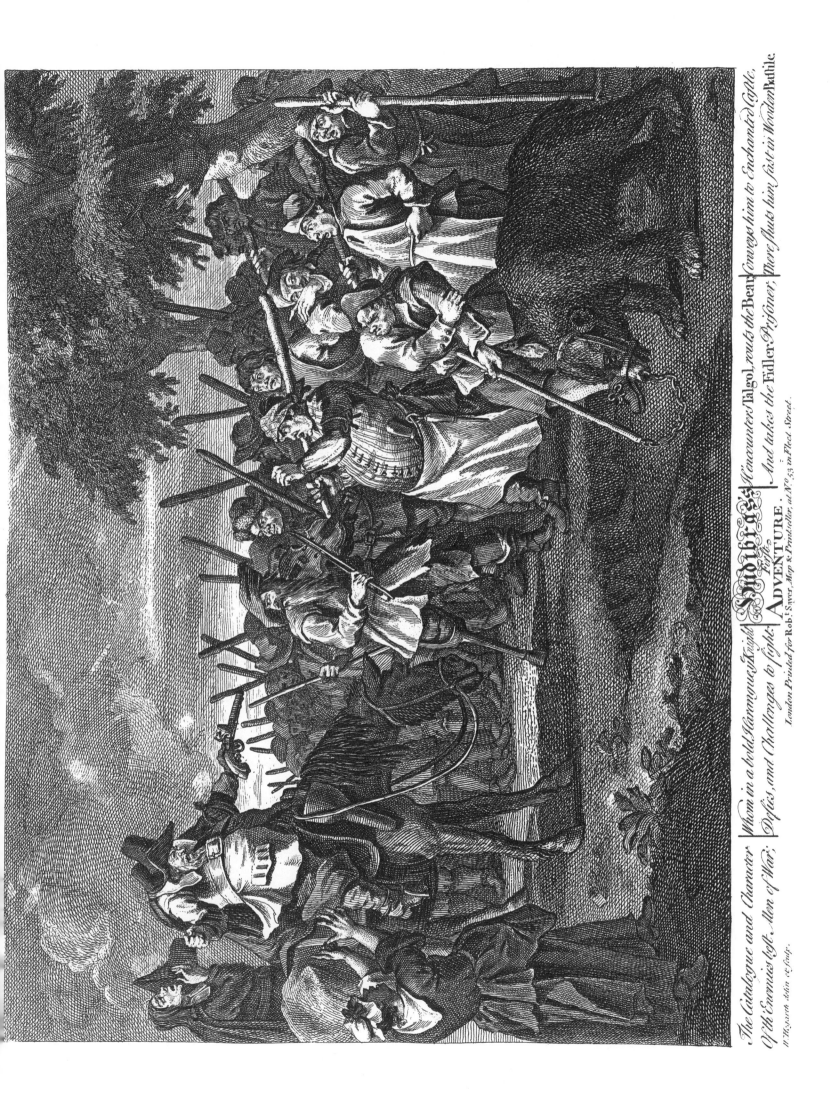

The Catalogue and Character | Whom in a bold Harmonious Fight | *Hudibras* | Encounters Talgol, routs the Bear, | Conveys him to Enchanted Castle,

Of th'Enemies left Men of War; | Poses, and Challenges to fight: | First | And takes the Fidler Prisoner, | There shuts him fast in Wooden Bastile.

ADVENTURE.

London, Printed for Rob.ᵗ Sayer, Map & Printseller, at Nᵒ. 53, in Fleet Street.

W. Hogarth delin: et sculp:

8

Illustrations for Samuel Butler's "Hudibras"
PLATE IV
HUDIBRAS TRIUMPHANT
THIRD STATE. $9\frac{5}{8} \times 13\frac{3}{16}$

The quotations are from the First Part, Canto II, ll. 1103–1108, 1113–1116, 1127–1130, 1147–1150, 1161–1164 and 1169–1170. The onlookers are not in the poem.

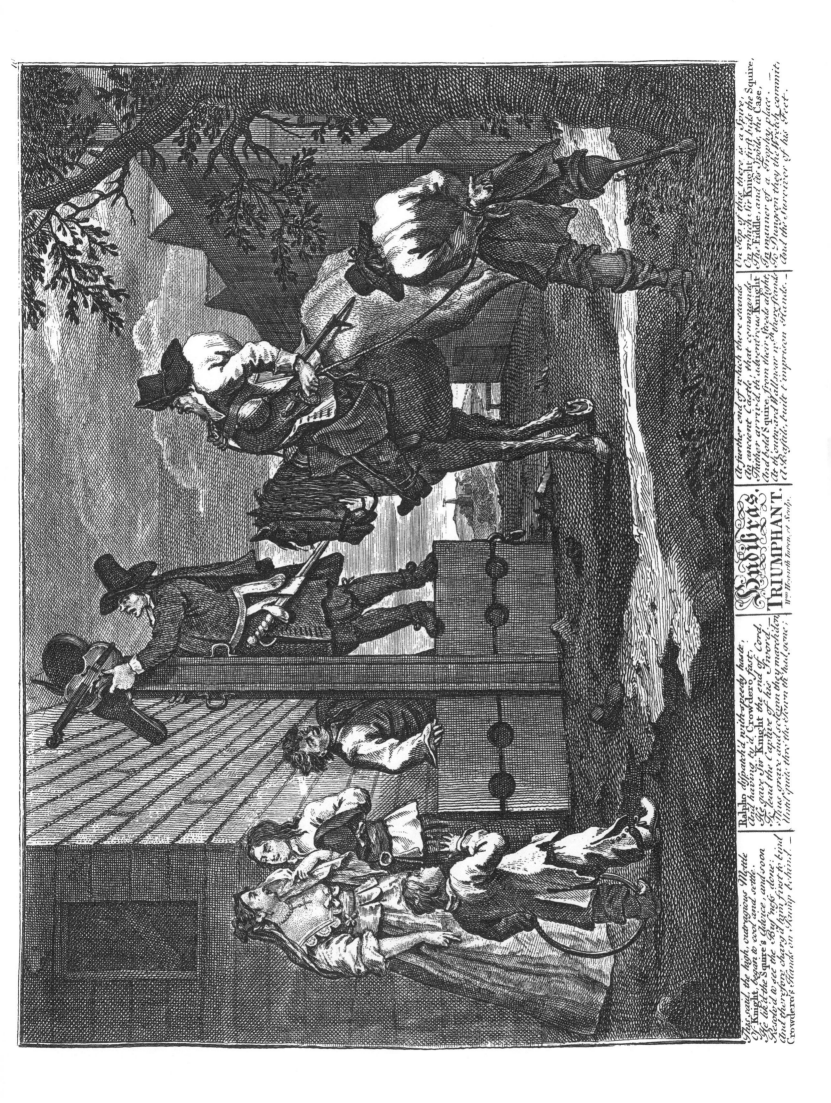

Thus said the high, outragious Mettle
The Knight, began to cool and settle.
He tod the Squire's advice, and soon
Resolved to see the Bus'nes done;
And therefore charging him first to bind
Crowdero's Hands on Rump behind —

Ralpho dispatch'd with speedy haste,
And having ty'd Crowdero fast;
He gave Sir Knight the end of Cord,
To lead the Captive of his Sword —
Thus, grave and sturdy they march'd on
Until quite thro' the Streets th' had gone:

Hudibras

TRIUMPHANT.

Wm Hogarth Inven. et Sculp.

On top of this, there is a Spire,
On which Sir Knight first hids the Squire,
Another arriv'd, th' adventr'ous Knight
The Fiddle, and its stold, the Case,
In manner of a Trophy, plac'd
At th' outward Wall near, th' others found,
To Dungeon they the Witch commit,
And this deceiver of his Feet.

9

Illustrations for Samuel Butler's "Hudibras"
PLATE V
HUDIBRAS VANQUISH'D BY TRULLA
FIFTH STATE. $9\frac{7}{16} \times 13\frac{3}{16}$

The quotations are from the First Part, Canto III, ll. 929–934, 937–942,
945–946, 949–956 and 995–996. Talgol advances on Hudibras while,
in the background, Orsin threatens Ralpho.

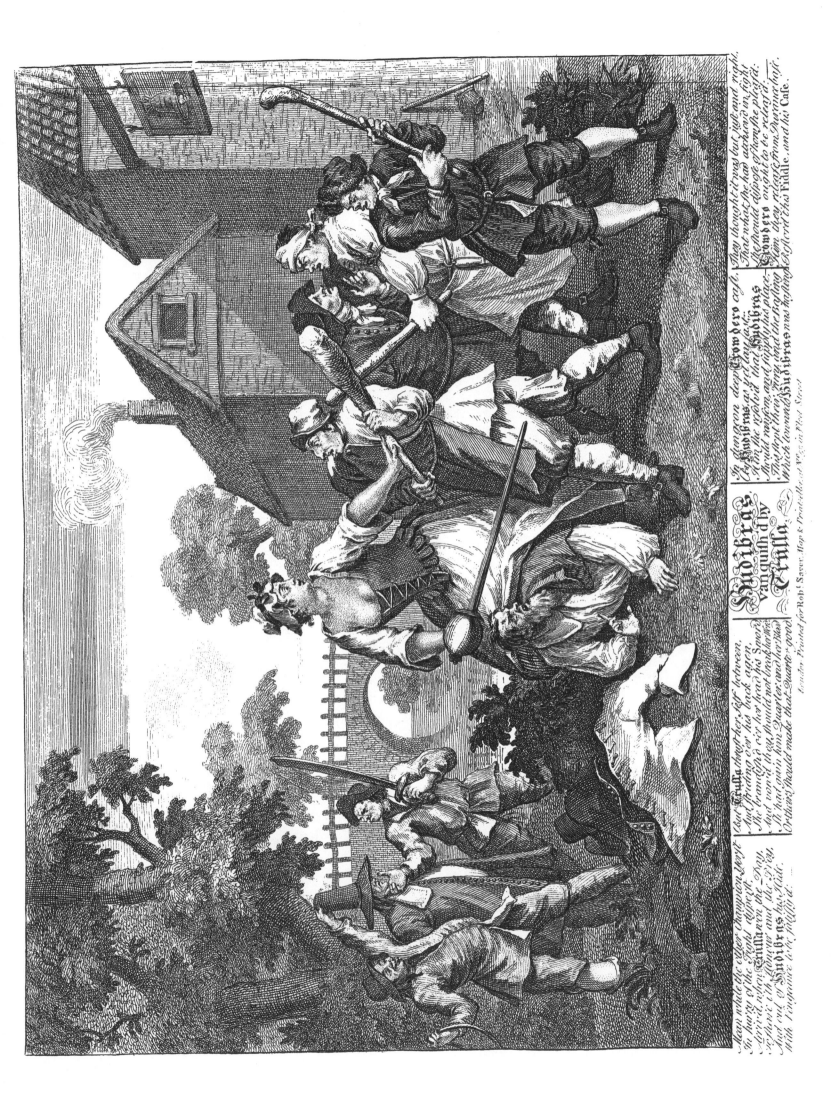

Man while the other champion-hew't
In fury of the fight, & cut off
And striking low left Talgol's mow,
Levell'd where Talgol was the Moll:
The branding'd cir hot head his Sword,
And cut, the Lenevit and the Wise,
Then wit, & Hudibras his Skull:
And cut, of Hudibras his Skull:
With Vengeance to fulfill it.

But Trulla, thrust her self between,
Arresting low his back agen,
And very nearly had done that
That should have had drunk that
Th' had own him Quarter: and hew had
Only was should make their Quarto good

Hudibras
vanquish'd by
Trulla

In dangerous deep, powdero cafe.
As Hudibras as if at longlaff,
For the report of that Hudibras
Should restore, and supplied that place,
They Trapt their lives; and the fighting
Which toward, Hudibras and thrfrom

They thought it was but just and right
That what he had acknow'd in fight,
He would defpote of how he play'd,
Crowd'ro ought to be retard.
Him they release, from Durae'chafe
Reftor'd the's Fiddle, and his Cafe.

Engraven Printed for Rob.t Sayer, Map & Printseller at N.o 53 in Fleet Street

Illustrations for Samuel Butler's "Hudibras"
PLATE VI
HUDIBRAS IN TRIBULATION
THIRD STATE. $9\frac{5}{8} \times 13\frac{7}{16}$

The quotations are from the Second Part, Canto I, ll. 87–88, 101–104, 115–120, 153–154, 175–176, 179–180, 217–218 and 221–224. The lady addressing Hudibras is the Widow. The supporting members of the scene, most of them comic figures, are Hogarth's.

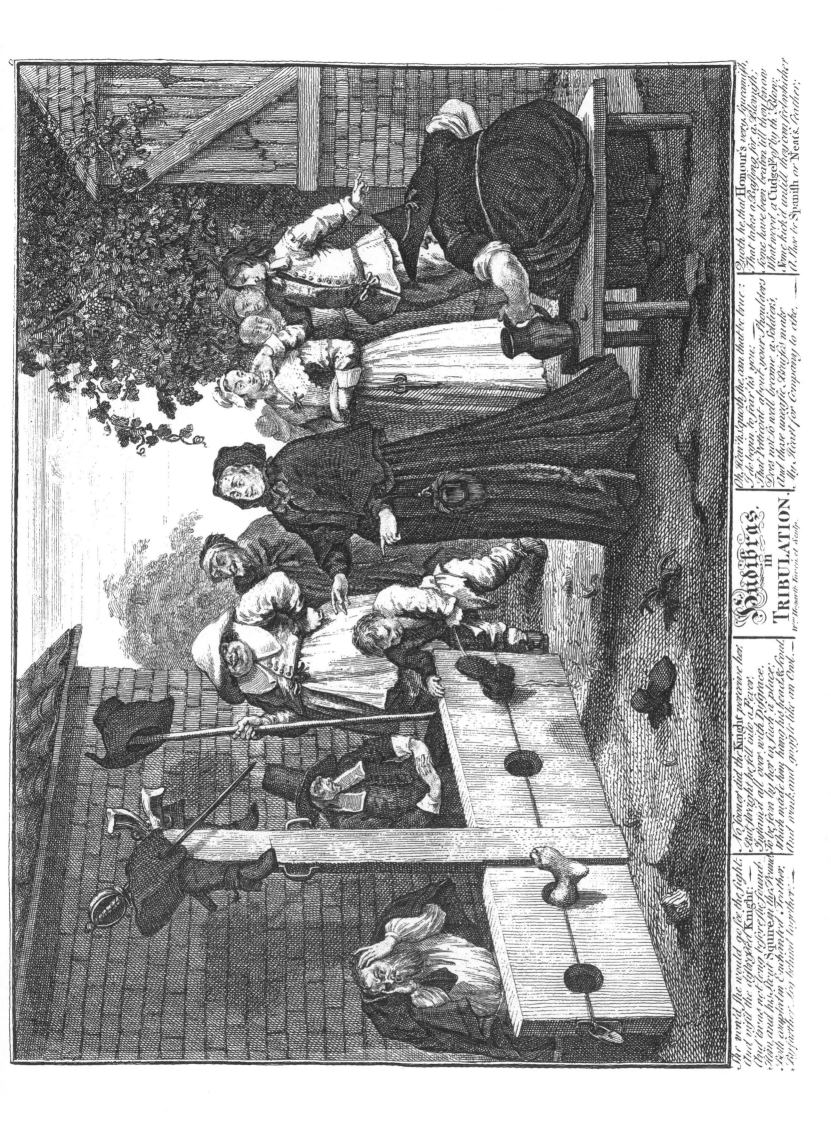

Hudibras in TRIBULATION.

Wm. Hogarth Invent. et Sculp.

No sooner did the Knight perceive her,
But wrightly He fell into a Fever:
Inflam'd all over with Disgrace,
To be seen by her or such a place;
Which made him hang his head & look,
As if his Breast could not contain,
But swell'd like Squirrel has Denuide,
As far as quickly He can that he true:
He began to fear its you;
That Petticoat about your Shoulders,
Does not so well become a Soldier;
And there uneasy Bright's make
My Heart for Company to eke. —

Quoth he, that Honour's very Squeamish,
That takes a Pageing for a Blemish,
Some have been beaten till they know
Whatwood a Cudgel's of by Blow;
Some kick'd, untill they can feel whether
A Shoe be Spanish or Neats, Leather;

The would he would get the light,
And with the diguis'd Knight;
But twas not long before He found,
Hee, and his Rent Squire has Bound,
With empleten Enchanted Tether,
By father, lies behind together. —

Illustrations for Samuel Butler's "Hudibras"
PLATE VII
HUDIBRAS ENCOUNTERS THE SKIMMINGTON
THIRD STATE. $9\frac{3}{4} \times 19\frac{15}{16}$

The quotations are from the Second Part, Canto II, ll. 753–760, 767–774, 777–780, 783–784, 791–794, 797–800, 815–818 and 831–832.

A skimmington is defined by the Oxford English Dictionary as "a ludicrous procession, formerly common in villages and country districts, usually intended to bring ridicule or odium upon a woman or her husband in cases where one was unfaithful to, or ill-treated, the other."

Many of the figures in this plate, like the man holding the spurs and glove on the sword and the boy putting a torch to the horse, are taken from the poem. Others—the figure urinating against the wall, the man about to toss the cat, and the youth stealing Hudibras' sausages—are original with Hogarth and are echoed in his later prints like "The March to Finchley" and "The Idle 'Prentice Executed at Tyburn."

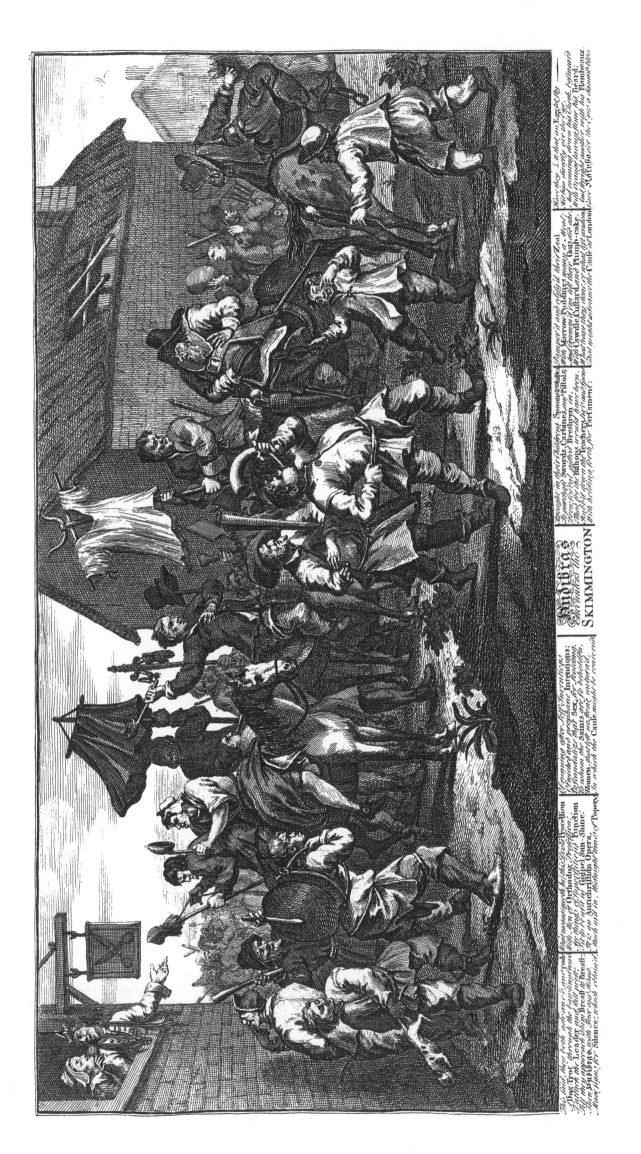

12

PLATE VIII

HUDIBRAS BEATS SIDROPHEL

SECOND STATE. $9\frac{11}{16} \times 13\frac{5}{8}$

The quotations are from the Second Part, Canto III, ll. 991–996, 999–1006 and 1031–1040.

In his attempt to win the Widow who visited him in the stocks ("Hudibras in Tribulation") the knight consults an astrologer, "A cunning man, hight *Sidrophel*,/ That deals in *Destinies* dark *Counsels*"; they dispute at length; Sidrophel offends Hudibras by revealing part of the knight's inglorious past; and they quarrel. Most of the grotesque motifs in the cell are Hogarth's and reappear in the quack doctor's office in *Marriage à la Mode*.

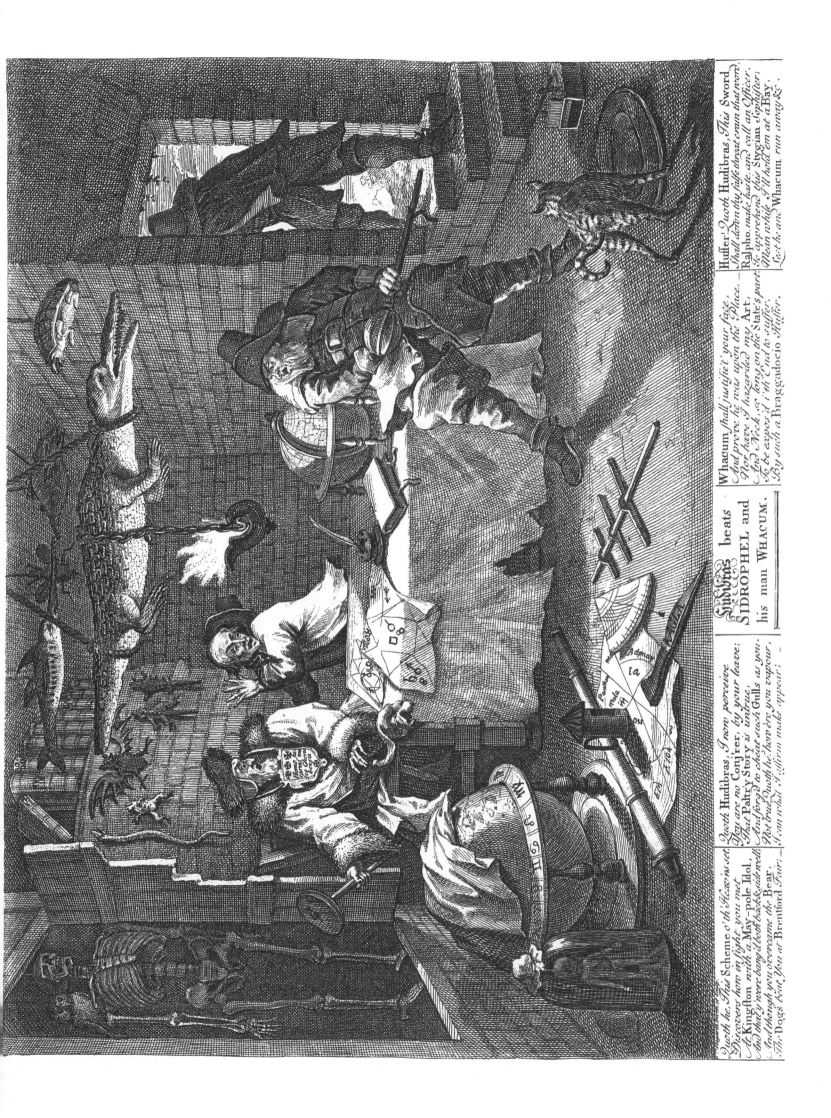

Quoth he, This Scheme o'th' Heav'ns set,
Discovers how in fight you met
At Kingston with a May-pole Idol,
And that y' were bang'd both back & side well;
And though you overcame the Bear,
Th' Dogs beat you at Brentford Fair; —

Quoth Hudibras, I now perceive
You are no Conj'rer, by your leave:
That Paltry Story is untrue,
And forg'd to cheat such Gulls as you.
Not true, Quoth he, how e're you vapour,
I can what I affirm make appear; —

Hudibras beats
SIDROPHEL, and
his man WHACUM.

Whacum shall justify't your face,
And prove he was upon the Place.—
Nor have I hazarded my Art,
And Neck, so long on the State's part,
To be expos'd i' th' End to suffer,
By such a Braggadocio Huffer.

Huffer, Quoth Hudibras, this Sword
Shall down thy false throat cram that word.—
Ralpho, make haste, and call an Officer,
To apprehend this Stygian Sophister;
Mean while I'll hold 'em at a Bay,
Catch and Whacum run away &c.

13

Illustrations for Samuel Butler's "Hudibras"
PLATE IX
HUDIBRAS CATECHIZ'D
THIRD STATE. 9⅝ × 13½

The quotations are from the Third Part, Canto I, ll. 1159–1162, 1175–
1178, 1185–1186, 1221–1224, 1263–1264 and 1273–1280.
 In this scene Hudibras is forced to confess his motives for wooing
the Widow.

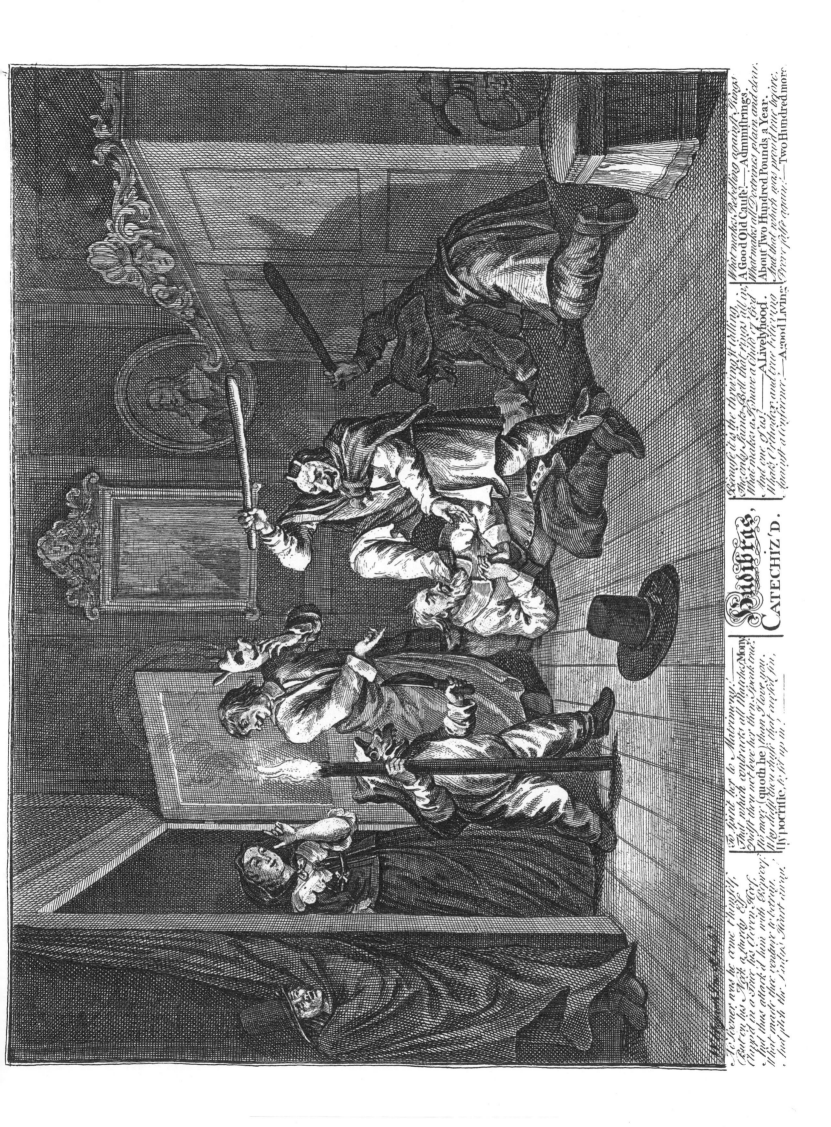

Hudibras

CATECHIZ'D.

14

Illustrations for Samuel Butler's "Hudibras"
PLATE X
THE COMMITTEE
FIFTH STATE. $9\frac{5}{8} \times 13\frac{1}{4}$

The quotations are from the Third Part, Canto II, ll. 237–240, 267–272, 285–286, 303–304, 313–314 and 1497–1504.

The committee of saints receives the news about the burning of rumps.

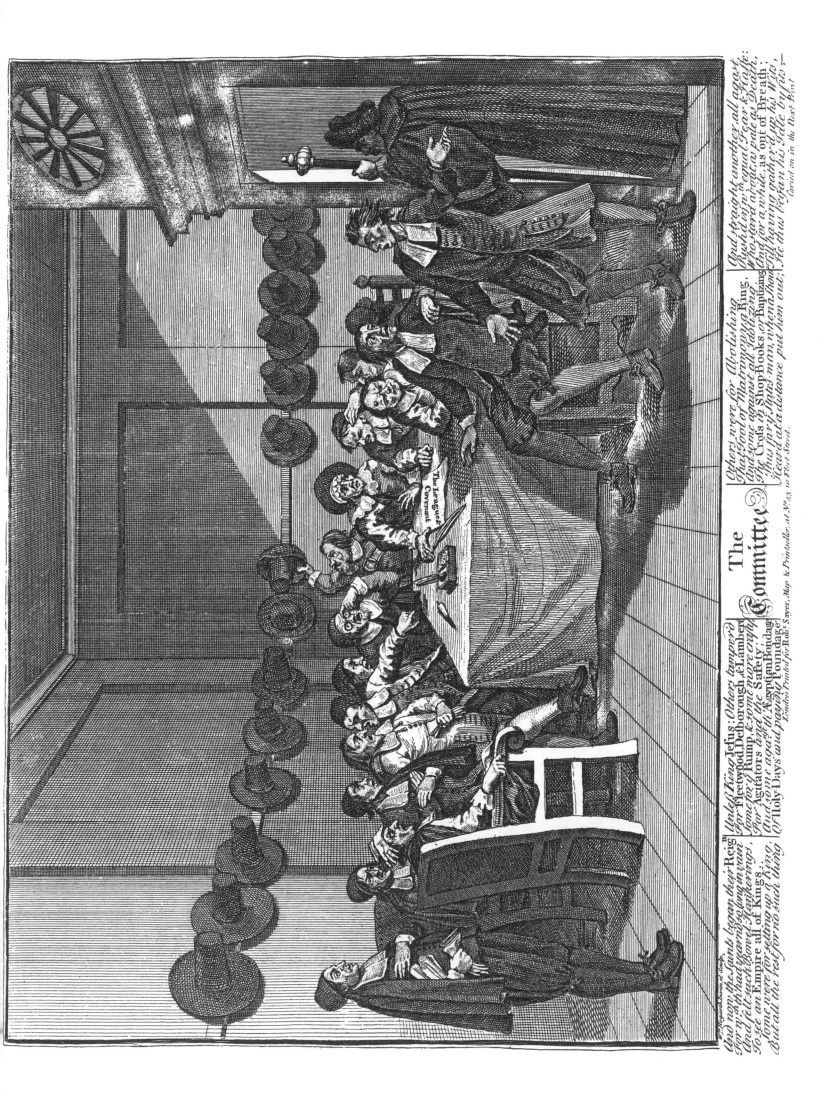

The **Committee**

And now the Saints began their Reign,
For w.ᶜʰ they'd long'd, but all in vain,
And cheated oft with Haukering's,
To see an Empire all of Kings,
Some were for setting up a King,
But all the rest for no such thing,

Unless King Jesus: Others temper
For Fleetwood, Desborough, & Lambert,
Some for y.ᵉ Rump, & some more crafty,
For Agitators and the Safety;
And some again th' Egyptian Bondage,
Of Holy-Days and payd.ᵈ Poundage,

Others were for Abolishing
That foot of Matrimony a Ring,
And some against all Iablizing,
The Cross in Shop Books or Baptizing,
Thus ev'ry distracted man, when then Stood
Scar'd at a distance put hem out;

And straight another all agast
Rush'd in w.ᵗʰ equal Fear & Haste,
Who star'd a'yod, as pale as Death,
And for a while, as out of Breath,
Till having gather'd up his Wits,
He thus began his Tale by fits.

Carried on in the Next Print

London Printed for Rob.ᵗ Sayer, Map, & Printseller, at N.ᵒ 53, in Fleet Street.

The League & Covenant

15

Illustrations for Samuel Butler's "Hudibras"
PLATE XI
BURNING YE RUMPS
FOURTH STATE. $9\frac{13}{16} \times 19\frac{3}{4}$

The quotations are from the Third Part, Canto II, ll. 1505–1520 and 1523–1530.

Samuel Pepys provides the best commentary on this plate portraying the events surrounding England's return to a free Parliament.

In Cheapside there was a great many bonfires, and Bow bells and all the bells in all the churches as we went home were a-ringing. Hence we went homewards, it being about ten o'clock. But the common joy that was every where to be seen! The number of bonfires, there being fourteen between St. Dunstan's and Temple Bar, and at Strand Bridge I could at one view tell thirty-one fires. In King-street seven or eight; and all along burning, and roasting, and drinking for rumps. There being rumps tied upon sticks and carried up and down. The butchers at the May Pole in the strand rang a peal with their knives when they were going to sacrifice their rump. On Ludgate Hill there was one turning of the spit that had a rump tied upon it, and another basting of it. Indeed it was past imagination, both the greatness and the suddenness of it.*

* Samuel Pepys, *The Diary of Samuel Pepys*, ed. Henry B. Wheatley (London: George Bell, 1893–1899), vol. 1:55.

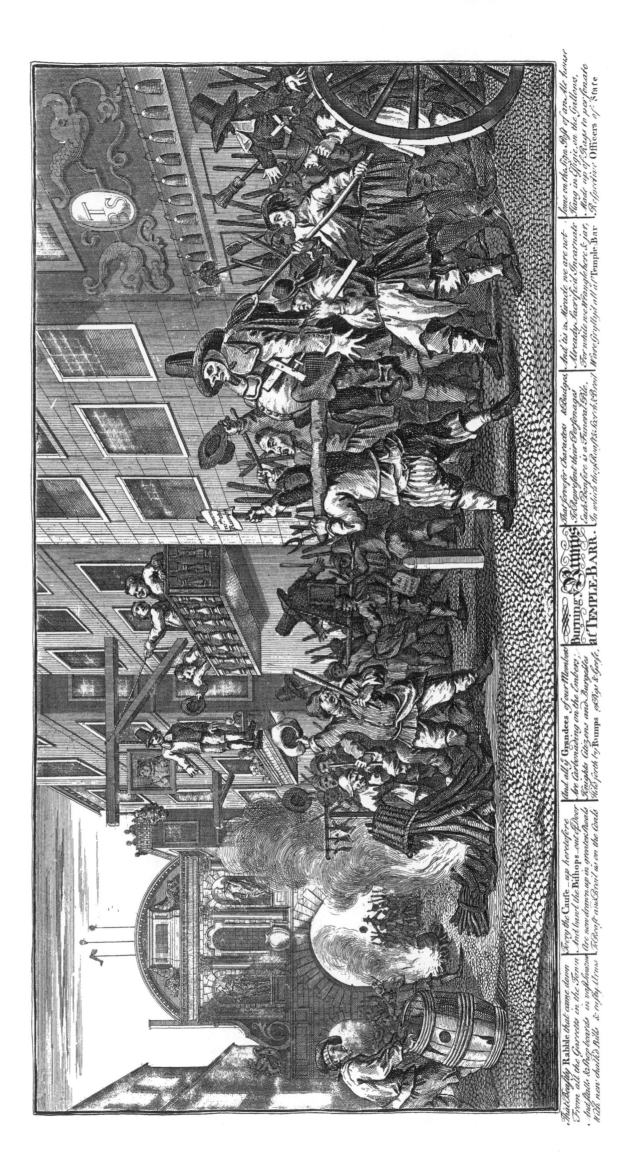

That Beast of Rabble that came down
From all the Garrets in the Town
And Stalls, & Shopboards in vast swarms
With new cleaned Belts & rusty Arms

Fury the Castle up heretofore
And bard the Bishops out of Door
the now strain up in pretended Head
Lo here is Prin's Beer'd as on the Coals

And all y Grandees of our Members
the Carbonading on the Embers
Knights Citizens and Burgesses
Held forth by Rumps of Pigs & Geese

That serve for characters & Badges
To represent their Personages
Each Bonfire is a Funeral Pile
In which their Bones & Flesh & Bowel

And 'tis in Miracle we are not
To Rump out their Personage

BURNING ∴ RUMPS
at TEMPLE-BARR.

16

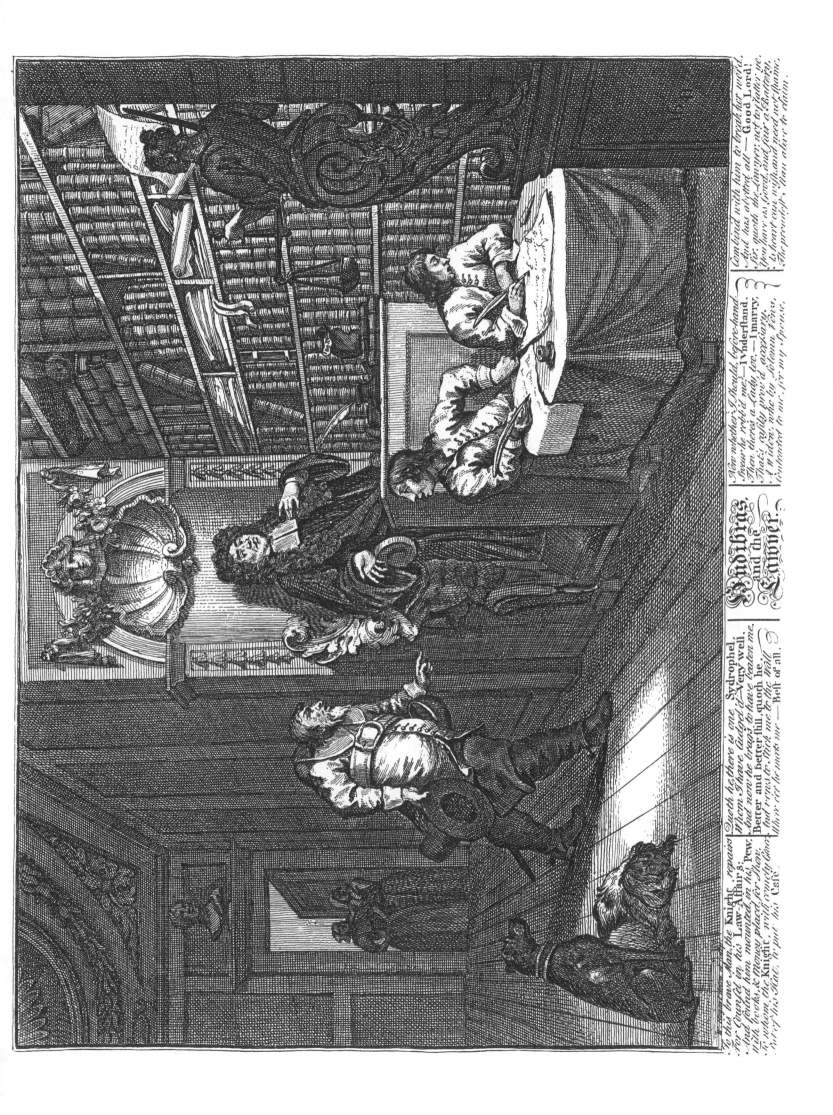

BOYS PEEPING AT NATURE

ETCHED FROM A DRAWING. FOURTH STATE. 1730/1. $3\frac{1}{2} \times 4\frac{3}{4}$

Hogarth used this etching as the subscription ticket* for three groups of prints: *A Harlot's Progress* (1732); "Strolling Actresses" (1738); "Moses Brought to Pharaoh's Daughter" and "Paul before Felix" (1752). This state shows a many-breasted statue of Nature, the source and end and test of all art, surrounded by three putti. Each is reproducing her form in a different medium and with varying effect.

In the first three states of this ticket (see the artist's preliminary drawing below), the line portrait held by the putto who stands before

* For the practice of subscription tickets, see Introduction, p. xiv, and Chronology, under "c 1745," p. xxvii.

Nature is replaced by an inquisitive satyr who is peering up Nature's dress. Two quotations appear in the previous states, "Antiquam exquirite Matrem. Vir." ("Look for the Ancient Mother": Vergil) and "necesse est/ Indiciis monstrare recentibus abdita rerum,/ . . . dabiturque Licentia Sumpta pudenter. Hor:" ("Abstruse matter must be presented in novel terms . . . license is granted if it is used modestly": Horace). Hogarth often used his subscription tickets as a forum for his artistic intentions. In this ticket he suggests that, like the roguish, empirical-minded satyr, he examines boldly and realistically, in his new art form, the progress, the earthy parts of Nature hitherto unexplored by the conventional-minded artists of the past.

Preliminary sketch. Reproduced by gracious permission of Her Majesty the Queen.

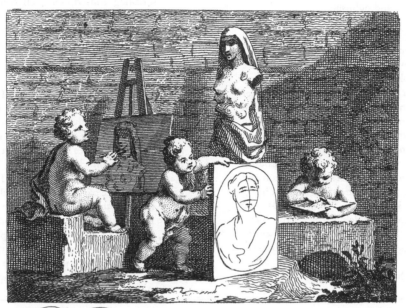

Receiv'd of

5 Shillings being the first Payment for two large Prints
one representing Moses brought to Pharoah's Daughter,
The other St. Paul before Felix, w.ch I Promise to deliver
when finish'd, on Receiving 5 Shillings more.

N.B. They will be Seven and Six Pence
each Print, after the time of Subscribing.

A Harlot's Progress

ETCHED AND ENGRAVED FROM PAINTINGS. APRIL 1732

Vertue gives an elaborate account of the appearance of the *Harlot* series:

> The most remarkable Subject of painting that captivated the Minds of most persons of all ranks and conditions from the greatest Quality to the meanest was the Story painted and designd by Mr. Hogarth of the Harlots Progress and the prints engravd by him and publishd.
>
> He began a small picture of a common harlot supposd to dwell in drewry lane just riseing about noon out of bed and at breakfast with a bunter waiting on her. This whore's desabillé was careless and she had a pretty Countenance and air. This thought pleasd many; some advisd him to make another to it as a pair which he did. Then other thoughts encreas'd and multiplyd by his fruitfull invention till he made six different subjects which he painted so naturally that it drew every body to see them. He proposed to Engrave in six plates and to print them at one guinea each sett. He had daily Subscriptions in fifty or a hundred pounds in a Week, there being no day but persons of fashion and Artists came to see these pictures, the story of them being related about how this Girl came to Town, how Mother Needham and Col. Charters first deluded her, how a Jew kept her, how she livd in Drury lane, when she was sent to bridewell by Sr. John Gonson, a Justice, and her salivation and death.
>
> Before a twelve month came about whilst these plates were engraving, he had in his Subscription between 14 *or fifteen* hundred (*by the printer* I have been assured 1240 setts were printed) Subscribers. He publickly advertiz'd that those that did not come in before a certain day shoud be excluded which he did, and all this without Courting or soliciting subscriptions, all comeing to his dwelling in common Garden where he livd with his father in Law Sr James Thornhill. And it is probable he might have had more. No Soonner were these publist but several Copies were made by other hands and dispersd all over the Countries.

A Harlot's Progress tells the story of the fall and speedy destruction of a girl who comes from the country to London to earn a livelihood. The work is primarily didactic; Hogarth's intention was to reveal through the girl's life the follies and miseries of vice with a view to providing his audiences with a negative example for their own conduct. Rigorous and unflinching as the tale is, however, it is not narrowly conceived or insensitively narrated. It is a discriminating portrayal of the fatal nature of human vanity and blindness, however innocuous, in the face of ruthless economic and sexual forces. It is also an account of the brutalizing effects of city life and a biting analysis of the institutions, classes and professions that exploit and destroy human beings and of the types of people that are attracted to them. Not least of all it is a tale of the vulnerable position of women in a society whose laws, customs and members are predisposed against them.

18

PLATE I

FOURTH STATE. $11\frac{11}{16} \times 14\frac{5}{8}$

Before the Bell Inn in Wood Street, Mary or Moll Hackabout, newly arrived in London, is caught between the aggressive agents of corruption, who are set against the crumbling tavern wall, and the ordinary (and passive) middle-class people arranged around the solidly built home. Dressed in modestly designed clothes and bearing the scissors and pin cushion of a dressmaker, she has just alighted from the York wagon. Though she appears as fresh and artless as the rose that covers her bosom, her expression suggests that she is a little flattered by the attention of the bawd.

Above Moll, a housewife, surrounded by chamber pots and laundry, hangs out clothing. She seems to represent the secure if unexciting bourgeois life the girl leaves behind. With his back to her an affluent clergyman, perhaps Moll's father, reads the address on a letter, probably a request to the Bishop of London for a sinecure ("To the Right Reverend Father in London"). Short-sighted and insensitive to the crises around him (including his own), like his horse, he is intent on fulfilling his personal ambitions and desires at the expense of his flock.

A bawd feels Moll with her naked hand in the same clinical way animals are inspected before purchase. This figure is said to resemble Mother Needham, the keeper of a notorious brothel patronized by the aristocracy; she had recently been stoned to death by the London populace when she was pilloried for managing a disorderly house. This procuress seems to be the instrument of the nobleman who stands in the shadow of the door leering intensely at the girl, his right hand fumbling suspiciously in his pocket. A symbol of aristocratic corruption, he has come with his pimp to prey on indigent, naïve young girls who alight here from the country. The nobleman has been identified as Colonel Charteris, the worst of the exploitative privileged class to which he belonged.

The coffin-like trunk with Moll's initials, the preoccupied clergyman (motifs which reappear in the final scenes) and the dead goose ("For my Lofing Cosen in Tems Stret in London") give a funereal and ominous cast to the scene.

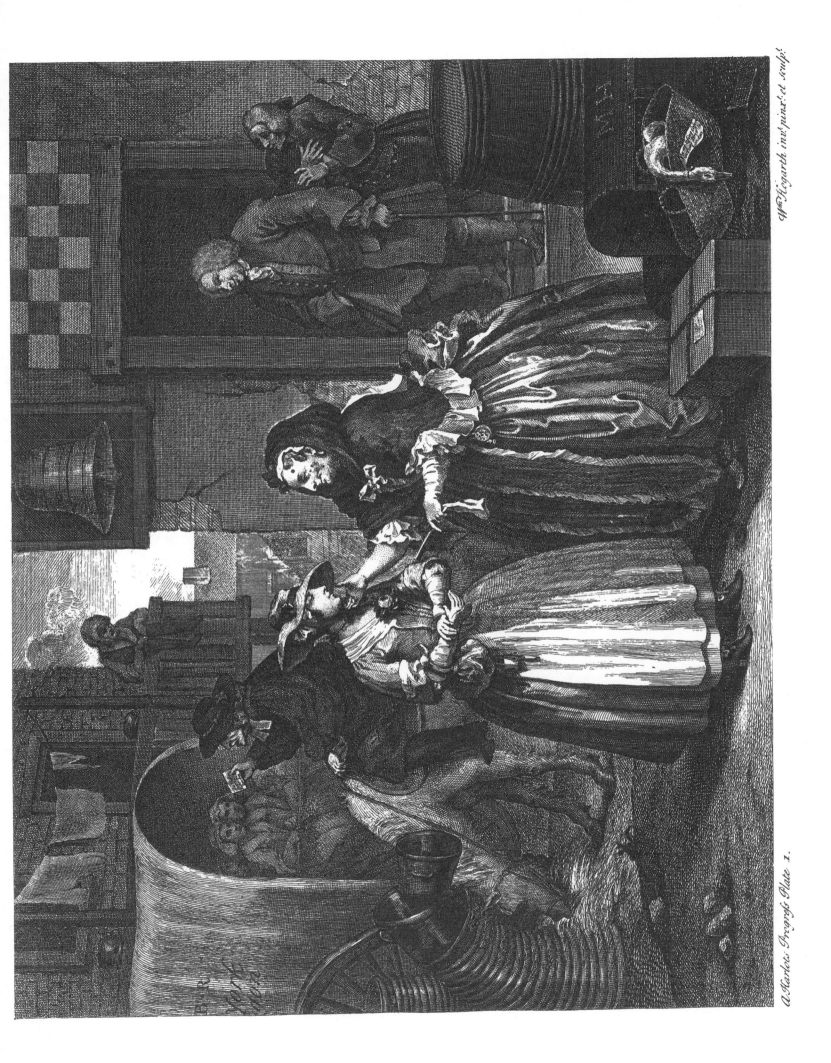

A Rake's Progress Plate 1.

Wm Hogarth invt pinxt et sculpt

19

A Harlot's Progress
PLATE II
FOURTH STATE. 11¾ × 14½

Seduced by the glitter of a life of wealth and comfort, Moll has fallen quickly from the hands of the procuress and nobleman into the keeping of an unattractive but wealthy Jewish businessman. Quite transformed by her experience, she apes the life style of the class to which she aspires; instead of her modest work clothes she wears silk stockings, stylish shoes and a fashionable dress that reveals her arms and her breast. Her face, which bears a look of spirited insolence, is adorned with a beauty spot that may hide the first signs of venereal disease.

Her apartment is richly appointed. She keeps a maid (dressed much as she herself was in Plate I), an exotic West Indian servant boy and a monkey. The monkey, the most pointed indication of her affectation, resembles the merchant in facial expression and posture, and there is little difference in her treatment of either plaything. Prominent on her dressing table is a mirror, symbol of vanity, beside it a jar of make-

up and a smiling white mask. The mask, which is not unlike a death mask, suggests that Moll has been taken to a masquerade by her partially but fashionably dressed visitor, a fellow noticeably more youthful and attractive than the middle-aged businessman who supports her.

Behind her hang small portraits of two contemporaries held to be atheists, Samuel Clarke and Thomas Woolaston. Above the whole scene are two large paintings, one of Jonah outside Nineveh seated next to an ivy plant, the other of David dancing before the Ark while Uzzah, attempting to touch it, is knifed in the back. The picture of Jonah may be a warning to heed the prophet's message to reform. The painting of David and Uzzah, one of whom is killed for his sacrilege, the other rebuked by his wife for his indecency, seems to foreshadow the fates that await the two characters in the scene.

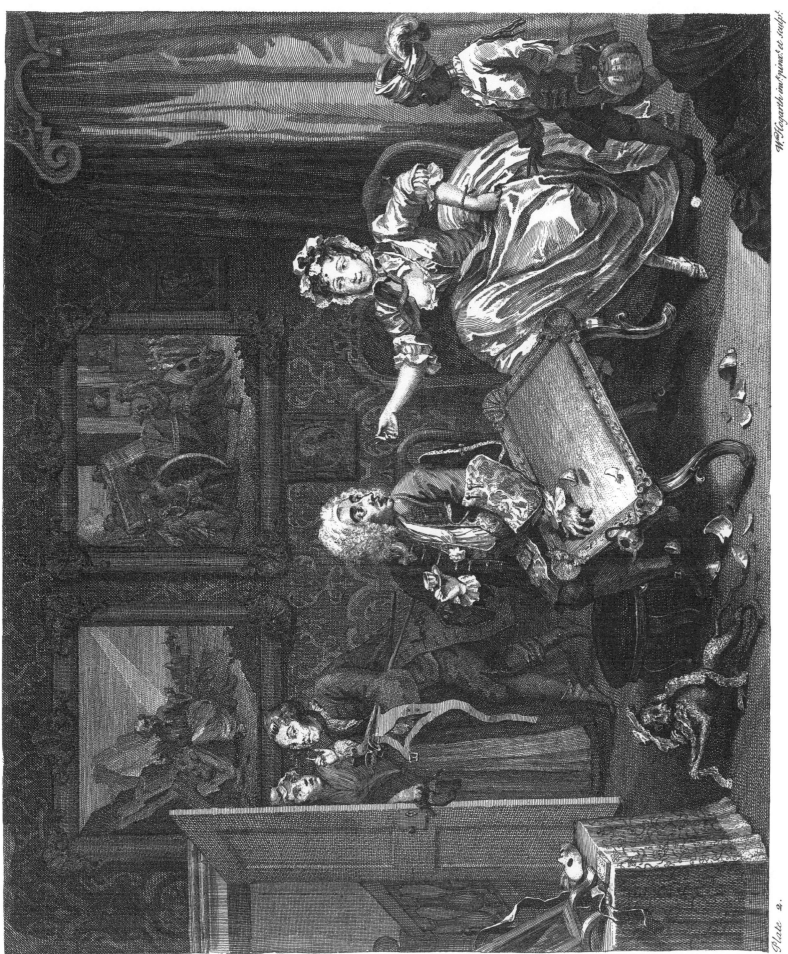

Plate 2.

A Harlot's Progress
PLATE III
THIRD STATE. $11\frac{3}{4} \times 14\frac{9}{16}$

Discarded by the merchant and her marketability reduced by disease, Moll is forced to live in a slum in Drury Lane and serve the population at large, even sexual deviants. Her principal lover is now a highwayman, James Dalton; his wig box rests on top of her crudely arranged canopy. In this breakfast scene, which exactly parallels the previous one, Moll rises at 11:45 A.M. to take her morning tea. Dressed a little less flamboyantly and looking considerably less vivacious, she dangles a watch taken from the previous night's customer.

An ugly but practiced woman whose nose has been eaten away by disease has replaced her naïve servants. The bunter seems intended to serve as an example of the fate of those superannuated harlots who survive the mortal effects of syphilis. Moll's bed, only partially visible in a discreet corner of her former apartment, now fills the room. The delicate silver teapot is replaced by a tin pot and the elegant table by a heavy, functional piece on which lie butter wrapped in a pastoral letter ("Pastoral Letter to") and some eating utensils. Her crude vanity holds a jar of professional make-up, a broken piece of mirror, a gin bottle, a fine-comb, a chipped punchbowl, a broken stem glass and a liquor measure. A letter addressed "To Md. Hackabout" lies in the vanity drawer. Beneath the table are ale measures and tobacco pipes.

The exotic monkey is replaced by a household cat that postures suggestively to indicate the girl's occupation. The large, expensively framed pictures of the previous apartment are here reduced to four small works. Above her chair (which holds her work coat, a candle and a dish—used as a chamber pot) is a medallion of some saint. Above that hangs portraits of Moll's idols, the roguish highwayman Mac(k)heath from Gay's *Beggar's Opera* and "Dr. Sacheveral S.T.P." (*sanctae theologiae professor*), a controversial divine of the period. Placed purposefully on top of these two portraits are a jar and two vials of "cures" for venereal disease.

Above the room's broken windows hangs a cheap print portraying an angel stopping Abraham from sacrificing Isaac; it seems to warn of the girl's impending and uninterceded fate at the hands of the law. Over Moll's bed hangs a witch's hat and a bundle of birch rods, suggesting that her condition requires her to engage in flagellation and black magic. A wig hangs on the drape behind her bed. Through her apartment door come an arresting magistrate and his constables to apprehend Moll for prostitution. The leading figure, who fondles his mustache effetely, has been identified as Sir John Gonson, a type of the perennial harlot-prosecutors whose righteousness is only equaled by their compulsiveness.

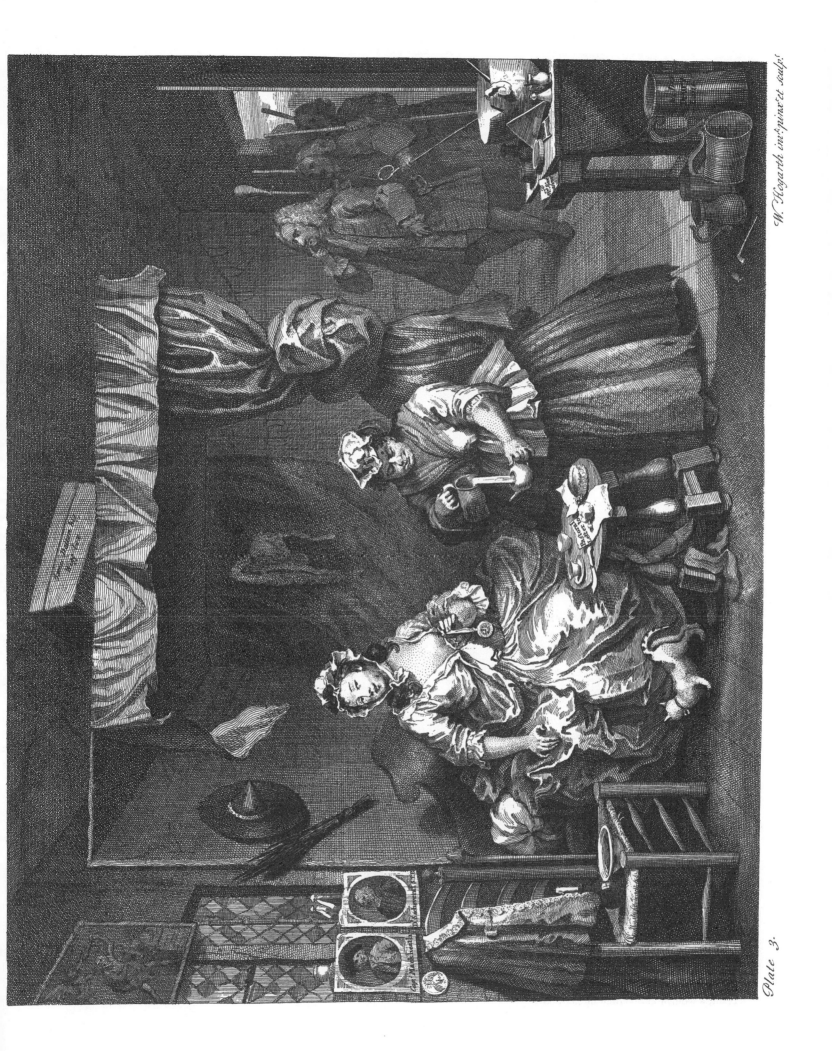

Plate 3.

A Harlot's Progress
PLATE IV
THIRD STATE. $11\frac{13}{16} \times 14\frac{13}{16}$

Sentenced to Bridewell Prison, Moll beats hemp with the other prisoners, mostly women, in this brutalizing house of "correction." The spirited look is gone from her tired, flabby face and her mouth droops slightly. She lifts her mallet only with great effort. Dressed in a grand gown, she is an object of ridicule to those around her. At her side stands a stern-faced jailer who threatens her with the leg-iron and cane—the stocks are already filled by another inmate.

The prison itself is a nurturer of crime; behind Moll a woman (perhaps the keeper's wife) steals an item of the girl's dress while she mocks her fashionable condition and acquired sensibilities. Moll's servant, dressed in rags but for a pair of incongruously gaudy shoes and stockings, smiles at the woman's treatment of her mistress. Beside the servant, a woman kills vermin on her body.

The prisoners are ranked by the warden according to their wealth and appearance. Next to Moll stands an older, well-dressed man who has been permitted to bring his dog to jail with him; the forged playing card that lies in front of him has betrayed him. Next to him stands a mere child with a look of resignation on her pretty face; she works with great earnestness and intensity. Beside her a more experienced, older woman rests on her mallet as she watches the keeper's movements. The last visible figure in the line is a pregnant Black, evidence that woman of all races are subject to the same fates. At the end of the shed is a crude vengeful stick drawing of Sir John Gonson hanging from the gallows; the letters "Sr J G." appear above it. On the left wall stands a whipping post with the warning "The Wages of Idleness."

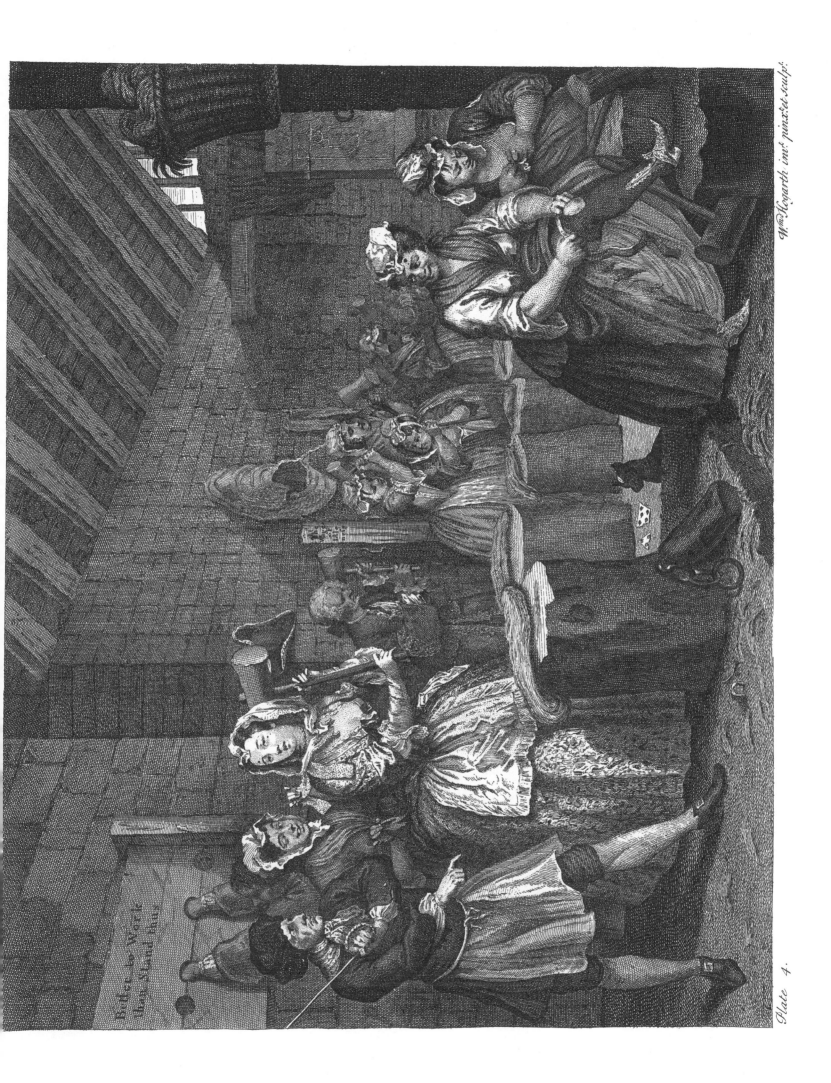

Plate 4.

22

A Harlot's Progress
PLATE V
THIRD STATE. $11\frac{7}{8} \times 14\frac{3}{4}$

Moll is dying of venereal disease; already her face is white and waxen and her head falls lifelessly backward. The scene around her is agitated and disordered. Two expensively dressed parasites (identified as Dr. Richard Rock and Dr. Jean Misaubin) quarrel violently over the efficacy of their cures as their patient-victim expires unattended in their view. Before Moll's corpse is cold, a strange woman (perhaps the land-lady) rifles her trunk. She has already selected for herself the most ominous articles of Moll's wardrobe: her witch's hat, her dancing shoes and her mask (now a black death mask) with a fan stuck grotesquely through its eyes. Moll's maid, with one comforting arm around the dying girl, attempts to stop the looting and the turmoil. The girl's son sits beside his mother, oblivious to her death, struggling with the lice in his hair and attempting to cook for himself.

The small apartment is the poorest and most primitive of Moll's abodes. Plaster has fallen from the walls; coal is stacked to the right of the fireside next to the bedpan covered with the plate ("B. . . Cook at the . . ."); holes in the door have been filled in to keep the place warm. The room is without any of the signs of Moll's personality that characterize her previous apartments. Instead of works of art there hang on the wall only a broken mirror and a fly trap (a Jewish Passover cake coated with a sticky substance).

Nor are there any of the usual signs of liquor; all her money has been spent on quack cures for her disease. On the floor, by the overturned table, lies an advertisement for an "anodyne" (pain-killing) necklace purchased to cure her own or perhaps her son's congenital syphilis. The mantelpiece is lined with similarly useless prescriptions. By the pipe, spittoon and old punchbowl, lie Moll's teeth; loosened by the fruitless use of mercury as a cure for venereal disease, they have come out. Over the expiring figure of Moll hang the limp, ghostly forms of her laundry.

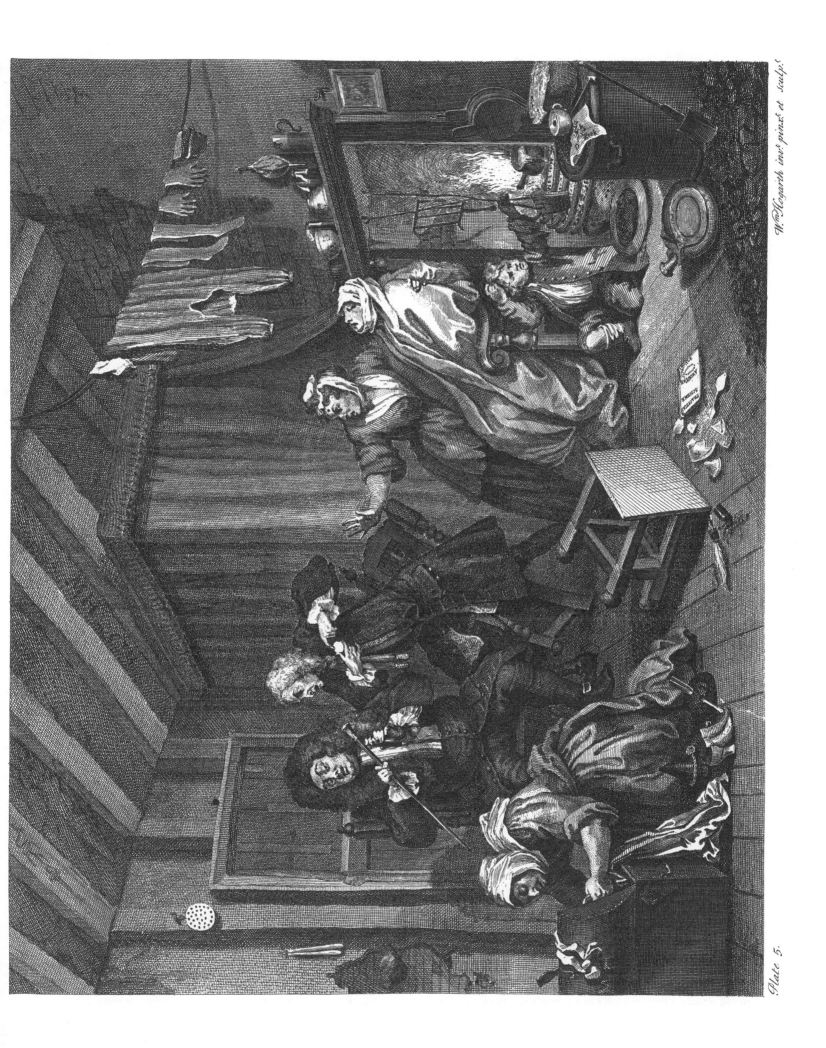

W.ᵐ Hogarth inv.ᵗ pinx.ᵗ et sculp.ᵗ

Plate 5.

23

PLATE VI

THIRD STATE. $11\frac{13}{16} \times 14\frac{13}{16}$

Moll, dead at the age of twenty-three, is being waked. The plate on her coffin reads: "M. Hackabout Died Sepr 2d. 1731 Aged 23." Nobody mourns her passing at the mock vigil held for her. Leading lives that are without options, her sisters have little to learn from her death. Gathered around her coffin, they exhibit a variety of contrasting attitudes toward the occasion. Their spiritual leader, the clergyman (identified by Hogarth as "the famous Couple-Beggar in The Fleet"), who is supposed to give a religious tone to the event, has his hand up the skirt of the girl beside him. His venereal preoccupation causes him to spill. The face of the girl who covers his exploring hand with a mourning hat is filled with a look of dreamy satisfaction.

Before the coffin Moll's son, decked out grandly as the principal mourner, plays with his spinning top. At the right side of the scene an old woman, probably Moll's bawd, howls in a fit of tears inspired as much by the brandy bottle at her side as by considerations of financial loss. Behind the bawd, an undertaker oversolicitously assists a girl with her glove; she postures as if in grief as she steals his handkerchief. At the mirror a girl adjusts her headgear vainly, oblivious to the prominent disease spot on her forehead. A weeping figure shows a disordered finger to a companion who seems more curious than sympathetic.

Only one person lifts back the coffin lid (which is being used as a bar) to look in detached curiosity, rather than in grief or reflection, upon Moll's corpse. In the background two older women huddle together demonstratively and drink. The only person with a sense of decorum is Moll's maid, who glares angrily at the conduct of the parson and his mate. Above the scene stands a plaque showing three faucets with spigots in them, the ironic coat of arms of the company.

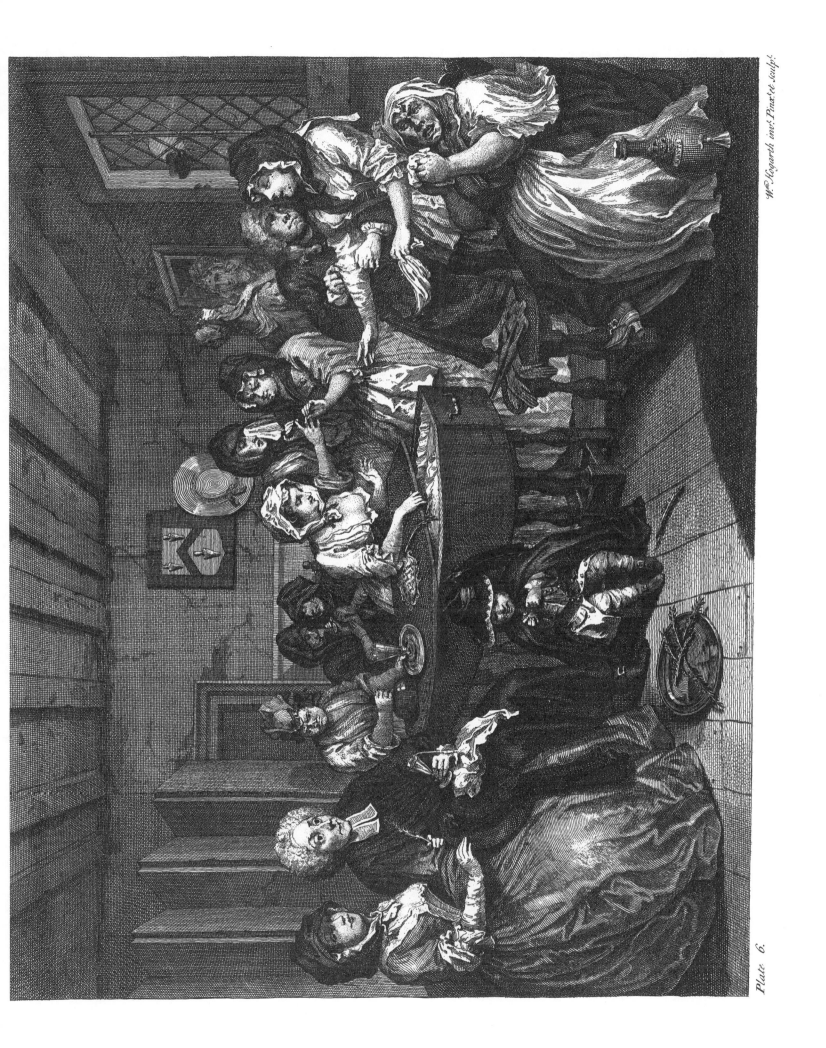

Wm. Hogarth invt. Pinxit sculpt.

24

A CHORUS OF SINGERS

ETCHED. THIRD STATE. DECEMBER 1732. $6\frac{1}{2} \times 6$

First used as the ticket for "A Midnight Modern Conversation," this print was later combined with "The Laughing Audience," "Scholars at a Lecture" and "The Company of Undertakers" as one of the set entitled *Four Groups of Heads*. The print portrays a rehearsal of the oratorio *Judith* written by William Huggins, a friend of Hogarth's, and set to music by William Defesch.

The print contrasts the various unangelic postures and expressions—grotesque, comic and inspired—which unselfconscious singers adopt.

The choir master has lost his wig in his athletic performance but is oblivious to his comic appearance; his energetic directing goes almost entirely unheeded by the choir. The section of the oratorio being performed is in four voices; the expressions of those in each voice are contrasted to those in the neighboring voices: the cherubic features of the boy sopranos with the laboring expressions of the tenors; the pained faces of the basses with the cheerful appearance of the altos. The stem of the bass viol is carved into the head of an expressive singer.

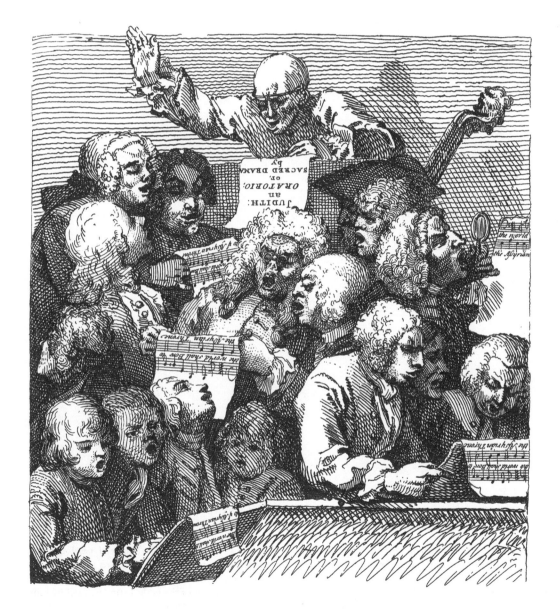

25

A MIDNIGHT MODERN CONVERSATION
THIRD STATE. ETCHED AND ENGRAVED FROM A PAINTING. MARCH 1732/3. $12\frac{7}{8} \times 17\frac{15}{16}$

However comic the figures in "A Chorus of Singers" may be, they certainly are intended by Hogarth to stand as an instructive contrast to the group in "A Midnight Modern Conversation." Conceived in the spirit of Jan Steen's drinking scene *As Old Folks Sing, Young Folks Pipe*, Hogarth's print is a realistic London version of the genre of paintings which celebrate bacchanalian festivals.* Less rigorously didactic and more comic than "Gin Lane" (which treats the drinking problems of the working classes), its purpose is to show the follies of overindulging in liquor, and to that end it exhibits a spectrum of effects produced by different degrees of intoxication.

The drunkest figure in the scene may be the soldier (with the cockade in his hat) who sprawls out on the floor, his hand pointing moralistically to the pile of empty bottles and the lemons beneath a table leg shaped at the top into a grotesque, Bosch-like thing. A stumbling physician attempts to administer aid to him by pouring liquor on his

head wounds. His glass balanced perilously on the table's edge, a wigless, snoring figure is about to tumble backward. Beside him two figures who seem to have quarreled sit back to back.

In the center of the table a stupefied fellow tells a heart-felt tale to an amused, skeptical lawyer. An excited man sings out a toast as he crowns a well-fed clergyman. The practiced clergyman, who stirs the punch solicitously with one hand and holds a pipe and a corkscrew in the other, is the only person still relishing the liquor. In contrast to this capacious parson, the figure next to him, in a vain attempt to reach the large, overflowing chamber pot, vomits at the table unnoticed. In more hazard, the man by his side attempting to relight his pipe (filled with "Freemans Best") has fired his ruffled sleeve. The politically divergent *London Journall* and *The Craftsman*, which lie significantly close to his oversized sword (not even the soldier is armed), suggest that he is a politician.

The morning light casts the window's reflection on the bottle the physician tips over. A tranquil Oriental scene decorates the punchbowl in the center of the picture.

* Antal, *Hogarth and His Place in European Art*, p. 95.

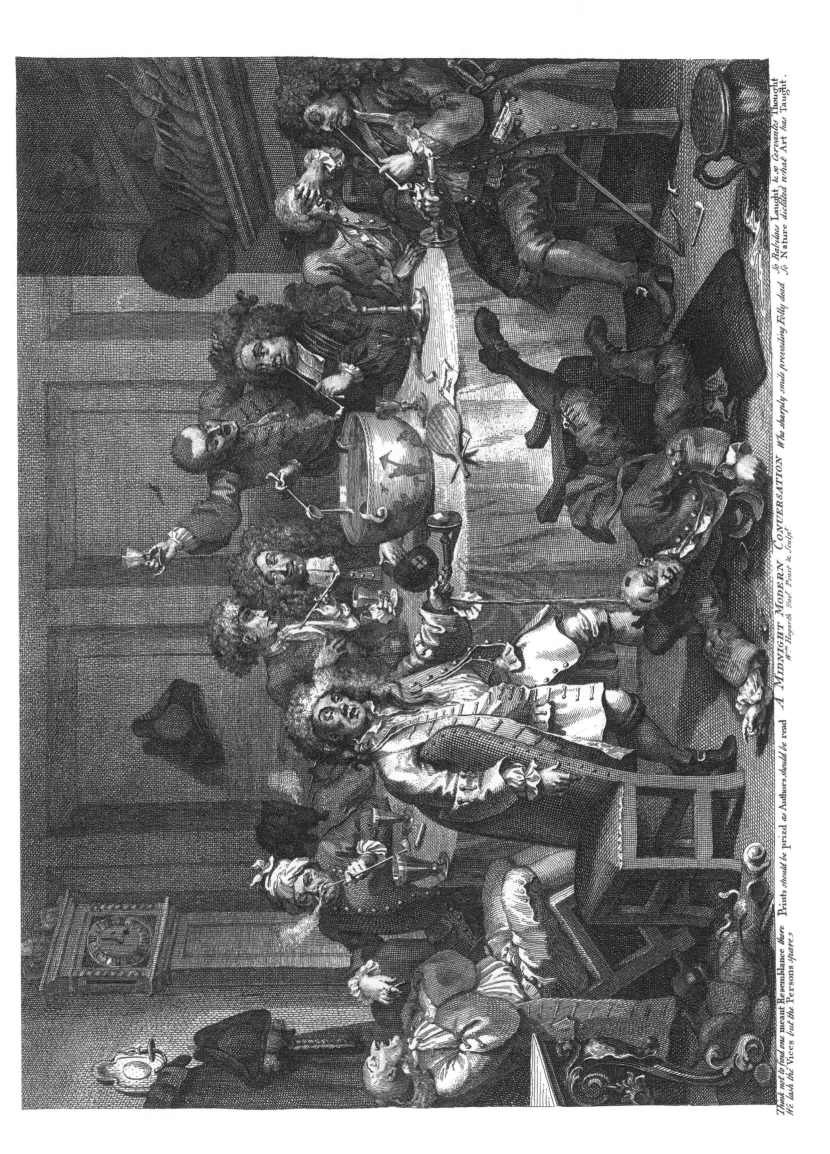

A MIDNIGHT MODERN CONVERSATION

Think not to find one meant Resemblance there Prints should be priz'd as Authors should be read
We lash the Vices but the Persons spare.

Who sharply smile prevailing Folly dead
To Nature dwellest what Art has Taught.

Wm Hogarth Inv! Pinx! & Sculp!

To Ridicule Laught & to Cervantes Thought

THE LAUGHING AUDIENCE
ETCHED. FOURTH STATE. DECEMBER 1733. 7 × 6⅛

Designed as the subscription ticket for "Southwark Fair" and *A Rake's Progress*, this print later became one of Hogarth's *Four Groups of Heads*. It contrasts the reactions of three classes of people to a dramatic performance. The earnest members of the orchestra, separated by the spiked partition from the pit, are absorbed in their performance. In the balcony two foppish, affected noblemen ignore the production to intrigue with an orange girl and a lady. In the pit, a variety of commoners, genuinely engaged by the performance, react in spontaneous, unselfconscious laughter. Only one figure, who seems not even to watch the show—probably a critic—scowls.

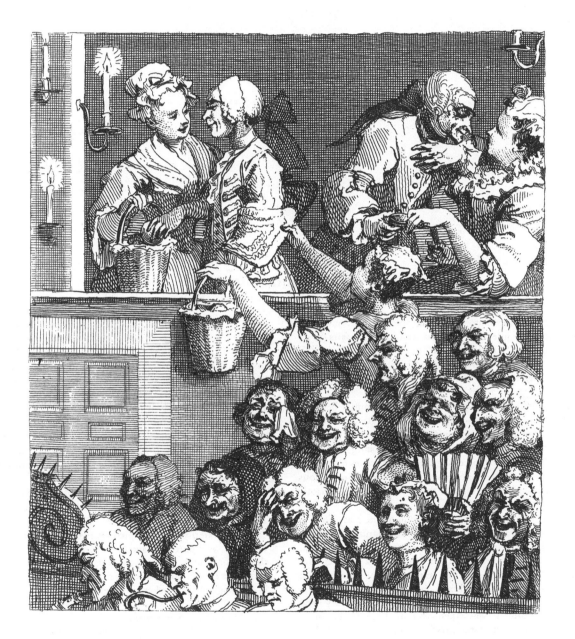

27

SOUTHWARK FAIR
ETCHED AND ENGRAVED FROM A PAINTING. JANUARY 1733/4. $13\frac{9}{16} \times 17\frac{13}{16}$

In this plate Hogarth represents a teeming scene from Southwark Fair, though he certainly intends it as a picture of all such fairs (in an advertisement he calls it "The Fair" and "the Humours of a Fair"). This event was held annually in September and often lasted a full fortnight; because of the riot and disorder that attended it, it was suppressed in 1762.

In "Southwark Fair" Hogarth plays on the incongruities between the high and low, the sublime and the ridiculous that appear in the scene. Exalted forms of art and entertainment (or what pass for these), many of them employing mythic subject matter, are being performed literally above the heads of the crowd. On the ground scenes from common life take place along with entertainments of a criminal or frivolous nature. At several points the high and the low mingle in a chaotic human circus.

At the extreme left the stage collapses (in a pun on the play, *The Fall of Bajazet*), heaving earthward, with complete loss of dignity, a company of regally costumed players who include the famous Cibber and Bullock. They fall into a china shop and onto a dice player and a gambler who are too engaged in a dispute to hear the warning of the latter's child.

The showcloth below the terrified monkey, "The Stage Mutiny," is a copy of a print by John Laguerre. It portrays a rift in the Drury Lane theatre that occurred after it was taken over by John Highmore, a gentleman turned amateur actor and director. Under the banner "We'l Starve em out," Highmore, who had bought control of the theater, points to a scroll reading "it Cost £6000." On his side are the company's scene painter, part-owner Mrs. Wilks (in mourning) and her daughter. Between the opposing factions hangs a monkey, Highmore's surrogate, protesting, "I am a Gentleman." Under the banners "Liberty & property" and "We eat," Theophilus Cibber ("Pistol's alive") and the bulk of the actors advance on the owners. Colly Cibber, who has sold his shares to Highmore, sits apart from the fray, "Quiet & Snug," with a money bag on his lap. The showcloth for a freak show below this one advertises the presence of a giant.

Amid the placid Surrey hills, a figure waving a flag from someone's shoulder has won a quarter-staff contest. A tame high-rope artist and a daredevil competitor perform, one on each side of the center stage. The reckless fellow takes his flight from a steeple, implying the church's involvement in the fair. A showcloth announces *The Siege of Troy*; it is presently being rehearsed for advertising purposes. To the right, on a more popular level, Punch's horse steals a clown's kerchief and a Punch and Judy show is performed. Above, a showcloth portraying Adam and Eve announces a scriptural drama; next to it a comic scene entitled "Punches Opera" shows a merry figure wheeling his wife into the jaws of a dragon. In the open area between the buildings on the right, a hat and shirt hoisted above the crowd are prizes for wrestling and running competitions.

At the extreme right stands the stall of the "Royal Wax worke"; "The whole Court of France is here." A monkey beating a drum, and a wax model, advertise the show. Below, a showcloth announcing "Fawxs Dexterity of hand" pictures two contortionists and the juggler beside his own portrait. Fawkes performs with a bird and a tumbler. In the foreground, a professional fighter, head wounds well displayed, enters the fair on horseback, his sword drawn and his face screwed up in challenge. A pickpocket purposefully points him out to an astonished couple. Two bailiffs who fail to see the crime to the right arrest an actor dressed as an emperor.

To the immediate left of the fighter, a couple embrace; beside them a man inspects two young girls (the motif is similar to the central action in *A Harlot's Progress*, Plate I). In front of them a woman with a small barrel organ on her back runs a peep show. On a platform among the crowd a physician eats fire to attract attention while his assistant retails his quackeries. In the center foreground a youthful drummer girl accompanied by a bugler advertise their play. Her striking beauty is admired awkwardly by two bumpkins. To the left a pathetic child operates puppets with his foot (his shoes are much too large for him) and plays bagpipes to himself. Beside his ragged figure he keeps a dog dressed as a foppish gentleman.

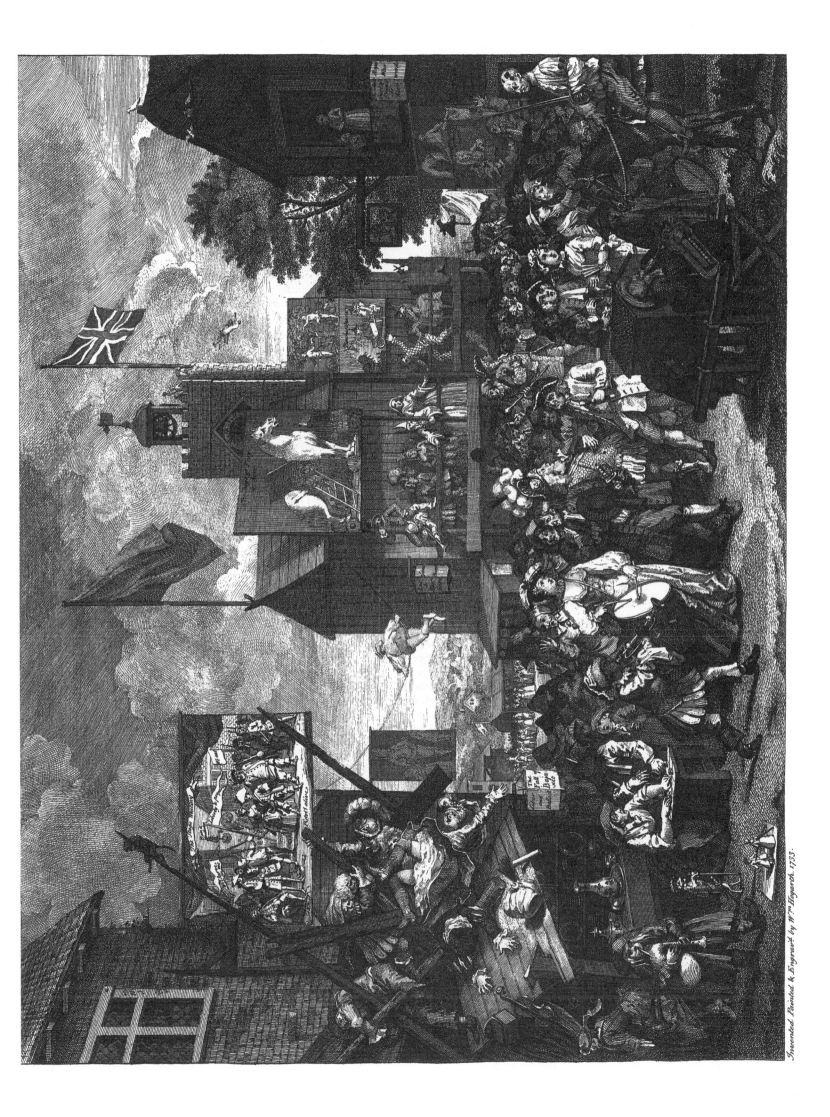

Invented Painted & Engraved by Wm Hogarth. 1755.

A Rake's Progress

ETCHED AND ENGRAVED FROM PAINTINGS. JUNE 1735.

A Rake's Progress was etched and engraved from a series of eight paintings completed in 1734. The progress, delayed so that it might be protected from pirates by the Engravers Act, was issued on June 25, 1735, the day the Act took effect. A little less popular than *A Harlot's Progress*, this series provoked the same types of explanations, interpretations, piracies and independent works of art.

While both the harlot's and the rake's progresses tell of parallel fatal attempts by young people to rise out of their social classes or circumstances, these stories have interesting differences. Moll's tale is about her attempt to make her livelihood in an alien, hostile environment; her struggle against a predatory society is a struggle for both social advancement and survival. The rake's fortune is already secure at the opening of his story. Deluded by the glitter of aristocratic life styles, he rejects a life of work and virtue and uses his own and another's wealth in follies and dissipations which lead to his ruin. Less the victim of circumstances, more self-destructive than destroyed, he is still preyed upon by many of the same institutions and types as Moll—the aristocracy, the businessman, the jail, the madhouse.

A Rake's Progress is a work of broader scope and greater complexity than *A Harlot's Progress*. It treats such topics as the rake's schooling and his father; and it embraces a range of experience and conduct that is much wider than what we see in Hogarth's earlier progress; it explores more involved, sustained relationships between characters. It has a fully developed subplot which chronicles the life of Sarah Young. The picture of a loyal, supportive female, Sarah is a sentimental and implausible creation. She is an important part of the series primarily because she represents many of the middle-class virtues (work, thrift, loyalty, Christian benevolence) that correspond to the rake's aristocratic vices. As a result she serves both as a contrast to Tom and a positive embodiment of some aspects of the life which Hogarth means to recommend to his viewer. The same rigorous moral purpose imbues this work as does *A Harlot's Progress*.

28

PLATE I
THIRD STATE. $12\frac{3}{8} \times 15\frac{3}{16}$

In Plate I, Hogarth explains Tom Rakewell in terms of a rejection of his father and contrasts the two very opposite characters. The plate depicts the rake spurning the middle-class values (duty, marriage, thrift) that his father has lived by. The miser has died suddenly, and the cracked, bare walls of his office—it has no home comforts—are being covered with black cloth for the wake. Funeral escutcheons, the motto and arms of old Rakewell, already hang on the wall, showing three vises (= vices) with the motto "Beware" (particularly appropriate advice to the unheeding son).

To assuage his curiosity about the extent of his newly acquired wealth, Tom has opened the closets, strongboxes and documents of the elder Rakewell (a name suited equally to father and son). The father's diary records with equal value his only son's homecoming and cheating someone with a fake coin ("Memordums 1721 May 3 my Son Tom came from Oxford 4th/ Dine at ye French Ordinary 5th put of my Bad Shilling"). Scattered carelessly around Tom's feet lies the miser's paper wealth: "India Bonds," "Mortgages," "Fines & Recoverys," "Lease & Release," and "This Indenture." A strongbox with a triple lock holds silver plate and money; it contains three sacks labeled "1000," "2000," "3000." A famished, snarling cat (the place is without food and therefore mice) guards the chest.

The last prophetic act of the miser has been to cut a sole for his shoe from a Bible cover; he has died before sewing the leather completely. Beside the mutilated Bible, a chest and a closet contain worthless trivia accumulated compulsively over the years; they include a broken lantern, a shovel, a pair of shoes, an odd boot, two swords, a broken jug, a bowl and wigs. Having long ceased to entertain, the miser has stored away a spit and jack in an inaccessible wall compartment. The old man's stick and crutch rest against the mantle, and his glasses (without lenses) hang near them.

The room is without decoration except for a picture of the miser himself who sits with a pair of scales in his hand (a comic reference to the scales of justice) counting money. Even in his portrait he wears his hat (now on the mantle beside the candlestick and candlesaver) and overcoat to avoid burning a fire. Money fearfully secreted in the ceiling spills down on his portrait. Three of the miser's former employees attend the rake. An old servant prepares to light a blazing fire; a lawyer (identified by his baize bag used to carry documents) interrupts his inventory-taking to claim his fee surreptitiously; and an ill-dressed, economical tailor measures Tom for a mourning suit.

Already Tom's past is troubling him. Sarah Young, a sentimental representative of middle-class good nature, patience and loyalty—everything that Tom is not—has been seduced at the university, in part by promises of marriage; in her drooping hand she holds a ring; and her mother carries love letters from Tom ("To Mrs. Sarah Young" and "Dearest Life . . . & marry you"). Pregnant, she comes to Tom with her mother who confronts Tom with an animal fierceness (she resembles in expression the cat by the strongbox). Tom, a childish-faced person, callously tries to buy the mother off with his newly acquired wealth as he postures to permit the tailor to continue his work without interruption. He shows no sign of grief at his father's death.

Hogarth's revisions of his plates are regularly pessimistic. In earlier states of this print, the desecrated Bible is absent, Sarah looks younger and less drawn, and Tom appears more youthful, naïve and expressive. Other minor differences include a shift in the location of the diary and the inclusion of a bill for the mourning cloth.

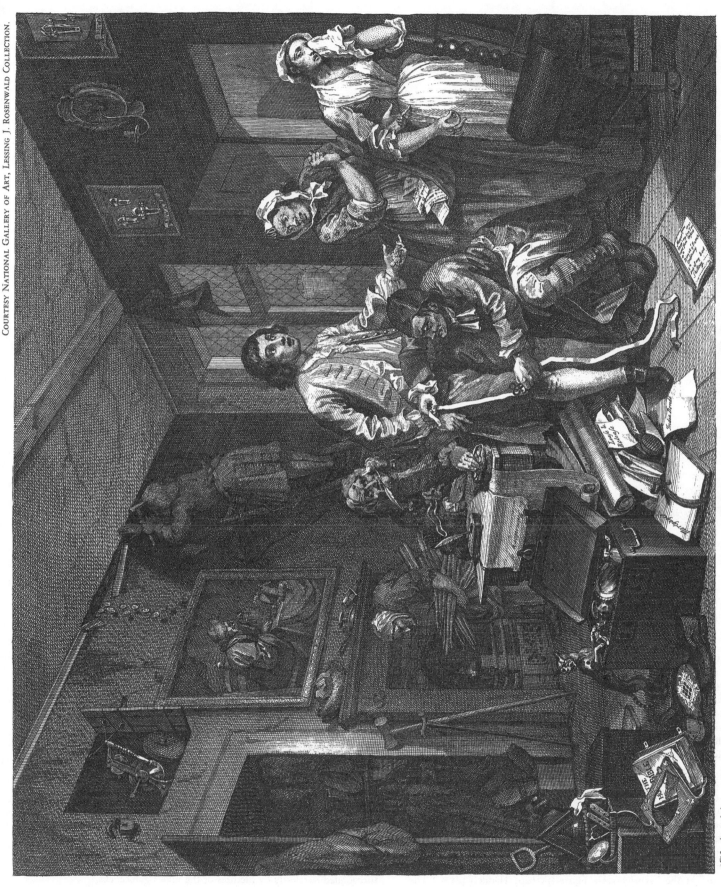

Vanity of Age, untaught, Why, thy tiresome Journey o'er; Hast Thou a Son; By Time to raise When? then shall flow, of Friendly Page; That youthful Mind with Freedom warn;
Cries Infancy ever froward; Layst thou in an useless Store? His views thy Toil with other Eyes — That social Commerce, honefest Peace; As finds of Father mix the Friend.
Why, thofe Belts & misey Chains, Hope along with Spine is flown, Reid mvg thy Kind raternal Care; Famelier; Piety without Priest,
Squint Suspicion, jealous Paine? For; canst thou reap of Field that own, Lockt in thy Chyfe, & bury'd there. Infraction from Example tried:

Painted Pictures framed by W.m Hogarth &
Publish'd Jan.y 25 1725 decerding to. Act.
of Parliament.

Plate. 1.

A Rake's Progress
PLATE II
FOURTH STATE. $12\frac{3}{16} \times 15\frac{1}{4}$

Tom's transition from a bourgeois life style to an aristocratic one, prodigal and inappropriate, is complete. The miser's dreary room has been replaced by a grand house, bright, spacious and fully appointed; here, at his morning reception, Tom receives—not his noblemen peers —but commercial people, each representing a separate aristocratic vice, affectation or entertainment.

In the center of these tradesmen stands Tom, dressed in a fashionable morning gown, giving his attention to a professional assassin; in his hand he holds a letter reading, "Sr. the Capt. is a Man of Honour. his Sword may Serve you Yrs. Wm. Stab." The grim-faced mercenary stands with one hand on his weapon and the other over his heart in an affectedly earnest profession of honor. Beside him a huntsman, one hand wearily in his pocket, sounds his horn impatiently. Below the rake a jockey displays a trophy won by his master's horse inscribed, "Won at Epsom/ Silly Tom."

On the left a French dancing instructor and a fencing master perform ostentatiously before their employer. In contrast to their artificial vivacity two stolid Englishmen stand in the background; both wear defeated looks on their faces that signal a consciousness of the disadvantages of their position in the presence of voguish foreign competition. At the harpsichord a figure (perhaps Handel) plays "The Rape of the Sabines. a New Opera." The "Performers" are famous contemporary foreigners. "Romulos Sen: Fari[nel]li 1 Ravisher Sen:

Sen[esi]no 2 Ravisher Sen: Car[esti]ne 3 Ravisher Sen: Coz-n Sabine Women Senra: Str-dr. Senra: Ne-gr* Senra: Ber[tol]le." Hogarth's title, *The Rape of the Sabines*, is a hit at the paradoxical combination of castrati and promiscuous women in the cast.

Behind the harpsichordist's chair another testament to the rake's taste for the foreign reads, "A List of the rich Presents Signor Farinelli the Italian Singer Condescended to Accept of ye English Nobility & Gentry for one Nights Performance in the Opera Artaxerses—A pair of Diamond Knee Buckles Presented by — A Diamond Ring by — A Bank Note enclosed in a Rich Gold Case by — A Gold Snuff box Chace'd with the Story of Orpheus Charming ye Brutes by T: Rakewell Esq: 100[£] 20[o£] 100[£]." On the floor at the dancing master's feet lies a title page inscribed "A Poem dedicated to T. Rakewell Esq"; it pictures Farinelli on a pedestal before a group of women crying in homage, "One G-d, one Farinelli"; two hearts burn below the singer.

In the wing, another passel of tradesmen wait; they include a milliner, tailor, wigmaker and a poet (who tries to separate himself from the commercial people). *The Judgment of Paris*, a technically inept picture of foreign manufacture passed off on the rake as a masterpiece, is surrounded tastelessly by pictures of the rake's gamecocks.

* Cuzzoni, Strada and Negri.

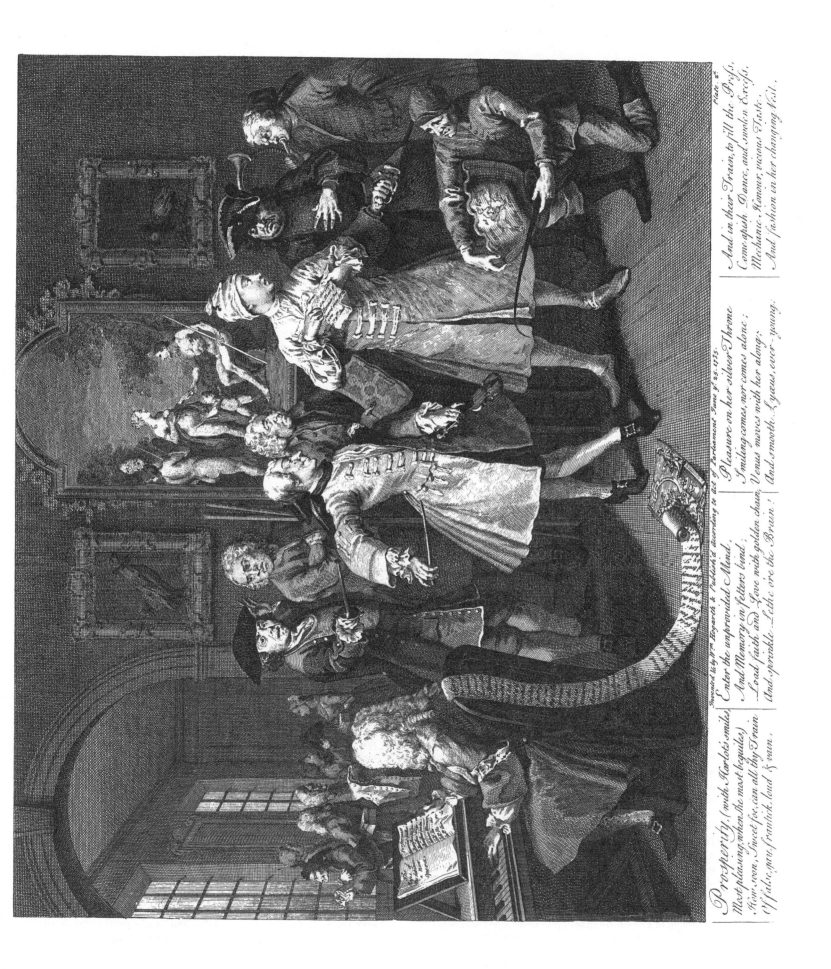

Invented & Engra'd by Wm Hogarth & Publish'd according to Act of Parliament June yᵉ 25. 1735.

Plate 2ᵈ

Prosperity, (with Harlots smiles)
Most pleasing, when she most beguiles,)
How soon, Sweet foe, can all thy Train
Of false, gay, frantick, loud & vain,

Enter the unprovided Mind,
And Memory in fetters bind,
Load faith and Love with golden chain,
And sprinkle Lethe o're the Brain!

Pleasure on her silver Throne
Smiling comes, nor comes alone;
Venus moves with her along,
And smooth-tongu'd, ever-young.

And in their Train, to fill the Prefs,
Come quick, Dance, and smooth Excess.
Mechanic Honour, vicious Tast,
And fashion in her changing Vest.

A Rake's Progress
PLATE III
THIRD STATE. $12\frac{1}{2} \times 15\frac{5}{16}$

Plate II illustrates Tom's morning entertainments; Plate III depicts his evening pleasures, exposing both Tom himself and the aristocratic model upon which he forms himself. He has ordered an extravagant orgy for himself and a single acquaintance. The affair takes place in a shabby room that may once have had pretensions to grandeur; the inscription on the large plate held by the servant with the infantile grin on his face reads " John Bonvine at the Rose Tavern Drury Lane."

Tom and his companion seem to have played a substantial part in the pointless destruction that has been visited on the place. The backs of the chairs have been broken, the room's mirror shattered and portraits of "Augustus," "Titus," "Otho," "Vitelius" and "Vespatianus" have been slashed. Only the portraits of "Nero" and "Pontac," a person after whom a well-known London restaurant was named, have survived. Surrounded again by commercial people and besotted by alcohol but still drinking, the rake reclines close to a bed, his clothes unbuttoned, on the bosom of a solicitous harlot.

With typical aristocratic disregard for the law, his unsheathed sword has been drawn in a cowardly attack upon an unarmed watchman. The watchman's battered lantern and staff lie at the rake's feet along with a broken glass, some scattered pills and part of a portrait of an emperor

("Iulius"). The innocent-looking (and very sober) harlot fondles Tom as she passes his watch to an accomplice.

At the table an angry woman spews a stream of gin at another who threatens her with a knife. A mischief maker sets fire symbolically to a map of the world. Below her the rake's drunken acquaintance and a stupefied harlot fondle mechanically. A very sober Black woman smiles at a half-conscious figure who spills the contents of the large punchbowl over herself in an attempt to consume it; she is restrained by a more delicate companion who drinks from a glass and bottle.

Behind them the "posture woman," wearing stockings bearing an incongruous coronet, undresses sleepily. She will perform on the large dish in the center of the table with the candle as her prop. Her underclothes lie piled on top of an emperor's face. Her index finger points to the stuck chicken although she herself does not seem to see the parallels between her own condition and the bird's. By the door stands a ragged ballad singer advertising the "Black Joke"; her pregnant, desolate state is a warning to the harlots about the hazards of their occupation. In the corner a trumpeter and harpist provide the music for the girl's act. It is morning; daylight shines through the window and is reflected on the bottles on the table.

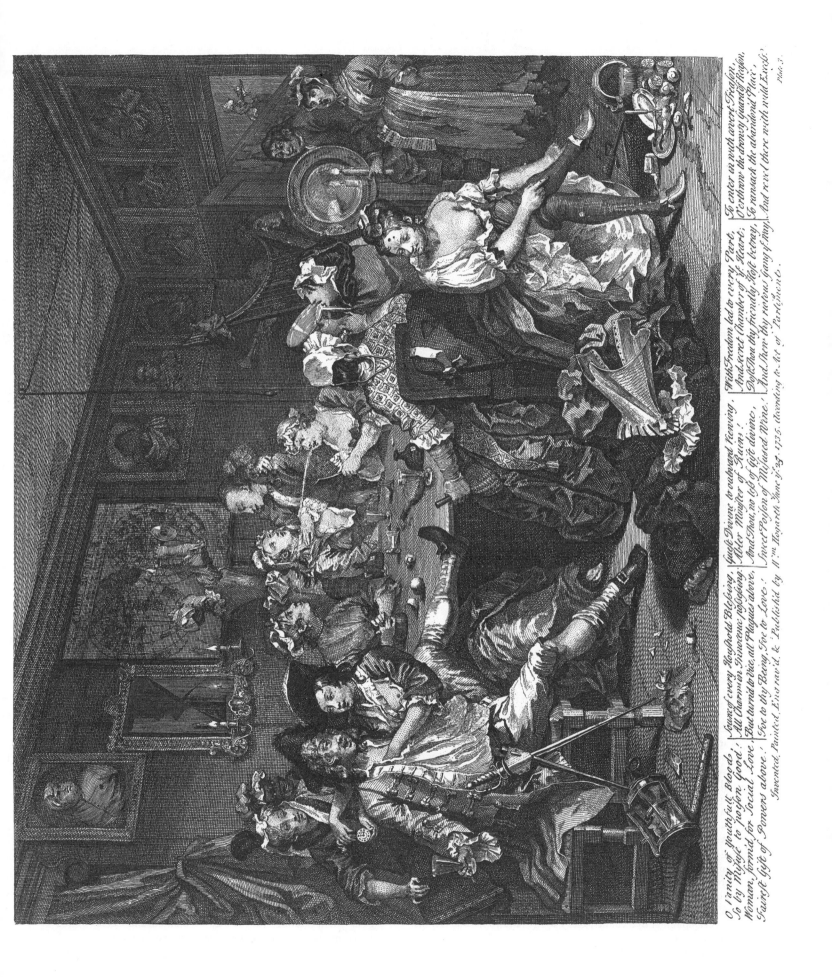

O Vanity of youthfull Blood, | Source of every Youthfull Blessing, | Gives Divens to outward Seeming, | With Freedom led to every Part, | To enter in with artfull Freedom,
So by Misguse to poison food; | All Charming Innocence refreshing, | Nobler Chamber of yf. Heart; | O'erthrow the drowsy guard of Reason,
Woman, form'd for Social Love, | But turn'd to Vice, all Plagues above. | And Thou, no less of gift divine, | To ransack the abandon'd Place;
Fairest Gift of Powers above. | For to thy Being, For to Love; | Sweet Poison of Misused Wine. | And rev't there with wild Excess.

Invented, Painted, Engrav'd, & Publish'd by Wm Hogarth Jan.ry 25 1735, According to Act of Parliament O.

Pag. 3.

A Rake's Progress
PLATE IV
THIRD STATE. $12\frac{7}{16} \times 15\frac{1}{4}$

In Plate IV the first inevitable consequences of Tom's new life style appear; his money runs short. The leek on the Welshman's hat identifies the date as March 1, the feast of St. David. Tom, dressed as a beau to assure his credit, seems to be on his way to White's to recover by gambling what he has squandered by excess. Despite the half-drawn curtain on his chair, he has been surprised by a polite but firm bailiff with an "Arrest" notice. The bailiff is accompanied by a threatening assistant who does not disguise his interest in Sarah Young.

Rakewell is rescued not by his aristocratic acquaintances whose carriages and chairs stand outside White's gambling den in front of St. James's Palace, but by the plainly dressed girl from Oxford who has preserved the middle-class values of work, thrift and compassion. In a pointed reversal of Tom's cynical attempt to buy her off in Plate I, she offers her earnings as a milliner to the bailiff. Above Tom an inattentive lamplighter by a saddlemaker's sign ("Hods[on] Sadle") spills oil from a vessel.

An outdoor gambling school operates beside a post labeled "Blacks."

Here mere children, corrupted by city life, ape the vices of the fashionable adults at places like White's. One steals Rakewell's handkerchief; another tiny, ragged figure smokes a pipe and bends like an old man over a newspaper (*The Farthing Post*). Two bootblacks in the foreground cast dice; both wager their means of livelihood in a throw. The figure with the star tattoo has lost all his clothes to his companion except for his cap and pants. The loser has a liquor glass and measure beside him, the winner three thimbles and a pea (another gambling device). Behind them a news vendor (the trumpet at his side) and election canvasser (the sign on his cap reads "Your Vote & Interest—Libertys") plays cards with an ape-like sweep. Behind the former a third boy signals the contents of his perplexed neighbor's cards to the sweep.

As the first state of this print reveals, the entire gambling school, the lightning bolt and the "Whites" sign were added in later states. The ragged youth stealing Tom's stick is omitted and Sarah Young's countenance is made slightly more angry in the later states.

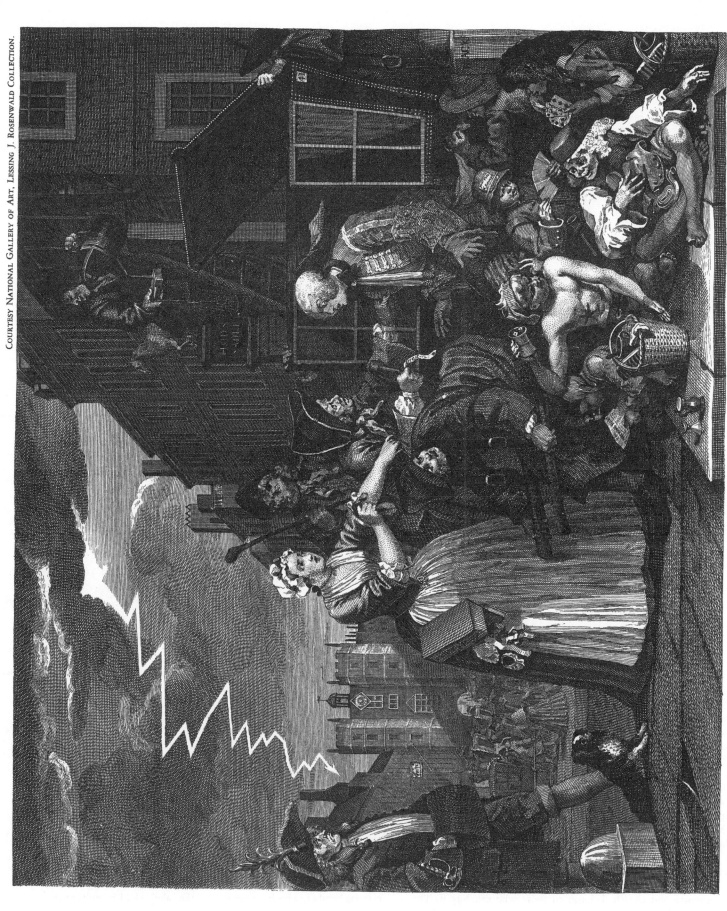

O Vanity of youthfull Blood, | Approaching ruins the Harpy Law, | Ready to seize the poor Remains | Cold Penitence, lame After-Thought, | laid back his guilty Pleasures dead,
So by Misfuse to poison Good: | That Vice hath lost of all his Gains. | With Fears, Despair; & Sorrows fraught; Whom he hath ruin'd, & whom betray'd.
And Poverty with icy Paw
Reason awakes, & views unbard
The sacred gates he watch'd to guard.

Invented, Painted, Engrav'd by Wm. Hogarth, & Publish'd. June yᵉ 25. 1735. According to Act of Parliament. Plate. 4.

A Rake's Progress
PLATE V
THIRD STATE. $12\frac{1}{4} \times 15\frac{1}{4}$

Unreclaimed to bourgeois life by Sarah Young and determined to pursue his career as a gentleman, the rake repairs his fortune by a cynical alliance with an aged, ugly partner who trades her wealth for sexual fulfillment and class advancement. The scene of this mock religious ceremony is the decayed church of St. Mary-le-Bone, famous for clandestine marriages (the gallery holds a plaque reading "This Church of St. Mary le Bone was Beautified in the year 1725, Tho Sice Tho Horn Church Wardens").

The condition of the church mirrors the nature of the act and actors in the scene; plaster has fallen from the walls; the creed on the right wall has rotted away, leaving only the words "I Believe"; and the tablet with the commandments is cracked. The sounding board behind the pulpit bears the outline of the preacher's hat. The pew at the left, like clergyman and church, belongs to those who can buy it. The inscription reads: "These: pewes vnscrvd: and: tan: in. svnde[r]/ In. stone: thers: graven: what: is: vnder/ To wit: a: valt: for: bvrial: there: is/ Which: Edward: Forset: made: for: him: and: his." "The poorˢ box" is covered with a cobweb.

The rake, a stately, attractive figure, is in the act of prostituting himself in much the same way as the harlot did in Plate II. As he slips the ring on his wife's finger, he glances calculatingly at her young maid. At the feet of these richly dressed figures, a ragged urchin with his toes peeping through his right shoe positions a kneeler for the bride. The wife, an overdressed, one-eyed, hunchbacked creature, leers and seems to wink at the clergyman, a figure much more her match in age and looks. The small crucifix on her breast and the halo-like "IHS" above her head cast her satirically as a saint. A large, aggressive dog and a smaller one-eyed bitch mirror the alliance taking place at the right. In the background a churchwarden battles with Sarah Young and her clawing mother, who have come with the rake's child to prevent the marriage.

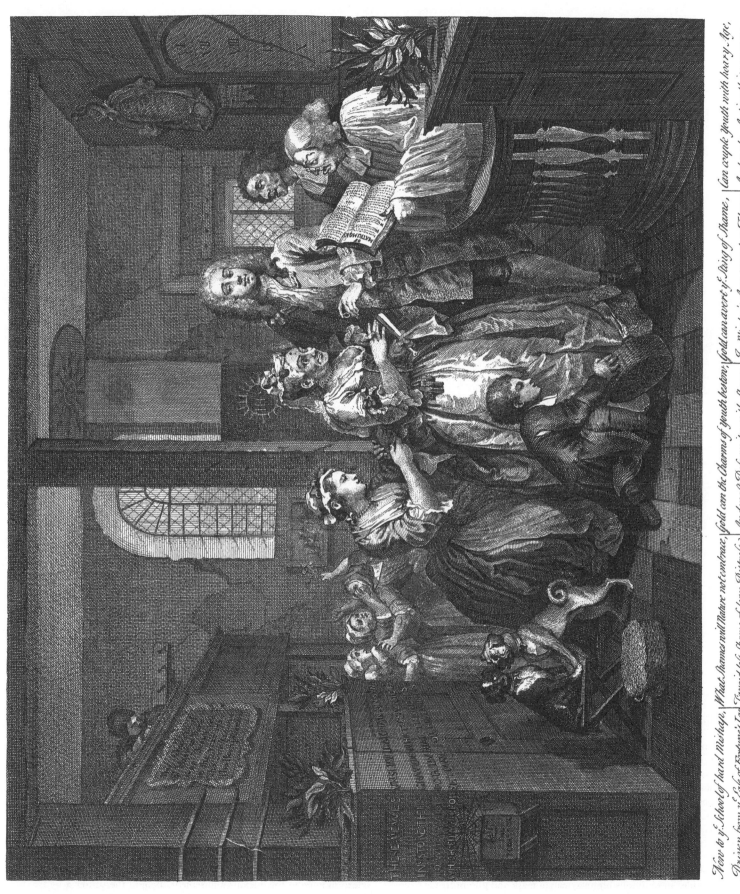

Now to yͤ School of hard Mishap, | What Shames will Nature not embrace, | Gold can avert yͤ Stings of Shame, | Can expose youth with heavy. Age, | Driven from yͤ Case of Fortune's Lap, | Favour'd yͤ Shame of mean Retreofs : | And make yͤ Deformity with Shern : | In Winter's Arms write a Flame, | And make Antipathies engage.

Invented Painted & Engrav'd by Wͫ Hogarth & Published Iune 25 1735 According to Act of Parliament.

Plate 5.

33

A Rake's Progress
PLATE VI
THIRD STATE. $12\frac{5}{16} \times 15\frac{1}{8}$

Drawn into gambling again, one of the most popular and fatal vices of his new social circle, the rake has lost a second fortune. The center of interest in the previous scene, that stately figure is now half mad. His clothes unbuttoned, his wig ripped off, he is alone in the midst of his companions. His fists clenched, teeth gritted and eyes bulging, he seems to curse heaven and fate. A mad dog (with a collar inscribed "Covent Gar[den]," the location of the gambling house) mirrors the rake's frenzy.

Too absorbed to notice the fire, those in the room (most are gentlemen) exhibit variously the effects of gambling in their conduct. By the fireside, an oblivious highwayman (a mask and gun protrude from his pocket), depressed and preoccupied by his losses, seeks consolation in a large gin. Completely withdrawn, the man behind him bites his nails in torment. To the left, two figures with satisfied countenances share the fruits of their collusion. Only the croupier and another man notice the fire. Behind them three figures are involved in a violent dispute. To his left, a gentleman expresses surprise at the entrance of the watch, who has seen the blaze from outside. Another casual and richly dressed fellow borrows money from a plainly clothed figure (reminiscent of the rake's father) who sits at a table covered with a rotting cloth and detachedly enters in his ledger "Lent to Ld. Cogg 500."

Above the fireplace hangs an advertisement reading "R Justian Card Maker to his Maj . . . Royal Family," suggesting that even the king and queen indulge in this vicious amusement. Behind the usurer a figure dressed in mourning convulses, perhaps over the loss of a newly acquired legacy.

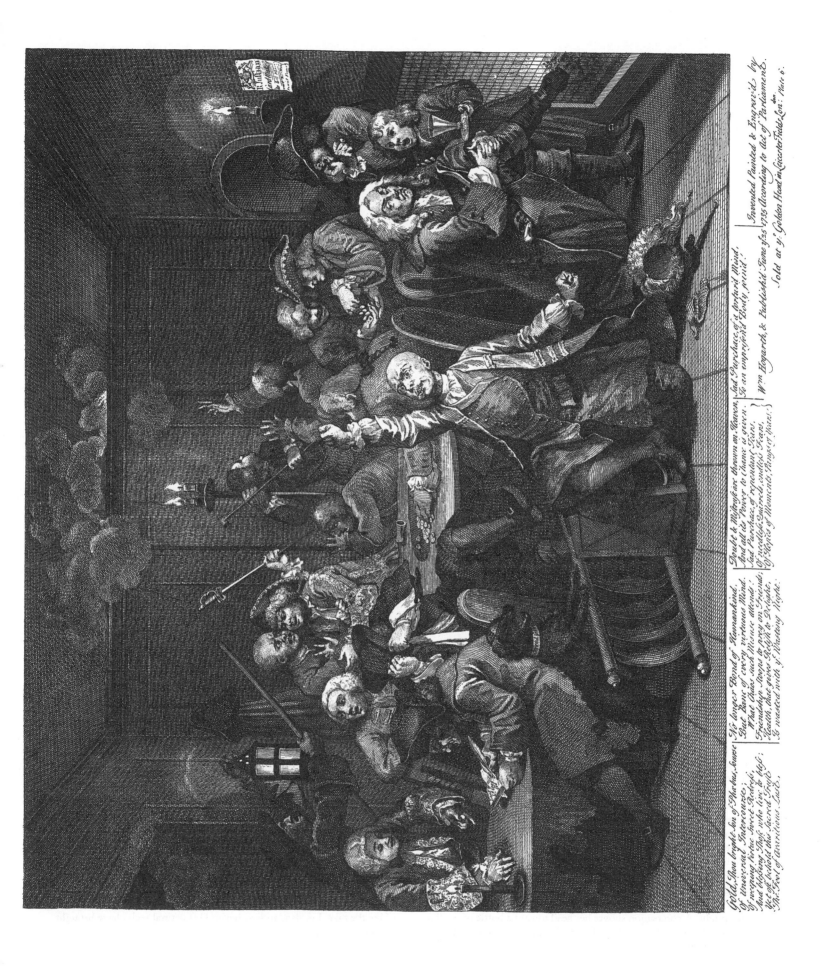

Gold, thou bright Son of Phœbus, Source | No longer Bond of Humankind, | Doubt & Mistrust are thrown on Heaven, | Sad Purchace, of a forfeit Mind.
Of universal Intercourse; | But Bane, of every vertuous Mind, | And all its Power to chance is given. | Is an unpitied Body pris'd.
Of wreping Vertue Sweet Redress, | What Chaos such Miscare attend: | Sad Purchace, of repentant Tears, | Invented Painted & Engrav'd by
And Wickans Thost, who live to thief; | Friendship Tempt to prey on Friends; | Of needless Quarrels, endless Fears, | W^m Hogarth, & Publish'd June y^e25 1735 according to Act of Parliament.
Yet of behold this Sacred Trust | Faith, that gives Relish to Delight, | Of Hopes of Moments, Pangs of Years, | Sold at y^e Golden Head in Leicester Fields Lon: Plate 6.
The Soul of Avaritious Souls. | Is wasted with y^e Wasting Night.

34

A Rake's Progress
PLATE VII
FOURTH STATE. $12\frac{3}{8} \times 15\frac{1}{16}$

The promise of Plate IV is here fulfilled and the rake, like the harlot before him, is jailed (for debt). The scene is the crude stone interior of the Fleet, a debtors' prison. The rake, slumped listlessly forward, his face filled with despair and anomie, besieged on all sides, gestures helplessly with his hands and feet. His last desperate attempt to earn money by writing a play has failed; beside him lies a curt rejection, "Sr. I have read your Play & find it will not doe yrs. J. R. . h." The mis-pelled "doe" seems to be a hit at the theater manager and pantomimist John Rich. Rakewell is now so destitute that he cannot give the turnkey the "garnish money" or pay the perturbed youth for a mug of beer. While his shrewish wife assaults him, Sarah Young faints in compassion at his plight. A companion shoves her head toward a bottle of smelling salts; another slaps her hand, while her daughter seems to rebuke the mother for her conduct.

The rake's two cellmates forecast his impending fate; both are, to some degree, mad. The unkempt fellow with the ragged wig and heavy beard who supports Sarah is a projector; though he cannot pay his own debts he has just invented a "Scheme for paying ye Debts of ye Nation." The fellow in the corner with the nightcap (who has been there a long time if we are to judge by his elaborate still and chimney) is a mad alchemist. He is too absorbed in his furnace project (probably attempting to turn metal into gold) to notice what transpires around him. His telescope sticks out through the prison bars; three mixing pots stand beside his meager library; a paper inscribed "Philosophical" protrudes from one volume. Above his canopy rests a pair of wings. Like the rake, his plans to soar beyond his natural realm have brought him only imprisonment and insanity.

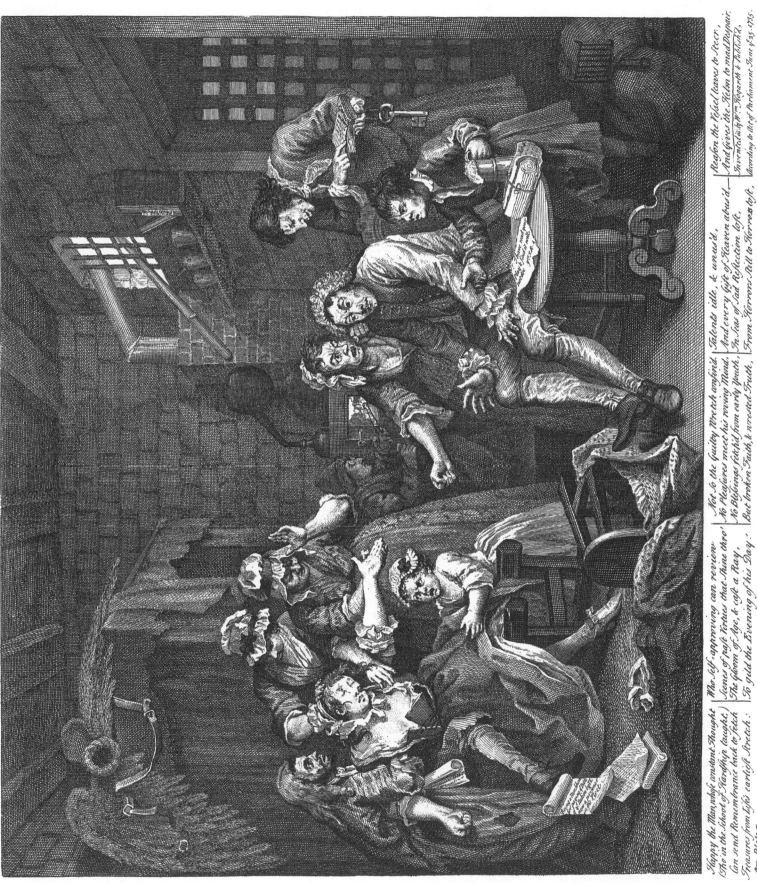

Happy the Man, whose constant Thought · | Who Self-approving can review · | Not to the Guilty Wretch, confin'd · | Talents idle, & unus'd · | Reform the Vessel leaves to steer ·
(Tho' in the School of Hardship taught,) | Scenes of rash Virtues that Shine thro' · | No Pleasures meet his roving Mind · | And every Gift of Heaven abus'd, — | And steers the Helm to mad Despair.
Can send Remembrance back to fetch | The Gloom of Age, & cast a Ray, | No Blessings Faithful from early Youth, | In Seas of Sad Reflection lost, | Invented by Wm. Hogarth & Publish'd.
Treasures from Life's earliest Stretch · : | To gild the Evening of his Day · ! | But broken Faith, & wrested Truth, | From Horrors Bill to Horror left, | According to Act of Parliament June of 25. 1735.

Plate 7

35

A Rake's Progress
PLATE VIII
THIRD STATE. 12⅜ × 15¼

The rake's life of excesses has finally driven him completely mad. Committed to Bethlehem Hospital (Bedlam), he is being chained to prevent him from injuring himself (the patch under his breast suggests he may have knifed himself). Half-naked, grinning and tearing his flesh fiercely, he is attended to the end only by the weeping Sarah Young. Two men restrain him, though one is more interested in Sarah than in the patient.

In the hospital science has claimed two victims. The fellow peering at the ceiling through a roll of paper which he imagines to be a telescope is an astronomer. Behind him the fellow who has drawn the ship, mortar and shot, earth, moon and various geometric patterns is attempting to discover a scheme for calculating longitude. Religion has two adherents here. The man in the first cell sitting on straw chained to a rock is a fanatic; he keeps a crucifix and icons of three saints ("St. Lawrance, St Athanatius [C]lemen[t]") beside him. His body is contorted in prayer and his adoring face is screwed up into the likeness of a wild animal. The person on the stairs with the cone-shaped hat and the triple cross who seems to sing imagines himself the pope.

In cell 55 a naked man with a crown of straw and a stick as scepter believes he is a king. He urinates. Two elegantly dressed court ladies, come in curiosity not in charity as Sarah has, smile at his exposed condition. In front of them a wretchedly dressed tailor with a wig of straw, patterns on his hat and tape in his hands, gestures vacantly. To his right a mad musician with sheet music on his head saws a violin with a stick; his fingers are covered with rings. Beside him sits a figure who suffers from depression over the loss of his love; he has carved her name ("Charming Betty Careless")* on the banister and wears her picture. The collar around his neck suggests he has attempted to hang himself.

On the wall stands the image of a halfpenny portraying Britannia with her hair flying madly behind her. It is chained to cell 54. Added in a late revision of the plate, it suggests that in 1763 Hogarth questioned the sanity of the British nation.

* Charming Betty Careless was the name of a particularly beautiful and well-known prostitute of the period.

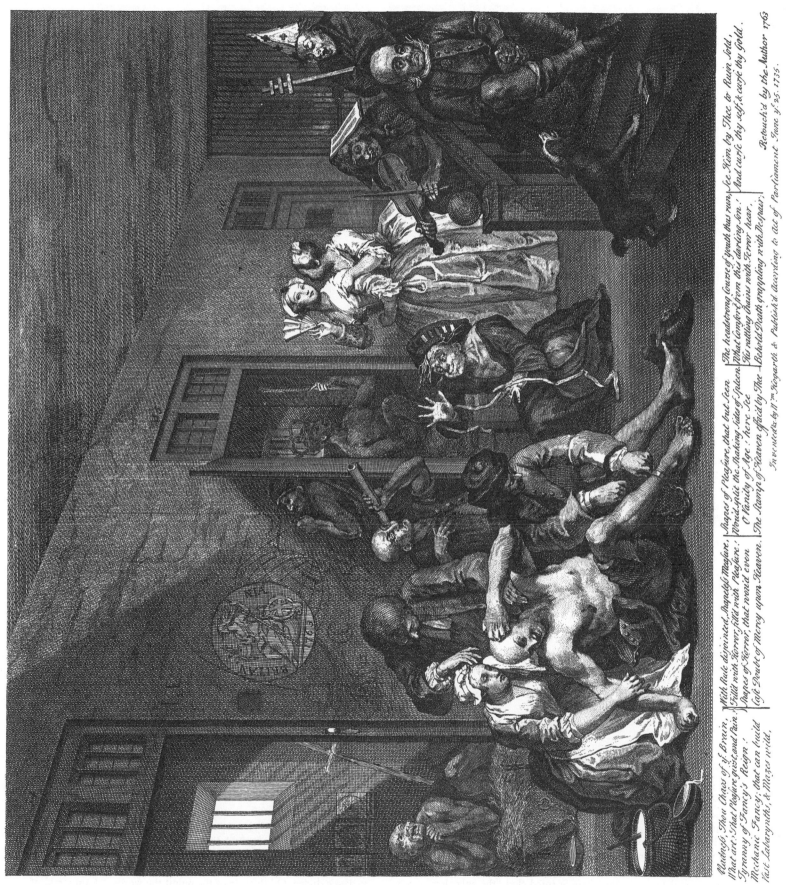

Madness, Thou Chaos of ye Brain,
What art? That Pleasure givst, and Pain?
Tyranny of Fancy's Reign!
Mechanic Fancy; that can build
Vast Labyrinths, & Mazes wild,

With Rule disjointed, Shapeless Measure,
Fill'd with Horror, fill'd with Pleasure!
Shapes of Horror, that wou'd even
Cast Doubt of Mercy upon Heaven.

Shapes of Pleasure, that but seen,
Would quit the Aking sides of spleen.
O Vanity of Age! here See
The Stamp of Heaven effac'd by Thee—

The headstrong course of youth thus run,
See him by Thee to Ruin Sold,
What Comfort from this darling Sin;
And curse thy self, & curse thy Gold.
His rattling chains with Terror hear,
Behold Death grappling with Despair;

Retouch'd by the Author 1763.

Invented & by Wm Hogarth & Publish'd according to Act of Parliament June ye 25. 1735.

36

THE SLEEPY CONGREGATION
ETCHED AND ENGRAVED FROM A PAINTING. FOURTH STATE. OCTOBER 1736. $9\frac{13}{16} \times 7\frac{11}{16}$

In this print Hogarth represents the triumph of sexual over religious motives at a divine service in a ponderous Gothic church in the country. The short, nearsighted preacher (said to resemble John Desaguiliers, a contemporary clergyman) labors through the sermon, his head buried in his book; the text, which has ironic application, is "Come unto me all ye yt Labour and are Heavy Laden & I will give you Rest Mat II 28." Behind the divine hangs his hat; at his side stands an expired hourglass. Below him, his coarse-featured clerk, the only alert person in the congregation, looks down the décolleté dress of an attractive, well-endowed girl. Bored by the sermon, she has opened her prayer book to the section which most interests her, "Of Matrimony." Five men sleep in the crowded free seats; four have their mouths open indicating that they are snoring. Two women in the congregation appear awake. In the balcony two more men sleep.

The church windows and the English royal arms are fashioned crudely and comically to satirize the quality of some church art. The emblem on the pillar bears a chevron and three owls, symbols of the pedantic divine. On the side of the pulpit the words, "I am afraid of you, lest I have bestowed upon you labour in vain/ Galats. 4th II" appear in judgment on the congregation.

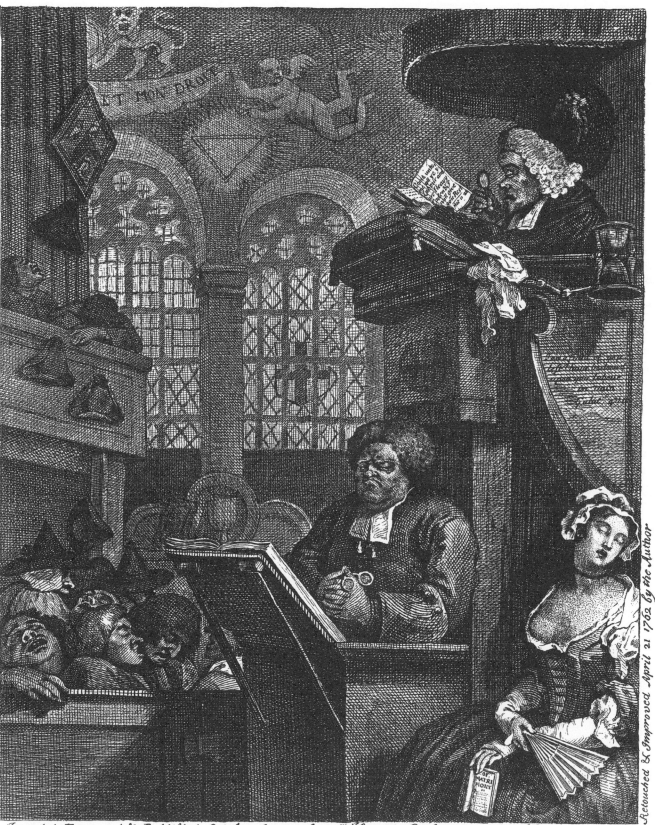

Invented Engraved & Published October 26: 1736 by W^m Hogarth Pursuant to an Act of Parliament Price One Shilling.

Retouched & Improved April 21 1762 by the Author

Before and After

ETCHED AND ENGRAVED FROM PAINTINGS. DECEMBER 1736.

These two prints were executed from a set of paintings said to be commissioned "at the particular request of a certain vicious nobleman." Outside the didactic tradition of most of Hogarth's series and lacking the teeming detail of the engraver's other works from the same period, these prints are frank, comic portrayals of contrasting sexual moods.

37

BEFORE

SECOND STATE. $14\frac{5}{8} \times 11\frac{7}{8}$

This scene contrasts a girl's last-minute resistance with her prior inclinations and preparations. With a look of alarm on her face, the girl seems to flee the embraces of her disheveled lover. Grinning wildly, his eyes bulging, he loses his wig in his passion, exposing his shaved head. The girl has, of course, invited him into her bedroom and even anticipated his response by removing beforehand her shackling underwear and displaying it advertisingly upon her chair. The source of her "fall" is to be found in the books on her tumbling vanity. She has been reading the witty, venereal "Poims" of "Rochester" along with some "Novels." "The Practice of Piety" lies vainly but ostentatiously open in her vanity drawer; it rests beside a love letter. A picture of a putto lighting a phallic rocket suggests the various roles and conditions in the scene. The girl's dog attempts to aid in her defense. An unromantic chamber pot rests beside her foot.

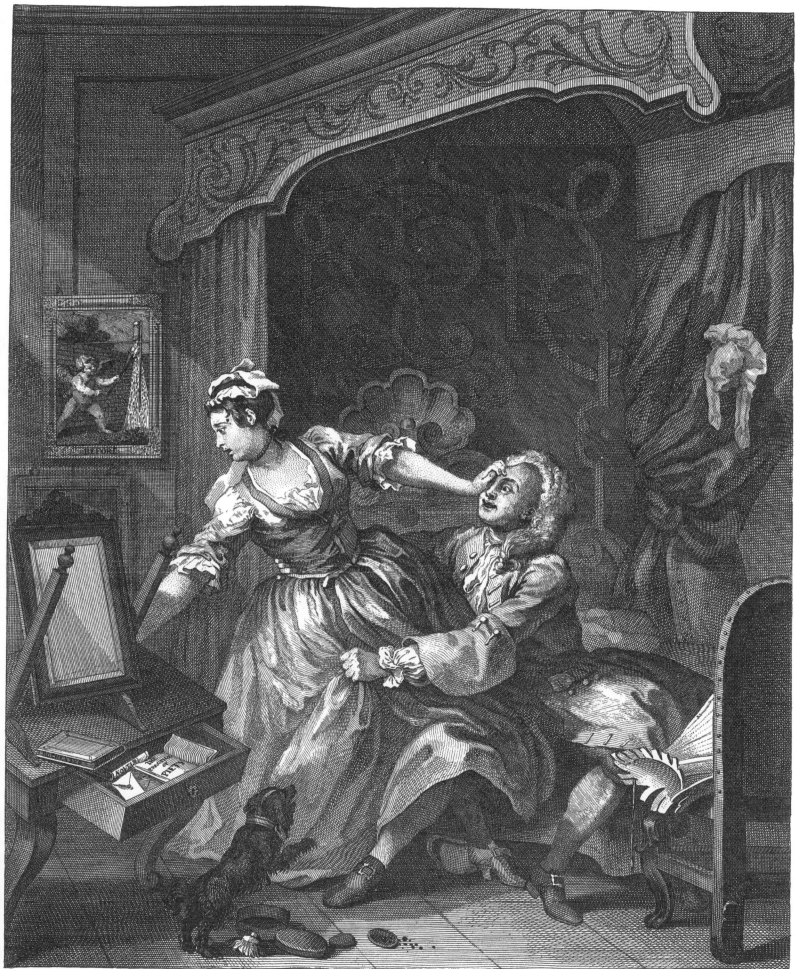

Invented Engraved & Published Dec.ʳʸ: 15ᵗʰ 1736 by Wᵐ Hogarth Pursuant to an Act of Parliament.　　　　Price two Shillings & 6pence.

38

Before and After
AFTER
SECOND STATE. $14\frac{11}{16} \times 12\frac{1}{16}$

In this scene the pursuit and flight of *Before* have become passive moods and reactions. The expression on the gentleman's face is changed from one of sexual frenzy to one of wonder and release. He dresses to leave. The girl's anxiety is changed to a clinging affection. In a reversal of roles, she now attempts to detain him.

On the floor a book is open to a page reading, "Omne Animal Post Coitum Triste/ Aristotle" (Every animal is sad after intercourse). The passage of time is marked by the sun's illumination of "After," a picture of the putto smiling at his exhausted rocket's downward course. Symbolic breakages fill the room: the mirror, the chamber pot, the curtain rail. The sleeping dog reflects its mistress' mood.

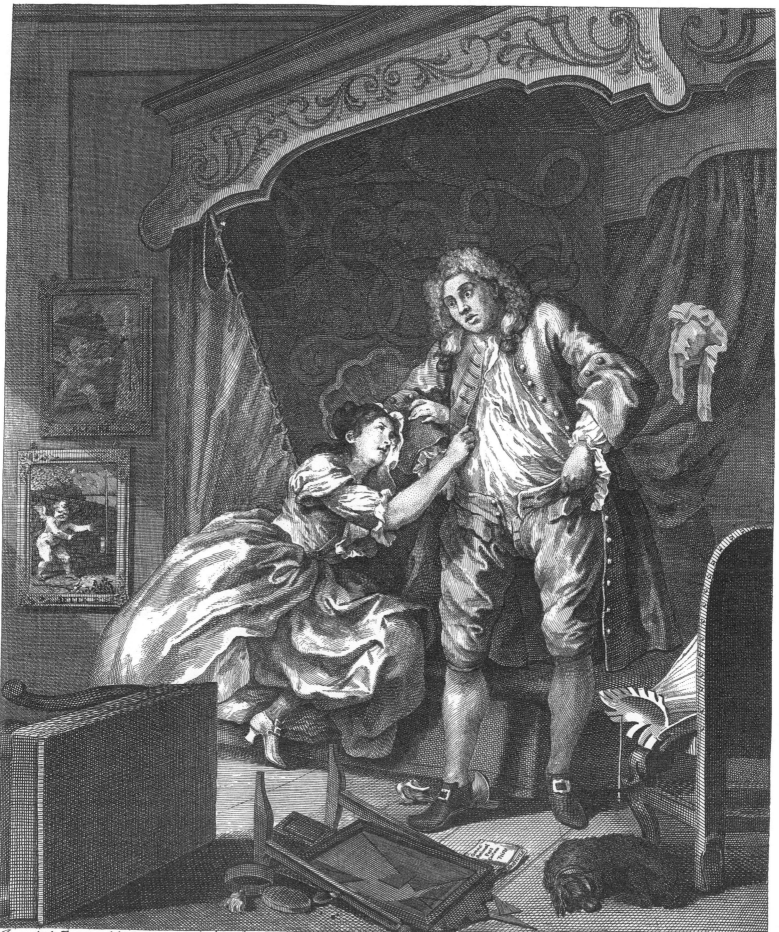

Invented Engraved & Published Decemʳ. yᵉ 15ᵗʰ 1736 by Wᵐ Hogarth Pursuant to an Act of Parliament.

Price two Shillings & 6 pence.

39

SCHOLARS AT A LECTURE

ETCHED AND ENGRAVED. SECOND STATE. JANUARY 1736/7. $8\frac{1}{16} \times 6\frac{7}{8}$

Issued as one of Hogarth's *Four Groups of Heads*, this crudely executed work depicts the effects that a tedious academic professor (believed to be William Fisher, Registrar of Oxford) has upon his audience. From his isolating perch, a mechanical pedant, his eyes glued to his lecture, "Datur Vacuum" (A vacuum/leisure is granted), reads at his audience.

Around him stand his students, who exhibit a variety of responses to the lecture in their caricatured faces: vacuity, indifference, boredom, scorn, amazement, skepticism, incredulity, drowsiness—every imaginable reaction but real interest.

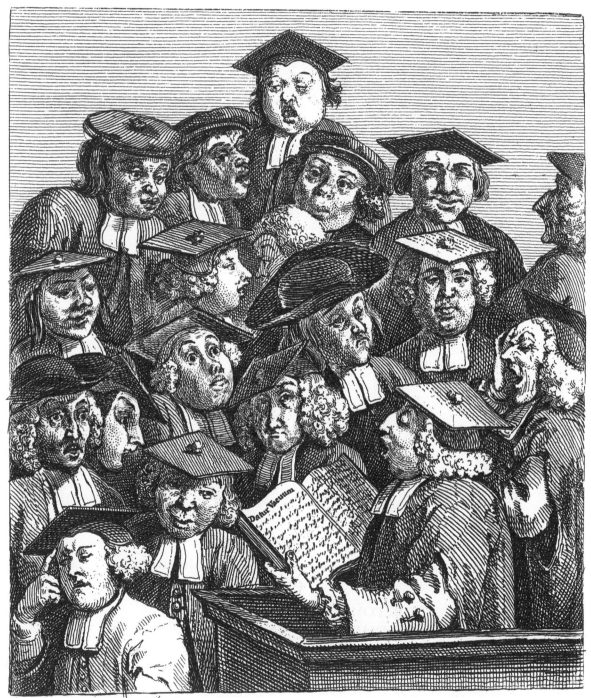

Publish'd by W Hogarth March 3ª 1736

THE COMPANY OF UNDERTAKERS
ETCHED AND ENGRAVED. SECOND STATE. MARCH 1736/7. 8½ × 7

As the contrived heraldic rhetoric of this print's caption makes clear, it is a satirical representation of a coat-of-arms for the medical profession. The theme of the escutcheon is not recovery but death. The print is bordered in black like a mourning card; it has ominous crossbones in the bottom corners; and its motto is "Et Plurima Mortis Imago" (And many an image of death).

The upper portion of the shield (the field "ermine" above the "nebulous" dividing line) shows three doctors, each with some obvious physical disorder. The center figure ("One Compleat Doctor") with the grim, thick-featured face wearing a clown's suit and a felt hat over a nightcap is cross-eyed. This masculine figure, said to represent Sarah Mapp, a well-known bone-setter of the time, points inarticulately to the human bone she is carrying as a cane. To the right stands a smiling, almost feminine-faced physician. He is supposed to portray Joshua Ward ("Spot Ward"), a doctor with a blood-colored birthmark on one side of his face—thus the shading. To the left stands a well-dressed oculist (his cane identifies his specialty) who has himself only one open eye, which stares erratically upward; he seems to wink ingratiatingly with the other. This figure is believed to represent John Taylor, a charlatan oculist.

Below these figures twelve more quacks huddle together. Nine smell the heads of their canes, which, in the eighteenth century, contained disinfectant. Two stare into a urinal to determine the color of its contents. A third dips his finger in the urine itself to taste it. All wear sour, disaffected expressions.

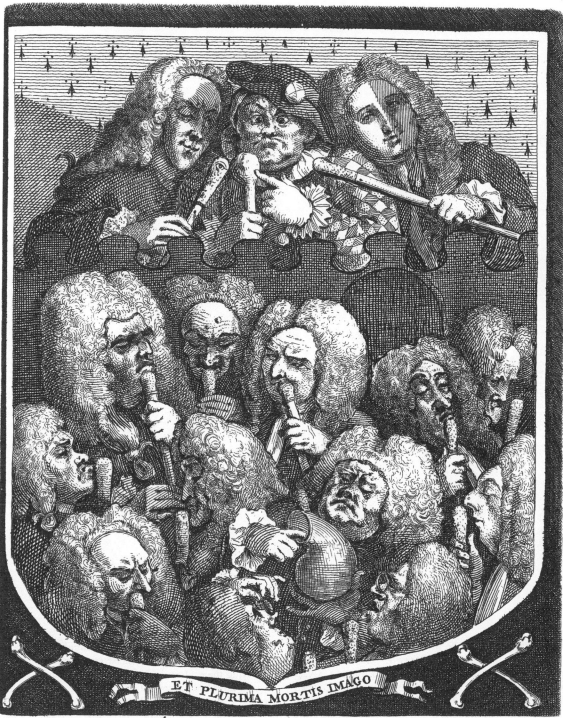

ET PLURIMA MORTIS IMAGO

The Company *of* Undertakers

Beareth Sable, an Urinal proper, between 12 Quack-Heads of the Second & 12 Cane Heads Or, Consul-
tant. On a*Chief Nebulæ, Ermine, One Compleat Doctor issuant, checkie sustaining in his
Right Hand a Baton of the Second. On his Dexter & sinister sides two Demi-Doctors, issuant
of the Second, & two Cane Heads issuant of the third; The first having One Eye conchant, to-
wards the Dexter Side of the Escocheon; the Second Faced per pale proper & Gules, Guardent. ——
With this Motto ———————— Et Plurima Mortis Imago.

Publish'd by W. Hogarth March the 3ᵈ 1736 Price Six pence

41

THE DISTREST POET

ETCHED AND ENGRAVED FROM A PAINTING. THIRD STATE. MARCH 1736/7. 12⅜ × 15¼

The source of this work seems to be the lines from Pope's *Dunciad*, Book 1, lines 111ff., used as a caption in state two: "Studious he sate, with all his books around,/ Sinking from thought to thought, a vast profound!/ Plung'd for his sense, but found no bottom there;/ Then writ, and flounder'd on, in mere despair." The print contrasts the exalted but vain and foolish aspirations of a Grub Street poet with the dreariness and distress which these unrealistic aspirations create.

In a dilapidated one-room garret with only a few pieces of crude, ill-matched furniture, the aspiring poet sits. Dressed in a ragged gown (his only suit is being mended by his exploited wife), he scratches his head in frustration. In state three the subject of his endeavor, "Riches a Poem," represents the topic he is most preoccupied with but knows least about. In state two his verse is "Poverty a Poem." Seven or more discarded versions lie under the table. Above him stands his slender library; beside him he keeps Bysshe's *Art of English Poetry*, a rhetoric for writing poetry, much of it (like its rhyming dictionary) rather mechanical. His pipe and tobacco stand upon the window sill; like the mug of beer on the chair behind him, they are his sources of inspiration. In state three a map entitled "A View of the Gold Mines of Peru"

hangs above his head; this map may suggest the remote and mercenary nature of his interests. In state two this print shows "Pope Alexander" striking the exploitative printer Edmund Curll with a stick bearing a page inscribed "Pope's Letters," as he turns Curll's words "Veni, vidi, vici 1735" (from the printer's introduction to Pope's letters) against their author. The "*Grub street Journall,*" a paper founded by Pope to satirize such poets, lies on the floor; apparently this fellow is too obtuse to recognize its satirical cast.

The man's poetic aspirations are not his only vain ambition; a shirt and lace cuffs hang before a small fire; a sword lies by the table and a greatcoat (used as a bed by a cat and her hungry kittens) is on the floor. All suggest that in spite of his wretched circumstances he considers himself a gentleman.

A milkmaid (she wears a device on her back for carrying pails) demands payment of her account. The supportive wife stares blankly at the lengthy bill; the child in the corner bawls in hunger. The cupboard is without food; a single loaf sits on the mantle beside a pestle and mortar. Above a teapot hangs a center mirror and eight smaller ones. The absorbed poet fails to see a dog steal their last chop.

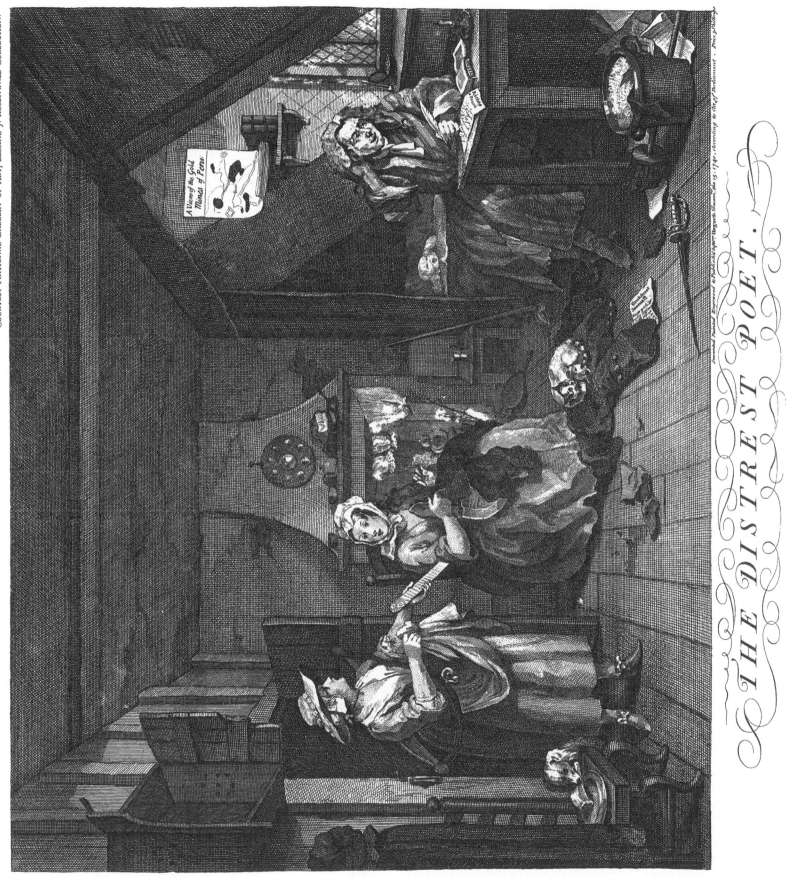

A View of the Gold Mines of Peru

THE DISTREST POET.

The Four Times of the Day

ETCHED AND ENGRAVED FROM PAINTINGS. MAY 1738.

The paintings for these prints were executed at the request of Jonathan Tyers for Vauxhall Gardens, an amusement park popular with the aristocracy. They were engraved by Hogarth (I, II, IV) and Bernard Baron (III), a French engraver then living in England. Like many of the works commissioned early in Hogarth's career, the prints of *The Four Times of the Day* are not as directly didactic as those the artist did for his general audiences, though they may be a subtle attempt to propagandize the aristocratic class on behalf of the proletariat. The series is a sympathetic account and a comic celebration of the everyday lives and entertainments of the common people of London.

42

PLATE I
MORNING
SECOND STATE. $17\frac{15}{16} \times 14\frac{13}{16}$

This print depicts the various activities of the people of Covent Garden on a winter's morning. By the clock on Inigo Jones' St. Paul's it is 6:55 A.M. Through the center of the market walks a lady whose austere countenance and fashionable dress are in marked contrast to those around her. Despite the snow and inclement weather, her affectation prompts her to expose her hands and bony chest to the cold. By her side dangles either a nutcracker or a pair of scissors in the form of a skeleton. Though on her way to church, she ignores the painful condition of the freezing page who carries her prayer book; she also evades the glance and outstretched hand of the beggar. She expresses on her face and with her fan moral horror at the activities of the engaging lovers in front of her. Behind the lovers the night's festivities at "Tom King's Coffee House" (purposefully eclipsing the church) conclude in a brawl which is about to erupt into the street.

Between the church and the tavern (the house with the large ale mug on a post and three small pitchers hanging from its eaves), a blind man escorted by a woman walks to church, and a porter rests to talk to another woman. To the left of the print's judgmental figure, the day's trade has begun. A large woman carts her vegetables to market on her head to the amazement of two little boys who lag in the square on their way to school. A quack with a bottle of "Dr. Rock's" nostrum displays a billboard bearing the royal arms to suggest court patronage.

Two odd-shaped footprints near the page are marks made by iron mountings attached to shoes to keep the wearer above snow and mud.*

A statue of Time bearing a scythe and an hourglass stands in warning above the clock, and below it the motto "Sic Transit Gloria Mundi" (Thus passes the glory of the world) is inscribed in judgment on the scene.

* Lichtenberg, *Lichtenberg's Commentaries on Hogarth's Engravings*, p. 215.

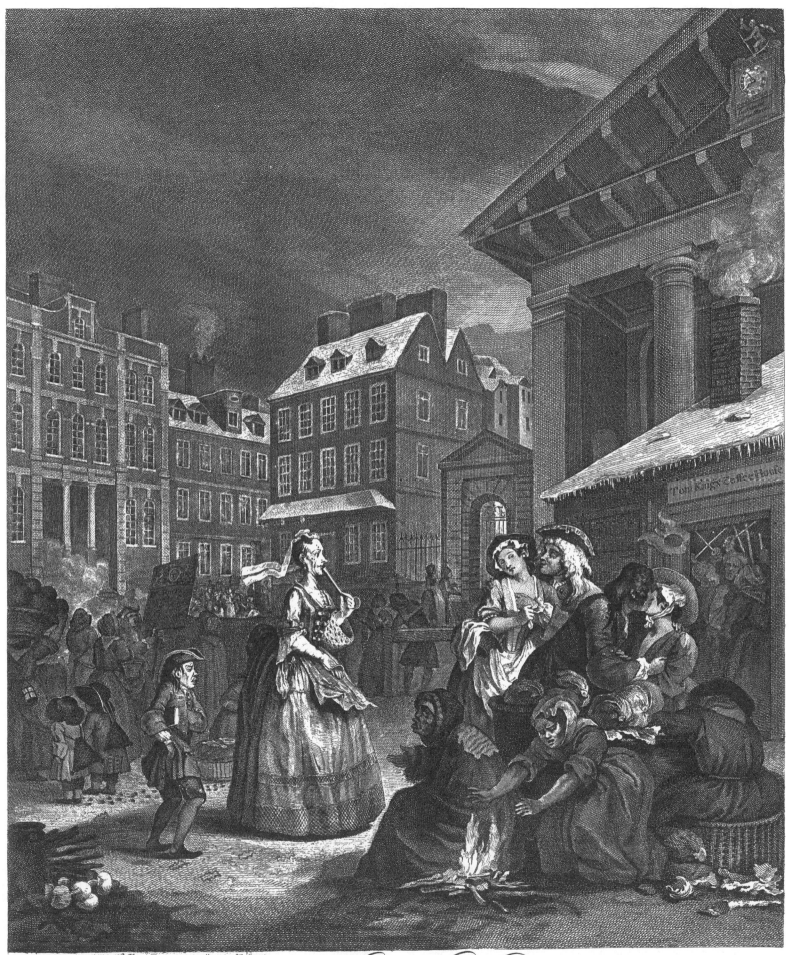

Tom Kings Coffee house

Invented Painted Engrav'd & Publish'd by W^m. Hogarth March 25 1738 according to Act of Parliament.

MORNING

43

The Four Times of the Day
PLATE II
NOON
SECOND STATE. $17\frac{11}{16} \times 14\frac{7}{8}$

This print sets the boisterous, robust lives of the English proletariat against the artificial conduct of the fashionable, affected French residing in England. It is 11:30 on the spire of St. Giles-in-the-Fields. From the church on the right (believed to be an historical church patronized by French refugees), the congregation spills out into the street. Beside a dead cat in the kennel, a beau dressed in an ornamented coat and vest, an oversized bow, velvet breeches and buckled shoes postures affectedly in the direction of a lady. He wears a sword and carries a cane. The lady, dressed every bit as elaborately, returns his gestures in the same stiff, pretentious manner.

In front of them stands what appears to be a diminutive adult but is actually a little boy dressed in the same ostentatious fashion as the beau, even to the point of wearing a bag wig and miniature sword. He seems to be glancing conceitedly at his dress. Another little boy wearing an outlandish wig shaped like a beehive walks in the opposite direction with a girl taller than he. Those in the congregation whose faces are not affected wear either dour looks or grotesque expressions.

The scenes on the other side of the kennel, set not against a church but against two taverns and an eating house, without a trace of artificial politeness, are marked instead by natural crises and conflicts. Across from the little beau a disheveled boy scratches his full head of hair and cries at his blunder. A girl stuffs one piece of the broken pie in her mouth and grabs for another. Across from the couple expressing their affection with awkward formality, an attractive girl responds to the fondling and kissing of a companion. Her pie is about to fall from her control. Above the inn door two figures quarrel over dinner and lose it. The sign above the door portrays a woman without a head which proverbially signified "The Good (i.e. Quiet) Woman." The sign in front of the eating house shows the head of John the Baptist; its inscription, "Good Eating" (enclosed in two parenthetical teeth), appears directly above the lovers.

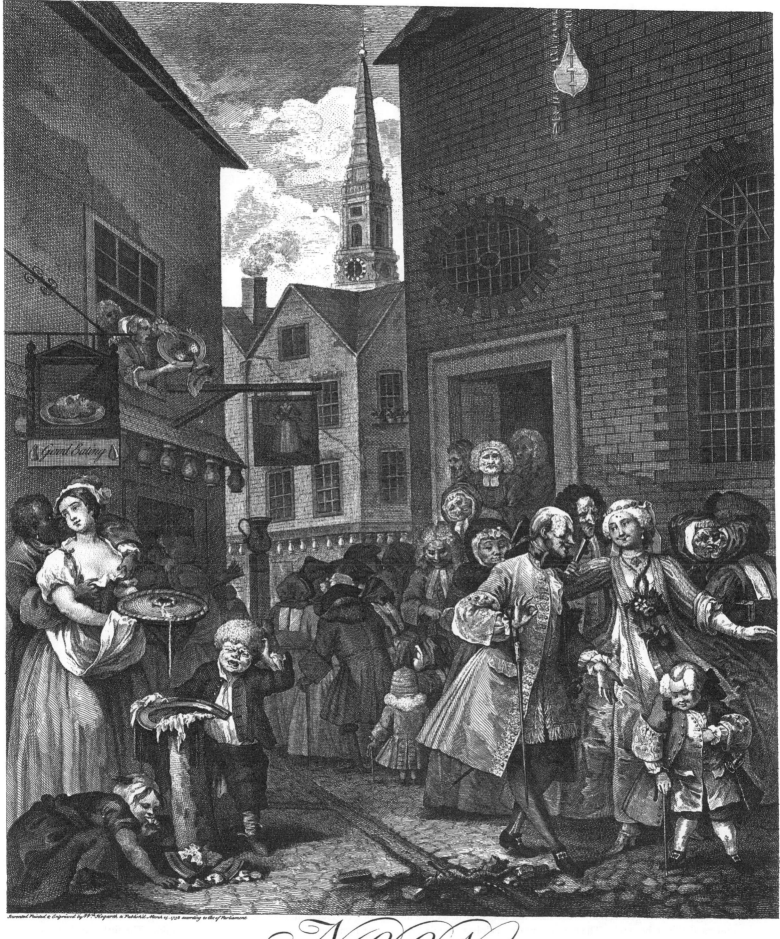

Invented Painted & Engraved by W.ᵐ Hogarth, & Publish'd March 25.1738 according to Act of Parliament

Noon

44

The Four Times of the Day
PLATE III
EVENING
THIRD STATE. $17\frac{7}{8} \times 14\frac{5}{8}$

This plate depicts the "entertainment" of a middle-class family in which traditional dominance roles have been reversed. A London dyer (in the second state the man's hands were blue to indicate his trade) and his family have left the city to visit "Sadlers Wells," an amusement center of popular appeal. The center of the print is the coarse, oversized and very pregnant wife who is suffering from the evening's heat. In contrast to her prosaic dress and appearance she affects gloves and a fan with a pretentious mythological subject on it (Venus detaining Adonis from the chase). A formidable personality, she not only tyrannizes her husband but has cuckolded him; the horns of the cow appear above him. He walks by her side, a small, thin figure, obediently carrying their youngest child (whose shoe has fallen off to expose an undarned hole in her sock). The husband bears a helpless, almost hypnotized expression on his face.

In front of the couple slouches their pregnant dog gazing at its appearance in the water. Behind the couple their children act out the relationship of their parents. A fierce-looking little girl demands her brother's gingerbread figure as she threatens him with her fan; he responds passively with tears (although he has his father's oversized walking stick between his legs). Behind the children their nurse unties one of their shoelaces.

To the right of the nurse a figure milks a cow, indicating the time of day (about 5 P.M.). At the extreme right a group of people sit in a tavern garden, while inside, in one of Hogarth's most peaceful tavern scenes, another set of Londoners, come to enjoy the country, crowd together in a smoky room and drink. The tavern sign bears the portrait of "Sr Hugh Middleton." This person brought water into the City of London from the surrounding countryside. The little canal in the foreground is probably intended as his work. The contrasting landscape in the background presents a quiet pastoral scene.

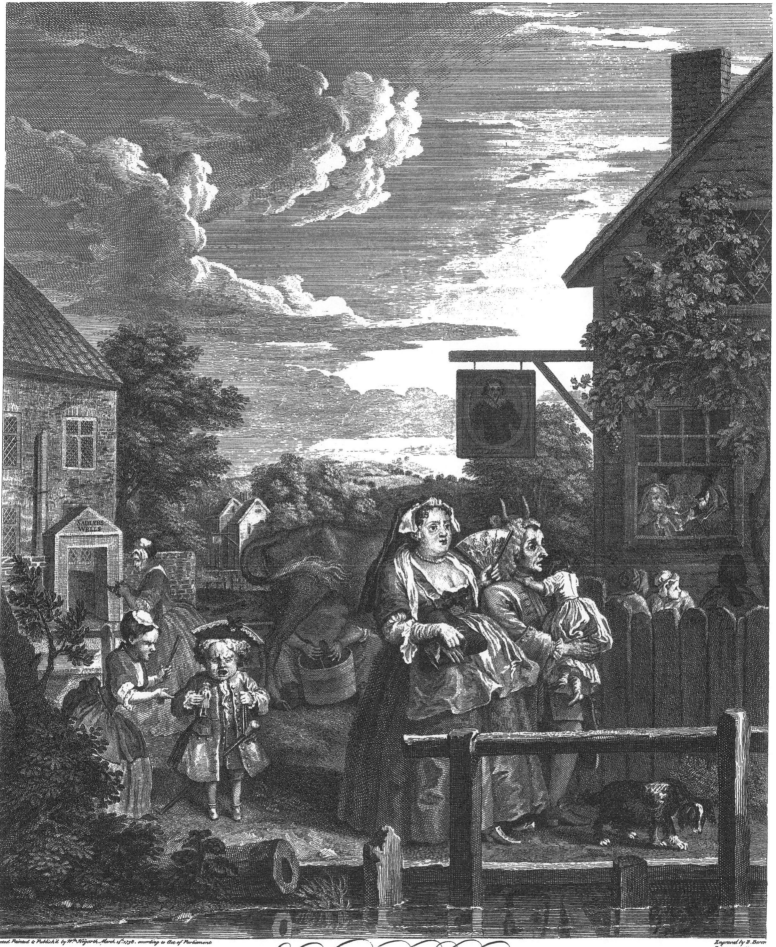

Invented, Painted & Publish'd by W.ᵐ Hogarth, March ſ.ᵗ 1738. according to Act of Parliament

Engraved by B. Baron
Price 5 Shillings

EVENING

45

The Four Times of the Day
PLATE IV
NIGHT
SECOND STATE. $17\frac{7}{16} \times 14\frac{7}{16}$

Set beside the mock pastoral "Evening," the print "Night," the most turbulent of this series, depicts the common city vices, miseries, violence and turmoil. The oak branches announce that it is May 29th, the day on which the restoration of Charles II was celebrated. In fact the scene is singularly devoid of any type of celebration.

In the background a cart of household furniture passes under the statue of Charles I in Charing Cross; its owners are fleeing their landlord by night. The sky above is filled with fire and smoke. On the left hang: a tavern sign portraying a wide, short glass; a brothel plaque inscribed "The New Bagnio" and a barber-surgeon's pole with a sign showing a man in torture having a tooth pulled. The illustration belies the legend "Shaving Bleeding & Teeth Drawn wth. a Touch/ Ecce Signum" (Behold the Sign). On the other side of the street stands a "Bagnio" and a tavern bearing the sign "Earl of Cardigan."

In the barber's shop a hairdresser-barber-surgeon, blind drunk, has just cut his customer who grips the chair in alarm. Because of the manner in which he holds the man's nose, the customer resembles a pig.

Outside the window stand dishes of human blood drawn from the day's patients. Beneath the ledge on which they stand, three homeless people huddle together in sleep, and a linkboy or guide blows his torch to a flame. Next to them a wealthy freemason in ceremonial dress with his carpenter's square around his neck lurches indecorously homeward, led with some difficulty by a patient lodge porter of smaller stature. From the window above, the contents of a chamber pot fall on his head; he responds by threatening the air with his cane; his wise and tolerant guide has confiscated his sword to avoid another battle like the one which has bloodied the mason's forehead.

In the middle of the street "The Salisbury Flying Coach" has overturned in front of a bonfire which seems to have caused the horses to bolt. The gun of one of the riders goes off in the fracas as they scramble to get out. Their plight is observed by a butcher boy and a youth with a wooden sword. In the midst of all this chaos a man calmly smokes a pipe and pours beer into a large barrel for a street celebration of the Restoration.

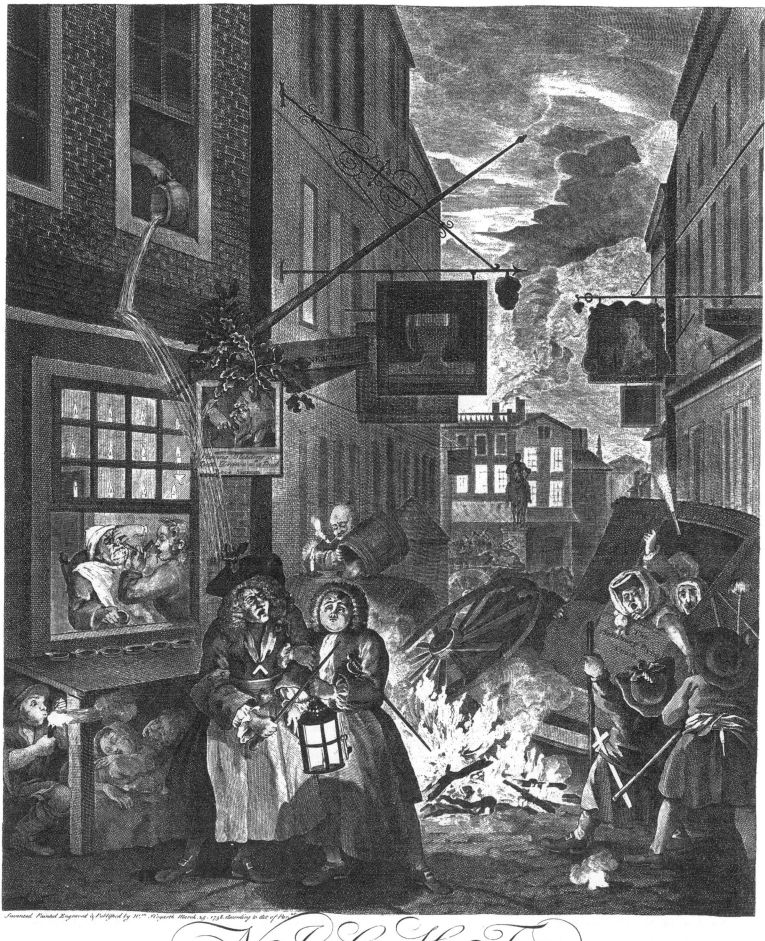

Invented, Painted, Engraved & Published by Wm. Hogarth March 25. 1738. according to Act of Parliament

NIGHT

46

STROLLING ACTRESSES DRESSING IN A BARN

ETCHED AND ENGRAVED FROM A PAINTING. SECOND STATE. MAY 1738. $16\frac{11}{16} \times 21\frac{3}{16}$

This iconoclastic print is a witty play on the comic incongruity between the dignity, grandeur and mythic dimensions of the roles, costumes and symbols of classical culture and the earthy, vexed and common nature of the real lives of the players who are now the guardians and transmitters of this past.

In 1737 "The Act against Strolling Players" (a copy of it sits on the crown) made it illegal for plays to be performed outside London and Westminster without a license; this troupe is giving its last performance before the act takes effect. The playbills on the bed announce the evening's varied entertainments. "By a Company of Comedians from The Theatres at London at the George Inn This Present Evening will be Presented The Devil to Pay in Heaven Being the last time of Acting Before ye Act Commences." Next to this lies the company's playbill, "Heaven . . . Being the last . . . Act Commences . . . The part of Jupiter by Mrs Bilkvillage/ Diana Mrs . . ./ Siren Mrs . . ./ Flora Mrs . . ./ Aurora Mrs . . ./ Juno by Mrs . . ./ Eagle by Mrs . . ./ Night Mrs . . ./ Cupid Mrs . . ./ two Devils Ghost & Attendance/ To which will be Added Ropedancing & Tumbling/ Vivat Rex."

In the center of the scene set in a barn, the girl playing Diana postures exaggeratedly. Though her head is dressed with flowers, plumes, pearls and a crescent, the body of this girl playing the goddess of chastity is half-naked, invariably a sign of casual sexual morality in Hogarth's work. Beside her foot stands a plaque of the head of Medusa, as if distraught at the scene before her. At an altar next to Diana two little children dressed as devils quarrel over a tankard of beer. Beside the beer mug on the altar stands Diana's robust lunch: her glass, some tobacco in a paper, her smouldering pipe and some bread. Next to the altar the end of a cat's tail (to leave tail for further amputations) is being sacrificed by two women to provide blood for a scene in the play. The figure dressed as a page is being clawed on the stomach and hands by the animal while the one-eyed crone with the tiny dagger in her cloak delights in the operation.

At the extreme right, Juno, looking skyward, practices her lines while a monkey urinates in front of her into a plumed Roman helmet;

as the goddess props her leg on a wheelbarrow, Night darns a hole in her stocking. Juno's book rests against a decorated salt box with a rolling pin in it (both used as noise makers). A thunderbolt and tinder box lie beside the salt box on the dilapidated trunk. Near the wheelbarrow lie a cushion, Night's lantern, a mitre filled with books entitled "Tragedys," "Farce" and "Farces." Next to the mitre lie a wig, a halter, a mantle and two cups containing juggling balls. Two kittens play with a regal orb and a lyre.

Candles stuck in clay for illuminating the stage rest on the floor; an iron grill sits against a bed on which lie four eggs, one of them broken. A full chamber pot stands beside an elaborate crown which serves as a stand for a saucepan of pap. Next to the crown a figure wearing a terrifying eagle's costume attempts to feed a baby. The child, scared by the threatening beak of the bird, spews out his food. Above them, a siren offers a half-dressed Ganymede a drink to relieve her toothache while a dark-skinned Aurora kills lice on the siren's dress.

Next to them stand a portico decorated with flowers, two sets of waves (on which three hens roost), a drum, a trumpet and a brush. Beside the siren's fishtail, Flora, wearing a hoop with her blouse front open, dresses her hair with flour and wax. She sits before a mirror fragment that rests on a wicker basket labeled "Jewels." A comb and a shell containing cosmetics lie next to the mirror. The candle beside the bed has ignited the jewel chest. Behind Diana, Apollo holds a ladder and with a cupid's bow points out a pair of stockings (which hang from a cloud) to the little winged figure who climbs a ladder and stretches on tiptoes to reach them.

The company props are stored in the roof. They include two dragons, a chariot, "Oedipus" and "Jocasta" in a cloud hidden behind the English flag with St. George's cross, a flail on some straw and two wings of scenery representing forests. On a trestle stand a palette and brushes, a chamber pot used for painting scenery and a Roman legion standard and a banner inscribed "SPQR." Two caps, ruffles, a shirt and an apron hang on a line to dry. A boy peeps curiously at the scene through a hole in the roof.

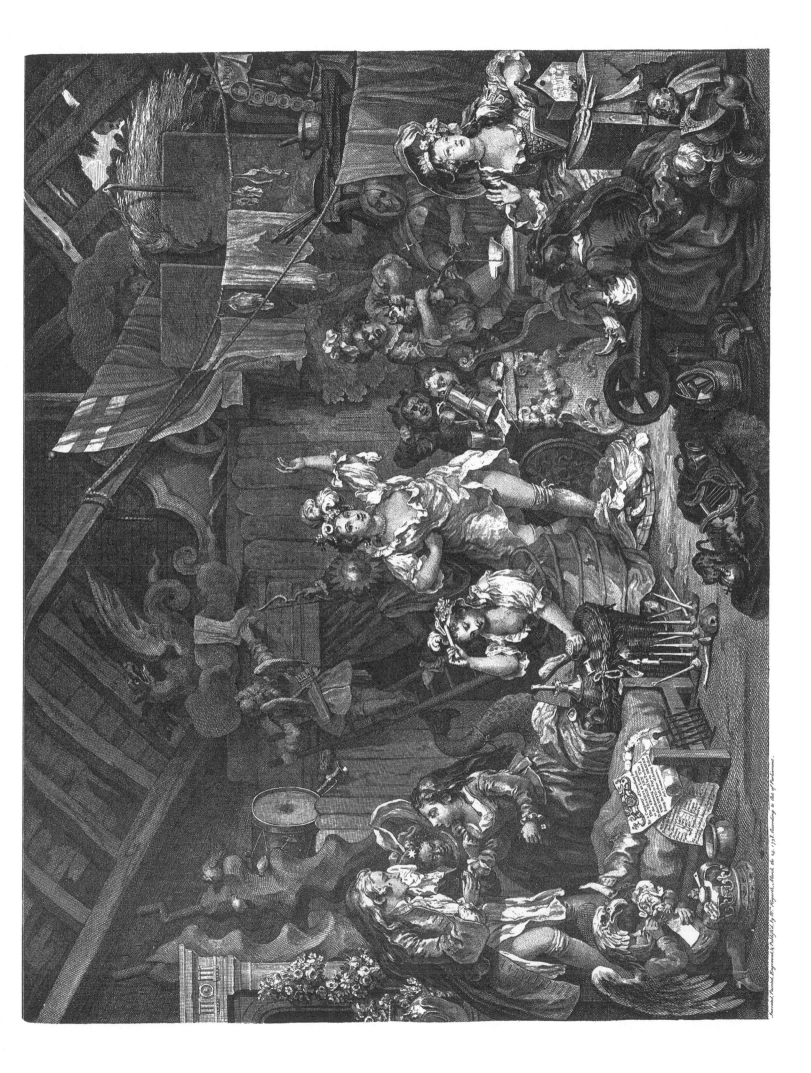

Invented, Painted, Engraved & Publish'd by W.^m Hogarth. March the 25. 1738 according to Act of Parliament.

47

THE ENRAGED MUSICIAN

ETCHED AND ENGRAVED FROM A PAINTING. THIRD STATE. NOVEMBER 1741. $12\frac{15}{16} \times 15\frac{3}{4}$

This print is a companion to "The Distrest Poet." It depicts the rage and frustration of an effete violinist, probably a foreigner and a court musician, at the occupational noises and common musical sounds of the London populace, their children and their animals.

The musician stares out his window with his hands over his ears; his violin, music sheets, ink and quill surround him. A playbill outside his window announces "The Sixty Second Day ... Comedians ... the ... [Theat]re Royal ... Beggars Opera ... Macheath by Mr. Walker. Polly ... by Mis Fenton. Peachum by Mr. Hippisley ... Vivat Rex." A parrot squawks at the musician from a lamp post. Below, a ragged pregnant woman with a crying child sings a vaguely autobiographical ballad, "The Ladies Fall." In front of her a little girl with a noisemaker drops her ball as her eyes bulge in interest at seeing a boy companion urinate down a coal hole. A writing slab is tied to the

boy's belt. Both children have constructed a bird trap and have planted twigs beside it. Directly below the violinist a street musician plays an oboe.

In the center of the scene a comely milkmaid plies her trade. In front of her a little figure dressed as a soldier with a wooden sword bangs mechanically on a drum. Beside him a man sharpens a meat cleaver on a grindstone; a dog barks at him. In the background an Irish laborer (his turned-up beehive cap reveals his nationality) lays pavement, a dustman rings his bell and shouts out, a blacksmith blows a horn, and a fish seller cries out his call. Across from the musician "John Long Pewterer" plies his noisy trade. On his roof a sweep calls to someone, and two cats fight. A flag flies from the church to mark a holiday, suggesting more noise from the churchbells.

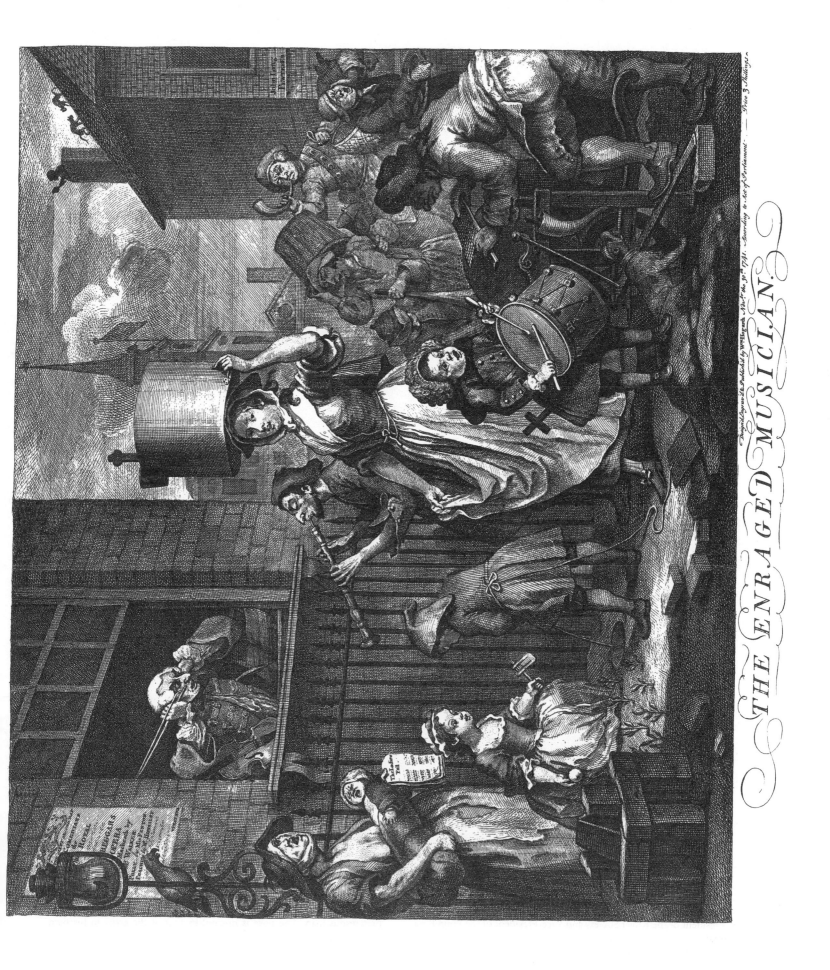

THE ENRAGED MUSICIAN.

48

MARTIN FOLKES ESQR.

ETCHED AND ENGRAVED FROM A PAINTING. FOURTH STATE. 1742. 11 × $8\frac{15}{16}$

A friend of the artist's, Martin Folkes, antiquarian and mathematician, was President of the Royal Society and Vice-President of the Foundling Hospital.

Drawing him in a didactic pose, Hogarth depicts this middle-class intellectual sympathetically as a pleasant, direct, self-assured and unpretentious man. The pose is not unlike that of the artist in his own famous self-portrait.

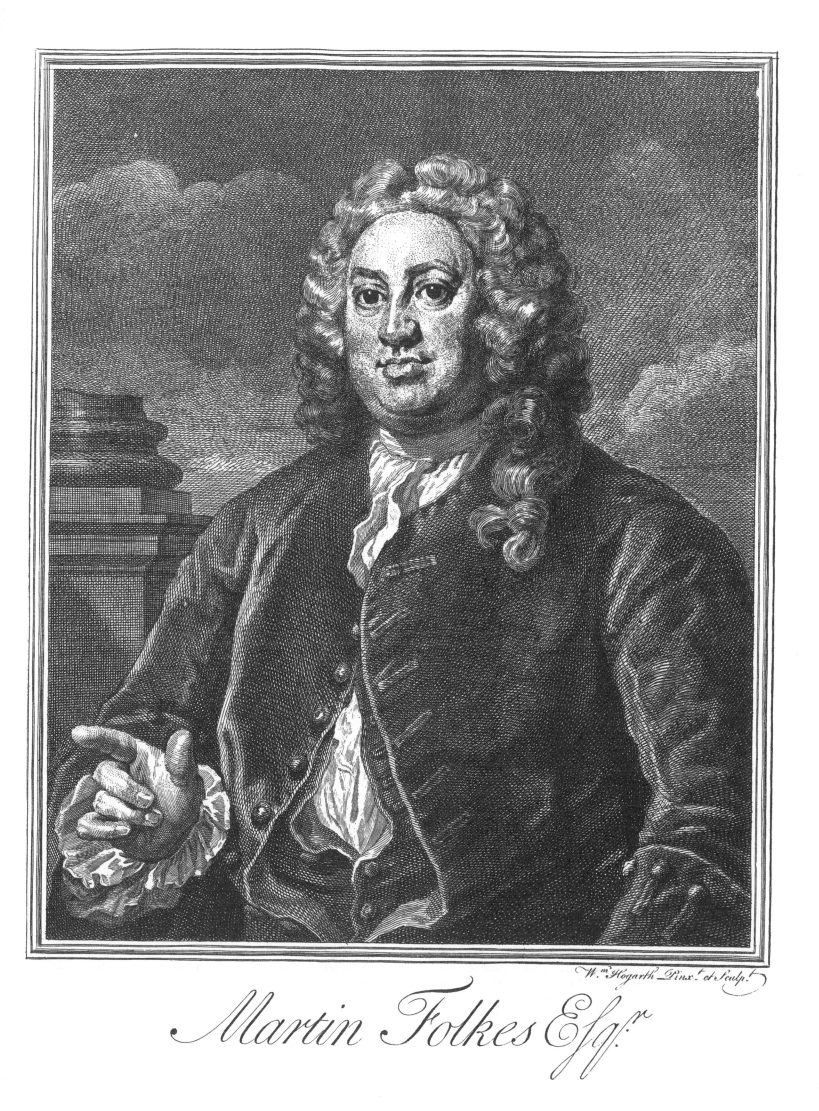

W.^m Hogarth Pinx.^t et Sculp.^t

Martin Folkes Esq.^r

CHARACTERS CARICATURAS

ETCHED. SECOND STATE. APRIL 1743. $7\frac{9}{16} \times 8\frac{1}{8}$

This print was first used as the ticket for *Marriage à la Mode*; later the receipt was cut off, and it was sold by itself. Like "Boys Peeping at Nature," this work is a statement by Hogarth about the nature of his art. In publishing *Marriage à la Mode*, a work directed to an upper middle-class and aristocratic audience, Hogarth was anxious to raise his art above the level of burlesque and caricature and to be regarded as a comic history painter following "nature" closely and dealing in psychological rather than merely in physiological realities.

The purpose of this print is to illustrate a relevant distinction made by Henry Fielding in the Preface to *Joseph Andrews*:

> Let us examine the Works of a Comic History-Painter, with those Performances which the *Italians* call *Caricatura*; where we shall find the true Excellence of the former, to consist in the exactest copying of Nature; insomuch, that a judicious Eye instantly rejects any thing *outré*; any Liberty which the Painter hath taken with the Features of that *Alma Mater*.—Whereas in the *Caricatura* we allow all Licence. Its Aim is to exhibit Monsters, not Men; and all Distortions and Exaggerations whatever are within its proper Province.
>
> Now what *Caricatura* is in Painting, Burlesque is in Writing; and in the same manner the Comic Writer and Painter correlate to each other. And here I shall observe, that as in the former, the Painter seems to have the Advantage; so it is in the latter infinitely on the side of the Writer: for the *Monstrous* is much easier to paint than describe, and the *Ridiculous* to describe than paint.
>
> And tho' perhaps this latter Species doth not in either

Science so strongly affect and agitate the Muscles as the other; yet it will be owned, I believe, that a more rational and useful Pleasure arises to us from it. He who should call the Ingenious *Hogarth* a Burlesque Painter, would, in my Opinion, do him very little Honour; for sure it is much easier, much less the Subject of Admiration, to paint a Man with a Nose, or any other Feature of a preposterous Size, or to expose him in some absurd or monstrous Attitude, than to express the Affections of Men on Canvas. It hath been thought a vast Commendation of a Painter, to say his Figures *seem to breathe*; but surely, it is a much greater and nobler Applause, *that they appear to think*.*

At the bottom of the print three characters are reproduced in profile from Raphael's cartoons: St. John in *The Sacrifice at Lystra*, a beggar from *Peter and John at the Beautiful Gate of the Temple* and Paul in *St. Paul Preaching at Athens*. The same three heads, exaggerated and distorted but in the same poses, appear in the area of the print labeled "Caricaturas." The first is by Pier Leone Ghezzi, the second and third by Annibale Carracci. A faint profile of a face with a huge nose and a big wart illustrates an even more extreme form of caricature. The fourth face is an almost featureless head by "Leonard da Vinci." Above these Hogarth has drawn over a hundred heads in varying expressions illustrating his affinity with Raphael. To prove that his theory derives from his practice he has taken many of these heads from *Marriage à la Mode*.

* Henry Fielding, *Joseph Andrews*, ed. Martin C. Battestin (Middletown: Wesleyan University Press, 1967), 6–7.

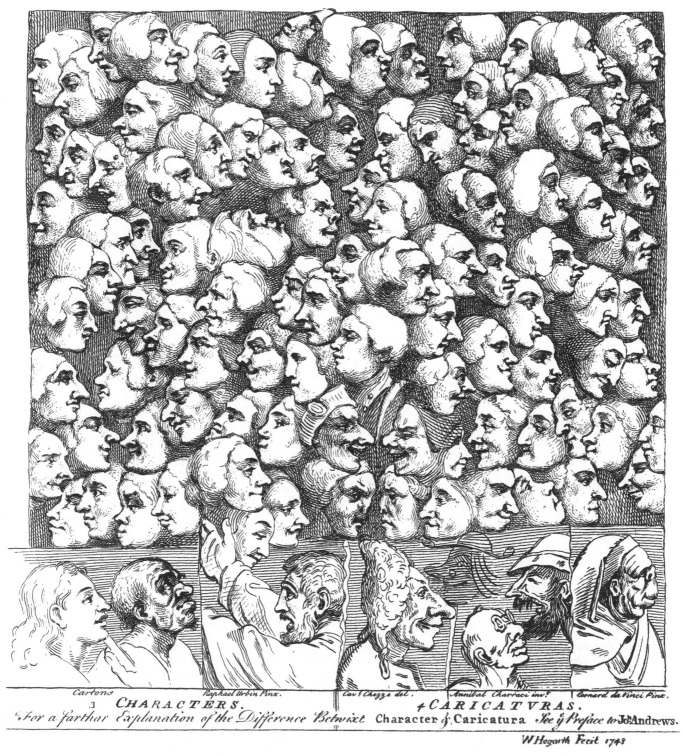

Cartons Raphael Urbin Pinx. Cav.^e Ghezzi del. Annibal Charracci inv.^t Leonard da Vinci Pinx.

3 CHARACTERS. 4 CARICATVRAS.

For a farthar Explanation of the Difference Betwixt Character & Caricatura See y^e Preface to J^s Andrews.

W Hogarth Fecit 1743

THE BATTLE OF THE PICTURES

ETCHED. FEBRUARY 1744/5. $6\frac{7}{8} \times 7\frac{13}{16}$

This print was designed as a bidder's ticket for the auction of the paintings *A Harlot's Progress, A Rake's Progress, The Four Times of the Day* and "Strolling Actresses Dressing in a Barn."*

Suggested by Swift's *The Battle of the Books*, it depicts Hogarth's progresses, representing original British art, in unequal combat with conventional religious and mythological paintings of foreign manufacture, most of them fakes and imitations or copies.

On the left stands an auction house with a conspicuous crack down its wall and a set of high steps to its entrance; its weathervane reads "PVFS" (that is, puffs or inflated praise). By the door stands a tiny half-length portrait engulfed in an elaborate frame. In front of this house of commerce stand long rows of pictures, each row with one

original and many copies (the "Dto" or "Do" stands for ditto). The "old masters" are *St. Andrew with his Cross, Apollo Flaying Marsyas* and the *Rape of Europa*. All these paintings are technically poor. An auctioneer's flag stands in the midst of them.

On the right side of the print stands Hogarth's studio. It contains a clock, a painting and a palette and brushes; the second painting of *Marriage à la Mode* stands on the easel. The battle invades the artist's studio and threatens his work in progress. *St. Francis* (marked "100£") punctures Hogarth's *Morning; Mary Magdalene* stabs the third picture of *A Harlot's Progress; The Aldobrandini Marriage* penetrates the second picture of *Marriage à la Mode;* Titian's *Feast of Olympus* fights with the third work in *A Rake's Progress,* and a bacchanalian scene drives back "A Midnight Modern Conversation." Small copies of the *Rape of Europa* and *Apollo Flaying Marsyas* enter the battle to reinforce the ancients.

* See Vertue's description of this sale in the Chronology under 1745.

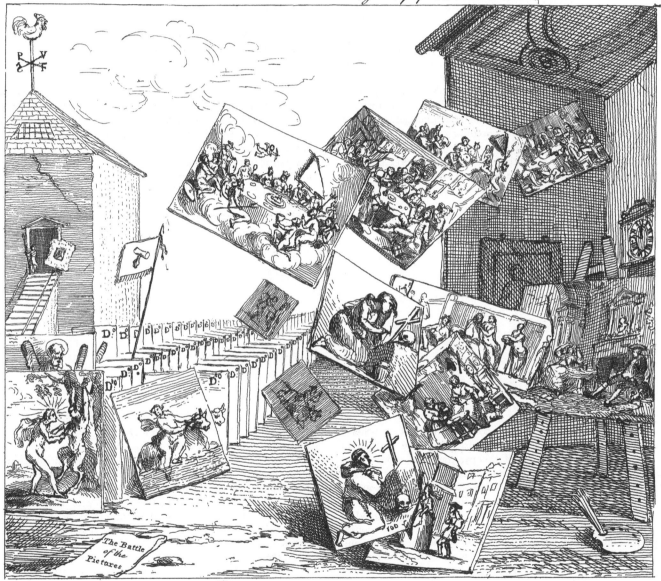

Marriage à la Mode

ETCHED AND ENGRAVED FROM PAINTINGS. JUNE 1745

These engravings were reproduced by the professional French engravers G. Scotin, B. Baron and S. F. Ravenet from paintings probably completed around 1743. Hogarth claims to have engraved the heads himself. The set was sold by subscription for one guinea.

Technically more sophisticated than Hogarth's other progresses, *Marriage à la Mode* was aimed at the upper middle class and the aristocracy, a smaller, more select audience than the artist usually addressed in this genre. The subject of his work, according to his advertisement, is the "Modern Occurrences in High-Life." It tells the story of two young people ill-suited to each other who are forced into a marriage ordained to failure. Serving only the vanity and avarice of their parents, the union drives the couple to destroy each other and wreck their

families. Unlike most of Hogarth's crowded scenes, this work scrutinizes five main characters, concentrating on the deterministic and increasingly desperate ways that the two protagonists develop in response to each other and to their circumstances.

Though the series appears to be an attack on the cynical opportunism of both the middle class and the aristocracy, its exposure of the aristocracy is much more complete and harsh than its criticism of the artist's own class. This bias is best revealed by the complete lack of sympathy with which young Squanderfield is portrayed. Effete and narcissistic from the beginning, he contrasts on a moral level with his middle-class wife, whose natural goodness is finally destroyed by his protracted neglect and repeated infidelity.

51

PLATE I
FIFTH STATE. 13¹³⁄₁₆ × 17½

This scene depicts the crude commercial transaction which yokes a powerless middle-class girl and a vain aristocratic beau together in marriage. Sitting under his grand canopy, the stout, gouty Lord Squanderfield points proudly to his family tree. His genealogy indicates that he is descended from "William Duke of Normandy"; his family, entirely aristocratic, has flourished except for a single member who married out of class. Through the window the Earl's new Palladian house is visible; work on the mansion has stopped for lack of money. Before the half-finished building loiter the curious, the scornful and the Earl's idle servants. At the window the architect, anticipating resumption of work on the place, studies "A Plan of the New Building of the Right Honble."

Across from the Earl the plainly dressed merchant sits stiffly in his chair, his sword sticking out awkwardly from between his legs. The chain on his vest suggests he is an alderman. He scrutinizes the "Marriage Settelmt of The Rt. Honble. Lord Viscount Squanderfield." Between the two men stands a thin usurer who accepts the Earl's newly acquired money (he holds several bags in his hand and some notes marked "£1000") for a "Mortgage."

In the background, appropriately enough, the couple to be married sit together on a couch. The effete beau has turned his back to his bride to admire himself in the mirror. He gazes so narcissistically at himself in the glass that he fails to notice the conduct of Lawyer Silvertongue

reflected there. Wearing a foolish look of self-approval, he takes snuff affectedly and balances himself on his tiptoes.

Hunched next to him sits his unsophisticated bride, dressed much more plainly than he, resentful and discontent at the way she is disposed of. She plays with her wedding ring. Beside her Councilor Silvertongue leans solicitously forward as he sharpens his pen. The girl, however, pays no attention to him. Beside this couple sit a pair of dogs, one with a coronet on its back; their manacled state is symbolic of the young couple's condition.

On the wall a head of Medusa seems to gaze at the scene in utter horror. Above the usurer hangs a portrait of the Earl. A burlesque of portraits executed in the sublime manner, it depicts the Earl as Jupiter with a thunderbolt in his hand, a comet flashing above him, a cherub blowing his wig in a different direction from his voluminous clothing and a cannon (placed near his groin) exploding. On top of the elaborate frame a lion seems to grin at the work. All the other pictures are scenes of disaster in the form of death or torture; they comment on different aspects of the calamitous marriage and the Earl's fashionable taste for foreign art of questionable worth. On the ceiling is a depiction of Pharaoh's armies in the Red Sea. On the walls hang pictures of David and Goliath, Judith and Holophernes, the martyrdom of St. Sebastian, Prometheus being tortured by a vulture, the massacre of the innocents, Cain killing Abel and the martyrdom of St. Lawrence.

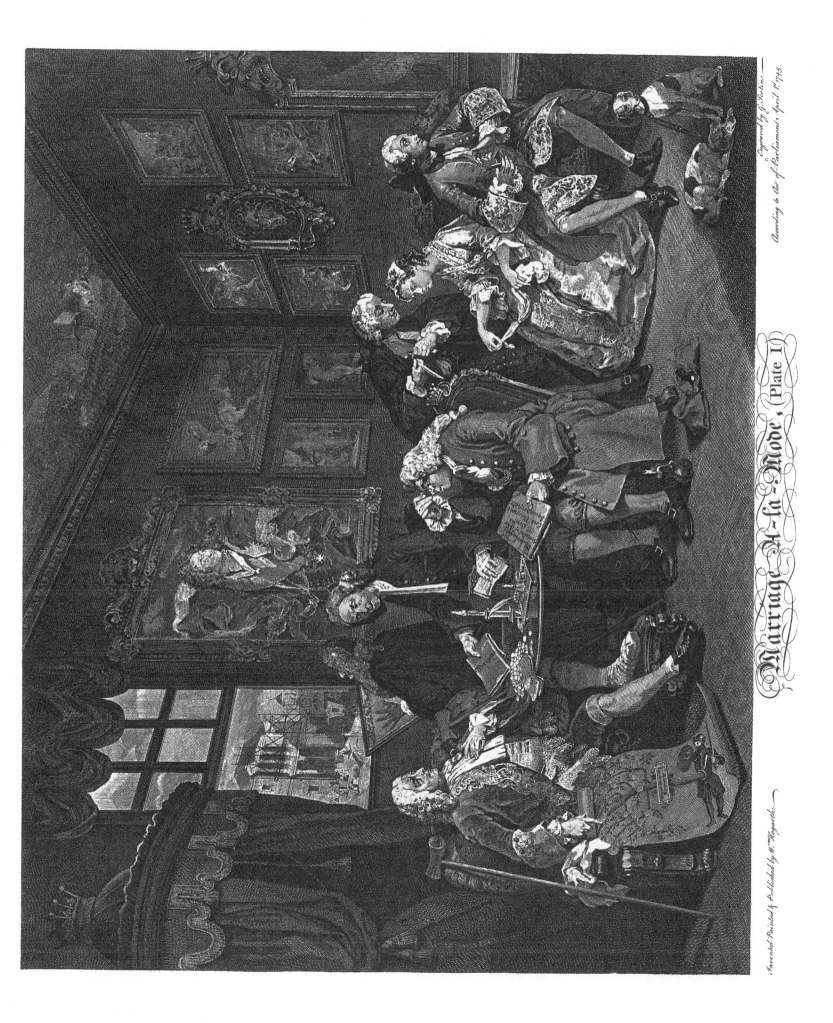

Engraved by G. Scotin

Invented Painted & Published by Wm Hogarth According to Act of Parliament April 1st 1745.

Marriage A-la-Mode. (Plate II)

52

Marriage à la Mode
PLATE II
THIRD STATE. $13\frac{15}{16} \times 17\frac{7}{16}$

Leading extravagant, vitiated lives, the husband and wife have become completely alienated from each other. It is 1:20 A.M.; they sit apart after a night of independent entertainments. Enervated and listless, the husband slumps back on a chair gazing dejectedly at the floor, unaware of his wife's presence. A dog pulls his mistress' cap from his pocket; before him lies his sword broken in a fight. His wife, stretching gracelessly, vainly attempts to win her husband's attention by her glance and outstretched foot. Her entertainment, much more innocent and middle-class than his aristocratic debauchery, has been to remain at home and entertain guests at cards. "Hoyle on Whist" lies at her feet.

Above his head hangs a clock ornamented with the comically incongruous images of a cat, a fish and a Buddha. The mantle is cluttered with tasteless, grotesque little statues; a Roman bust with a broken nose stands in the center. In a picture above the mantle, Cupid plays the bagpipes; his bow lies broken beside him.

The young nobleman has his father's problems with money. His despairing Methodist steward (he carries a copy of "Regeneration" in his pocket) leaves with a sheaf of bills in one hand and a single one marked "Rec'd. June 4, 1744" in the other.

In a second room, every bit as disordered as the first, a sleepy, carelessly dressed servant leans against a chair. The room is decorated with a row of mirrors, and a picture so obscene that it is covered is juxtaposed with portraits of Saints Matthew, John and Andrew. The candle stubs indicate the card party has been an all-night affair. One of the candles sets fire to a chair.

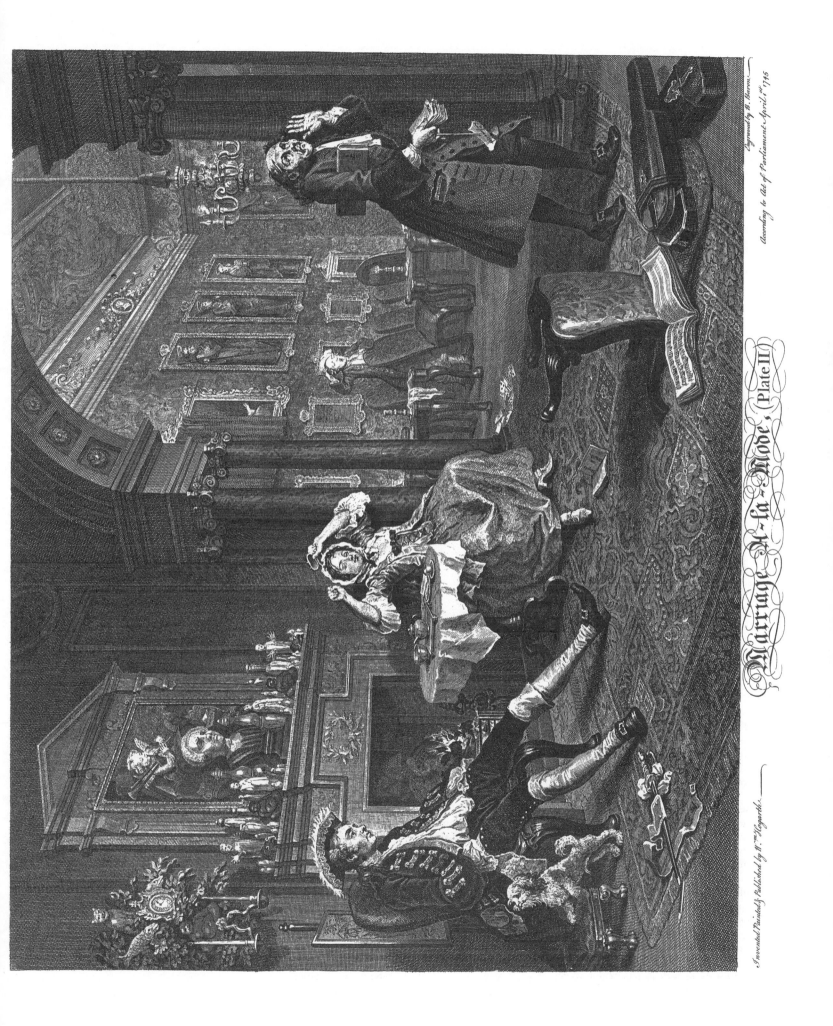

Invented Painted & Published by Wm. Hogarth.

Marriage A-la-Mode. (Plate II)

Engraved by B. Baron.
According to Act of Parliament April 1 1745

53

Marriage à la Mode
PLATE III
SECOND STATE. $13\frac{7}{8} \times 17\frac{1}{2}$

The young couple's depravity has increased and their idle, pleasure-seeking lives are now so unconnected that they are portrayed in separate plates. Plate III shows the husband attending to one of the consequences of his debauchery. He has come to a quack whose house is a gallery of grotesque objects, many of them images of death.

In a glass case behind the young nobleman a human skeleton makes sexual advances to a preserved cadaver. A wig block stands beside them. The horn of a narwhal projects from the side of the case; the horn and the shaving dish between the pillboxes and the urinal warn that this quack was trained as a barber.* The rest of the items hint at the practice of a science more ominous and occult than medicine; they include: a femur, a human head with a pill in its mouth, a tripod shaped like a gallows, a bone, a hat, shoes, a spur, a chained crocodile, a sword and shield, a bug and the picture of a child. Above these hangs a stuffed crocodile with an ostrich's egg attached to its belly.

Through the door the quack's laboratory is visible. In the left foreground stand two threatening machines used for oddly divergent pur-poses: "An explanation of two superb machines, one for setting shoulders, the other for pulling corks, invented by Mr. Pill, seen and approved by the Royal Academy of Sciences of Paris." On the right side of the room stands a cupboard full of labeled jars and drawers. A ferocious wolf's head seems to warn of their contents and of their owner's voraciousness. Beside the chest stand two mummies and two pictures of abnormal human beings.

Squanderfield, half-threateningly and half-cajolingly, complains about the efficacy of the doctor's pills. The bowlegged quack, standing beside a *memento mori*, defends himself. The pathetic, tearful child standing between the nobleman's legs seems to be the victim of his decadent appetite for girl-children, his interest in normal sexual relationships having been exhausted. The relationships between the nobleman, his child-mistress and the commanding, fierce-eyed woman who opens the clasp knife is unclear. The wild-eyed woman may be his second mistress, prompted to violence by disease acquired from the man or by jealousy of the younger girl; she may be the girl's mother or procurer about to revenge her pollution or defend some aspect of her business reputation.

* See the barber's shop in "Gin Lane."

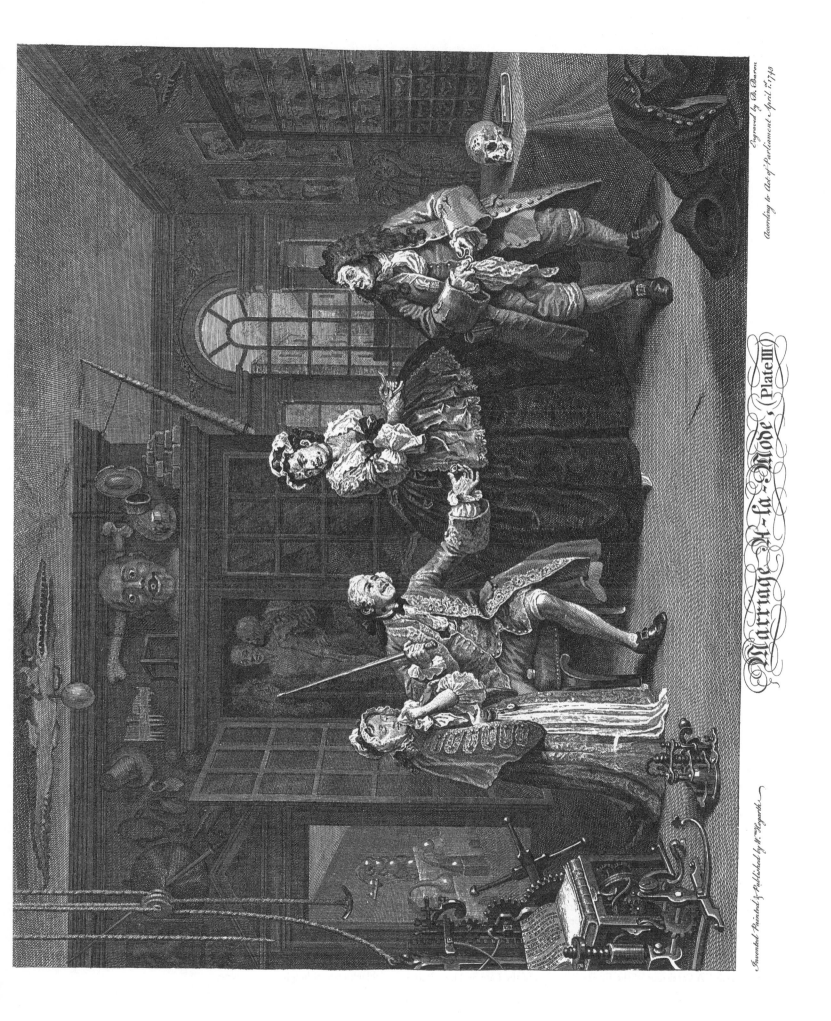

Engraved by B. Baron.

According to Act of Parliament April 1.1745

Invented, Painted & Published by W.ᵐ Hogarth.

Marriage A~la~Mode, (Plate III)

54

Marriage à la Mode
PLATE IV
THIRD STATE. $13\frac{13}{16} \times 17\frac{5}{8}$

Having cast off her middle-class awkwardness and inhibition, the Countess imitates the life style of the aristocracy (the coronets about the room indicate that the old Earl is dead). In contrast to her husband's bizarre passion for young girls, the Countess's middle-class origins reveal themselves in her interest in an ordinary love affair. Wearing jewelry on her hair and fingers and dressed in a low-cut gown, she sits at her levee with her back to her guests, oblivious to the music, attentive only to the addresses of Silvertongue. A child's rattle on her chair reveals that she has a baby which she has the servants care for.

Looking very much at home, Silvertongue lolls on the couch beside her, leaning intimately toward her. He points to the screen behind him and, as he explicates the masquerade scene on it, arranges an assignation for the night. The paper in his hand reading "1st Door," "2 d Door," "3 d Door" is a key to the screen. Beside him lies "Sopha," a venereal novel by Crébillon. The art in the room comments on the lady's preoccupation. Above her are pictures of Lot's daughters preparing to seduce their father and Jupiter possessing Io. On the opposite wall hang a version of the rape of Ganymede and a portrait of Silvertongue himself. Before them a black boy plays with a group of tasteless art objects purchased by the lady at an auction. A book beside them reads "A Catalogue of the Entire Colection of the Late Sr Timy. Baby-house to be Sold by Auction." The lot includes a tray inscribed with an erotic version of Leda and the swan by "Julio Romano" and a statuette of Actaeon; the boy points to Actaeon's horns to interpret the import of the conversation behind him.

Lying on the floor across from the youth are playing cards and correspondence, both indicative of the Countess's social life. "Ly Squanders Com is desir'd at Lady Townlys Drum Munday Next"; "Lady Squanders Company is desir'd at Miss Hairbrains Rout"; "Lady Squanders Com is desir'd at Lady Heathans Drum Major on next Sunday"; "Count Basset begs to no how Lade Squander Sleapt last nite." The spelling in these notes is a judgment upon their authors' literacy.

Most of the group sit around in strained, affected poses. The center of focus is a bloated castrato (probably Francesco Bernardi, an Italian singer who lived in England for a while). Overdressed in gold lace and tastelessly bedecked with jewels, the vain fellow sits haughtily back in his chair, unaware that only two in the whole group listen to him. Next to the singer sits a man with his hair in papers, bored but formally attentive. Beside him a fellow gestures preciously and screws his face up in feigned appreciation. A man with a riding whip snores while his wife strains ostentatiously forward in the direction of the castrato. A black servant laughs at the scene.

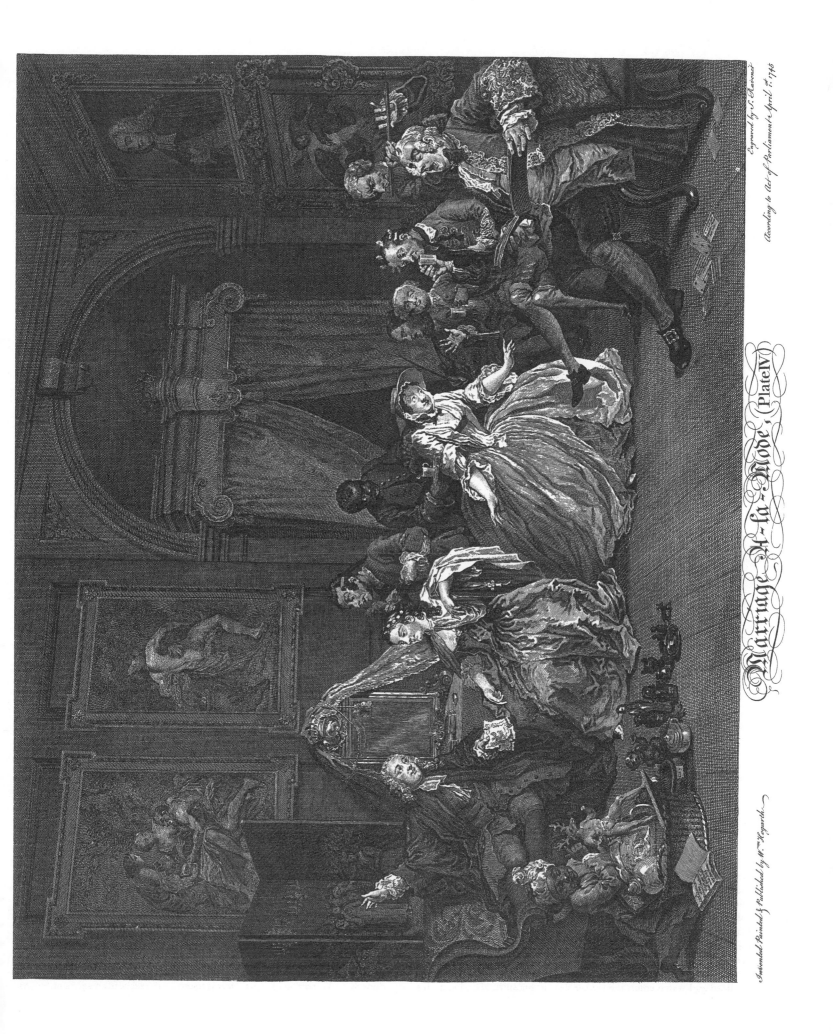

Invented Painted & Published by W.m Hogarth ⋅

Marriage A ⁓ la ⁓ Mode, (Plate IV)

Engraved by S. Ravenet ⋅

According to Act of Parliament April 1: 1745

55

Marriage à la Mode

PLATE V

FOURTH STATE. $13\frac{3}{4} \times 17\frac{9}{16}$

Hearing of the lawyer's and Countess's assignation, the young Earl has come to their dreary meeting place, challenged the councilor to a duel and died in the defense of a virtue which he neither honored nor valued in a woman he did not love. From a masquerade, the couple have gone to the Turks Head bagnio (a paper with a Turk's head and the words "The Bagnio" lies by the woman's underwear). Undressing hastily, they have gone to bed but have been surprised before the end of the night. In the ensuing fight, the Earl is killed and, as the horrified landlord and watch enter, the lawyer flees in his shirt, abandoning his mistress to the police and her dying spouse. She kneels in tears to beg his forgiveness.

The eerie lighting from the fire, the shadows from the tongs and the sword, the scattered undergarments and the grinning masks (prophetic death masks) give a grotesque atmosphere to the scene. The tapestry on the main wall depicts in a caricatured manner the judgment of Solomon. The portrait of a prostitute with a squirrel in her hand is satirized by the appearance of a soldier's legs beneath it. Above the door St. Luke, patron of artists, seems to record the scene in amazement.

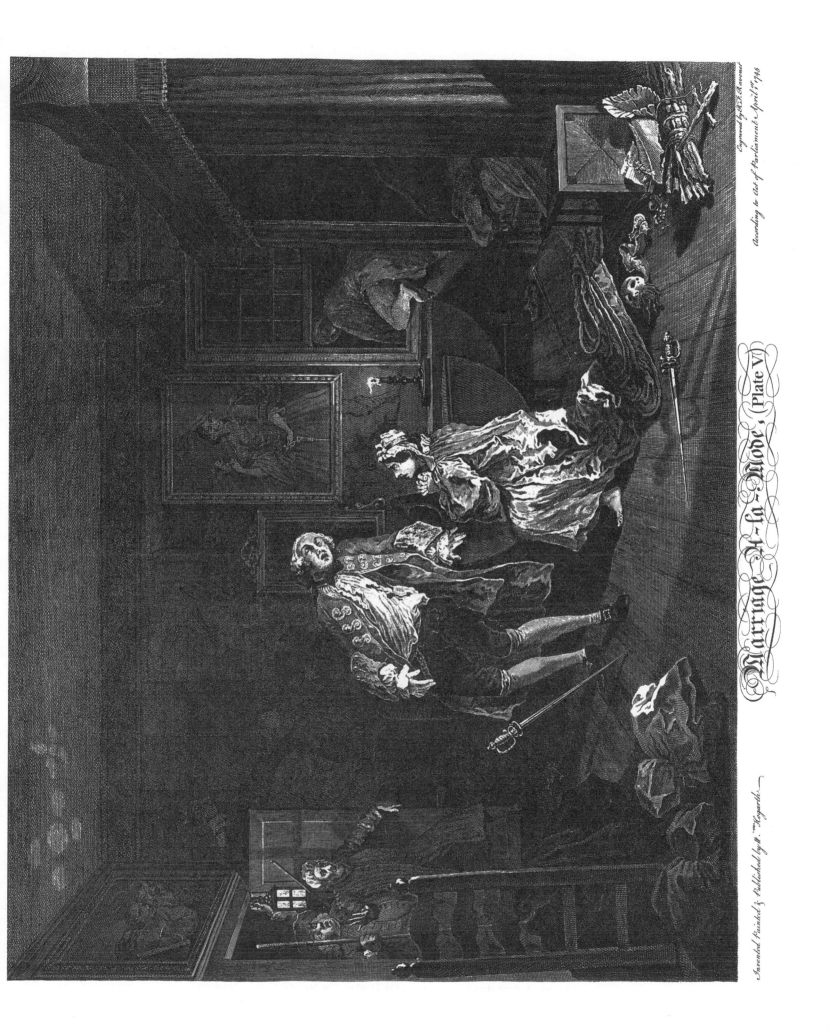

Invented Painted & Published by W.ᵐ Hogarth.—

Marriage A-la-Mode, (Plate VI)

According to Act of Parliament April 1ˢᵗ 1745

Engraved by R.ᵈ S.ᵗ Avernel

56

Her husband killed and her lover hanged, the Countess, returned to her father's house, is driven to suicide by the tragic consequences of the foolish and ill-fated venture perpetrated on her.

Plainly dressed, she expires on a chair as an ineffectual hysician scurries away. On the floor lies a bottle of "Laudanum"; next to it the precipitating cause of her suicide, "Counseller Silvertongues last Dying Speech." As her impassive, mercenary father, anticipating her burial, dispassionately removes the ring from her finger, a withered old nurse holds her daughter to her for a dying kiss. The crippled girl has inherited both her father's venereal disease and his beauty spot; since the young Earl has no male child, his family line has ended. The apothecary, who has a stomach pump and a "julep" bottle in his pocket, points to the empty laudanum bottle, and berates the servant who looks at it uncomprehendingly. The fellow, who wears his master's ill-fitting coat buttoned askew, is an idiot hired cheaply by the alderman.

The house reflects the alderman's miserly life style, which has supported his costly and tragic manipulation of his daughter's life. A dark apartment with bare floors and cobwebbed windows with broken panes, it is located near London Bridge, which at that time had houses built across it. On the wall hangs the alderman's robe, a clock with its figures reversed (it should be 1:56 P.M.) and an "Almanack." Three "Dutch" paintings (really satires of Dutch realism) decorate the walls; the first (unframed) depicts a man urinating; the second is a still-life crowded with "low" objects (an arbitrary collection of kitchen utensils, jugs and food); the third shows a drunkard lighting his pipe from the swollen nose of a companion. In the alderman's cabinet stands a single liquor bottle, some pipes and a library of five books; four are financial records: "Day Book," "Ledger," "Rent Book" and "Compound Interest." The hall is lined with fire buckets.

From the meager fare on the table, a skeleton-like dog steals a lean pig's head.

The painting used as the source of this work (see below) is largely identical to the engraving; the differences are mostly technical. The series hangs in the National Gallery, London.

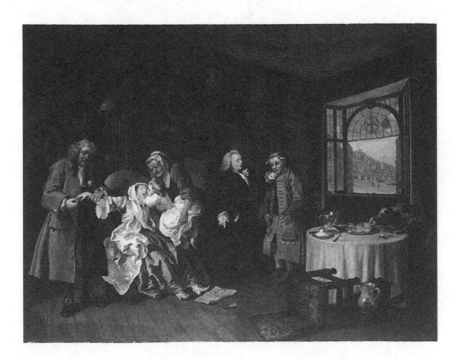

Oil painting. Reproduced by courtesy of the Trustees, The National Gallery, London.

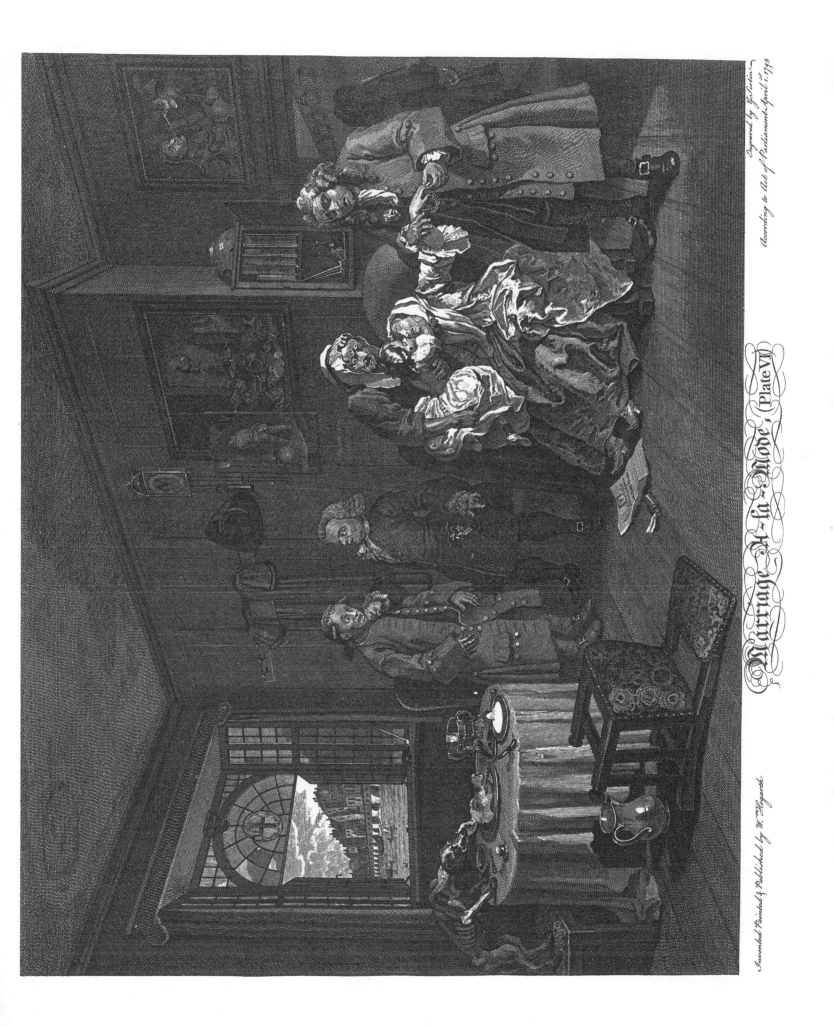

Invented Painted & Published by Wm. Hogarth

Marriage A-la-Mode, (Plate VI)

Engraved by G. Scotin

According to Act of Parliament April 1, 1745

57

MR. GARRICK IN THE CHARACTER OF RICHARD THE THIRD

ETCHED AND ENGRAVED FROM A PAINTING. SECOND STATE. JULY 1746. $15\frac{1}{8} \times 19\frac{13}{16}$

This print was engraved from a painting modeled on Le Brun's *The Family of Darius before Alexander the Great*.* Hogarth's original was executed for a Mr. Duncombe of Duncombe Park who paid the artist £200 for it, the highest price paid a British painter for a single portrait up to this time.

The work is at once a full-length portrait, a dramatic history painting and a Le Brun-like study of the passion of fear. It portrays Hogarth's friend David Garrick playing the Shakespearean part by which he first became famous and helped to popularize and celebrate British drama.

* Antal, *Hogarth and His Place in European Art*, p. 69.

It does not appear to depict an actor (there is no hint that this action takes place on stage) but rather an historical personage of great importance, Richard III, properly costumed and surrounded by the elaborate drapery and symbols (armor, crown, sword) of his position which were traditional in such portraits. Because it catches Richard in a moment of crisis as he has awakened from a nightmare (V, iii), it is primarily a study of the operations of fear as it manifests itself in the face, posture and actions of an individual. At Richard's feet lies a note bearing the words from the play, "Jockey of Norfolk, be not so bold/For Dicken thy Master is bought & Sold."

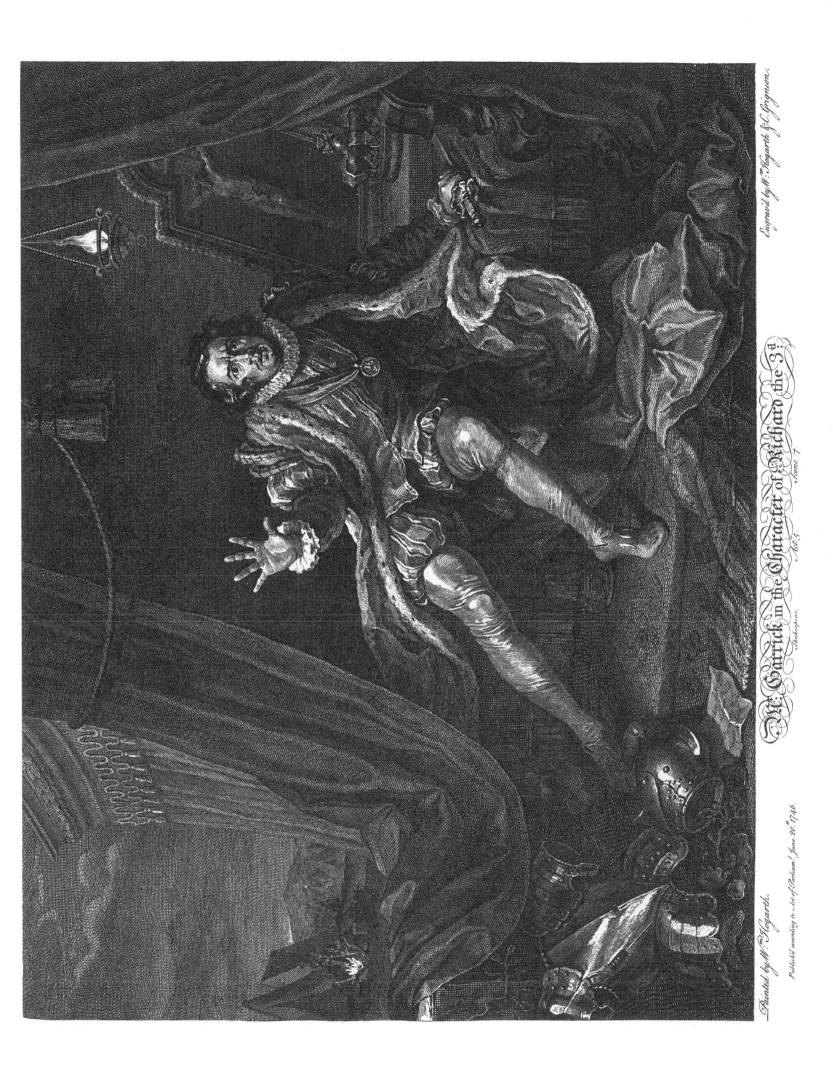

Painted by W.^m Hogarth.

Engrav'd by W.^m Hogarth & C. Grignion.

M.^r Garrick in the Character of Richard the 3.^d

Act 5. Shakespear. Scene 7.

Published according to Act of Parliam.^t June 20.th 1746.

SIMON LORD LOVAT

ETCHED. SECOND STATE. AUGUST 1746. $13\frac{1}{16} \times 8\frac{3}{4}$

This was Hogarth's most successful popular engraving, earning the artist £12 a day for three or four weeks. The best of his psychological studies of criminals, it portrays Simon Fraser at an inn in St. Albans on his way to trial and execution for rallying the Highland clans on behalf of the Pretender in 1745. The etching, which shows Lovat counting the number of clans supporting the Stuart cause on his fingers, portrays a crafty, sly person. The deviousness of his narrow eyes, the toad-like quality to his build, the calculating nature of his gestures and the cunning of his half-smile suggest the deception and cynicism of the man's character.

A faded motif of two putti bearing a crown appears (with ironic intent) on the chair behind Lovat's head.

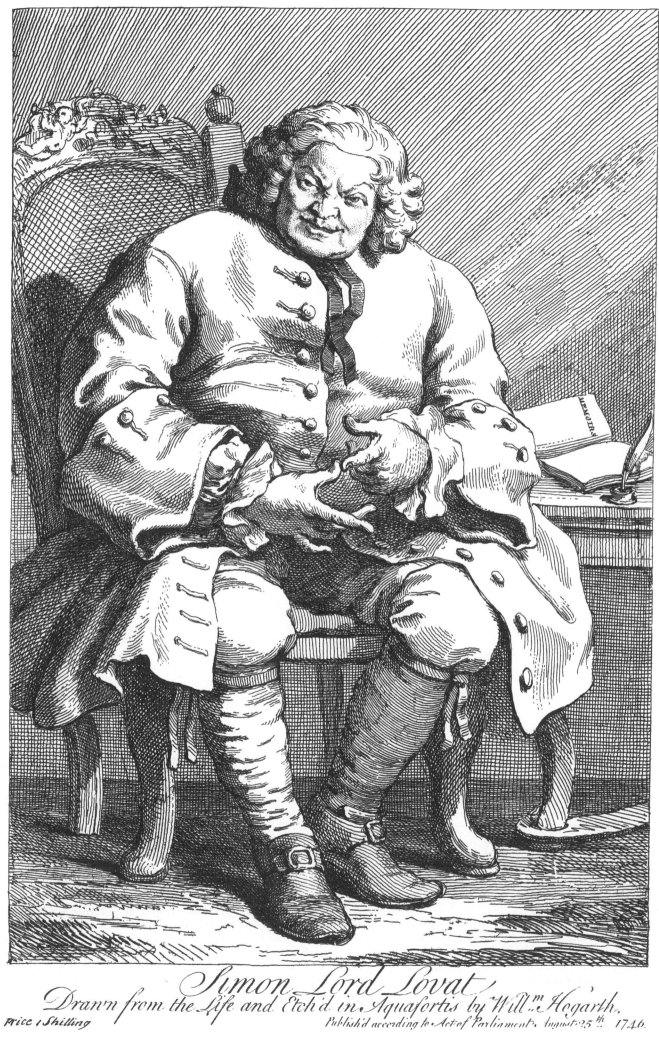

Simon Lord Lovat

Drawn from the Life and Etch'd in Aquafortis by Will.ᵐ Hogarth.

Price 1 Shilling

Publish'd according to Act of Parliament. August 25.ᵗʰ 1746.

59

A COUNTRY INN YARD AT ELECTION TIME: THE STAGE-COACH

ETCHED AND ENGRAVED. THIRD STATE. JUNE 1747. $8\frac{1}{8} \times 11\frac{5}{8}$

This print illustrates the various events and moods that attend the departure of a coach from a country inn. The scene is "The Old Angle In" run by "Toms. Bates." At the left the mistress of the inn announces vociferously from the bar the departure of the coach "From London." The symbols on the board to her right are tallies for drinks. By the inn door two lovers embrace. Outside a thin, gaunt woman snaps her fingers in irritation at a crying child. In the window above a drunk blows a horn while another leans on the sill to vomit on the complaining woman below.

An election agent with "An Act" (probably against bribery) in his pocket looks with grave distrust upon the innkeeper, who protests his honesty as he presents the agent with a lengthy bill. An oversized woman is helped into a coach by a push on the backside; her skinny spouse hands her liquor in after her. Next in line, an equally fat man

carrying a cane and sword looks with concern at the lady's bulk. He ignores the plea of the tiny hunchback postillion in the oversized boots for a gratuity. An old woman sits in a hamper smoking her pipe contentedly.

On the coach roof an English sailor "of the Centurian" (a British vessel that was the nemesis of the French navy) tips the cocked hat of a dejected French footman whose sword lies defensively across his legs. A political protest takes place in the courtyard. An effigy holding a baby's rattle and an "ABC" book is being carried around by a mob armed with sticks. In state two a flag behind the effigy bore the words "No Old Baby"; the protest is an expression of opposition to the candidacy of John Child Tylney, only twenty years of age when he ran for election in Essex.

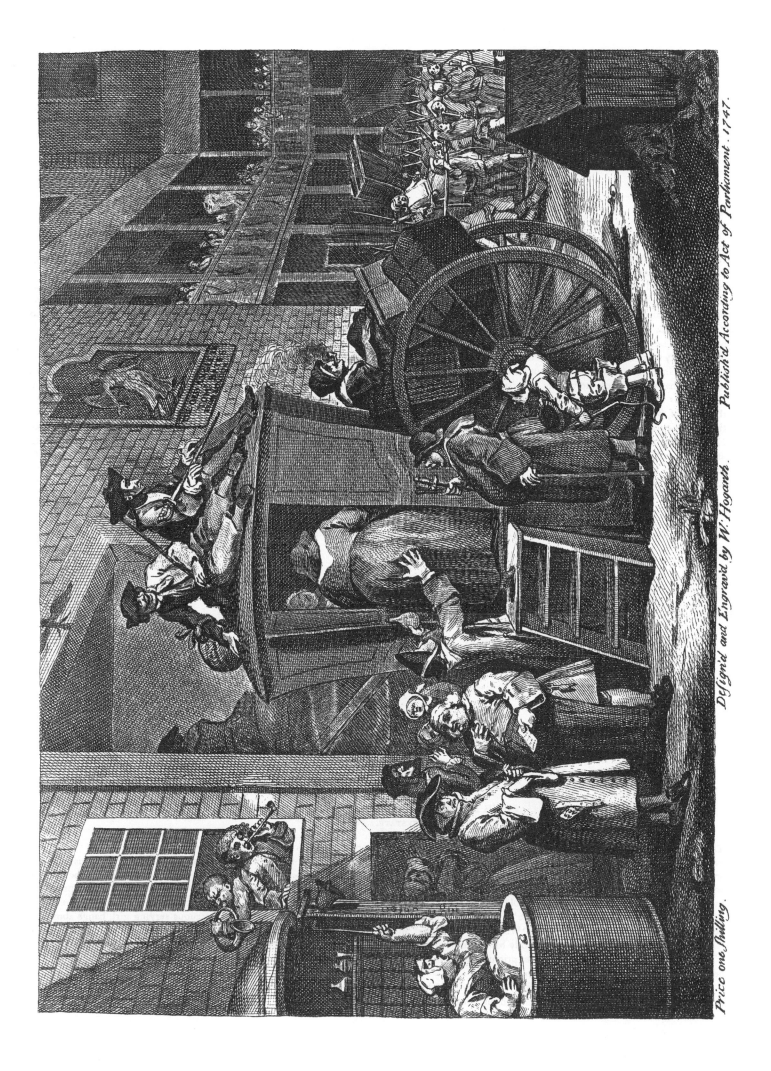

Design'd and Engrav'd by W.ᵗ Hogarth. Publish'd According to Act of Parliament. 1747.

Industry and Idleness

ETCHED AND PARTS ENGRAVED FROM DRAWINGS. OCTOBER 1747.

As the scriptural quotations suggest, this series of engravings was designed expressly to teach the apprentice class of London those moral values associated with the middle class. "The Effects of Industry & Idleness Exemplified in the Conduct of two fellow prentices in twelve points Were calculated," writes Hogarth in his *Autobiographical Notes*, "for the use & instruction of those young people wherein every thing necessary to be convey'd to them is fully described in words as well as figure. Every thing necessary to be known was to be made as intelligible as possible and, as fine engraving was not necessary to the main design provided that which is infinitely more material viz the characters and Expressions were well preserved, the purchase of them became within the reach of those for whom they were chiefly intended." The inspiration for the progress may be found in two bourgeois plays, the revived Elizabethan drama *Eastward Ho* by Jonson, Chapman and Marston, and *The London Merchant* by George Lillo. In an early drawing for Plate I, Hogarth named his merchant Barnwell from Lillo's work.

This progress was executed in a crude, unpolished style that is more concerned with striking the passions than with artistic finish and con-sistency. It is interesting to note that, in Plate XI, Idle's face is recognizable only as a countenance filled with the fear of death.

The progress deals with the lives of Francis Goodchild and Thomas Idle, representatives of the middle and lower classes in London. The focus of the work is the public, economic lives of these people and their relationship to their institutions. The perspective of the story is the middle-class belief in the salvific nature of work and the inexorable fate that awaits those who flaunt that belief. Though it draws Thomas Idle as a prodigal, it does not flinch from depicting the uncongenial, pre-industrial revolution conditions of work which reveal the alienating and unattractive nature of labor in the eighteenth century. Unlike most of Hogarth's work, this progress sets forth an ideal, a positive example for its audience, employing contrast, antithesis and balance that increase the force and import of the story. The most interesting minor figure in the story is Idle's whore, who is in every sense quite the antithesis of Sarah Young.

The scriptural quotations are believed to have been selected by the Rev. Arnold King. To make it available to the apprentice class, the progress was sold on two grades of paper for 12/– and 14/–.

PLATE I
THE FELLOW 'PRENTICES AT THEIR LOOMS
SECOND STATE. $10\frac{1}{16} \times 13\frac{1}{8}$

The two apprentices begin their careers in circumstances identical in every respect; this suggests the different characters of the two youths and their antithetical attitudes toward work. The industrious apprentice with a radiant, almost saintly countenance labors religiously at his loom, shuttle in hand. Beside him a wheel holds his flax; an open, well-preserved copy of "The Prentices Guide" lies next to his wheel; behind him hang a calendar ("July") and "Whitington Ld Mayor" and "The London Prentice," items that embody his concerns and ideals. "The London Prentice" shows, in a rather primitive allegory, a figure defending himself from two voracious lions.

The disheveled idle apprentice, his hair uncombed and his eyes sunken and dark, sleeps against his loom with his arms folded; a cat plays with his shuttle. His wheel is empty and his copy of "The Prentices Guide" is torn and deteriorated. The symbols of his life style surround him: an ale measure (inscribed "Spittle Fields," the location of the shop and consequently a place frequented by riotous apprentices) and a tobacco pipe rest on his motionless loom; a page from *Moll Flanders*, Defoe's tale of a promiscuous serving girl, hangs above his head. The apprentice's master looks in and threatens Tom Idle with his cane; the owner's face is filled with righteous exasperation.

Outside the picture, on the left side of the print, there hangs ominously a hangman's rope, a scourge and manacles; on Goodchild's side are a sword of state, the mace of the City of London and an alderman's chain.

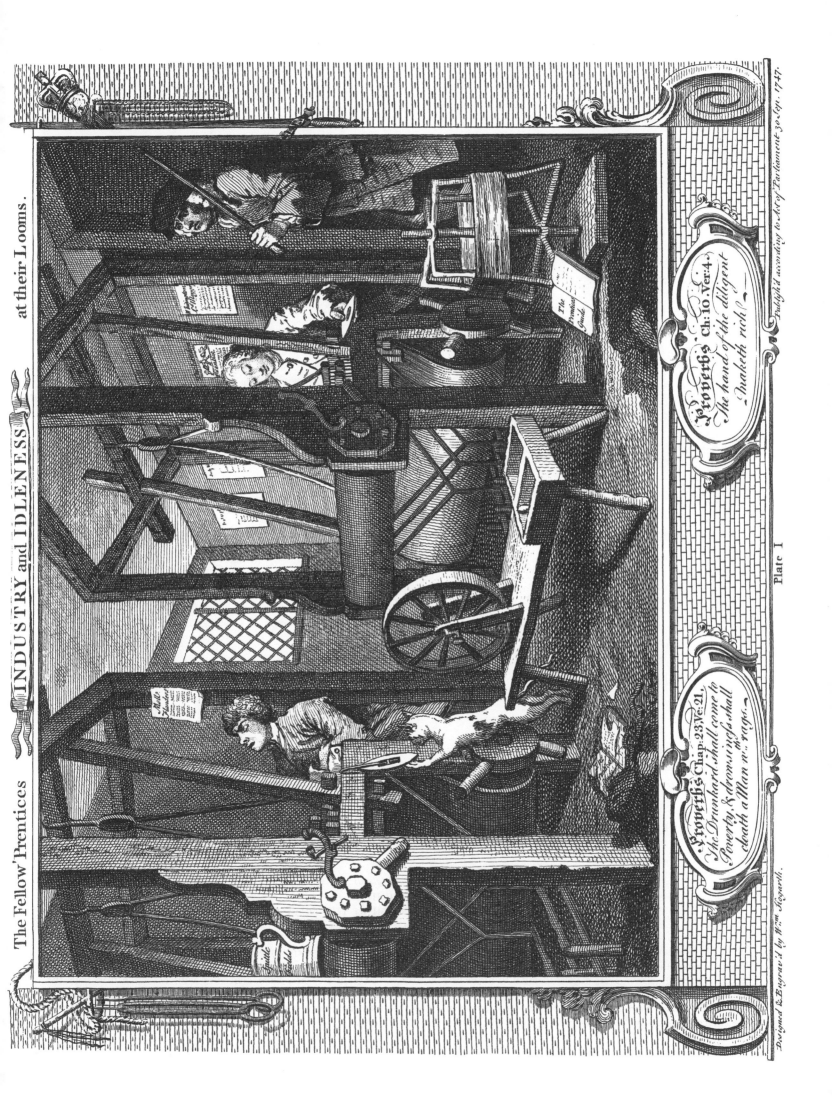

The Fellow'Prentices

INDUSTRY and IDLENESS

at their Looms.

Proverbs Chap: 23 V. 21.
The Drunkard shall come to
Poverty; & drowsiness shall
cloath a Man in rags.

Proverbs Ch: 10 Ver: 4.
The hand of the diligent
maketh rich.

Designed & Engrav'd by Wm. Hogarth.

Plate I

Publish'd according to Act of Parliament 30 Sep. 1747.

61

Industry and Idleness
PLATE II
THE INDUSTRIOUS 'PRENTICE PERFORMING THE DUTY OF A CHRISTIAN
SECOND STATE. $10\frac{1}{16} \times 13\frac{5}{16}$

While Plate I establishes the apprentices' attitudes toward work, Plates II and III reveal their outlook on religion. The industrious apprentice's devotion to religion is in every respect identical to his dedication to work. With similarly intense concentration the boyish youth, dressed in a neat long coat, sings attentively at service. He is accompanied by the attractive, modestly dressed daughter of his master. Behind him a man snores irreverently while a small gentleman and a huge woman with a large fan sing.

The pew-opener, more concerned with her trade than with the divine service, sits with her back to the ceremony. The service is well attended, even if the congregation is not uniformly attentive; most sit in the free seats in the center aisle.

The INDUSTRIOUS' PRENTICE performing the Duty of a Christian.

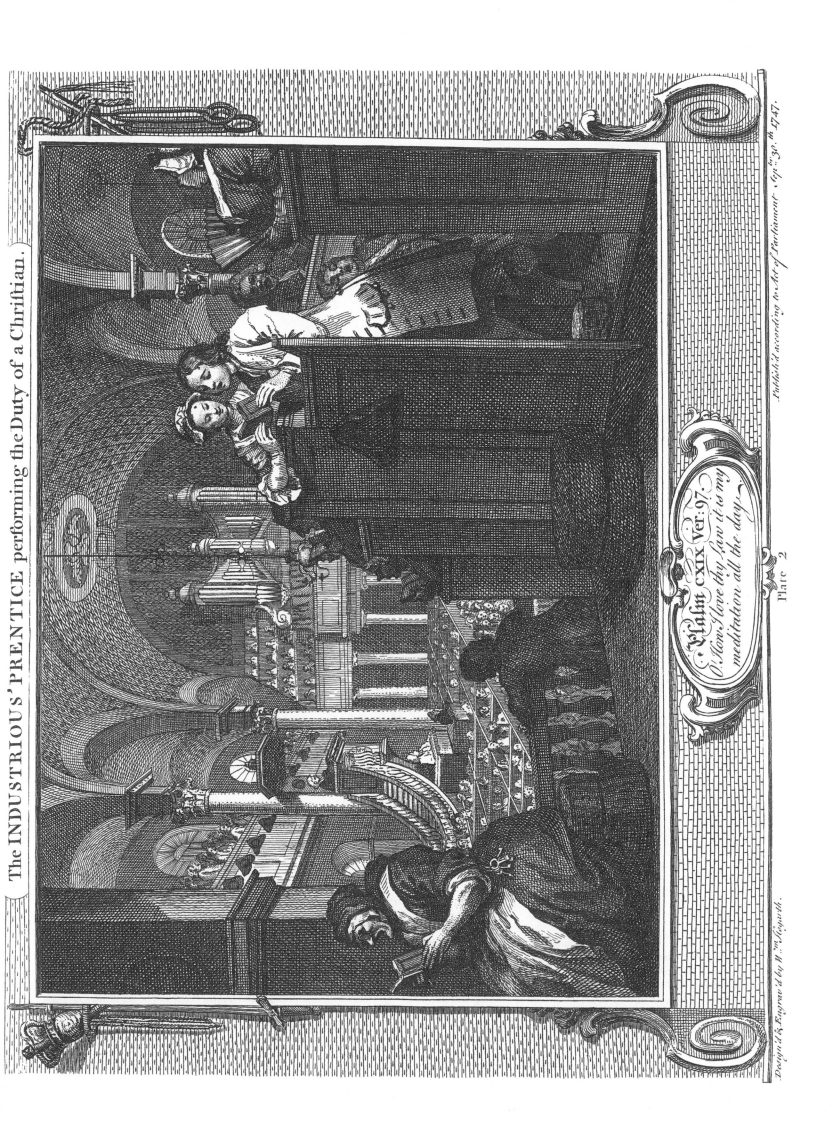

Psalm cXIX Ver: 97.
O: How I love thy law it is my
meditation all the day.

Design'd & Engrav'd by W.ᵐ Hogarth.

Published according to Act of Parliament Sepᵗ. 30.ᵗʰ 1747.

Plate 2

62

Industry and Idleness
PLATE III
THE IDLE 'PRENTICE AT PLAY IN THE CHURCH YARD, DURING DIVINE SERVICE
SECOND STATE. 10 × 13⅜

While Goodchild performs his duty as a Christian in an inspiring church with an exemplary companion, Tom Idle gambles away his earnings in an ominous graveyard with companions of even lower stature than himself. In the background stands a brick church with the insignia of the City of London over its door; the last of the congregation files into the service.

Tom lies on a sinking grave on which the words "Here," "Body" and "of" are visible. Tom's own form replaces the name of the de-ceased. He attempts to cheat a villainous-looking fellow with an eye-patch and a ragged bootblack by covering money with his hat. The bootblack discovers him and seems to reach into his clothes for a weapon. A third youth watches the proceedings in amusement. Tomb-stones with death's-heads and human skulls and bones thrown up from a sinister gaping grave surround the players with signs of impending doom. Behind Tom a beadle, considerably less benevolent than Tom's master, makes an equally vain attempt to reform the youth.

The IDLE 'PRENTICE at Play in the Church Yard, during Divine Service.

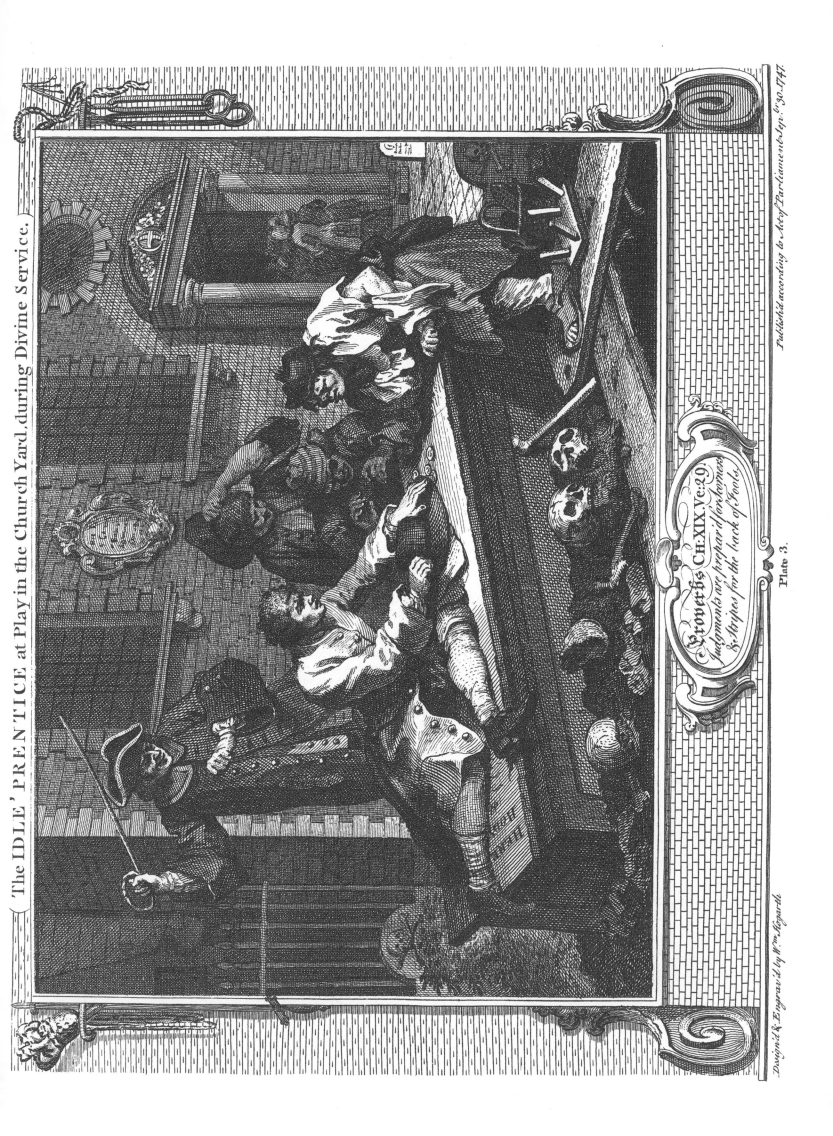

Proverbs Ch:XIX.Ve:29.
Judgments are prepared for scorners
& stripes for the back of Fools.

Plate 3.

Design'd & Engrav'd by Wm Hogarth.

Published according to Act of Parliament Sepr 30.1747.

63

Industry and Idleness
PLATE IV
THE INDUSTRIOUS 'PRENTICE A FAVOURITE, AND ENTRUSTED BY HIS MASTER
SECOND STATE. 10 × 13$\frac{5}{16}$

Plates IV and V illustrate the consequences of Idle's and Goodchild's attitudes toward work. Goodchild has won both friendship and promotion from Mr. West. Clothed now like his master and wearing a short wig, the apprentice holds Mr. West's keys, "Day Book" and money. His master leans symbolically on Goodchild and regards him affectionately as he gestures to the weavers they both supervise in the shop below them. On the counting-house desk two gloves symbolize the unity of master and apprentice. A "London Almanack" which depicts Industry seizing Time reveals the secret of Goodchild's success.

In the shop below these figures, some of the possible reasons for Idle's alienation from his work appear. A row of identical looms stretches across the room. Isolated from each other, the laborers perform their repetitive tasks. Interestingly enough the workers in this plate are all women. A porter with a bulbous nose wearing the arms of the City of London delivers some cloth "To Mr West." Beside him a dog threatens a cat.

The two preliminary sketches reveal the accumulating nature of Hogarth's method.

Preliminary sketches in the British Museum, London.

The INDUSTRIOUS 'PRENTICE, a Favourite, and entrusted by his Master.

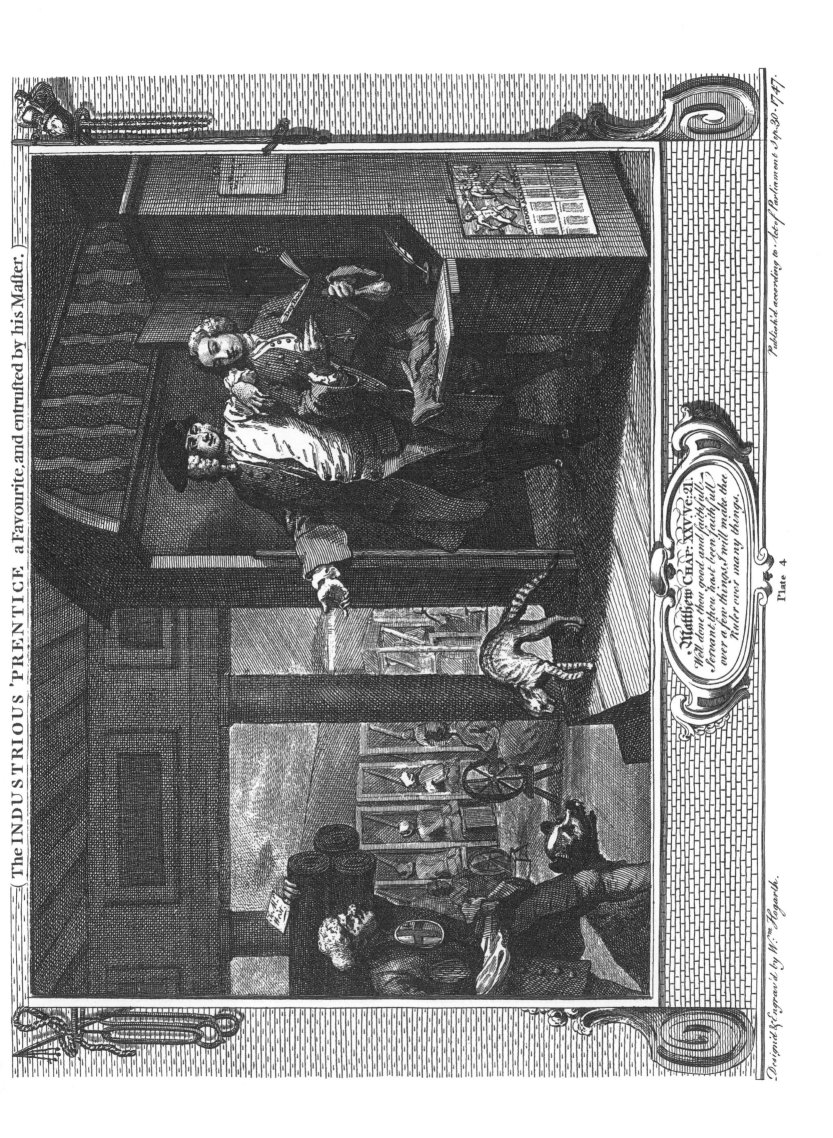

Matthew Chap: XXV. Ve: 21.
Well done thou good and faithfull
Servant, thou hast been faithfull
over a few things. I will make thee
Ruler over many things.

Designd & Engravd by W:m Hogarth.

Plate 4

Published according to Act of Parliament Sep.r 30. 1747.

64

Industry and Idleness
PLATE V
THE IDLE 'PRENTICE TURN'D AWAY, AND SENT TO SEA
SECOND STATE. 10 × 13¼

At the time Goodchild is promoted, Idle is dismissed. Abandoning his respectable career as a weaver, he descends to the unsavory occupation of a sailor. He has cast his apprentice's contract ("This Indenture") into the sea and is being rowed to a waiting ship, escorted by two companions who taunt him. One holds a lash in front of him; another points to the ship he is to sail on and to the gallows on the peninsula. A noose hangs over the side of the boat. Idle's widowed mother, the only person still attached to him, expostulates tearfully with him, but he responds by making a cuckold sign in her direction.

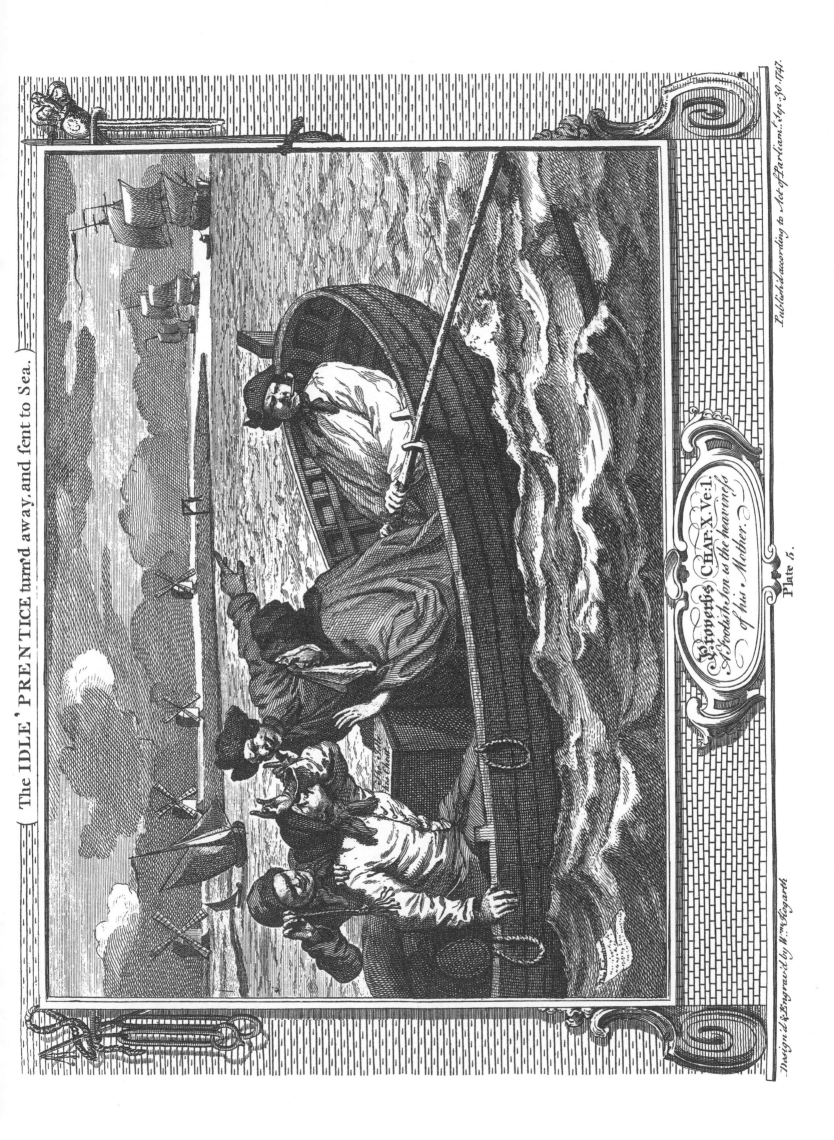

The IDLE 'PRENTICE turn'd away, and sent to Sea.

Proverbs CHAP: X. Ve:1.
A foolish son is the heaviness
of his Mother.

Publish'd according to Act of Parliam.t Sep.r 30. 1747.

Plate 5.

Design'd & Engrav'd by W.m Hogarth.

Industry and Idleness
PLATE VI
THE INDUSTRIOUS 'PRENTICE OUT OF HIS TIME, AND MARRIED TO HIS MASTER'S DAUGHTER
FOURTH STATE. 10 × 13⅛

Plates VI and VII describe the two apprentices' attitudes toward the institution of marriage. Goodchild marries the master's daughter and by that means advances in his profession. The couple appear in this scene after their wedding at the window of their substantial family residence. They drink tea as the industrious apprentice rewards a drummer for his group's music. The sign on the house showing a lion with a cornucopia on each side and the names "West and Goodchild" indicates that the apprentice is a full partner with his master.

At the door of the house a footman gives the leftovers of the feast to a kneeling woman with a child. An unkempt man without legs who sits in a tub leans forward on his small crutch and offers a song he has composed, " Jesse or the Happy Pair. A new Song." Above him stands a butcher who has made music with a bone and a cleaver. To the right another butcher assaults a violinist. The scene takes place close to the Fire Monument inscribed "In remembrance . . . of Burning ye Protestant City by the treachery of the Popish Faction In . . . year [o]f our . . . Lo[r]d 1666."

The INDUSTRIOUS' PRENTICE out of his Time, & Married to his Master's Daughter.

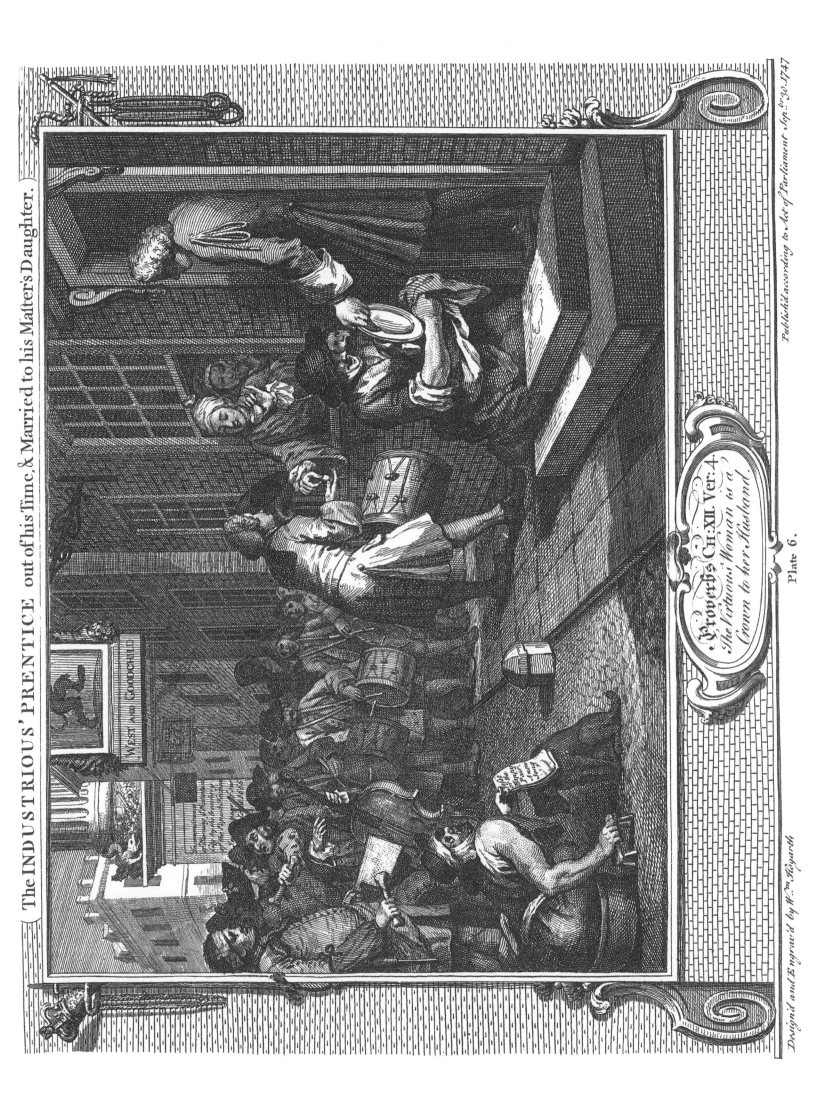

Proverbs Ch. XII. Ver. 4.
The Virtuous Woman is a
Crown to her Husband.

WEST AND GOODCHILD

Designed and Engrav'd by Wm. Hogarth

Published according to Act of Parliament Septr. 30. 1747

Plate 6.

66

Industry and Idleness
PLATE VII
THE IDLE 'PRENTICE RETURN'D FROM SEA, AND IN A GARRET WITH A COMMON PROSTITUTE
SECOND STATE. $10\frac{1}{16} \times 13\frac{3}{8}$

Tom Idle, descended from a sailor to a highwayman, has likewise found himself a companion, but not in marriage; he has bought the favors of a prostitute of criminal character for the night. Housed in her garret with holes in the floor and deteriorated walls, Idle and his whore lie in a broken bed. Though the door is bolted, locked and barricaded, the noise made by a cat chasing a rat down the decayed chimney into the room has alarmed the guilty Idle; he sits up in terror, his hair on end and his face twisted in fear. His calm companion ignores him to admire a trinket from the evening's booty. Above the bed hangs the woman's hoop, covering a drafty window; beside it lie the signs of Idle's life: a set of pistols, a liquor glass and a bottle. Next to a gaping hole in the floor, a plate, a knife and a broken jug rest. On the mantle sits the harlot's "cures" for venereal disease.

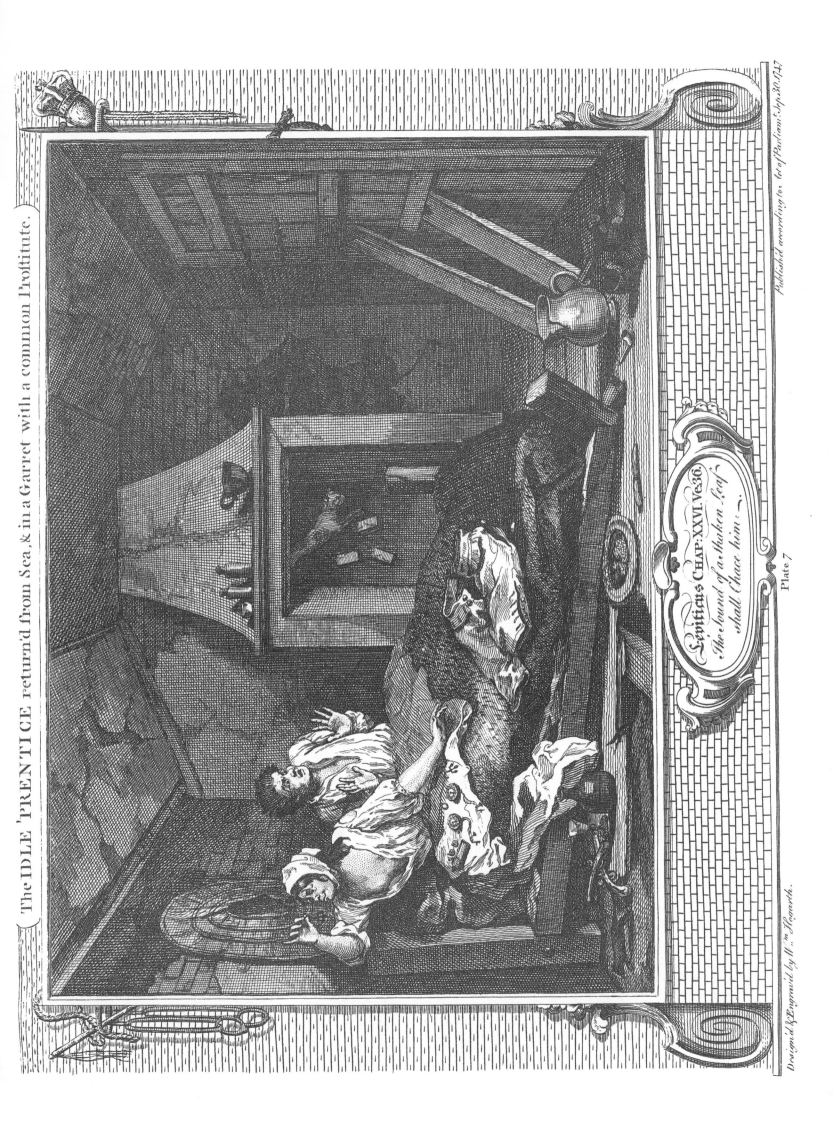

The IDLE 'PRENTICE return'd from Sea, & in a Garret with a common Proſtitute.

Leviticus Chap:XXVI Ve:36.
The ſound of a ſhaken Leaf
ſhall Chaſe him.

Deſign'd & Engrav'd by Wm. Hogarth.

Publiſhed according to Act of Parliamt. Sepr 30. 1747

Plate 7

67

Industry and Idleness
PLATE VIII
THE INDUSTRIOUS 'PRENTICE GROWN RICH, AND SHERIFF OF LONDON
SECOND STATE. $9\frac{15}{16} \times 13\frac{3}{16}$

Goodchild's wealth has caused him to win political office. A barely distinguishable figure in the background of a prosaic scene, he presides with his wife over a banquet in his position as sheriff of London. A mace and sword stand by their chairs. Above hangs a picture of William III. In a niche between the windows is a statue of "Sr William Walworth Kt," the fellow who fatally stabbed Wat Tyler, a peasant revolutionary.

On a balcony a group of musicians perform for the diners. The silent men at the end table, though of different sizes and shapes, share a gluttonous preoccupation with food and drink. A letter reading "To the Worship'd Fras Goodchild Es. Sher[iff] Londo[n]" is examined at the door by an officious beadle.

The INDUSTRIOUS 'PRENTICE grown rich, & Sheriff of London.

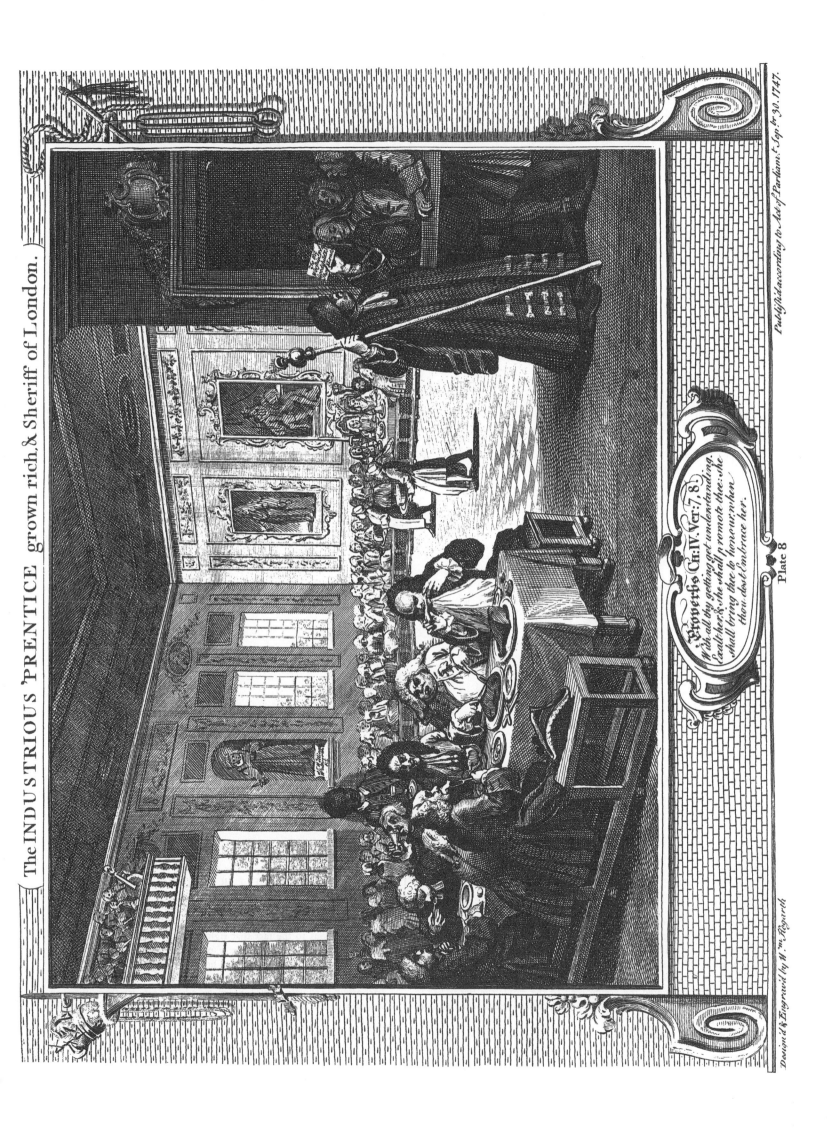

Proverbs Ch:IV.Ver:7,8.
With all thy getting get understanding.
Exalt her, & she shall promote thee: she
shall bring thee to honour when
thou dost Embrace her.

Plate 8

Design'd & Engrav'd by W.m Hogarth

Publish'd according to Act of Parliam.t Sep.r 30. 1747.

68

Industry and Idleness
PLATE IX
THE IDLE 'PRENTICE BETRAY'D BY HIS WHORE, AND TAKEN IN A NIGHT CELLAR WITH HIS ACCOMPLICE
THIRD STATE. $10\frac{1}{8} \times 13\frac{1}{4}$

Formerly just a robber, Tom Idle has now become a murderer and is betrayed in the act of giving up the spoils of a recent crime. A magistrate with his staff of office enters a thieves' den (said to resemble a notorious place called Blood Bowl House) with his bailiffs. For a single coin Tom's whore betrays him to the magistrate. Tom has presumably robbed and murdered the young man to the right; the booty lies in his hat, a pistol protrudes from his pocket and another cocked gun lies near him.

The playing cards suggest he has lost at least part of the loot to his gambling companion (Plate III); they argue over the division of the swag, oblivious to the fact that right next to them the corpse of the victim is being stuffed down a trapdoor. A barmaid with a leather triangle covering the hole left by her decayed syphilitic nose brings the two a drink with which they ironically intend to celebrate. In the background a violent battle takes place; a heavy-set man sleeps through it, and a melancholy fellow with a pipe and liquor measure ignores it. To the right of the fire, a soldier urinates against the wall. A rope hangs ominously from the rafters.

The IDLE 'PRENTICE betray'd by his Whore, & taken in a Night Cellar with his Accomplice.

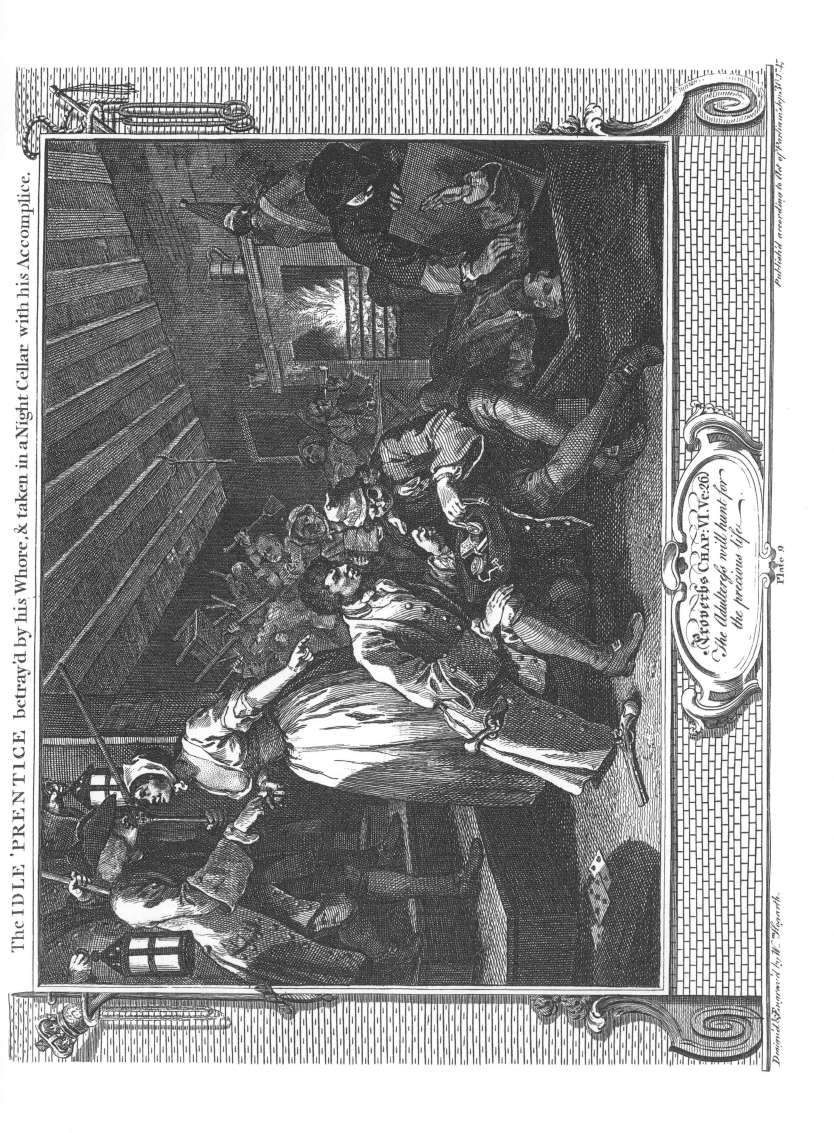

Proverbs Chap: VI. Ve:26.
The Adulterers will hunt for the precious life.

Plate 9.

Designed & Engraved by Wm. Hogarth.

Published according to Act of Parliament Sep.t. 30. 1747.

Industry and Idleness
PLATE X
THE INDUSTRIOUS 'PRENTICE ALDERMAN OF LONDON, THE IDLE ONE BROUGHT BEFORE HIM AND IMPEACH'D BY
HIS ACCOMPLICE
SECOND STATE. $9\frac{3}{4} \times 13\frac{1}{8}$

In a scene that repeats the contrast of Plate I and fulfills its prophecy, the two former apprentices meet again as Tom Idle is arrested for murder and brought to judgment before Goodchild, now Alderman of London. Goodchild, dressed in a fur-trimmed robe and wearing the chain of his office, sits in an ornate chair with his hand over his eyes in an attitude of despair, rejecting the half-kneeling Idle's plea for mercy. Beside him a clerk writes out his order "To the Turnkey of Newgate."

In contrast to the righteousness and integrity of Goodchild, a second clerk accepts a bribe from a woman to overlook the fact that the chief witness swears with his left hand on the Bible, an indication of the worthlessness of his testimony. The witness is Idle's former accomplice who is giving evidence against him. He stands in a pose of counterfeited sincerity with his right hand over his heart. Behind him a bailiff holds up Tom's sword and pistols and points to the culprit. The prisoner's mother (in the same pose as she was in Plate V) attempts to intercede on her son's behalf. A pompous beadle remonstrates with her. Fire buckets hang from the frieze. The "SA" on them may refer to a Sheriff Alsop who held the office in 1742–1743.*

* Paulson, *Hogarth's Graphic Works,* 1:200.

The INDUSTRIOUS 'PRENTICE, Alderman of London, the Idle one brought before him & Impeach'd by his Accomplice.

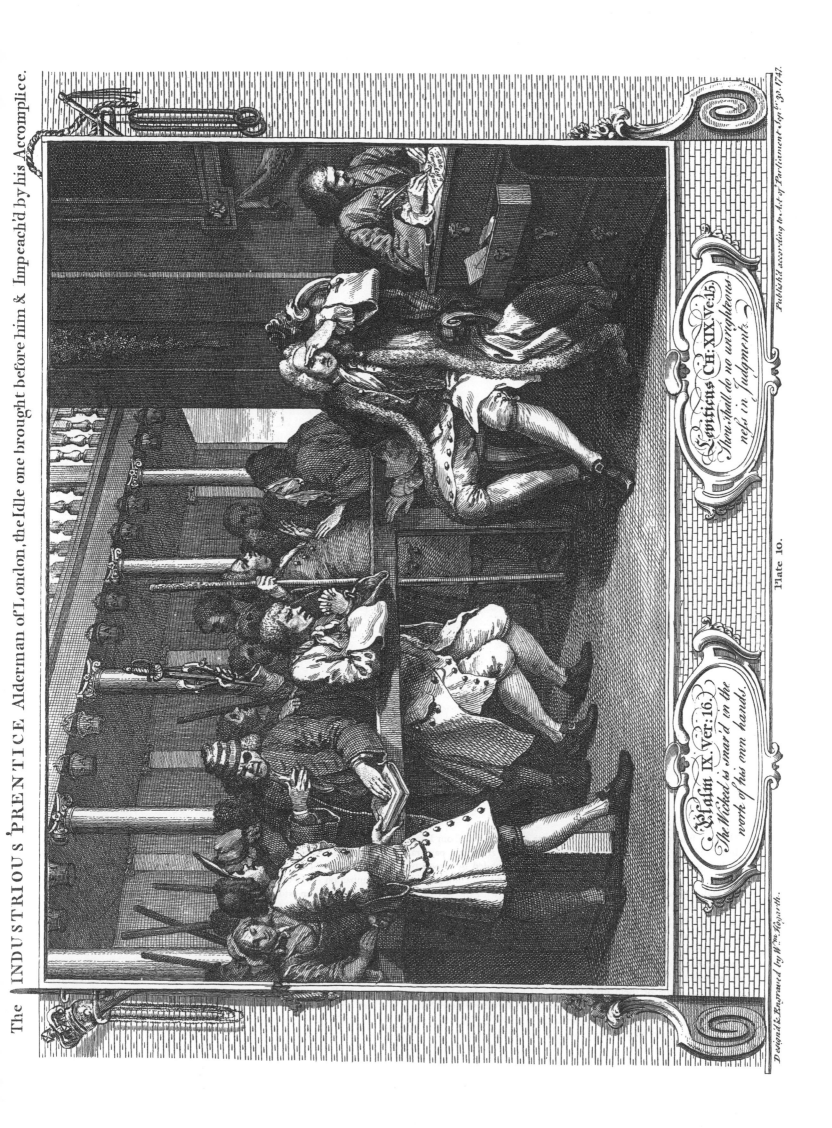

Leviticus Ch: XIX Ve.15.
Thou shalt do no unrighteous-
ness in Judgment.

Psalm IX Ver: 16.
The Wicked is snar'd in the
work of his own hands.

Plate 10.

Design'd & Engrav'd by Wm. Hogarth.

Published according to Act of Parliament Septr. 30. 1747.

Industry and Idleness
PLATE XI
THE IDLE 'PRENTICE EXECUTED AT TYBURN
THIRD STATE. $10\frac{3}{16} \times 14\frac{7}{8}$

The two final plates chronicle, in elaborate comic scenes, Tom Idle's death and the climax of Francis Goodchild's life. Against a pastoral background Tom Idle is brought to execution attended by a mob of spectators; in the cart with him are his coffin and a demonstrative Methodist preacher whose exhortations (together with the horror of death reflected so prominently on the apprentice's face) seem to have reformed him at the last minute. They are preceded by the Newgate Ordinary, who sits in his own carriage isolated and functionless.

On the gallows' top a hangman smokes his pipe nonchalantly. In the stands a pigeon is released to signal Idle's approach. A number of carts stand to the right of the scene; the center wagon contains several prostitutes, some of them drinking. A girl is helped in by a fellow who uses the opportunity to look up her skirt. In the next cart Idle's mother weeps again; a little boy beside her tries to get her attention. Below them a man with a patch over his eye sells biscuits; his supply lies in a basket which has five candles on it, each with a paper shade (he has come before sun-up). A little boy picks the man's pocket, suggesting the inefficacy of capital punishment as a deterrent to crime; a companion looks enviously at the biscuits. Next to them an enraged woman claws an astonished man who has upset her barrow of oranges. Beside them a fellow is about to throw a dog into the prisoner's cart.

In the center foreground a woman with a child sells "The last dying Speech & Confession of Tho Idle." Next to her a woman trounces a man who has fallen to the ground; beside them lies a child with blood pouring from its head; it is observed only by a gin seller. A butcher stands near her carrying a wig on a stick. To the left two children laugh at a soldier caught in a stream. A company of guards follows Idle's cart. At each side of the scene outside the picture hang skeletons suspended by pins driven into their skulls reminiscent of "The Reward of Cruelty."

The IDLE 'PRENTICE Executed at Tyburn.

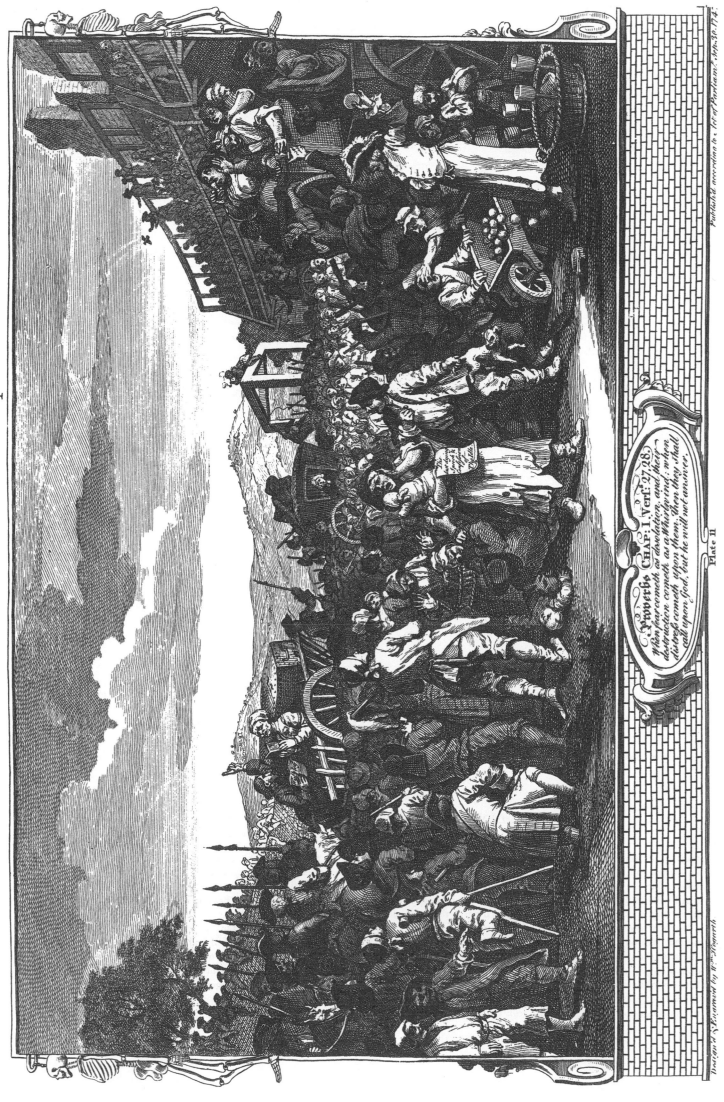

Proverbs CHAP: I. Verf: 27,28.
When fear cometh as desolation, and their
destruction cometh as a Whirlwind; when
distress cometh upon them, then they shall
call upon God, but he will not answer.

Plate II

Design'd & Engrav'd by W.ᵐ Hogarth.

Published according to Act of Parliam.ᵗ Sep.ʳ 30. 1747.

7¹

Industry and Idleness
PLATE XII
THE INDUSTRIOUS 'PRENTICE LORD MAYOR OF LONDON
THIRD STATE. 10¼ × 14¾

Francis Goodchild has fulfilled the British middle-class dream by rising from his position as an apprentice to Lord Mayor of London. Again barely visible, he takes part in the procession of the Lord Mayor at which Frederick Prince of Wales and his consort are mere observers.

In the center of the scene Goodchild's coach heads the procession; the Mayor's sceptre and the sword of state are carried at the coach windows. Behind the coach march the guilds bearing their various banners. In the viewing stand at the left a man waves his hat, another sounds a bugle, and a third kisses a girl who resists by scratching the fellow's face. Below the stand a boy peers up the girl's skirt while a drunken soldier leans against a post. A little girl wheels her fruit barrow past him and, next to her, a blind man feels his way along with a stick.

In the center of the foreground a crude viewing stand has collapsed to the delight of a sweep. In the lower right corner a comic group of city militia of all sizes and shapes mill about aimlessly. One wears a sword in a way that suggests it has pierced him; another closes his eyes, looks away and discharges his gun, which is pointed at people on the roof; a third carries a huge tankard of ale. Beside the latter a boy reads a broadsheet entitled "A full and true Account of ye Ghost of Tho: Idle. Which" A group of common citizens enjoy the gala occasion; and above them the Prince of Wales and his peers gaze formally on the procession or converse together. The building to their left is the east end of St. Paul's.

The INDUSTRIOUS 'PRENTICE Lord-Mayor of London.

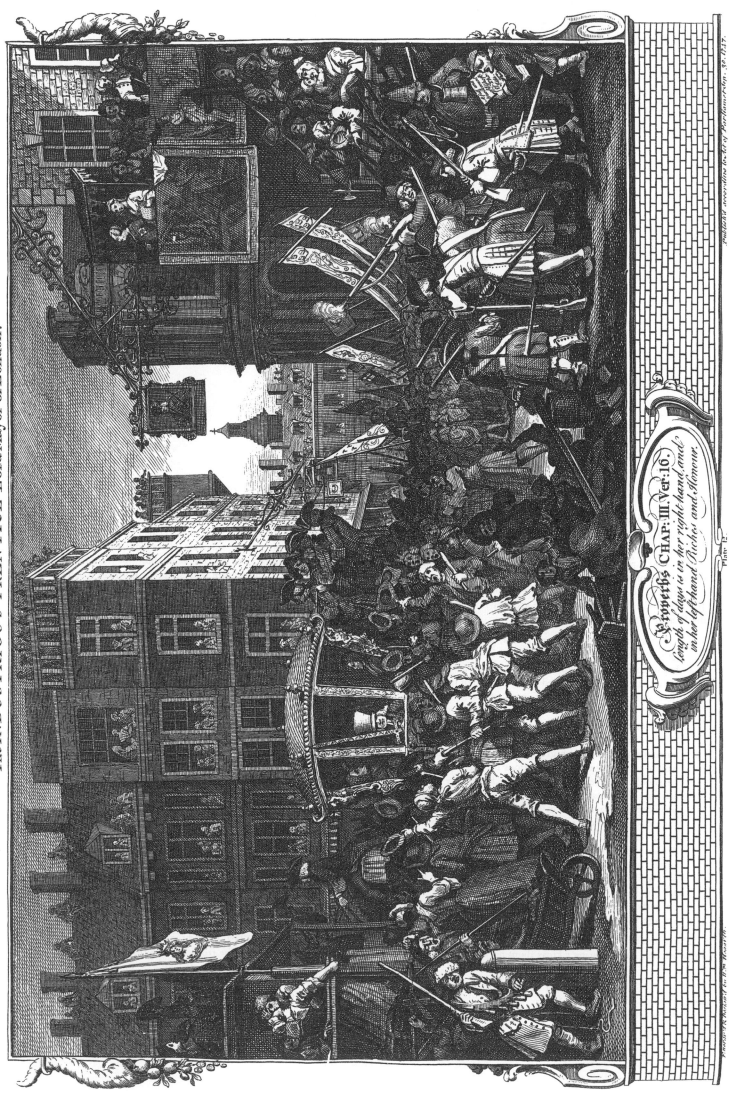

Proverbs Chap: III. Ver: 16.
Length of days is in her right-hand, and
in her left-hand Riches and Honour.

Plate 12.

Publish'd according to Act of Parliam.t Sep.r 30. 1747.

O THE ROAST BEEF OF OLD ENGLAND: THE GATE OF CALAIS

ETCHED AND ENGRAVED FROM A PAINTING. SECOND STATE. MARCH 1748/9. $13\frac{9}{16} \times 17\frac{5}{16}$

"O the Roast Beef of Old England," propagandistic in tendency, depicts the French as a starved, ragged people oppressed by their religion and exposed to ridicule by their affectation. The engraved title of the plate comes from a nationalistic anti-French song popular during the period. The following narrative of the print's origins provided by John Ireland may in some measure account for Hogarth's attack on the French in this work:*

Ignorant of the customs of *France*, and considering the gate of *Calais* merely as a piece of ancient architecture, he began to make a sketch. This was soon observed; he was seized as a spy, who intended to draw a plan of the fortification, and escorted a by file of musqueteers to *M. la Commandant*. His sketch-book was examined leaf by leaf, and found to contain drawings that had not the most distant relation to *tactics*. Notwithstanding this favourable circumtance, the governor with great politeness assured him, that had not a treaty between the nations been actually signed, he should have been *under the disagreeable necessity of hanging him upon the ramparts*: as it was, he must be permitted the privilege of providing him a few *military* attendants, who should do themselves the honour of waiting upon him, while he resided in the dominions of the *Grande Monarque*. Two *centinels* were then ordered to escort him to his hotel, from whence they conducted him to the vessel; nor did they quit their prisoner, until he was a league from shore; when, seizing him by the shoulders, and spinning him round upon the deck, they said he was now at liberty to pursue his voyage without farther molestation.†

The scene shows Calais through two jaw-like gates. In the foreground three women, each wearing a cross about her neck, gather enthusiasti-

cally (one in adoration) around some fish. They smile at the almost human grin on a skate, unaware of its similarity to their own faces. Two carry burdensome loads of vegetables; the third is a fishwife. The food they carry and admire represents the normal French fare. Above them Hogarth appears by a sentry box, sketching the scene. A pike hovers over his head and an arresting hand has been laid on his shoulder. A comparison between the engraver's countenance and those of the other personages in the work suggests the caricatured nature of the latter's faces.

In front of him a ragged soldier (his pants are closed with a wooden skewer, his elbow is out and his ruffles, bearing the proprietary tag "Grand Monarch P," are made of paper) stares in amazement at the beef just arrived from England. The soldier appears to be suspended from the drawbridge chain to suggest the mechanical nature of his role—Paulson calls him a puppet. The butcher, a little less ragged than the other people, staggers under the weight of the meat as he carries it "For Madm Grandsire at Calais," who catered to English visitors. The stout, ugly friar, the only well-fed and well-dressed Frenchman in the scene, rests his fat hand on his chest in an anticipatory way and fingers the meat.

Behind the butcher two more soldiers view the beef. A skinny, unkempt Frenchman with a bayonet on his gun spills his thin soup in awe at the sight. A small fellow with a bullet hole in his hat and a sword that trails on the ground stares at the meat. Two ragged cooks carry off a cauldron of soup; one wears a wig while his shirttail sticks out through a hole in his pants. Below them sits a wounded, anguished Scot, in exile for supporting the Stuart cause. He wears a plaid outfit, worn-out shoes and a sporran with a pipe in it. A cake, an onion and an empty liquor measure lie at his side. The small soldier is by tradition thought to be Irish. That he and the Scot bear marks of battle suggests they have been put in the front lines by the French.

Through the threatening teeth-like gate four people can be seen in the deserted town kneeling servilely for a religious procession that passes before a tavern with the ironic sign of a dove representing the Holy Ghost.

* For Hogarth's own account of the same events, see the Chronology, under "1748–1749," p. xxvii.

† Ireland, *Hogarth Illustrated*, 1:217–218.

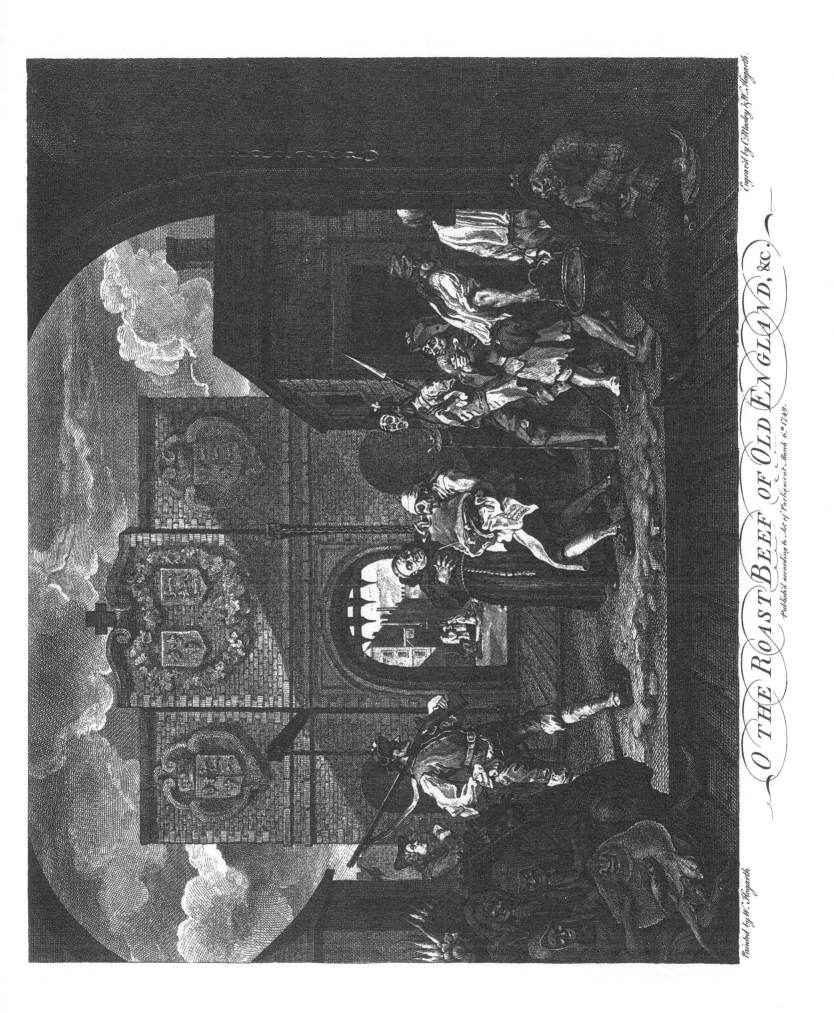

O THE ROAST BEEF OF OLD ENGLAND, &c.

Publish'd according to Act of Parliament March 6th 1749.

73

GULIELMUS HOGARTH
ETCHED AND ENGRAVED. FOURTH STATE. MARCH 1748/9. $13\frac{1}{2} \times 10\frac{5}{16}$

In the same genre as "Martin Folkes Esqr.," this print, Hogarth's most famous self-portrait, depicts the artist as a genial, sober, alert person whose manner is both direct and pleasant. Resting among the symbols of his work, his portrait sits on three volumes which may represent his theoretical interests.* His palette is highlighted more than his burin.

* In the painting, the books are identified as those of Shakespeare, Milton and Swift to emphasize Hogarth's literary relationships.

The "Line of Beauty" was taken by the artist to embody the basic form of all natural and artistic beauty.

There is an appropriate domestic tone to the portrait of this great middle-class artist in the presence of his dog Trump, and the quality of the engraver's comedy is revealed in the resemblance between master and dog, especially in the eyes.

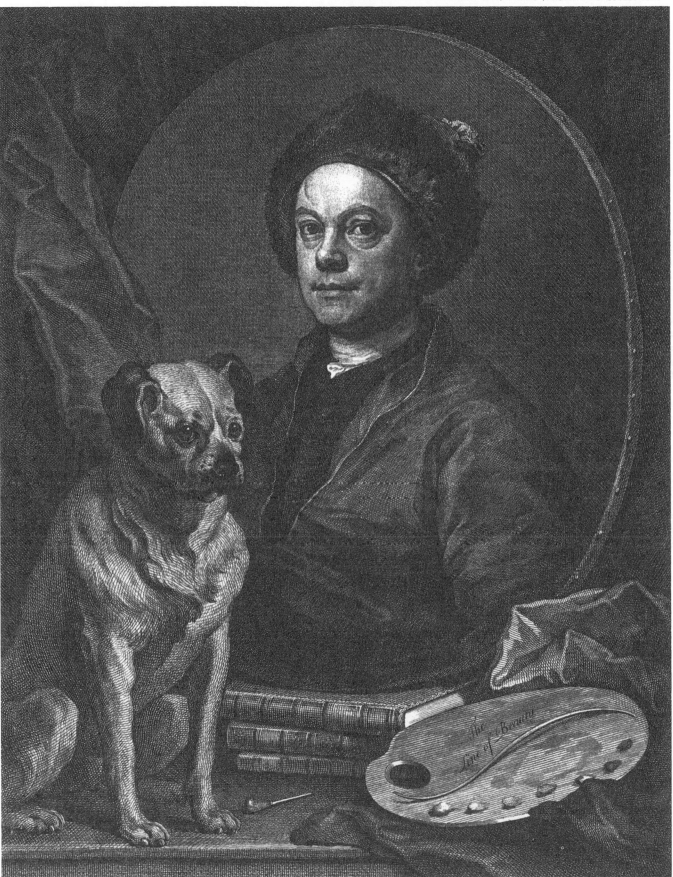

The Line of Beauty

Gulielmus Hogarth.

Se ipse Pinxit et Sculpsit 1749.

THE MARCH TO FINCHLEY

ETCHED AND ENGRAVED BY LUKE SULLIVAN FROM A PAINTING BY HOGARTH. EIGHTH STATE. JANUARY 1750/1. $16\frac{5}{16} \times 21\frac{5}{16}$

This burlesque of military order and discipline portrays British soldiers (on their way to Finchley to defend London from Bonnie Prince Charles) as disorganized, confused and betrayed by their human natures into situations and relationships which have utterly distracted them from their call.

Against a background of soldiers marching in orderly ranks, the guards mill around between a whorehouse and a tavern. In their center stands the group's commander, whose frantic shouts and gestures fail to win any attention. Near him a soldier with an absent, miserable expression on his face is claimed by two women. The younger woman, of the king's party (she sells "God save our Noble King") bases her claim on love and duty. She is pregnant. The frenzied older woman, a Jacobite (she sells *The Remembrancer,* the *London Evening Post* and *The Jacobite Journal*), claims the fellow by threat and force. The cross on her back suggests she is Catholic. The group is observed by a fascinated child, whose innocent face contrasts with that of the two intriguing Jacobites (a Frenchman and a Scot) who, in the middle of the enemy camp, share some secret message about Prince Charles. In front of them a drummer drowns out the cries of his wife and child; he is aided by a young piper. Behind him a soldier urinates below an advertisement for a prescription of "Dr Rock"; the pained expression on his face and his interest in the advertisement suggest he has syphilis. A woman at a window in front of him covers her eyes.

Two signs hang before the houses on the left. One reads "Totenham Court Nursery 1745"; the other, inscribed "Giles Gardiner," depicts Adam and Eve tempted by the snake. Under the sign two soldiers, goaded by a rabid crowd that includes an hysterical woman, engage in a boxing match. The regiment's wagon passes through the crowd bearing their utensils, tents and some women and children. Only the feet of its recumbent driver are visible.

Before the whorehouse stands a picture of Charles II ("CR"), patron of brothels, bearing a phallic design above it. At one window the plump keeper prays for the success (i.e. the return) of the soldiers. A whore refuses a letter tendered on a pike. Above, a girl throws money to a cripple.

On the roof of the building sit three cats, emblems of the figures at the windows. In the right foreground a drunken soldier sits in a puddle; he refuses water to reach for the gin his wife pours. His emaciated child also grabs for it. Two chicks call for their mother, whose wing is visible in the pouch of the kneeling soldier. Behind him a drunk brandishes a dagger which he has used to pierce the liquor barrel of a porter. Next to them a soldier kisses a milkmaid and thrusts his hand into her dress while his companion steals her milk. An amused little urchin asks for a share of the spoils, and another soldier points out the escapade to a pieman in order to steal the gleeful and uncircumspect man's wares.

Subscription ticket: "A Stand of Arms." Etched and engraved, March 1749/50. $6\frac{5}{8} \times 7\frac{5}{8}$.

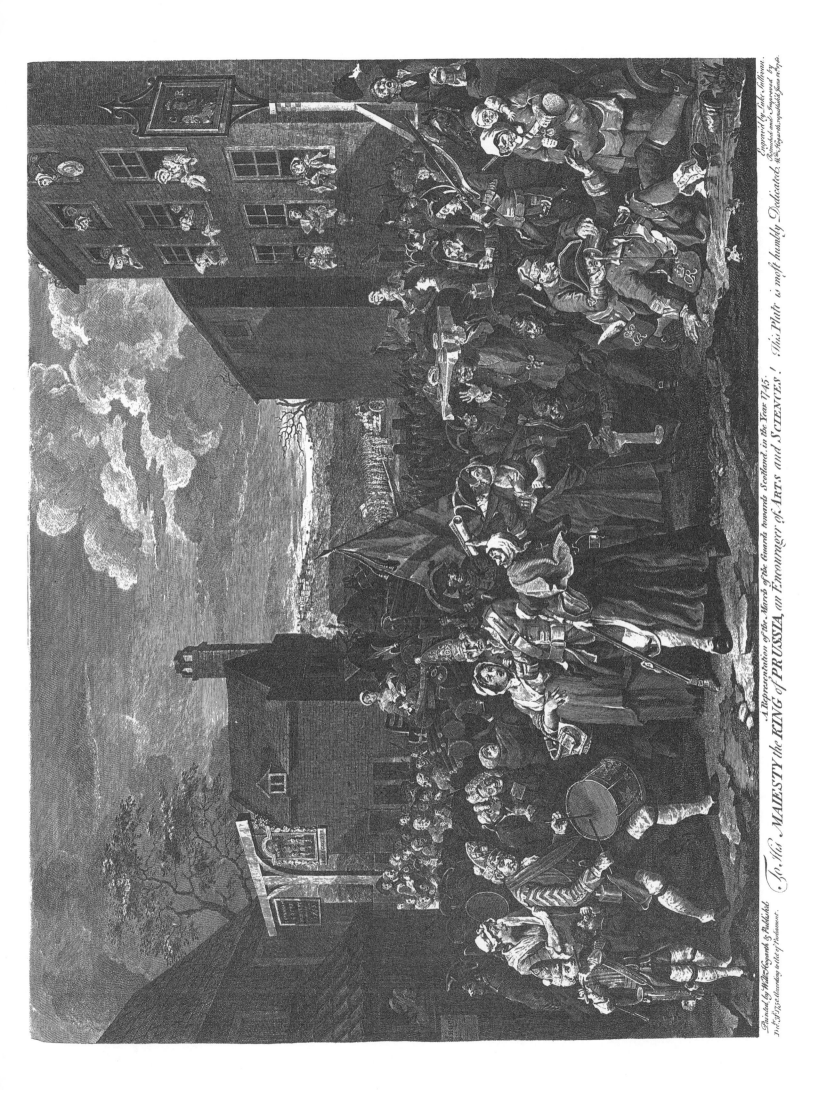

Drawn by Jn.o Gullievre.

Painted by Will.m Hogarth & Publish'd.

A Representation of the March of the Guards towards Scotland, in the Year 1745.

Engrav'd by Luke Sullivan.

Retouch'd and Improved by Wm. Hogarth, republish'd June 1.st 1761.

To His MAJESTY the KING of PRUSSIA, an Encourager of ARTS and SCIENCES! This Plate is most humbly Dedicated.

Dec. 31.st 1750 according to the y.e Parliament.

Beer Street and Gin Lane

ETCHED AND ENGRAVED FROM DRAWINGS. FEBRUARY 1750/1

These prints are concerned with the high consumption of gin among the working classes in the eighteenth century; the plates were part of a general attempt to legislate the sale of the alcohol which brought about the Gin Act in 1751. Hogarth himself writes of their origin and comments on them in his *Autobiographical Notes*:

> Bear St and Gin Lane were done when the dredfull consequences of gin drinking was at its height. In gin lane every circumstance of its horrid effects are brought to view; nothing but Idleness, Poverty, misery and ruin are to be seen. Distress even to madness and death, and not a house in tolerable condition but Pawnbrokers and the Gin shop.
>
> Bear Street, its companion was given as a contrast, where the invigorating liquor is recommend in order drive the

other out of vogue. Here all is joyous and thriveing; Industry and Jollity go hand in hand. The Pawnbroker in this happy place is the only house going to ruin; where even the smallest quantity of the liquor flows around, it is taken in at a wicket for fear of farther distress.

Among Hogarth's bluntest, most heavily didactic works, they are simple, direct prints somewhat hyperbolic in statement. "Beer Street," less vital and less compelling than "Gin Lane," represents one of Hogarth's few attempts to express his ideas positively. Bruegel's "La Cuisine Maigre" and "La Cuisine Grasse" provided models for these prints.* Hogarth's friend, Rev. James Townley, composed the verses.

* Antal, *Hogarth and His Place in European Art*, p. 30.

75

BEER STREET
THIRD STATE. $14\frac{1}{16} \times 11\frac{3}{4}$

A panegyric on ideal middle-class drinking habits, *Beer Street* depicts the health, prosperity and happiness that attend the tranquil, well-regulated lives of the London tradesmen and working classes who drink beer even as they labor. A church steeple rises in the background (perhaps St. Martin's-in-the-Fields); its flag suggests it is October 30, the birthday of George II. Blocking the church from view is a flourishing tavern with the sign of a radiant sun. Four men work on its roof; three drink and wave their hats joyfully, the fourth descends to share some ale with the three tailors in the building across from them.

In front of the tavern two chairmen bearing a very heavy woman pause; one refreshes himself with beer. In the street three pavers work; a fourth caresses a responsive girl who rests beside her bag of vegetables; she holds a key, the symbol of access to the good life. A fat butcher chuckles at the couple. On the table in front of him lie *The Daily Advertiser* and a paper reading "His Majesty's Most Gracious Speech To both Houses of Parliament On Tuesday ye 29 Day of November 1748." It says: "Let me earnestly recomend to you the Advancement of Our Commerce and cultivating the Arts of Peace, in which you may depend on My hearty Concurrence and Encouragement."

Behind the butcher a blacksmith raises a tankard in one hand and a large piece of meat in the other. Above the blacksmith, a thin painter in tattered clothes paints an advertisement for gin. The gin bottle to his right is both his model and his source of inspiration. The sign celebrating beer above this shows a happy crowd in a farmyard dancing around and on a stack of barley. "Health to the Barley Mow" is inscribed below the scene. In the center of the foreground two sisterly fishwives pause to read "A New Ballad on the Herring Fishery by Mr. Lockman." To their right a porter drinks down the last of his ale before carrying his basket of books, "For Mr. Pastem the Trunk maker in Paul's Ch. Yd." The basket contains volumes which Hogarth detested; the books are "Modern Tragedys Vo: 12," "Hill on Royal Societies," "Turnbul on Ant[ient] Painting," "Politicks Vol: 9999" and "Lauder on Milton." Only the house of "N Pinch Pawn Broker" is dilapidated on Beer Street. Here the pawnbroker is a debtor instead of creditor and must receive his ale cautiously through a hole in his door. An empty mousetrap, symbol of his business, is visible through the upper window of his crumbling establishment. The man's cat is dead, perhaps of hunger.

In an earlier state, Hogarth, still smarting from his Calais humiliation, depicted the hefty smith hoisting an overdressed, skinny Frenchman in the air; later the artist replaced him with the amorous couple and the meat.

A preliminary sketch reproduced here contains much less detail and a number of figures not included in the final states.

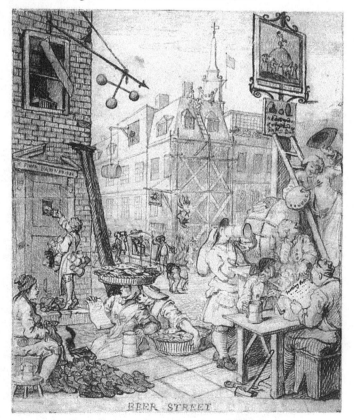

Preliminary sketch. Reproduced by permission of the Trustees of The Pierpont Morgan Library, New York.

BEER STREET.

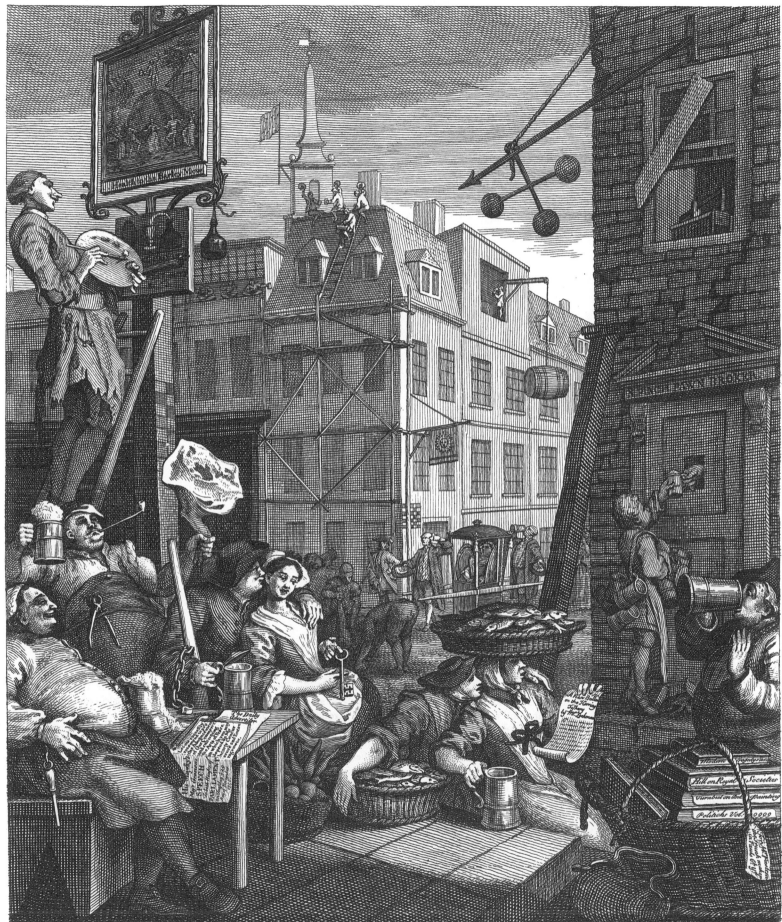

Beer, happy Produce of our Isle
Can sinewy Strength impart,
And wearied with Fatigue and Toil
Can chear each manly Heart.

Labour and Art upheld by Thee
Successfully advance,
We quaff Thy balmy Juice with Glee
And Water leave to France.

Genius of Health, thy grateful Taste
Rivals the Cup of Jove,
And warms each English generous Breast
With Liberty and Love.

Design'd by W. Hogarth.

Publish'd according to Act of Parliament Feb. 1. 1751.

Price 1.ˢ

76

Beer Street and Gin Lane
GIN LANE
THIRD STATE. 14 × 11⅞

This agitated scene illustrates in a somewhat exaggerated manner the ill effects of gin drinking on the working classes. In the right foreground a ballad seller (he holds "The downfall of Mdm Gin"), half-naked because he has pawned his clothes and wasted away to a virtual skeleton, dies clasping a glass in one hand and a large bottle in the other. In contrast to the pretty girl with the key in the same pose in "Beer Street," an unkempt, stupefied woman, her tattered clothes hanging off her, takes snuff; her unattended son plummets to his death in front of the "Gin Royal." This cavernous pub, bearing the invitation "Drunk for a Penny/ Dead drunk for two pence/ Clean Straw for Nothing," seems more a stable than a tavern.

Above it a dog and a man, indistinguishable in their animal ferocity, fight for a bone. Next to them a person sleeps so soundly that a snail crawls up his arm. A carpenter pawns his coat and saw (his means of livelihood) to the exploitative "S. Gripe Pawn Broker," the most perverse figure in the print; he examines the goods with an assumed skepticism. An anxious woman stands behind the carpenter to pawn her kitchen utensils. Gripe's flourishing house, together with the tavern, the undertaker's, the distiller's and the church (which stands noticeably above and distant from the scene), are the only firm and solidly built houses in the neighborhood.

In the background a beadle oversees two figures lowering a woman's body into a coffin; beside the coffin, the woman's child weeps. Behind this burial scene three men in a funeral procession (?) are about to be killed by a collapsing building. Close by, an insane alcoholic, chased by a screaming woman, dances down the street with a pair of bellows on his head and a live child skewered on a staff. Next to him a woman feeds gin to another infant being wheeled home in a barrow. Behind them a man has taken away a blindfolded cripple's crutch and uses it as a weapon against him. The staggering cripple aims a stool at his tormenter; a crowd enjoys the cruel battle. In the ruins of a house a barber has committed suicide, possibly from loss of trade and alcoholism. Several figures are being waited on at "Kilman Distiller." Behind them two unchaperoned young girls from St. Giles (one bears "GS" on her shoulder) parish school drink openly. In front of them a mother forces gin on her unwilling infant. The instances of the mother compelling her child to drink and the two unaccompanied girls taking liquor suggest that Hogarth saw gin addiction as growing out of social as well as individual causes.

GIN LANE.

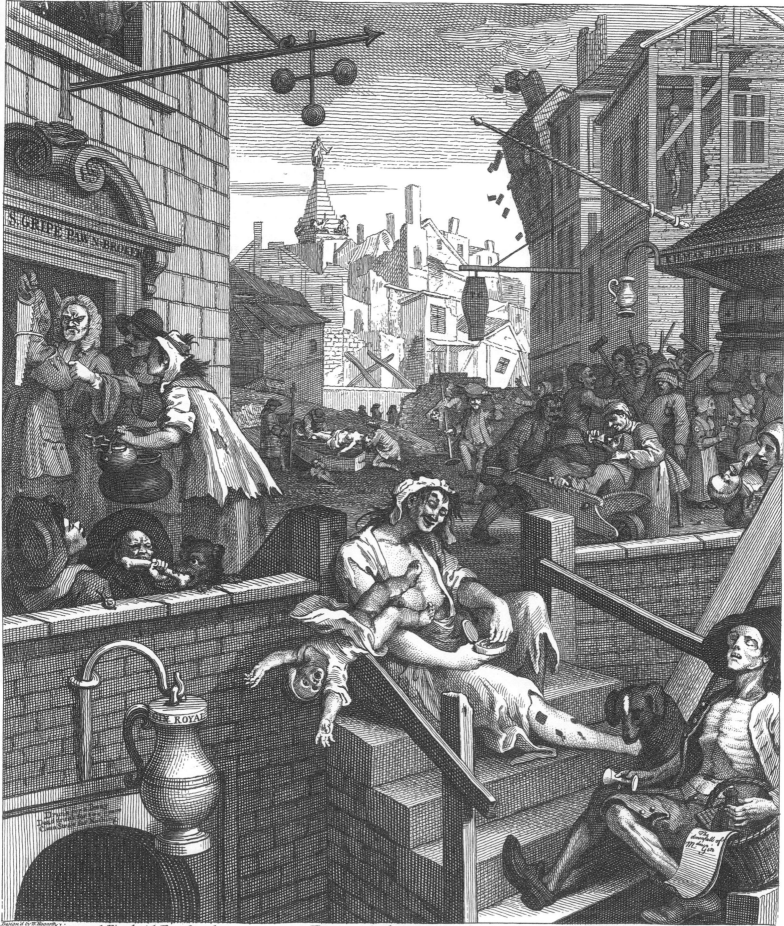

Design'd by W. Hogarth.

Gin cursed Fiend, with Fury fraught,
Makes human Race a Prey;
It enters by a deadly Draught,
And steals our Life away.

Virtue and Truth, driv'n to Despair,
It's Rage compells to fly,
But cherishes, with hellish Care,
Theft, Murder, Perjury.

Damn'd Cup! that on the Vitals preys,
That liquid Fire contains,
Which Madness to the Heart conveys,
And rolls it thro' the Veins.

Publish'd according to Act of Parliam.t Feb.y 1.1751. Price 1.s

The Four Stages of Cruelty

ETCHED AND PARTS ENGRAVED FROM DRAWINGS. FEBRUARY 1750/1

Humanitarian in impulse, these prints are aimed at the same audience as "Beer Street" and "Gin Lane" and employ the same techniques to achieve similar effects. In a passage just subsequent to his discussion of "Beer Street" and "Gin Lane," Hogarth describes his intention and his art in this series:

> The four stages of cruelty, were done in hopes of preventing in some degree that cruel treatment of poor Animals which makes the streets of London more disagreeable to the human mind, than any thing what ever, the very describing of which gives pain. But it could not be done in too strong a manner, as the most stony hearts were meant to be affected by them The circumstances of this set, as the two former, were made so obvious for the reason before mentioned that any farther explanation would be needless. We may only say this more that neither great correctness of drawing or fine Engraving were at all necessary, but on the contrary would set the price of them out of the reach of those for whome they were cheifly intended. However what was more material, and indeed what is most material even in the very best prints, viz the Characters and Expressions are in these prints taken the utmost care of and

I will venture to say farther that precious Strokes can only be done with a quick Touch would be languid or lost if smoothed out into soft engraving. Fine engraving which requires cheifly vast patience care and great practice is scarcely ever attained but by men of a quiet turn of mind.

Addressing the widest possible audience, composed mostly of members of the servant class, Hogarth tells a melodramatic, simplified story. Using only one main character and the single theme of cruelty, he repeats the theme both from plate to plate and several times within each engraving. Depicting progressively more cruel acts, he avoids either great complexity or subtlety. Deterministic in its movement, the confined, moralistic lesson of this literal exemplum represents an attempt to propagandize the working classes, especially in their attitude to private property.

Because he was anxious to make this series widely available, Hogarth attempted to have it reissued in inexpensive woodcuts. The project became too costly, however, and only the last two plates were issued in this form. He did print the entire series on two qualities of paper, however, one selling for a shilling, the other for one and six pence. The verses are by the Rev. James Townley.

77

FIRST STAGE OF CRUELTY
FIRST STATE. $14 \times 11\frac{5}{8}$

In this print a number of children visit upon domestic pets the type of savagery traditionally attributed only to animals. They torture them and train them to maim and kill each other. In the center of the scene an orphan boy called Tom Nero and two friends plunge an arrow (tipped with alcohol?) up the anus of a dog. A well-dressed middle-class child, possibly the dog's master, attempts to stop the boys by force and bribery. To the left of this group a boy sketches a prophetic stick drawing of "Tom Nero" hanging from a gallows. Above Nero a grinning linkboy watches with sadistic joy as his companion burns out the eye of a captive bird to satisfy his curiosity.

Across from them a group of cheering children watch two suspended cats claw each other in fright. Below them a boy aims a stick at an unsuspecting cock held in position by another youth. To the left a man has set his dog upon a cat while close by a youth ties a bone to the tail of a pup that licks his hand gratefully in response. From a garret two people release a cat on artificial wings in an ill-fated attempt to make it fly.

FIRST STAGE OF CRUELTY.

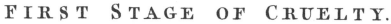

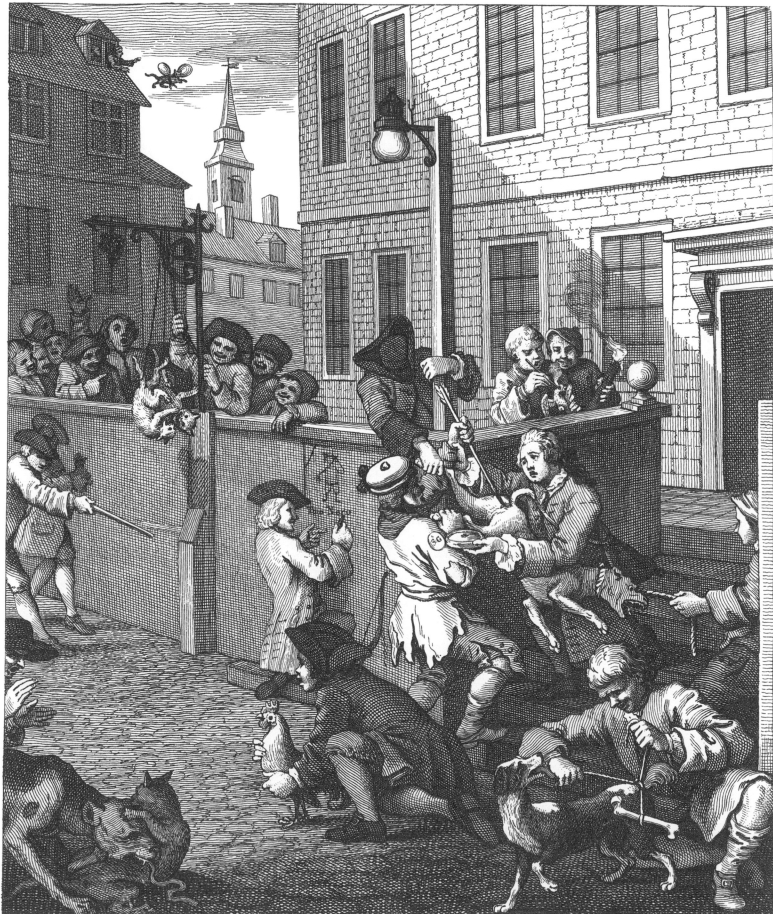

While various Scenes of sportive Woe
The Infant Race employ.
And tortur'd Victims bleeding shew
The Tyrant in the Boy.

Design'd by W. Hogarth

Behold! a Youth of gentler Heart,
To spare the Creature's pain
O take, he cries—take all my Tart,
But Tears and Tart are vain.

Published according to Act of Parliament Feb.1.1751.

Learn from this fair Example—You
Whom savage Sports delight,
How Cruelty disgusts the view
While Pity charms the sight.

Price 1.ˢ

78

The Four Stages of Cruelty
SECOND STAGE OF CRUELTY
FIRST STATE. $13\frac{13}{16} \times 11\frac{3}{4}$

Having become a hackney coach driver, Tom, like his peers, transfers the practice of his malicious cruelty to the animal he encounters in his occupation. By permitting too many stingy barristers to ride his coach for a higher fare, he has caused his horse to break its leg, overturning the carriage in front of the "Thavies Inn Coffee house." As the frightened barristers escape, Tom flogs the animal, senselessly gouging the eye from the crying horse. His name and coach number ("No 24 T. Nero") are noted by a benevolent man who will report the fellow to his master.

Various other cruel practices occur around Tom: a drover clubs a tardy lamb (symbol of peace and innocence) to death; a driver of a beer cart, asleep and probably drunk, runs over a fallen child; a man prods an overloaded donkey with a pitchfork; and a mob baits a bull. On the wall stand posters of legitimized human cruelty. "At Broughtons Amphitheater . . . James Field and Geo: Taylor . . ." announces a boxing match. A sign below it proclaims "Cockfighting."

SECOND STAGE OF CRUELTY.

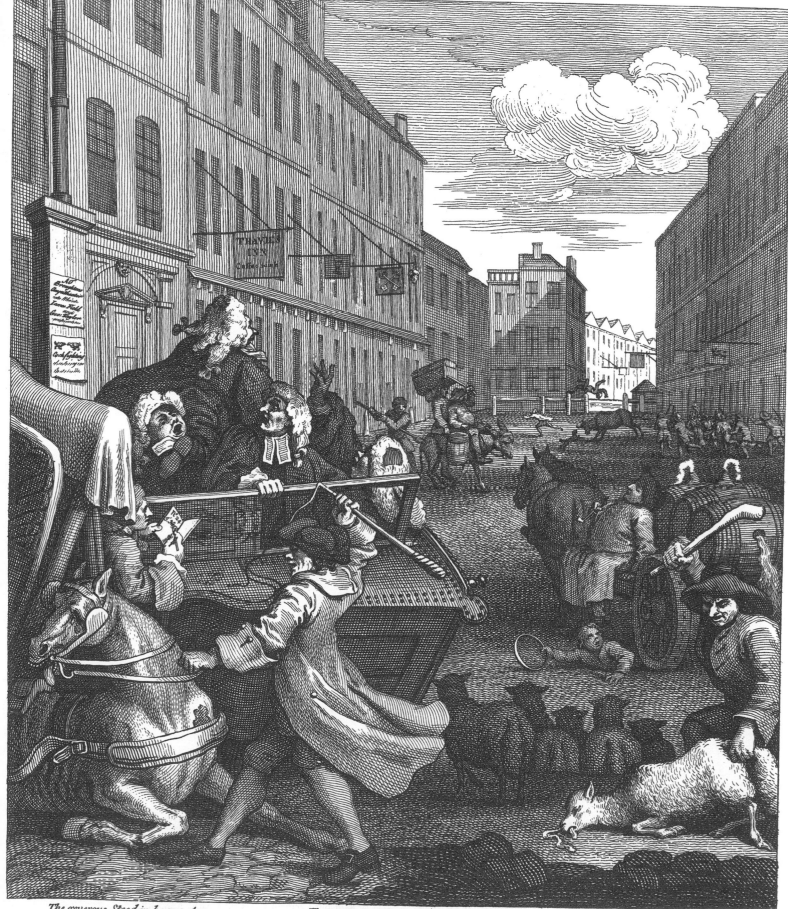

The generous Steed in hoary Age
Subdu'd by Labour lies;
And mourns a cruel Master's rage,
While Nature Strength denies.

Designed by W. Hogarth.

The tender Lamb o'er drove and faint,
Amidst expiring Throws,
Bleats forth it's innocent complaint
And dies beneath the Blows.

Published according to Act of Parliament Feb.1.1751.

Price 1.ˢ

Inhuman Wretch! say whence proceeds
This coward Cruelty?
What Intrest springs from barbrous deeds?
What Joy from Misery?

79

The Four Stages of Cruelty
CRUELTY IN PERFECTION
$13\frac{15}{16} \times 11\frac{11}{16}$

Tom Nero's cruel tendencies have led him to murder. Apprehended in a churchyard at 1 A.M. by a group of outraged farmers, Nero is himself revolted at the sight of the pregnant corpse that he has hacked sadistically and then murdered. The pistols and watches suggest that he has become a highwayman. Over the corpse of his mistress stands a tombstone with the skull and crossbones and the words "Here lieth the Body." Beside her sits her vanity box (initialed "A G"); her severed hand points to "God's Revenge against Murder" and the *Book of Common Prayer*. Next to it, in a pool of blood, lies the booty the girl has stolen. A letter "To Thos Nero at P" contains its own special ironies. "Dr Tommy My Mistress has been the best of Women to me, and my Conscience flies in my face as often as I think of wronging her, yet I am resolv'd to venture Body & Soul to do as you would have me so don't fail to meet me as you said you would. For I shall bring along with me all the things I can lay my hands on. So no more at presant but I remain yours till Death. Ann Gill."

A bat and an owl hover eerily over the Gothic scene.

CRUELTY IN PERFECTION.

Price 1ˢ.

To lawless Love when once betray'd,
 Soon Crime to Crime succeeds:
At length beguil'd to Theft, the Maid
 By her Beguiler bleeds.

Yet learn, seducing Man! nor Night,
 With all its sable Cloud,
Can screen the guilty Deed from Sight;
 Foul Murder cries aloud.

The gaping Wounds and blood-stain'd Steel,
 Now shock his trembling Soul:
But Oh! what Pangs his Breast must feel,
 When Death his Knell shall toll.

Published according to Act of Parliament Feb. 1. 1751.

Design'd by W. Hogarth.

80

The Four Stages of Cruelty
THE REWARD OF CRUELTY
FOURTH STATE. 14 × 11¾

Designed both as a fitting end to Tom Nero's life and as a satire on surgeons, the final scene shows a number of sadistic doctors, oblivious to the grotesqueness of their autopsy, delightedly carving up the corpse of Nero, who appears to suffer at their knives. With a large pulley screw in his head and the hangman's rope around his neck, Tom's body (the initials "T N" appear on his arm) is the subject of an anatomy lesson. One surgeon gouges out his eye in much the same way as the boy in Plate I scoops out the bird's eye; a second murderous-looking fellow pulls out his entrails, which a casual assistant puts in a tub; a third carves open his foot. The victim's finger points admonishingly to the boiling pot of skulls and bones which rests on a stand of human femurs. Next to the pot a smiling dog takes his revenge on Tom's cruelty to animals by eating his heart.

The anatomy lesson is narrated programmatically by an impassive figure. Above his head the emblem of the Royal College of Physicians depicting a doctor's hand taking a pulse stands in contrast to the grotesque scene below. Above that hangs the royal arms. The physicians in the foreground read, joke or talk together; those in the background pay no attention whatsoever to the lecture. One figure looks at Tom's corpse and points to the grinning skeleton of "James Field," a famous boxer, as if to suggest that Nero's skeleton will replace Field's. The skeleton of "Macleane," a well-known highwayman, stands in the niche on the right.

A preliminary sketch (below) depicts a much more macabre scene. The presiding figure is absent, giving the scene a more chaotic quality and there are intimations of cannibalism in one motif.

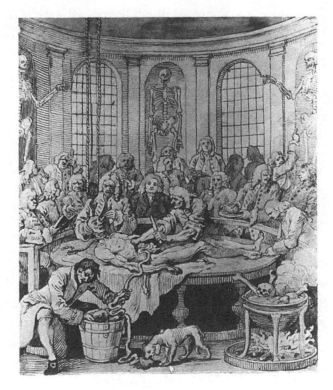

THE REWARD OF CRUELTY.

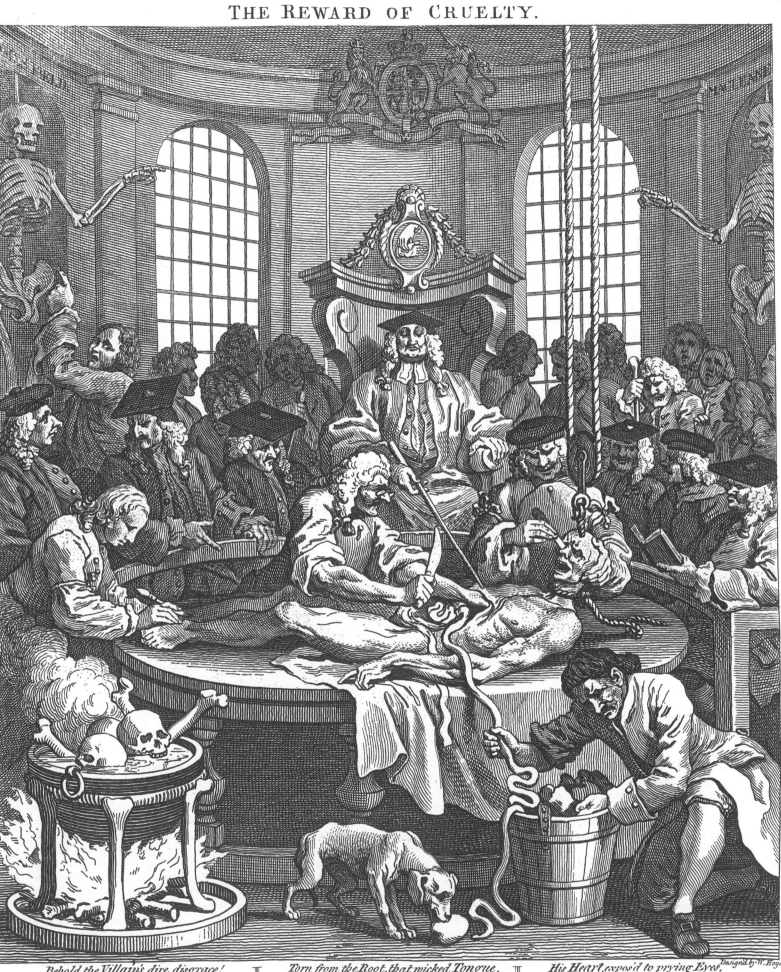

Behold the Villain's dire disgrace!
Not Death itself can end.
He finds no peaceful Burial-Place;
His breathless Corse, no friend.

Torn from the Root, that wicked Tongue,
Which daily swore and curst!
Those Eyeballs from their Sockets wrung,
That glow'd with lawless Lust!

His Heart, expos'd to prying Eyes,
To Pity has no Claim:
But, dreadful! from his Bones shall rise,
His Monument of Shame.

Designd by W. Hogarth.

Published according to Act of Parliament Feb. 1. 1751.

81

PAUL BEFORE FELIX BURLESQUED
ETCHED. FOURTH STATE. MAY 1751. $9\frac{3}{4} \times 13\frac{5}{16}$

Designed as a subscription ticket for "Paul before Felix" and "Moses Brought to Pharaoh's Daughter," this print became so popular that Hogarth later sold it as an independent work. The scene portrayed here is one in which Felix, governor of Caesarea, had invited Paul, his prisoner (charged with the time-tried crimes of agitation and conspiracy), to speak to him about his ideas but found himself unable to listen to Paul, so threatened was he by what the apostle said. Hogarth presents this sublime subject in a realistic mode that is exaggerated and vulgar as a means of satirizing the work of Dutch artists.

In a dark, confined court, Paul, complete with halo, a toothless fellow who enumerates mechanically on his fingers as he talks, must stand on a stool to be seen. His corpulent, ineffective guardian angel snores, as a tiny devil (added in later states) saws off a leg from the stand the angel steadies. A dog wearing a collar inscribed "Felix" bites the angel's wing. Above Paul a fat, slouching figure representing justice holds a set of unbalanced scales, several moneybags and a partisan knife bearing part of the coat of arms of London. The figure wears a bandage over one eye and glances back at Felix with the other.

Paul's effect on Felix has been to move his bowels; the slight, anxious governor sits on his chair in embarrassment and discomfort. Next to him his wife Drusilla (with a pup on her knee) and a counselor complain about the odor and point accusingly to Felix. The mad chief priest Ananias is restrained from attacking Paul. The gallery is filled with common people, some of them dressed in Dutch costumes; a number of the people sleep from boredom. Among the scribes one pert man sharpens his quill; three others react to the odor. In the left corner Tertullus, the advocate employed by the Jews against Paul, tears up his speech. A devil reassembles it. It reads, "Seeing that by thee we enjoy great quietness and that very Worthy deeds are done by th[y] Providence we accept it always an[d] in all places Most Noble Felix with all thankfulness . . . We have found this Man A Pestilent Fellow a mover of Sedition among the Jews [a] ringleader of the Sec[t]."

PAUL BEFORE FELIX.

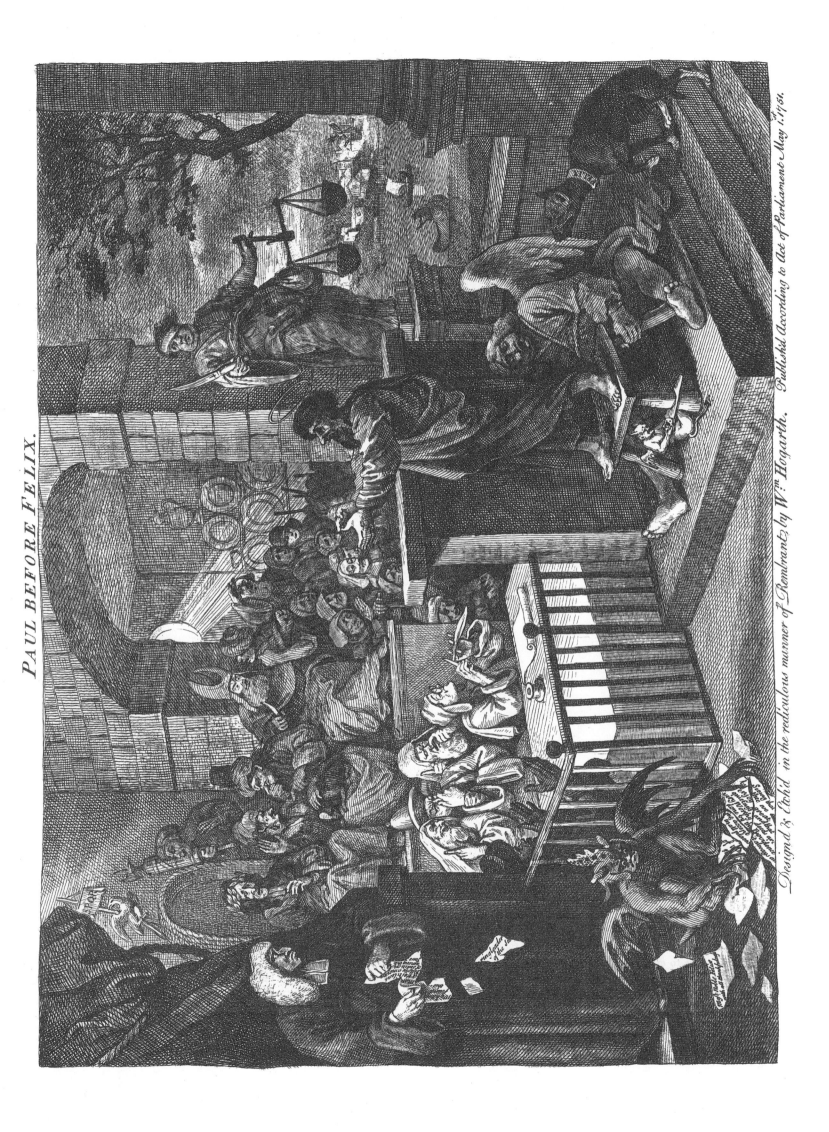

Designd & Etch'd in the rediculous manner of Rembrant by W^m Hogarth. Published according to Act of Parliament May 1st 1751.

82

PAUL BEFORE FELIX
ETCHED AND ENGRAVED FROM A PAINTING. THIRD STATE. FEBRUARY 1752. $15\frac{1}{16} \times 19\frac{15}{16}$

This print was engraved from the painting *Paul before Felix*, which was commissioned for Lincoln's Inn Hall in London. For this solemn hall Hogarth chose to execute a history painting in the grand or heroic manner. The scene is set in a spacious, dignified palace; only a few main characters, portrayed in a somewhat generalized manner and each expressing an individual emotion on his or her countenance, appear in the picture.

Paul, a monumental, dignified figure despite his chains, stands in an arresting pose before the assembly. A scribe looks up at his solemn face in awe as does a centurion and a woman from the crowd. Felix starts back from him, his face filled with fear; he grasps his wife's hand for support. Drusilla raises her hand to her head in puzzlement at the apostle. The chief priest regards Paul with resentment; next to him a Jew eyes the saint anxiously. A figure behind them with folded hands seems to have been converted by Paul. In the foreground Tertullus regards the apostle analytically.

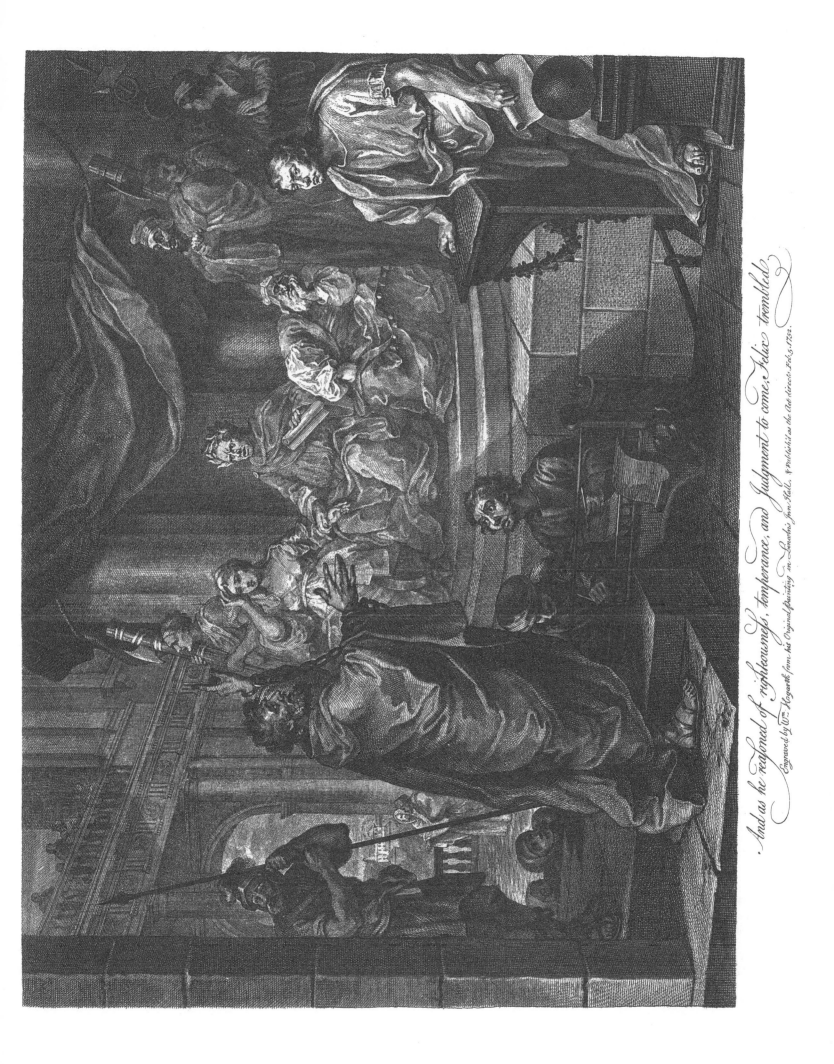

And as he reasoned of righteousnefs, temperance, and Judgment to come, Felix trembled.

Engraved by Wm. Hogarth from his Original Painting in Lincolns Inn Hall, & Published as the Act directs Feb 5, 1752.

83

MOSES BROUGHT TO PHARAOH'S DAUGHTER

ETCHED AND ENGRAVED. THIRD STATE. FEBRUARY 1752. $15\frac{1}{8} \times 19\frac{11}{16}$

The painting from which this print was engraved was executed for the Foundling Hospital, Hogarth's favorite charity. Taking the appropriate Biblical story of Moses being trusted to the care of Pharaoh's daughter by his mother who poses as a nurse, Hogarth renders the scene largely as a study of certain passions in the sublime style. The print represents the story in a simple, direct and somewhat formal manner.

In a grandiose palace balcony Moses' mother, glancing forlornly at her son, accepts payment for her services as a nurse from the gruff, hardened treasurer. Next to his grim countenance a comic face is drawn on a pillar of the building across the court. Moses looks at Pharaoh's daughter but hangs on his mother's girdle. The princess, reclining on a regal chair, extends her hand forward to the boy in affection. A malevolent-looking crocodile peers out from the foot of the chair. Behind the princess two servants speculate on whether or not she herself is Moses' mother.

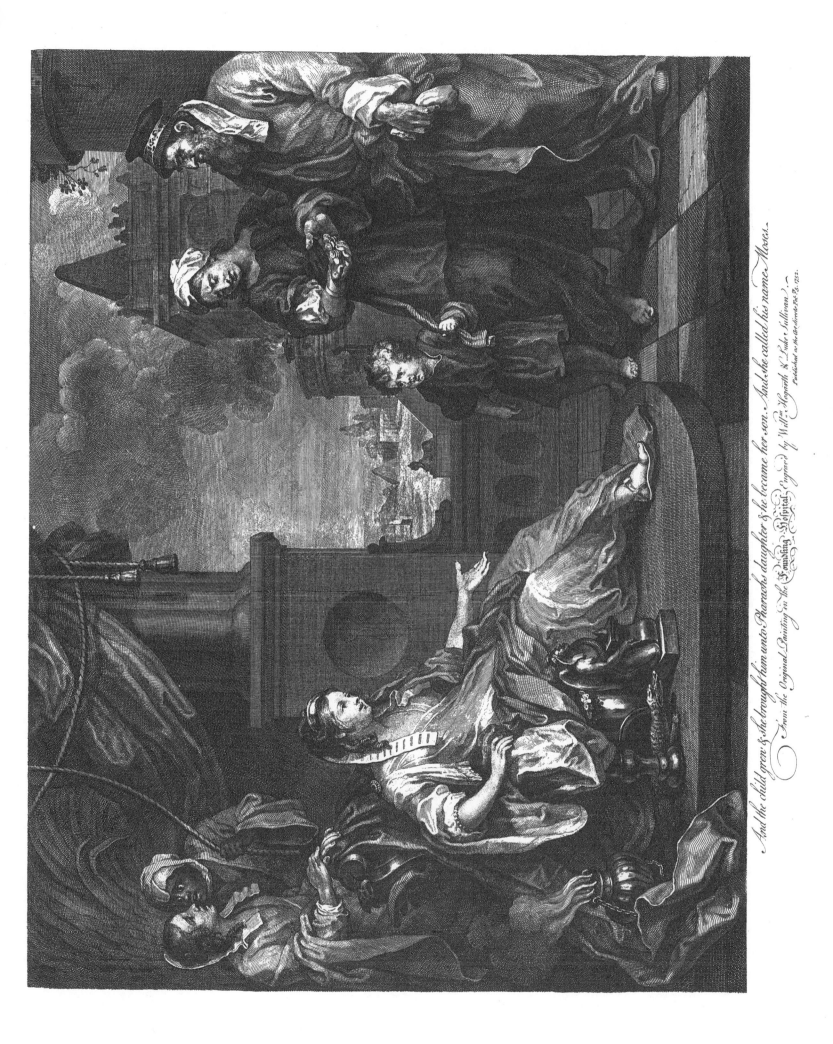

And the child grew & she brought him unto Pharaoh's daughter & he became her son. And she called his name Moses.

From the Original Painting in the Foundling Hospital. Engrav'd by Wilᵐ Hogarth & Luke Sullivan.

Published as the Act directs Feb. 25. 1752.

Analysis of Beauty

ETCHED AND ENGRAVED FROM DRAWINGS. MARCH 1753.

These two prints were designed as illustrations for Hogarth's aesthetic treatise *The Analysis of Beauty*. Sold separately from the book, because of their comic and serious interests, they were intended as independent collector's items to be appreciated in their own right and as illustrations to be bound into the *Analysis*.

PLATE I

THIRD STATE. $14\frac{11}{16} \times 19\frac{3}{8}$

This print depicts a statuary yard in which Hogarth has collected the various artifacts he wishes to comment on. The scene is believed to have been inspired by Socrates' discussion of beauty stimulated by the art objects in the yard of his friend Clito; the dialogue was translated from Xenophon's *Memorabilia* by Dr. Morell, a friend of the engraver. The yard contains the dignified classical sculptures known to the age with a miscellaneous and often comic assortment of modern art objects. In the center stands the Medicean Venus. To the right are statues of Julius Caesar hanging from a pulley and Apollo Belvedere. A short, overdressed Brutus stands on one side of Apollo over the falling Caesar; on the other side another overdressed figure clad as a judge sits with his foot on the head of a cherub. A second putto with a gallows in its hand cries at the judge's feet.

The Laocoön stands behind the Venus; on either side of the Venus lie a graceful sphinx and the satyr Silenus reclining on a wineskin. In the foreground rests "Michaelangelo's torso" by "Apollonius, son of Nestor." Beneath the Farnese Hercules a dancing master attempts to correct the posture of Antinous. Under two statuettes of Isis is another Hercules. The boot and the anatomical sketches of the three legs are balanced by the highly symmetrical figures (by Albrecht Dürer and G. P. Lomazzo) on the right.

Above the scene, a serpentine line wound around a cone, Hogarth's "Line of Beauty," stands as the keystone to his aesthetic theory. It appears in the figures in the central scene and in the drawings that border the print (most of which illustrate points in the *Analysis*).

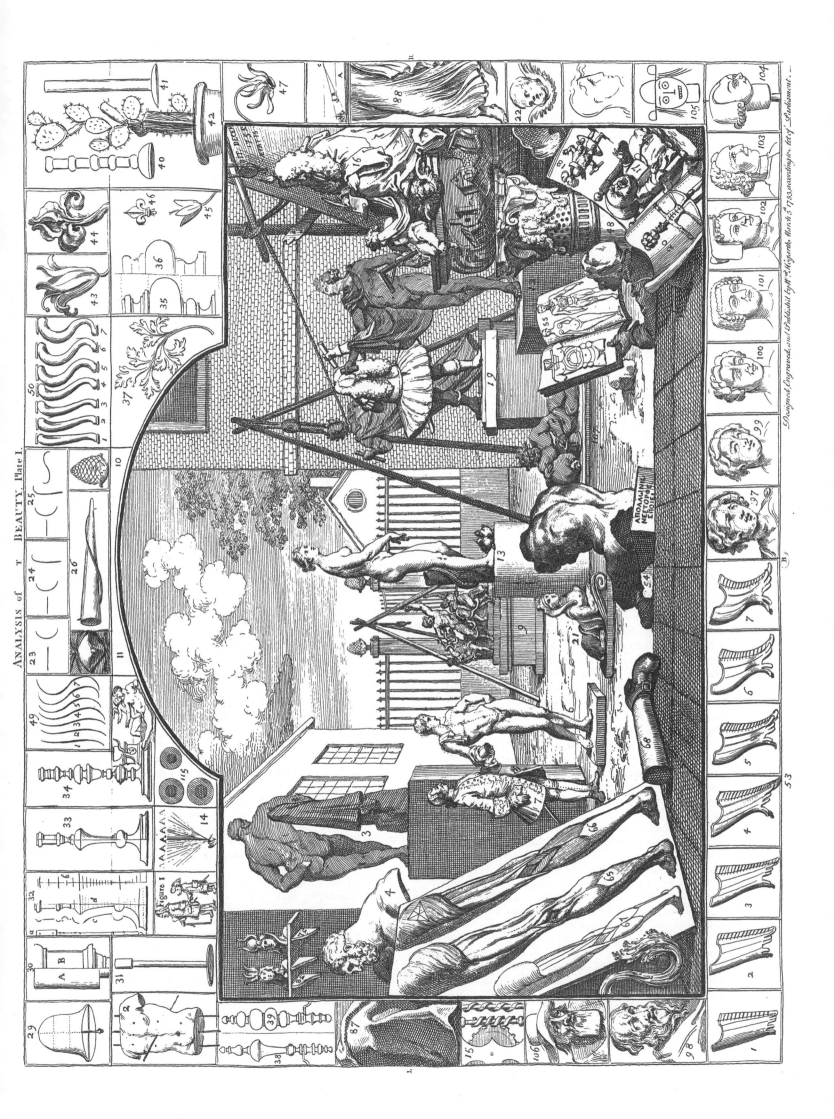

ANALYSIS of ⸿ τ BEAUTY. Plate I.

Analysis of Beauty
PLATE II
THIRD STATE. $14\frac{3}{4} \times 19\frac{11}{16}$

Adapted from a design intended as part of the *Happy Marriage* series, the engraver's complement to *Marriage à la Mode*, this plate (which is usually said to represent the Wanstead Assembly with the Earl of Tynley and his household) illustrates Hogarth's theory about the linear presentation of attitude and action:

Thus, as two or three lines at first are sufficient to shew the intention of an attitude, I will take this opportunity of presenting my reader (who may have been at the trouble of following me thus far) with the sketch of a country-dance, in the manner I began to set out the design; in order to shew how few lines are necessary to express the first thoughts, as to different attitudes; see fig. 71. T. p. 2, which describe in some measure, the several figures and actions, mostly of the ridiculous kind, that are represented in the chief part of plate 2.

The most amiable person may deform his general appearance by throwing his body and limbs into plain lines, but such lines appear still in a more disagreeable light in people of a particular make, I have therefore chose such figures as I thought would agree best with my first score of lines, fig. 71.

The two parts of curves next to 71, served for the figures of the old woman and her partner at the farther end of the room. The curve and two straight lines at right angles, gave the hint for the fat man's sprawling posture. I next resolved to keep a figure within the bounds of a circle, which produced the upper part of the fat woman, between the fat man and the aukward one in the bag wig, for whom I had made a sort of an X. The prim lady, his partner, in the riding-habit, by pecking back her elbows, as they call it, from the waste upwards, made a tolerable D, with a straight line under it, to signify the scanty stiffness of her peticoat; and a Z stood for the angular position the body makes with the legs and thighs of the affected fellow in the tye-wig; the upper parts of his plump partner was confin'd to an O, and this chang'd into a P, served as a hint for the

straight lines behind. The uniform diamond of a card, was filled up by the flying dress, &c. of the little capering figure in the spencer-wig; whilst a double L mark'd the parallel position of his poking partner's hands and arms: and lastly, the two waving lines were drawn for the more genteel turns of the two figures at the hither end.

The best representation in a picture, of even the most elegant dancing, as every figure is rather a suspended action in it than an attitude, must be always somewhat unnatural and ridiculous; for were it possible in a real dance to fix every person at one instant of time, as in a picture, not one in twenty would appear to be graceful, tho' each were ever so much so in their movements; nor could the figure of the dance itself be at all understood.

The dancing-room is also ornamented purposely with such statues and pictures as may serve to a farther illustration. Henry viii. fig. 72. p. 2, makes a perfect X with his legs and arms; and the position of Charles the first, fig. 51. p. 2, is composed of less-varied lines than the statue of Edward the sixth, fig. 73. p. 2; and the medal over Q. Elizabeth, as well as her figure, is in the contrary; so are also the two other wooden figures at the end. Likewise the comical posture of astonishment (expressed by following the direction of one plain curve, as the dotted line in a french print of Sancho, where Don Quixote demolishes the puppet shew, fig. 75, R. p. 2) is a good contrast to the effect of the serpentine lines in the fine turn of the Samaritan woman, fig. 74. L. p. 2, taken from one of the best pictures Annibal Carrache ever painted.*

In the right-hand corner of the print an exchange takes place which is typically Hogarthian in its self-contained, dramatic nature. To her displeasure a young wife or daughter is being compelled to leave the dance by a country squire (complete with dog) who points insistently to his watch. The girl accepts a letter from her lover as she dons her cloak.

* Hogarth, *The Analysis of Beauty*, ed. Joseph Burke, pp. 146–148.

ANALYSIS of ᴛ BEAUTY. Plate II.

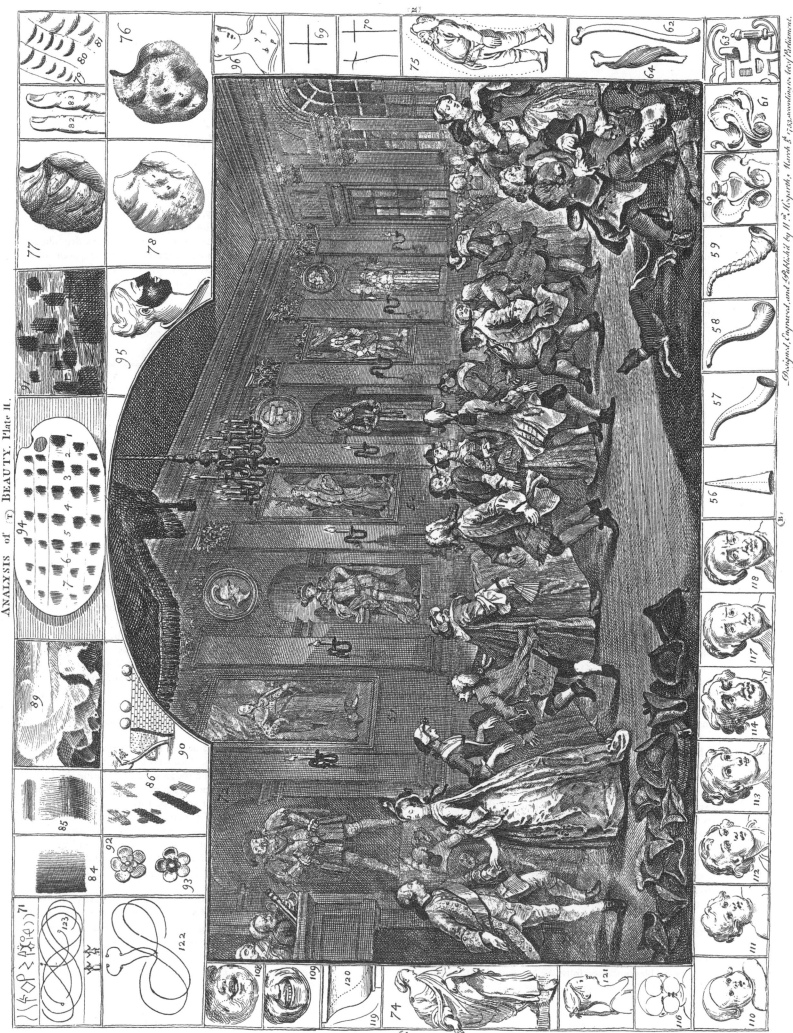

Designed, Engraved, and Published by Wm Hogarth, March 5th 1753, according to Act of Parliament.

Four Prints of An Election

ETCHED AND ENGRAVED FROM PAINTINGS. 1755–1758.

This progress, Hogarth's last, is based on the disorderly, riotous Oxfordshire election of 1754 in which the Duke of Marlborough, a Whig ("the New Interest"), challenged the entrenched Tories ("the Old Interest") in the established stronghold of the latter party. Like "Southwark Fair," however, this work is not concerned with a specific event but aims to present a generalized picture of a violent, chaotic election.

Aimed at the upper middle and upper classes, this series shows the cynicism of the aristocratic class toward electoral politics and delineates their attempted manipulation of the populace. It depicts politicians of both parties using slogans, flattery, bribery, alcohol, food and trinkets to exploit the population in the interests of their own undemocratic ambitions. It exposes both parties as exciting the most degrading proclivities of the least able sections of the electorate (the poor, the simpleminded, the maimed, the dying) to produce a violence and an anarchy that ultimately envelops all and threatens the very ambitions they sought to satisfy.

The subscription ticket for this progress is reproduced facing Plate 88.

86

PLATE I
AN ELECTION ENTERTAINMENT
EIGHTH STATE. FEBRUARY 1755. $15\frac{7}{8} \times 21\frac{3}{16}$

This crowded print depicts the drunkenness, gluttony, violence, bribery and deception that occur at an alcoholic political banquet. The feast takes place in an inn decorated with a picture of William III (slashed by the celebrating Whigs); next to it hangs a politician's coat of arms showing three guineas and the words "Speak and Have." A bellowing mouth surmounts the emblem.

At the head of the table sits one of the two Whig candidates for Parliament. His name, according to the rectangular petition being given him, is Sir Commodity Taxem. This precious beau endures with a patient smile the kiss of a fat, toothless woman whose face is pushed into his. The prankster who holds these two together burns the politician's wig with his pipe. The victim puts his arm as far around the stout woman as it will go. A little girl steals the ring from his finger. The party flag "Liberty and Loyalty" hangs above them. Next to them the second politician is beset by two drunks; the first, whose face bears four scratch marks, oppresses the man with his talk and blinds him with his pipe smoke; the second plays lustfully with his hand. Behind them two men vie for a lady's favors.

Further down the table sits a prodigiously fat clergyman surrounded by food and good drink—the bottle next to him is marked "Champagne." Next to him a convivial old man has drawn the fiddler from the band by means of a drink. Behind them a Scot remonstrates with the idle musician and scratches himself. At the second table three simpleminded figures share a bottle of "Burgundy" while one of them makes faces on a kerchief. A cripple in acute but undefined distress sits next to him. At the end of the table the mayor, slumped back in his grand chair, is being bled unsuccessfully; he has passed out, perhaps died, from overeating; an oyster remains on his fork.

Directly behind him an election agent attempts to bribe a Methodist tailor who stands in the pose of a saint. The tailor's wife tries to persuade him with her fist, and his son supports her by pointing to the toes which peer through his shoe. A brick has struck another election agent as he enters names in his ledger under "Sure Votes" or "Doubtfull." His fall has overturned the table behind him and spilled food on the floor. Next to a lobster (which appears about to eat a pork chop) lie a box of pipes and some tobacco ("Kirtons Best"); the "Act against Bribery and Cor[ruption]" has, appropriately enough, been made into spills.

In the center of the foreground sit two thugs returned from battle; the broken club of one lies on the floor next to a captured Tory sign "Give us our Eleven Days." * The rough butcher (wearing the Latin dictum "Pro Patria" on his hat) pours gin into the head wound of his companion, who drinks the liquor as an anesthetic. To the amazement of the boy who fills up a tub of punch, the man's head accepts the liquid as if it were empty. An unhappy Quaker who has come to sell election insignia looks at a credit note reading "April 1 1754 I promise to Pay to Abel Squat the Sum of Fifty pounds Six m[o]nths after date Value Re[cei]ved Rich Slim." At the door a hand-to-hand combat of uncertain cause takes place.

Outside a Tory procession passes by, bearing the party platform slogans "Liberty and Property," "Marry and Multiply in Spite of the Devil" and "No Jews" on an effigy of a Jew. The Tories throw rocks in through the window. One Whig empties a chamber pot on the mob, and another prepares to throw a stool out the window.

* In 1752 England adopted the Gregorian Calendar and eleven days were omitted in September.

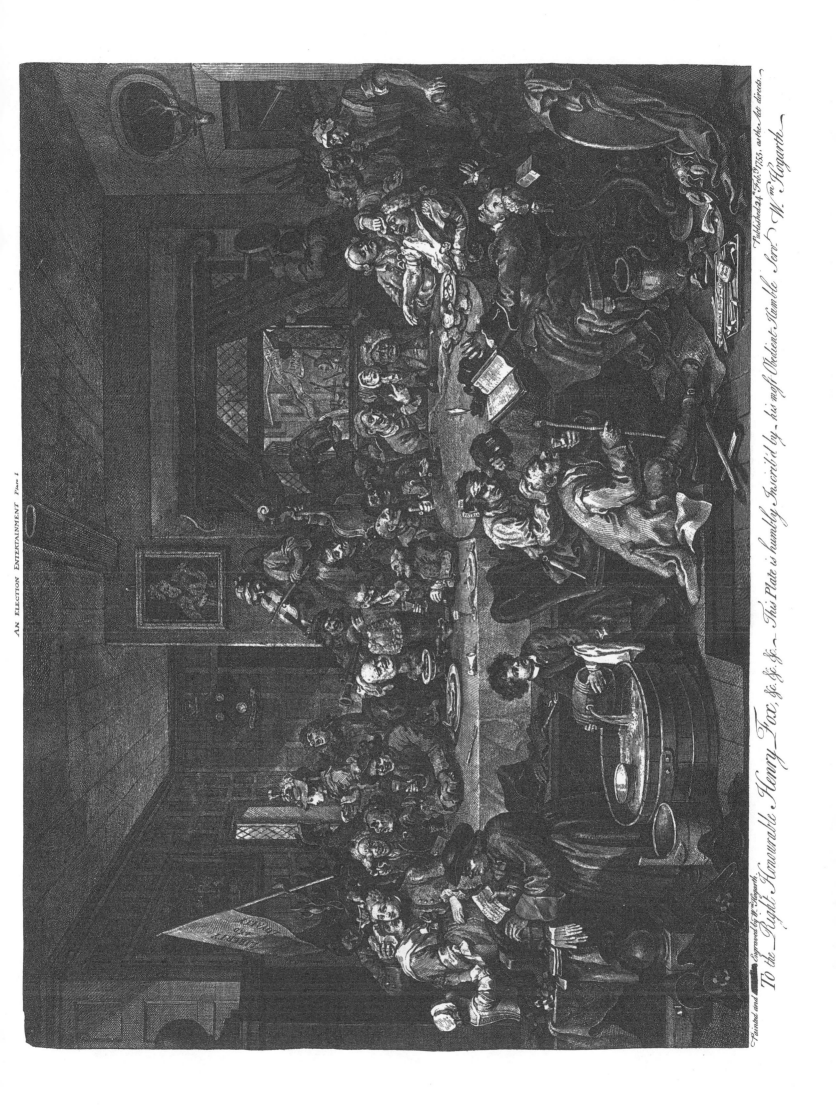

Painted and Engraved by Wm. Hogarth. Published 24 Feb. 1755, as the Act directs.

TO the Right Honourable Henry Fox, &c. &c. &c. This Plate is humbly Inscrib'd by his most Obedient humble Serv.t Wm. Hogarth.

Four Prints of An Election
PLATE II
CANVASSING FOR VOTES
SIXTH STATE. FEBRUARY 1757. $15\frac{13}{16} \times 21\frac{1}{8}$

"Canvassing for Votes" illustrates the continuing violence, deception and bribery practiced, of course, in equal measure by both parties; this time the scene is out-of-doors. On the right stands the Royal Oak; its sign depicts Charles II's head with three crowns around it; two Parliamentarian horsemen search for him. This inn, the Tory headquarters, displays a broadcloth satirizing the Whigs entitled "Punch Candidate for Guzzledown." The top part shows money pouring out of the British treasury for bribes, and depicts a coachman's head being knocked off by William Kent's impractically low arch on the Horse Guards building with its comic beer-barrel clock tower. The second part of the cloth shows the Whig candidate as Punch shoveling money indiscriminately from two bags marked "9000" and "7000."

Below Punch stands the local Tory candidate; he buys trinkets from a peddler for two girls, one coy, the other forward. At the inn door a soldier observes the attractive mistress of the house as she counts her "take"; she sits on a British lion that devours a French lily (early states show the lion with a powerful set of teeth). In the inn's bay window (which bears the mark of political violence in its broken pane) one man eats a whole bird with his hand while another fills his mouth from a steak twice his size. A porter has delivered two parcels to the candidate, one marked "Punch's Theatre, Roy[al] Oak Yard," the other "Sr Your Vote & Interest." On bended knee, the messenger offers the politician a letter addressed "To Tim Partitool Esq."

A Tory mob besieges the Whig headquarters, an inn with a crown as its sign and the words "The Excise Office" inscribed on it. One man saws off the sign, unaware that he will fall with it; two others help him bring it down with a rope tied to its support. Someone fires point blank into the crowd from a second floor window.

Outside the third inn called the "[Por]tobello" in honor of a famous British naval victory over the French, a barber and a cobbler reenact the battle. The drunken barber, whose jug, basin and cloth sit next to the table, seems to have lost a wager in the affair to his meditative opponent. In the background a quiet village rests among the hills.

The print, as is usually the case, is reversed from the painting.

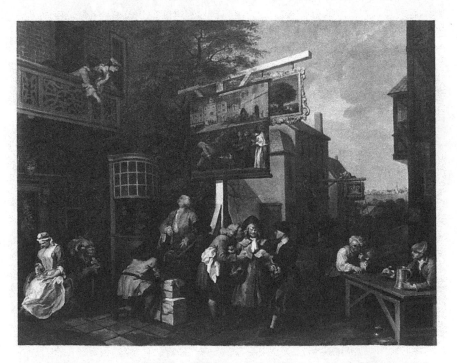

Oil painting. Reproduced by permission of the Trustees of Sir John Soane's Museum, London.

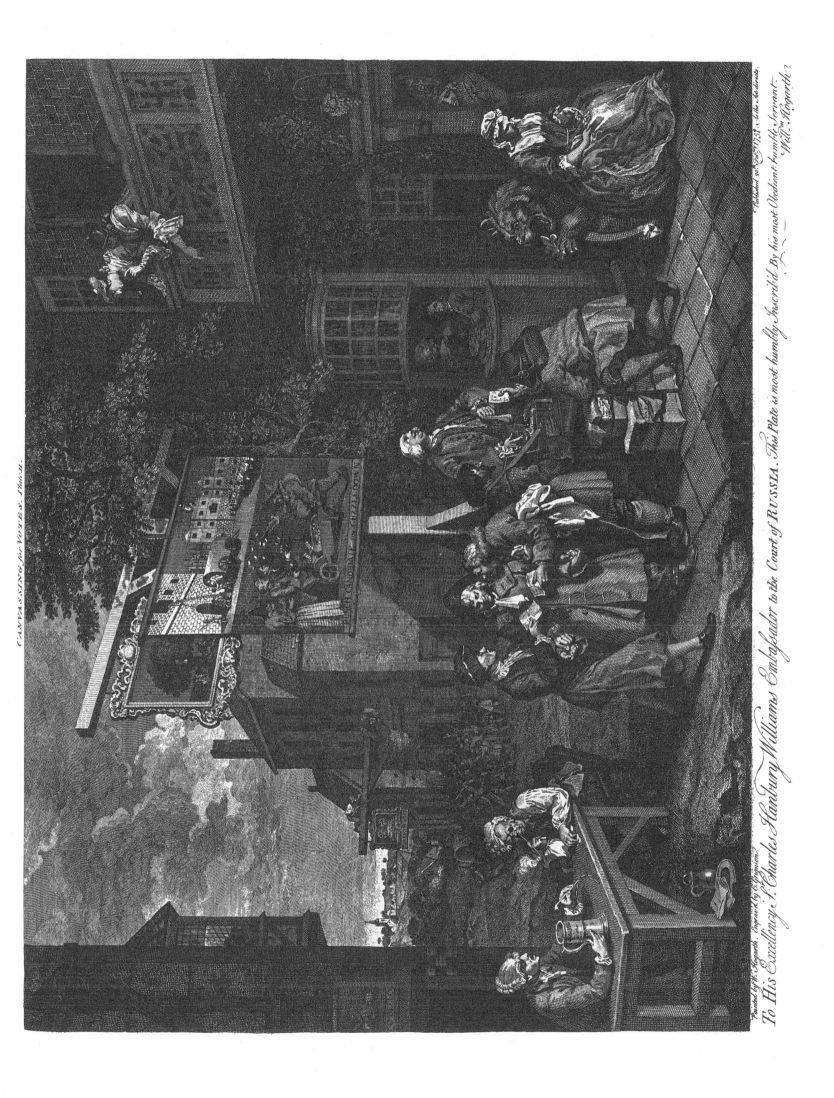

CANVASSING for VOTES. Plate II.

Painted by Wm. Hogarth. Engrav'd by C. Grignion. Published 20. Feb.y 1757. as the Act directs.

To His Excellency S.r Charles Hanbury Williams Embassador to the Court of RUSSIA. This Plate is most humbly Inscrib'd, By his most Obedient humble Servant.
Wm. Hogarth.

88

Four Prints of An Election
PLATE III
THE POLLING
THIRD STATE. FEBRUARY 1758. $15\frac{13}{16} \times 21\frac{1}{4}$

Burlesquing the corrupted voting process, "The Polling" depicts a scene of cynicism, confusion and trickery in which the maimed, the insane and the dying elect a member of Parliament. A soldier who has lost three of his four limbs is first in line to take the oath. From his pocket sticks a "Milicia Bill," a bill instituting a draft to which even this helpless fellow is subject. The clerk tries to hide his crude amusement at the man's hook which rests on the Bible. On each side of him two lawyers from opposite parties argue the validity of his oath. An imbecile locked in his chair with a stick takes the oath behind the soldier; he is prompted by a fellow with a manacled leg. The letter in the prompter's pocket reading "The 6th Letter to the . . . by that . . ." suggests he may be its author, Dr. Shebbeare, an enemy of the Hanoverians. Behind him a dying man wearing the ribbons "True Blue" is dragged up the stairs by his nurses; the first, who holds a pipe in his mouth, has lost his nose from venereal disease; the second, who laughs

at the political ploy, has an oversized nose with warts on it. These are followed by a blind man guided by his stick and a boy. A cripple follows them.

In the polling place the two candidates sit with a sleeping beadle between them. One is disconcerted, the other—presumably the one in the lead—composed. Three men enjoy a caricature of the figure beside them. Before the other candidate a group of men share a ballad with a scaffold pictured on it sold them by the old woman at the front of the balcony. Another group of men drink merrily together.

A boisterous procession crosses the bridge. Below it Britannia's coach has broken down and is about to overturn because the inattentive, cheating coachmen, like the politicians, have no concern for their duty. The tree beside the coach resembles a human face bearing a pained expression.

Subscription ticket for the progress *Four Prints of An Election*: "Crowns, Mitres, Maces." Etched. Fourth state. March 1754. $8\frac{7}{16} \times 7\frac{1}{8}$.

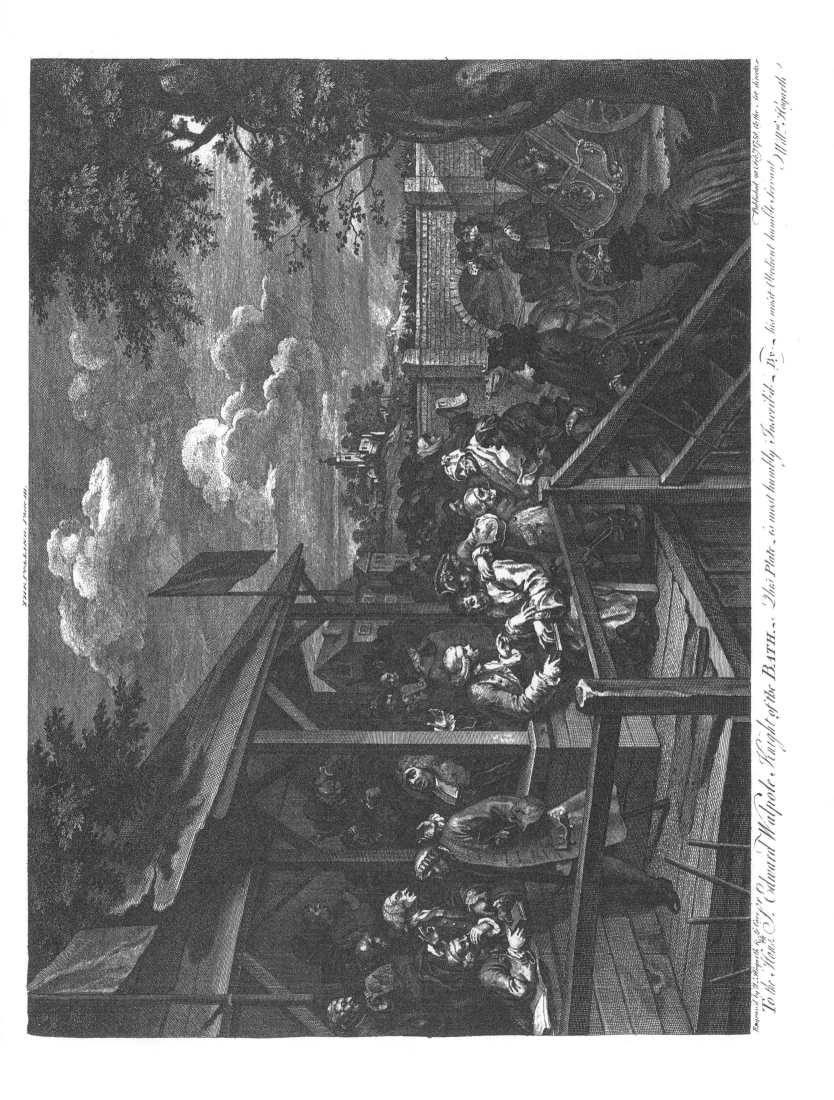

Engrav'd by W. Hogarth & Published according to Act of Parliament 20 Feb.y 1758. to the the directs.

To the Hon.ble S.r Edward Walpole, Knight of the BATH. This Plate is most humbly Inscrib'd. By his most Obedient humble Servant Will.m Hogarth

Four Prints of An Election
PLATE IV
CHAIRING THE MEMBERS
THIRD STATE. FEBRUARY 1758. $15\frac{13}{16} \times 21\frac{5}{16}$

"Chairing the Members" depicts the riotous, chaotic and ignominious victory procession of the new members of Parliament. The triumphant parade of animals and men is led by a blind, half-mad fiddler. Behind him the procession is at a halt as a bear with a monkey on its back rummages in a garbage pail carried by a grazing donkey. As the donkey's master raises a stick to club the bear, the alarmed monkey, dressed as a soldier, discharges his gun. In the path of the bullet a sweep plays prophetically with a death's-head while his companion watches the procession. Next to these blackened, impoverished imps a fainting lady, perhaps a relative of the toppling politician, is revived by two servants, one of whom sees the little sweep's danger. Above the unfortunate sweep is a sundial with the words "We Must [All Die]." *

The bear and ape belong to a one-legged sailor who fights with a man whose club strikes one of the chairmen, causing the politician to topple into the stream. In a parallel procession a litter of pigs and their parent dash in the direction of the rivulet. Below the chair the feet of a woman who has been tossed by the animals are visible. Behind her a shrew beats her tailor husband, perhaps for not selling his vote. Two men carry a barrel of beer while another fellow, in a posture similar to the nearby pig, drains a second barrel. In the background a militant mob makes noise with bones on meat cleavers and carries

* Paulson, *Hogarth's Graphic Works*, 2:234.

staffs and a "True Blue" flag. The shadow of the second victorious politician appears against the town hall, the façade of which is decorated with primitively designed angels.

The losing side takes refuge in a vandalized house; though new, part has been torn down and many of its windows are smashed. Before the house a half-dressed sailor takes tobacco after a fight; his broken cutlass lies behind him near a post reading "XIX Miles [from] London." Three servants bring dinner into the house. Some of those on the second floor gaze with delight on the difficulties of the victorious party; others mourn their own loss. From the top window a lawyer's parchment reading "Indintur" is visible. The lawyer may be preparing to contest the election and start the whole process over again. Of the goose flying across the sky, a poetic commentary published with Hogarth's approval says:

> Minerva's sacred bird's an owl;
> Our Candidate's, behold a fowl!
> From which we readily suppose
> (as now his generus Honour's chose)
> His voice he'll in the Senate use;
> And cackle, cackle, like—a goose.

The sun dial in the painting bears the date 1755 and is inscribed "Pulvis et umbra sumus" (We are dust and shadow [Horace, *Odes*, IV, 7]).

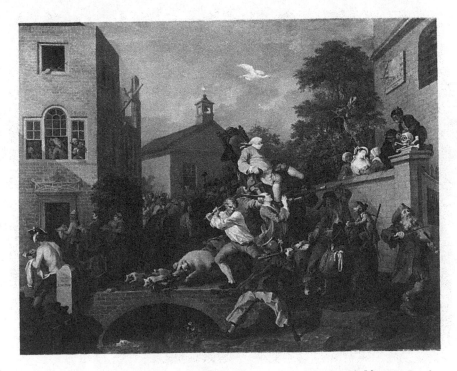

Oil painting. Reproduced by permission of the Trustees of Sir John Soane's Museum, London.

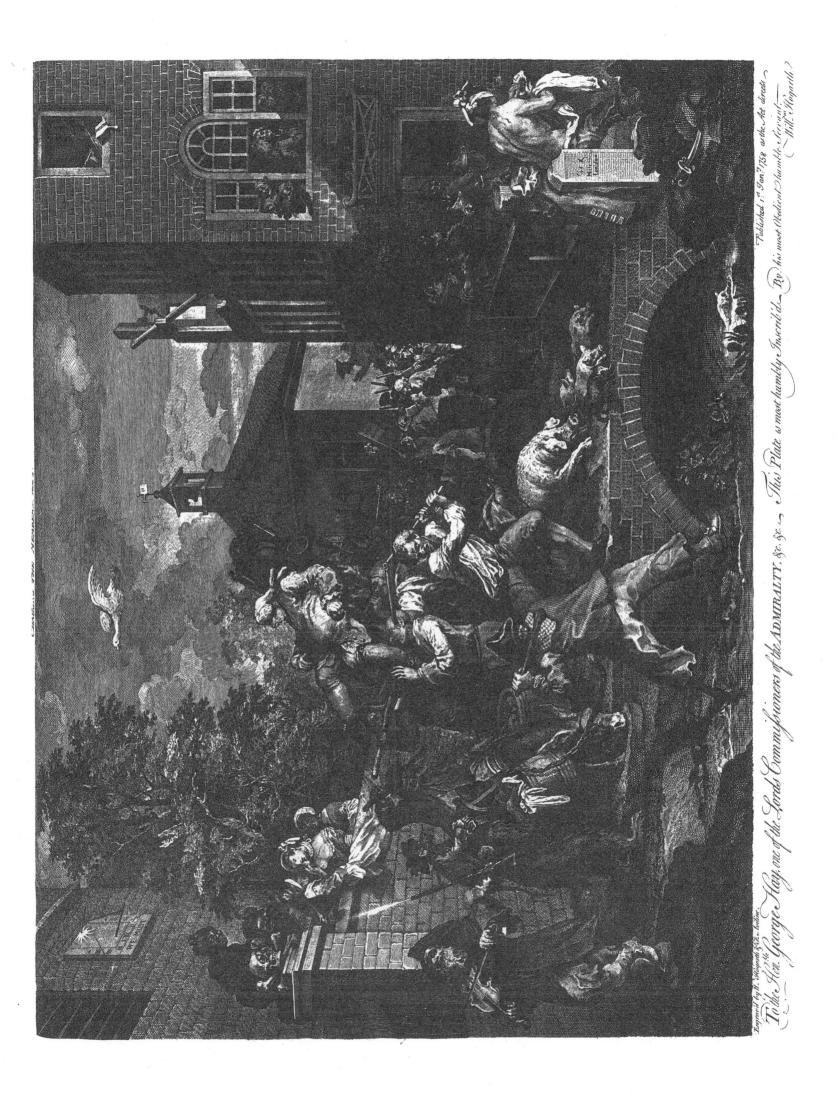

Engrav'd by W. Hogarth &c. Author Published 1.st Jan.ry 1758 at the Act. direct.

To the Hon.ble George Haymore of the Lords Commissioners of the ADMIRALTY. &c. &c. This Plate is most humbly Inscrib'd. By his most Obedient humble Servant.
— Will.m Hogarth.

The Invasion

ETCHED. MARCH 1756.

These two plates were published at the beginning of the French and Indian War (the Seven Years' War) when an invasion from France was rumored. Intended as propaganda posters "Proper to be stuck up in publick Places," as their advertisement suggested, their principal function was to boost public spirit and morale by caricaturing the enemy and glorifying the native land.

David Garrick wrote the verses for these crudely executed engravings.

90

PLATE I
FRANCE
THIRD STATE. $11\frac{3}{8} \times 14\frac{1}{4}$

The scene depicts a starved, unwilling and fanatical French army preparing to invade England. In the foreground a sadistic, well-fed monk tests the edge of his executioner's axe. He is armed with various engines of torture, a statue of St. Anthony with a pig and a "Plan pour un Monastere dans Black Friars a Londre." With these he hopes to impose his Roman Catholicism on the British.

Next to him, a group of hungry soldiers mill about confusedly; three of them look enviously at a fellow roasting frogs on his sword who points to the flag which exhorts "Vengence et le Bon Bier et Bon Beuf de Angletere." Two others dance hysterically before this banner.

Behind them is an inn bearing the sign "Soup Meagre a la Sabot Royal." A shoe hangs from the beam, and some meatless ribs are visible through the window. While women plough the fields, the soldiers are forced to board their ship for the invasion.

Many of the same themes are treated in "O the Roast Beef of Old England" with some instructive differences.

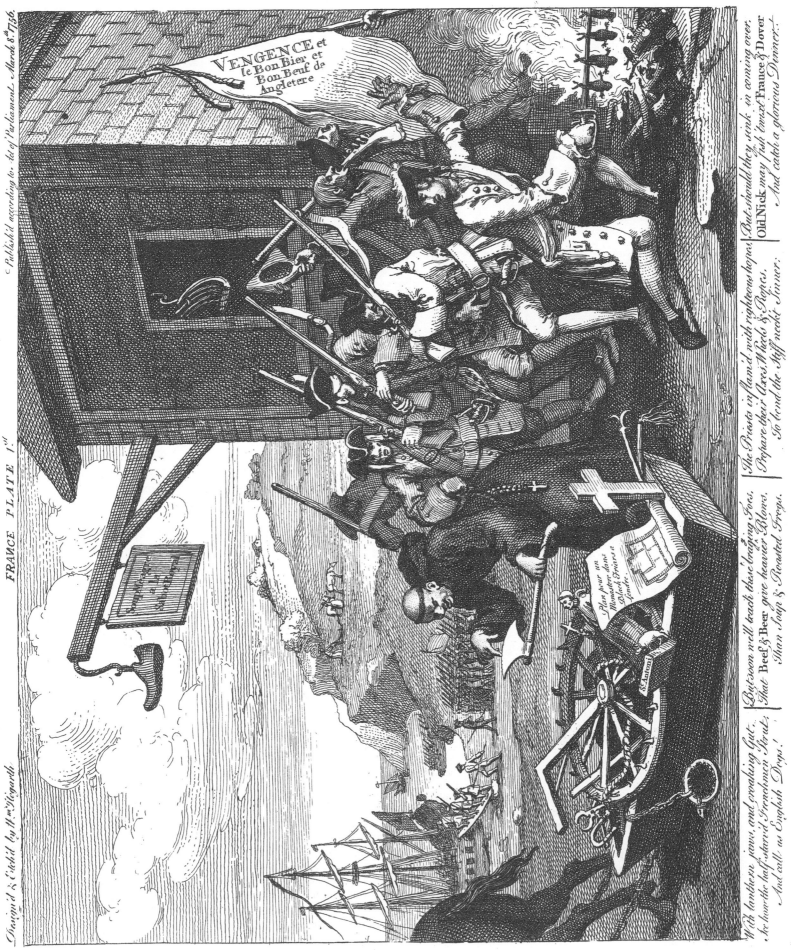

FRANCE PLATE 1.ˢᵗ

Design'd & Etch'd by Wᵐ Hogarth

Publish'd according to Act of Parliament. March 8ᵗʰ 1756.

VENGENCE et
le Bon Bier, et
Bon Beuf de
Angletere

Plan pour un
Monastere dans
Black Friars a
Londre.

St. Antoni

With lanthern jaws, and croaking Gut,
See how the half-starv'd Frenchmen Strut,
And call us English Dogs!

But soon we'll teach these bragging Foes,
That Beef & Beer give heavier Blows,
Than Soup & Roasted Frogs.

The Priests inflam'd with righteous hopes,
Prepare their Axes Wheels & Ropes,
To bend the Stiff neck'd Sinner:

But should they sink in coming over,
Old Nick may fish 'twixt France & Dover
And catch a glorious Dinner.

91

The Invasion
PLATE II
ENGLAND
THIRD STATE. $11\frac{7}{16} \times 14\frac{5}{8}$

This print shows the spirited, well-trained English troops preparing with vigor and enthusiasm to meet the French invasion. Its propagandistic nature is best revealed by contrasting it with the very finished "March to Finchley," which presents a more compelling and considerably less flattering picture of the same army.

Before a tavern with a sign advertising beef "Roast & Boil'd every Day" and showing the "Duke of Cumberland" (who defeated the French-supported Stuarts in 1745), a soldier paints a caricature of the French king saying "You take a my fine Ships, you be de Pirate, you be de Teef, me send my grand Armies & hang you all, Morblu." One girl measures the caricaturist's broad back with a cloth; another feels the point of a meat fork. The soldier's giant beefsteak (defended by his sword) sits on the table with a beer mug (defended by the sailor's pistol) and a song sheet reading "Rule Britannia/ Britannia rules the Waves,/ Britons never will be Slaves." Behind the table the soldier and sailor jeer at the caricature. In front of it a boy plays "God save great George our King."

In contrast to the French, who must be forced to fight, an undersized British boy stands on his toes so that he may appear tall enough to the recruiter to join the army. In the background a troop of soldiers march around in orderly fashion.

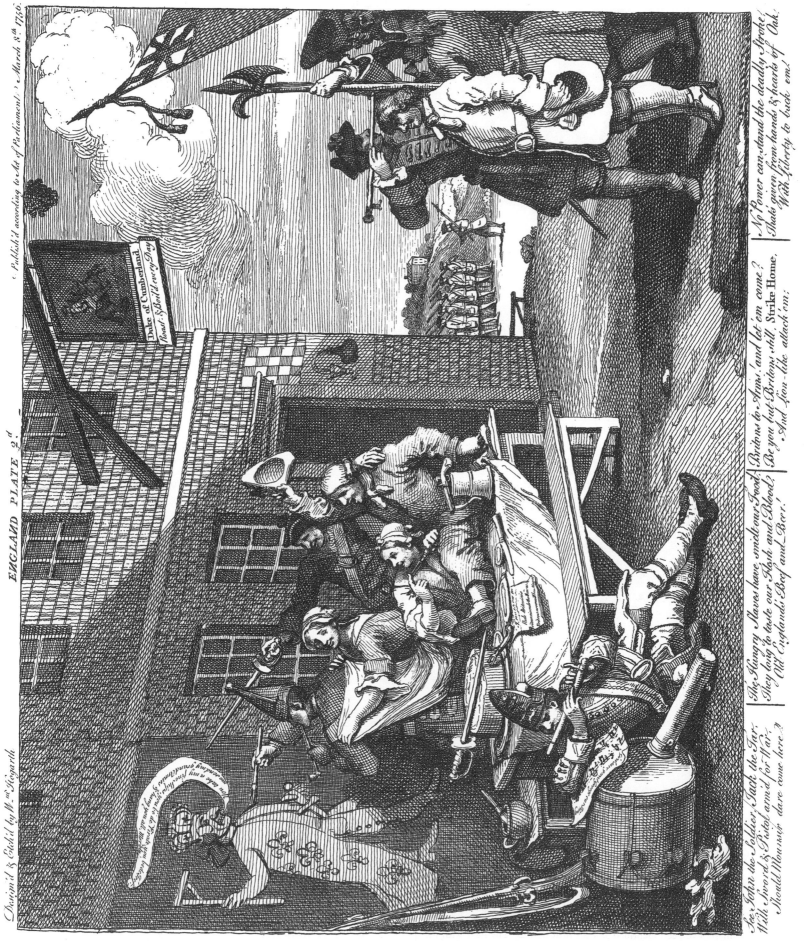

Designd & Etched by Wm Hogarth

ENGLAND PLATE 2d.

Publish'd according to Act of Parliament, March 8th 1756.

See John, the Soldier, Jack, the Tar, | The hungry Slaves have smit our Food, | Britons to Arms! and let 'em come? | No Power can stand the deadly Stroke,
With Sword & Pistol arm'd for War? | They taste to taste our Flesh and Blood? | Be you but Britons still, Strike Home, | That's given from hands & hearts of Oak.
Should Mounseer dare come here? | Old England's Beef and Beer? | And Lion-like attack 'em: | With Liberty to buck 'em!

92

THE BENCH

ETCHED AND ENGRAVED FROM A PAINTING. FIFTH STATE. SEPTEMBER 1758. $6\frac{11}{16} \times 7\frac{13}{16}$

This print is another of Hogarth's manifestoes about his art. Refining on his work in "Characters Caricatures," he attempts to define more closely and illustrate further the terms "character," "caracatura" and "outrè." He illustrates the term "character" by representing four pompous judges listening to a case in the Court of Common Pleas. Callously inattentive to the case before them, these undignified, pompous men, buried in their robes and wigs, slumber or read. That they are characters is suggested by the fact that their faces and posture are comic and revealing without being sharply exaggerated, and by the fact that the men have been identified as historical figures. The man with the quill is Chief Justice Sir John Willes; the one to the right with the long nose, Henry Bathurst; the third is William Noel; in the background is Sir Edward Clive.

The line of heads above the judges is an unfinished addition to the print; Hogarth worked on it the day before his death but did not complete it. The faces here seem intended as examples of "caracaturas" and "outrè"; the heads are of the lame man in Raphael's *Sacrifice at Lystra*, the Apostles from Leonardo's *Last Supper* and the long-nosed judge portrayed below. Early states depict the royal arms instead of the row of heads.

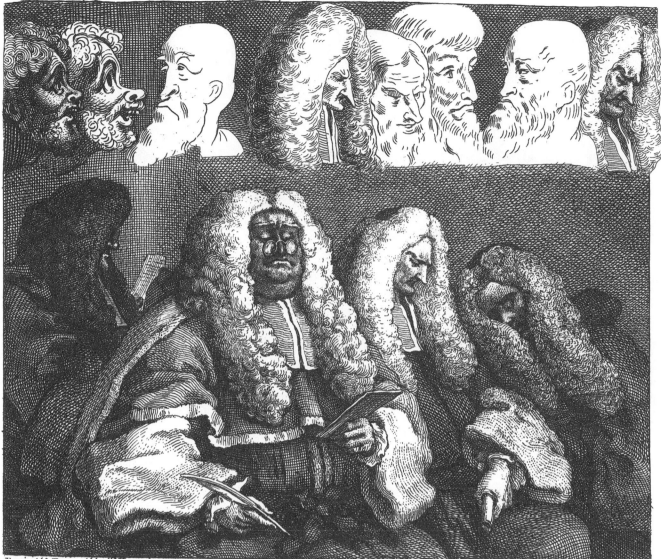

Design'd & Engrav'd by W. Hogarth

The BENCH.

Publish'd as the Act directs 4 Sep. 1758.

Of the different meaning of the Words Character, Caracatura and Outrè in Painting and Drawing.

There are hardly any two things more essentially different than Character and Caracatura nevertheless they are usually confounded and mistaken for each other: on which account this Explanation is attempted It has ever been allow'd that, when a Character is strongly mark'd in the living Face, it may be consider'd as an Index of the mind, to express which with any degree of justness in Painting, requires the utmost Efforts of a great Master. Now that which has, of late Years, got the name of Caracatura, is, or ought to be totally divested of every Stroke that hath a tendency to good Drawing: it may be said to be a Species of Lines that are produc'd rather by the hand of chance than of Skill; for the early Scrawlings of a Child which do but barely hint an Idea of an Human Face, will always be found to be like some Person or other, and will often form such a Comical Resemblance as in all probability the most eminent Caracaturers of these times will not be able to equal with Design, because their Ideas of Objects are so much more perfect than Childrens, that they will unavoidably introduce some kind of Drawing: for all the humourous Effects of the fashionable manner of Caracaturing chiefly depend on the surprize we are under at finding our selves caught with any sort of Similitude in objects absolutely remote in their kind. Let it be observ'd the more remote in their Nature the greater is the Excellence of these Pieces; as a proof of this, I remember a famous Caracatura of a certain Italian Singer, that struck at first sight, which consisted only of a streight perpendicular Stroke with a Dot over it. As to the French word Outrè it is different from the foregoing, and signifies nothing more than the exagerated outlines of a Figure, all the parts of which may be in other respects a perfect and true Picture of Nature. A Giant or a Dwarf may be call'd a common Man Outrè. So any part as a Nose, or a Leg, made bigger or less than it ought to be, is that part Outrè, † which is all that is to be understood by this word so injudiciously us'd to the prejudice of Character. ——— See Excess Analysis of Beauty. Chap. 6.

⁎ The unfinish'd Groupe of Heads in the upper part of this Print was added by the Author in Oct.ʳ 1764: & was intended as a further Illustration of what is here said concerning Character Caracatura & Outrè, He worked upon it the Day before his Death which happened the 26.ᵗʰ of that Month.

93

PIT TICKET: THE COCKPIT
ETCHED AND ENGRAVED. NOVEMBER 1759. $11\frac{11}{16} \times 14\frac{5}{8}$

This print depicts a crowd of men from many professions and of all classes and ages reacting in various—mostly fanatical—ways to their fortunes at this ironically dubbed "Royal Sport."

In the center of the composition (which reflects Leonardo's *Last Supper*) stands a blind nobleman (Lord Albemarle Bertie) accepting bets impassively from seven frantic men, most of them common people. They include a postboy (he wears a horn in his belt) with a gaping hole in his coat, a Black servant, an old gentleman and a butcher who attempts to show his money to the blind bookie. So intensely involved are all these in placing and accepting bets that they fail to see a youth steal a note marked "Pay to £20" from the bookie.

To the right of this cluster a fellow cracks his knuckles as he looks with intense anxiety at the fight. Above him a gentlemen examines his coat where it has touched the postboy; above the gentleman a Quaker sneezes at the snuff which a ridiculous sweep takes affectedly. Below the sweep a carpenter (his rule sticks from his pocket) has fallen on a fat nobleman, who has crushed the man directly in front of him, who in turn has caused a third to be dashed against the arena. To the right of this group a man seems to urge his cock.

On the left side of the mock Christ figure, a happy little man with a wart on his forehead writes out "Bets." Next to him a dour fellow holds a bag with a cock's head sticking out of it; the cock seems to smile with naïve interest at the fight. In contrast to the trainer's solemnity a toothless man beside him laughs hysterically, and a third fellow in his shirtsleeves points vehemently to his coin in the arena. Behind this group a deaf cripple is addressed without effect through his horn. Above him a farrier climbs out of the pit, and a fat gentleman sneezes from snuff spilled by the Frenchman. This foreigner (who resembles the sweep in posture) stands outside the pit against the English royal arms and looks disdainfully at the madness below him. A dark-faced messenger wearing a helmet with the emblem of Mercury on it stands beside him. To the right a disinterested man lights his pipe next to a dog that shows a lively interest in the fight. A portrait of "Nan Rawlings," a famous trainer, hangs on the wall.

In the foreground two men make a bet by knocking the butts of their whips together. To the right a drunk is about to have his purse snatched away on the end of a cane. The man with the gallows on his back is the public hangman, whose presence fails to discourage the criminal. The fellow to the hangman's right seems about to start a fight.

The feet of the rival trainers are visible at opposite ends of the arena. The shadow in the center is that of a man who has been suspended above the crowd for not paying his debts. Unaffected by his experience, he attempts to bet with or barter his watch.

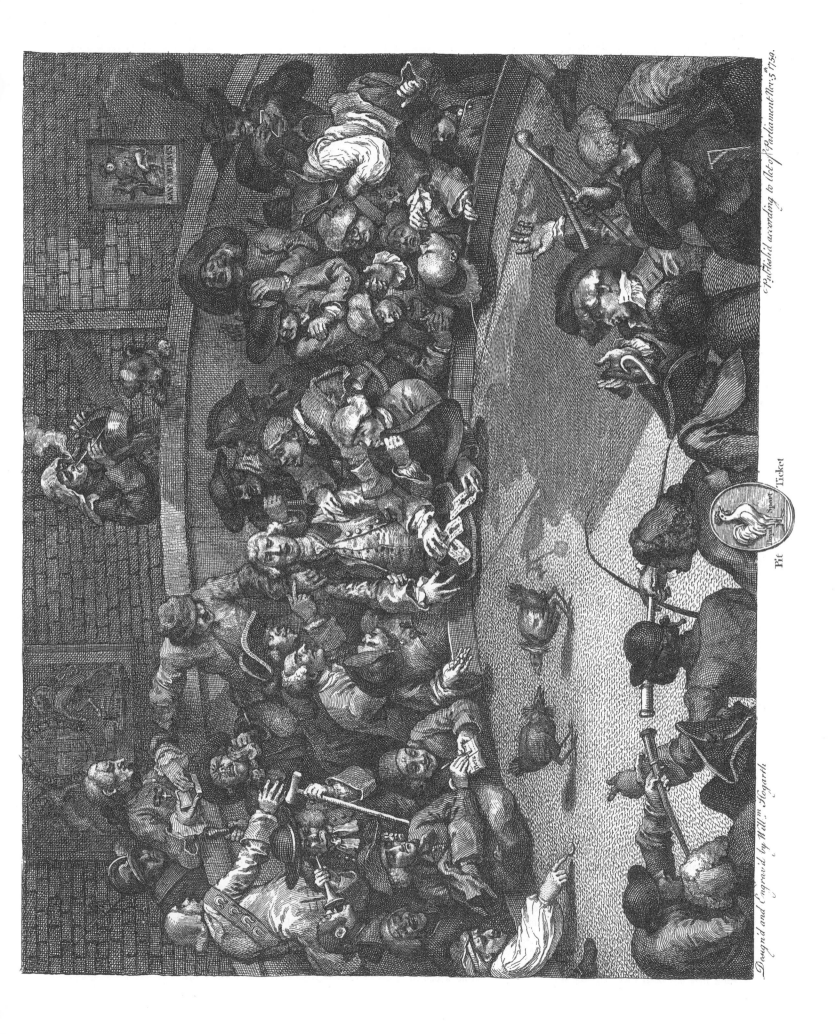

Designed and Engraved by Will.^{m.} Hogarth

Published according to Act of Parliament Nov.^r 5, 1754.

Pit Ticket

94

TIME SMOKING A PICTURE

ETCHED FROM A DRAWING. SECOND STATE. MARCH 1761. $8\frac{11}{16} \times 6\frac{11}{16}$

This print, designed as the subscription ticket for *Sigismunda*, expresses Hogarth's fear of time as a force destructive to art while it combats the general enthusiasm in England for "dark masters" articulated by Addison in the "*Spectator* Vol: II: Page 83." In that *Spectator* (No. 83) Addison denigrates modern art as the product of such motives as vanity, avarice and envy while he sees the lifelike work of "those Great Masters that were dead" as improved and mellowed by time.

In opposition to this view Hogarth draws Time sitting irreverently on a statue he has destroyed. The sculpture looks almost like a human being that has been executed; the noseless head, wearing a pained expression, is detached from its body. The statue's hand, also detached, points to Time's obscuring "Varnish." Time himself views a painting impassively as his scythe destroys its canvas and he obscures its detail with smoke.

The quotation from the comic dramatist Crates translates "Time is not a great artist but weakens all he touches." This quotation has been reworked by Hogarth to serve his own ends; the original reads, "Time has bent me double; and Time, though I confess he is a great artist, weakens all he touches." *

* Paulson, *Hogarth's Graphic Works*, 1:242.

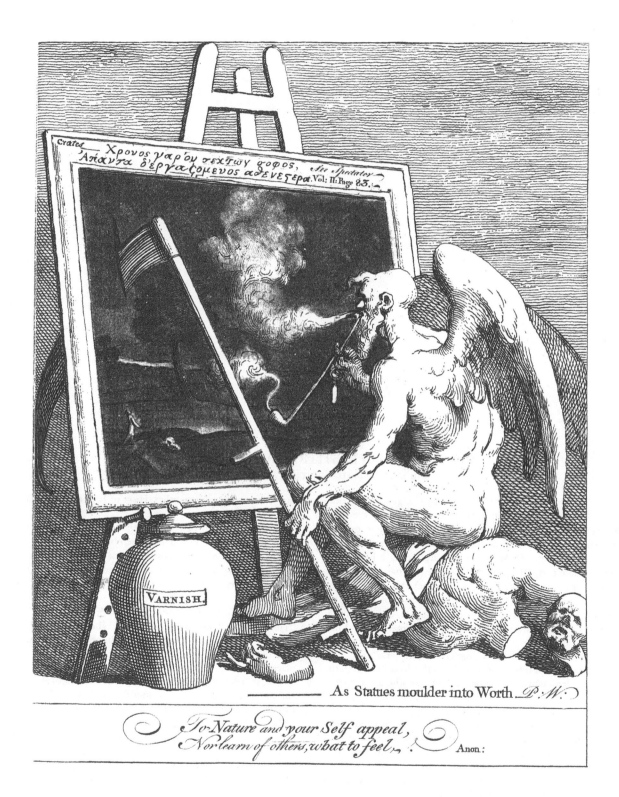

Crates Χρονος γαρ ου τεκτων σοφος, See Spectator
Ἁπαντα δ ἐργαζομενος ἀδενεςερα Vol: II: Page 83.

VARNISH.

————— As Statues moulder into Worth *P.M.*

To Nature and your Self appeal,
Nor learn of others, what to feel. Anon:

CREDULITY, SUPERSTITION AND FANATICISM

ETCHED AND ENGRAVED. SECOND STATE. APRIL 1762. $14\frac{1}{2} \times 12\frac{9}{16}$

In contrast to the soporific mood of "The Sleepy Congregation," this plate depicts a Methodist service in infernal terms. Stressing the connection between sexual and religious excitement, it focuses on the affinity between various forms of enthusiasm and madness. An avaricious preacher-performer, "St Money-trap," dressed as a harlequin, bellows on the ironic text, "I Speak as a Fool"; his roar has cracked the sounding board above him. In his athletic act the imposter has lost his wig with its satiric halo to reveal the tonsure of a Catholic priest. He terrorizes his congregation by two puppets, a devil with a broiling iron and a witch offering her milk to an animal. Around his pulpit hang three doll ghosts, one of Julius Caesar and two from the eighteenth century, "Mrs. Veal" and "Sr. Geoᵉ. Vill[i]ers."

Below, a minister in heat thrusts an icon down the dress of an ecstatic girl. Beside them a devil whispers in a sleeper's ear; another man weeps. "The Poors Box," undisturbed by contributions, is covered with a web. In the foreground two "magicians" perform "supernatural" acts. A woman splinters a gin glass in the throes of giving birth to rabbits; she is probably meant to represent a Mrs. Tofts famed for this trick. Beside her a shoeshine boy spits nails. His sources of inspiration are a gin bottle corked with an icon, "Whitfields Journal" and "Demonology by K. James 1st," the first Stuart king of England. A dazed fellow, traditionally identified as a Jew, kills lice; by his book he keeps a knife inscribed "Bloody" which belies his conversion. At a lectern on which "Continually do Cry" appears, two disembodied cherubs with birds' wings (satires on bad church art) surround the clerk who may be in the likeness of Whitefield. The man seems to observe the lovers dourly; by his side is the ambiguous text, "Only Love to us be

giv'n/ Lord we ask no other Heav'n/ Hymn By G. Whitfield Page 130."

The ape-like faces of the congregation are convulsed with emotion. Over them hangs a chandelier resembling a grotesque creature. The threatening celestial mechanism is inscribed: "A new and correct globe of hell by Romaine"; one eye reads "Bottomless Pit," the other "Molten Lead Lake"; the nose is inscribed "Pitch and Tar Rivers," the mouth "Eternal Damnation Gulf"; one cheek reads "Parts Unknown," the other "Brimstone Ocean"; the equator line is marked "Horrid Zone" and the small sphere above "Deserts of New Purgatory." The amazed "infidel" gazing in on the Christian scene and the bars on the windows give a prison or madhouse atmosphere to the place.

Two thermometers replace the usual church hourglass. The top one, surmounted by a nose and mouth bawling "Blood Blood Blood Blood," measures "Vociferation." The bottom one, which has as its bulb an enlarged (and distempered?) human brain resting on Wesley's Sermons" and "Glanvil on Witches," depicts various degrees and states of "religious" emotion from "Suicide" to "Raving Madness." Though the congregation seems convulsed it registers only "Luke Warm." The thermometer is surmounted by a portal in which stands a notorious "ghost" of the period; most of the congregation carry its image. Above it stands the image of a Roundhead soldier-preacher called "Tedworth" who is supposed to have haunted a man who once attacked him.

An earlier version of this print entitled "Enthusiasm Delineated," bawdier and much sharper in its attack on religion, never was published.

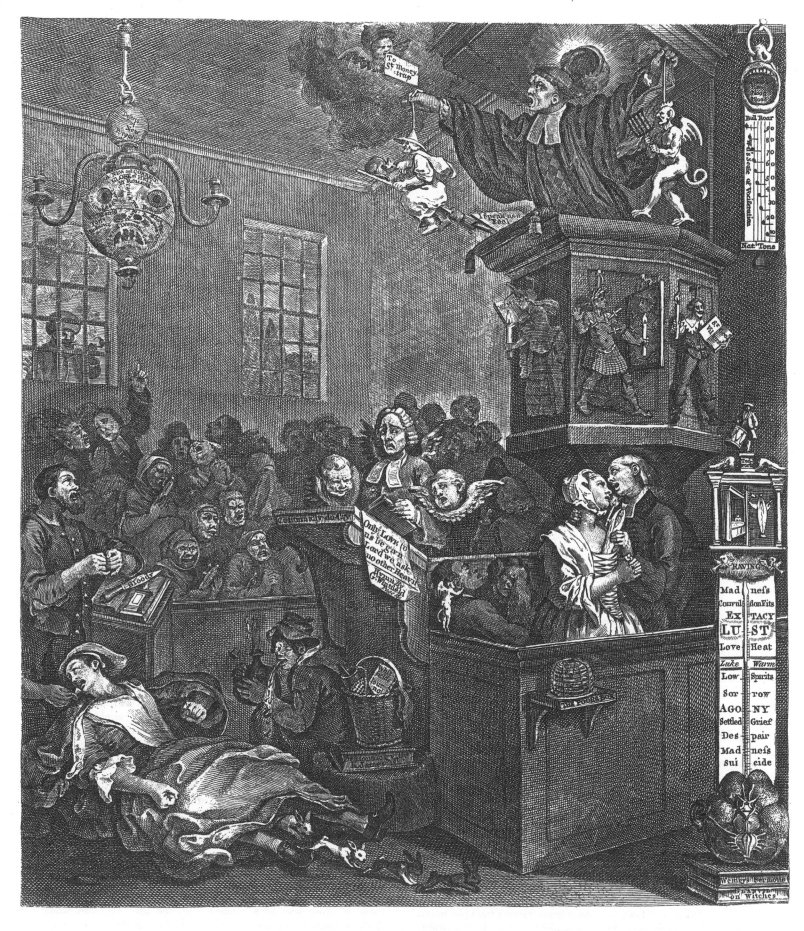

CREDULITY, SUPERSTITION, and FANATICISM.

A MEDLEY.

Believe not every Spirit, but try the Spirits whether they are of God: because many false Prophets are gone out into the World.

1. John. Ch. 4. V. 1.

Design'd and Engrav'd by Wm. Hogarth. Publish'd as the Act directs March ye 15th 1762.

THE TIMES, PLATE I

ETCHED AND ENGRAVED. THIRD STATE. SEPTEMBER 1762. $8\frac{1}{2} \times 11\frac{9}{16}$

In this elaborate political allegory Hogarth idealizes and defends George III and the Earl of Bute's ministry and discredits its enemies. The print depicts a conflagration (war), which has spread through several buildings representing different countries. The house with the sign of the two men shaking hands stands for Spain's and France's united war effort against England; the place with the two-headed eagle represents Germany, the house with the lily, France. The widespread nature of the war is revealed by the globe ablaze.

Fanning the fire is Pitt (in early states Henry VIII), the real power in the former government. Elevated artificially by stilts, he towers above his fanatical mob of supporters who include three adoring City aldermen and some noisy, clamorous butchers. Around his neck he wears a millstone inscribed "3000 £ per annum," his pension at retirement.

In the center of the scene stands a fire-engine (Britain) bearing the royal arms, four hands joined in cooperation and the words "Union Office," identifying it as being from Cheapside's Union Fire Office and referring to the union of England and Scotland.* Atop the engine the king ("GR") attempts to extinguish the fire; over his head flies a dove bearing an olive branch. He is aided by industrious citizens, one of whom, a Scot, is impeded by a malicious fanatic who carts copies of the *Monitor* and *North Briton* to feed the fire. In the background a wagon marked "Hermione" bears home the administration's triumphs, money and goods captured from the Spanish vessel *Hermione* by the English navy.

From the "Temple Coffee House" three men direct their fire hoses not at the conflagration but at the unperturbed king. The faceless character is Earl Temple, Pitt's brother-in-law. The two garret dwellers (i.e. hacks) are probably Wilkes and Rev. Charles Churchill (with the surplice). On the adjacent building, representing the state of England, a slaughterhouse worker and his companions erect a rival sign to the king's, showing four clenched fists and the date "1762" and inscribed "The Patriot Armes" (referring to Pitt's name for his party, "The Patriots"). Two signs, one reading "The Post Office," the other depicting a castle with the words "[N]ew Castle Inn," tumble in ruins from the building. The first sign refers to the fact that Pitt's organ of patronage, the post office, is gone; the second refers to the resignation of Newcastle, a Pitt supporter in the ministry and its nominal Prime Minister. Below these hangs a plaque marked "Norfolk Jig" showing soldiers in line of march and "Airs Compd by Harrington" satirizing the artificial and mechanical abilities of the Norfolk militia trained by George Townshend ("GT Fect").

Below this a naked man holds two money bags in his hand, one labeled "1000," the other "00"; he wears more bags around his waist; behind him stand two barrels of produce. The sign reads "Alive From America." A man intended as William Beckford points to it and blows a trumpet to draw attention to the wealth derivable from exploitive colonial adventures. In the right-hand corner is a refugee camp of those who have escaped from the fire. The man who fiddles insanely is supposed to represent the king of Prussia. The rest (including six children) endure suffering and death—two children and one adult have expired—while they cling to the few goods they have salvaged.

In the opposite corner sits a Dutch merchant watching the chaos and smoking on his pipe contentedly. A fox sits beside him.

* Paulson, "New Light on Hogarth's Graphic Works," *Burlington Magazine*, 109 (May, 1967), 284.

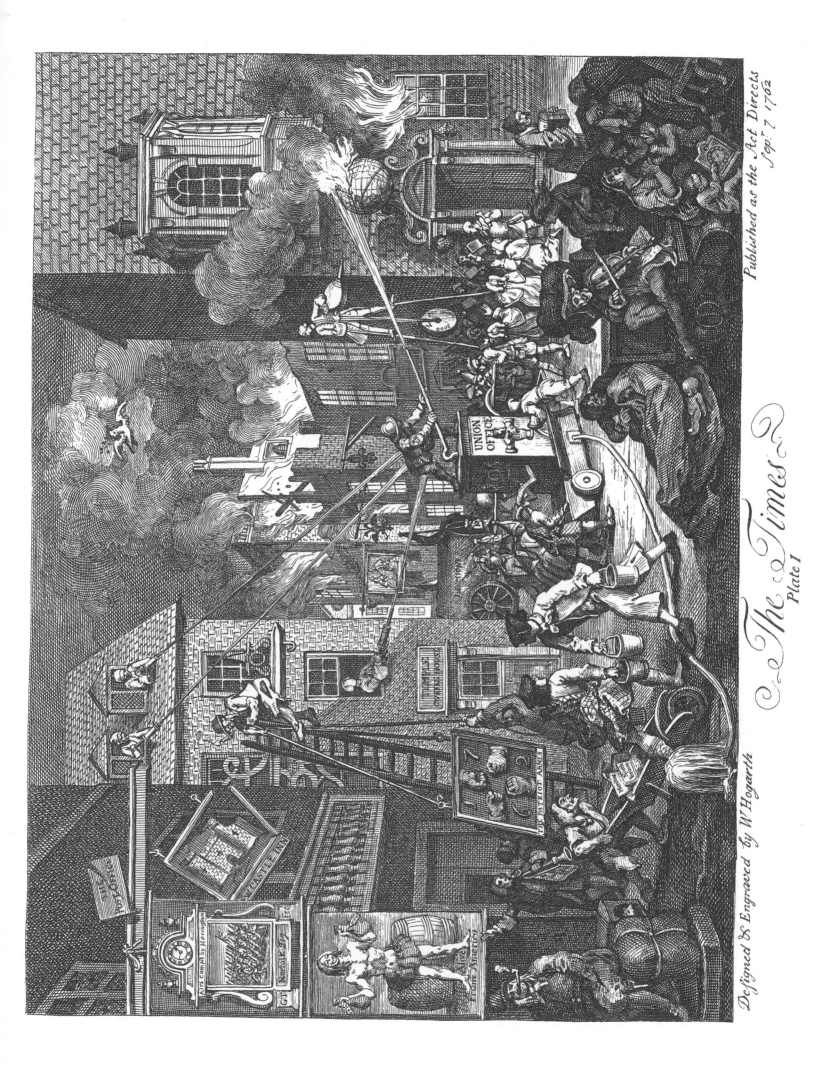

Designed & Engraved by W. Hogarth

The Times
Plate I

Published as the Act Directs
Sep.r 7 1762

THE TIMES, PLATE II

ETCHED AND ENGRAVED. FOURTH STATE. 1762 or 1763. $9\frac{1}{16} \times 11\frac{13}{16}$

This political allegory, suppressed by Hogarth and his widow and published in 1790 after their deaths, is intended as a complement to "The Times," Plate I. Though the motifs of conflict and conflagration are replaced by images of order and growth, the print is shot through with pessimism about political matters. In the center of the print on a man-made island isolating him from both Parliament and citizenry, a statue of George III wearing a saintly, boyish countenance stands above the scene on a pedestal. The carpenter's plumbing board and the angularity of the statue suggest the probity of George's rule and satirize the aesthetic method of "A Ramsey delt." A gardener identified as Lord Bute mans a pump controlling the flow of water. The water, representing royal favor, is distributed through symbols of class privilege to shrubs which sit flatteringly around the statue. These represent court favorites and sinecure holders, many of whom have recently changed their allegiance hastily from "James III" (blacked out) to "George III."

A flourishing evergreen marked "Culloden" represents the Duke of Cumberland who defeated the Scots at the battle of that name; his relentless pursuit of the rebels earned him the title "the butcher." A dog with the word "Mercy" inscribed on its collar barks at the bush. Out of favor, the plant is watered by Aquarius from a zodiac rainbow. A gardener wearing a hat shaped like a fox (Henry Fox) dumps clipped shrubs—former court favorites—into the moat. His pace is impeded by

a roller marked "1000000000£," representing the national debt.

On the left sits Parliament, presided over by speaker Sir John Cust; members in one section sleep or chat while those in the other section shoot at the dove of peace. The figure with the longest gun and the gouty leg is Pitt. In the background stands the ridiculous Chinese Pagoda from Kew Garden and a "Hospital." Another is under construction. To the right is St. Mary-le-Strand and, partially blocking it, the home of the Society for the Encouragement of the Arts. The Society's members are hoisting up a palette marked "Premium," a reference to their custom of offering prizes to promising young artists, a practice opposed as misleading by Hogarth.

Only a sprinkle of royal favor falls on the populace. None reaches the maimed veterans who stand on a bridge to the royal presence; a barrier prevents them from either seeing or visiting the king. Two veterans receive a blessing from "Dr. Cants ye Man Midwife" who is believed to be the Archbishop of Canterbury, Thomas Secker.

In the pillory is "Ms Fanny," a notorious "ghost" of the period; her candle ignites Wilkes' newspaper, the *North Briton*. Wilkes' empty pockets are turned out to reveal his lack of money. A maid shakes her mop over his head, and a boy urinates on his foot. Below him sit two musicians, a sweep and a man with a purse. From a barrel with Wilkes' initials ("IW"), a gin seller draws liquor.

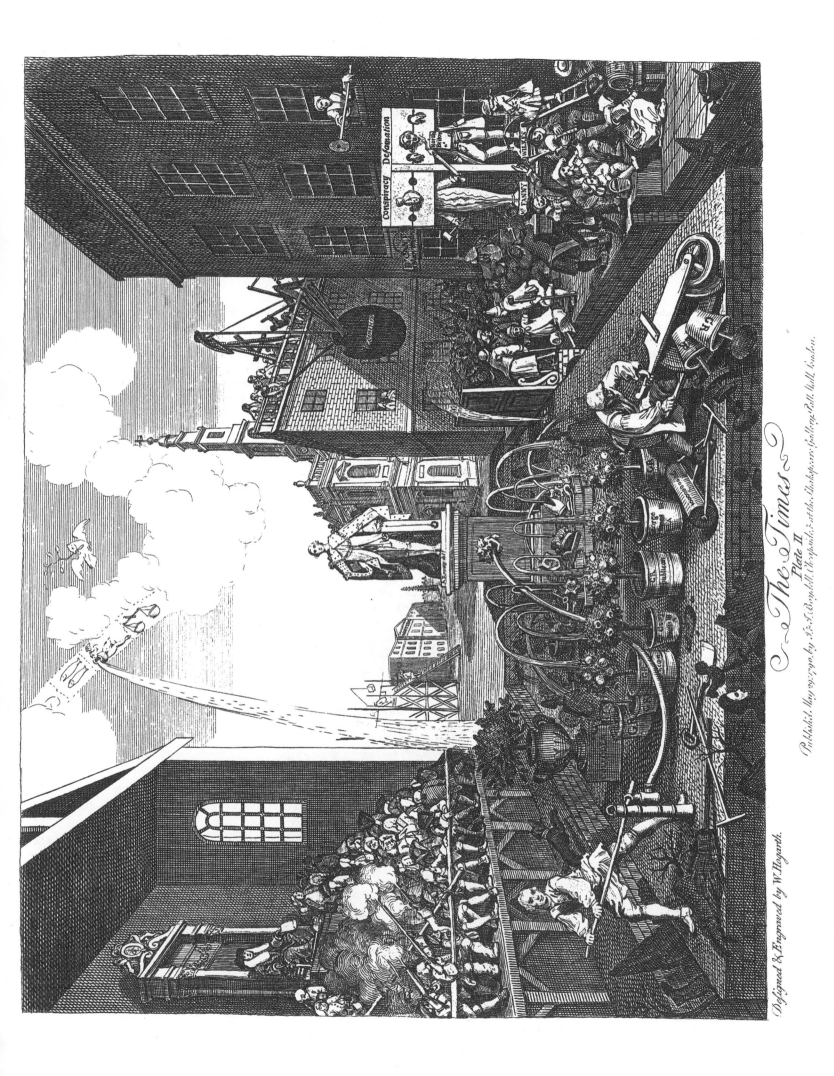

Designed & Engraved by W. Hogarth.

The Times
Plate II

Published May 29. 1790. by Boydell, at the Shakespeare Gallery, Pall Mall, London.

JOHN WILKES ESQR.

ETCHED. FIRST STATE. MAY 1763. $12\frac{5}{16} \times 8\frac{11}{16}$

John Wilkes, offended at the anti-middle-class bias of Hogarth's *The Times*, Plate I, attacked the artist's character and his work, particularly his history painting and his *Analysis*, in the *North Briton* No. 17. Shortly afterward, Wilkes criticized George III's defense of the Peace of Paris in the *North Briton* No. 45 (suggesting numerically the last Stuart uprising). For disrespect to the king, Wilkes was unjustly arrested and jailed, but, in a decision that reaffirmed fundamental liberties, he was acquitted. At the trial, according to Wilkes' comrade, Charles Churchill,

> Lurking, most ruffian-like, behind a screen
> So plac'd all things to see, himself unseen
> Virtue, with due contempt, saw Hogarth stand,
> The murd'rous pencil in his palsied hand.

Significantly, Hogarth classes this work with his popular genre of criminal portraits. Wilkes sits on a chair holding the Cap of Liberty on the Staff of Maintenance; beside him are a table with his writing stand and his attacks on Hogarth and the king, both apparently of equal and related significance. Leaning forward in an ingratiating, intimate manner, Wilkes wears a leer on his face. His mouth is twisted in mockery, and the pupils of his eyes are disturbingly crossed. His wig is fashioned to suggest that he wears fiendish or demonic horns. Wilkes emerges in the portrait as a man of treacherous, unprincipled character, shifty, cynical and derisive.

Preliminary sketch in the British Museum, London.

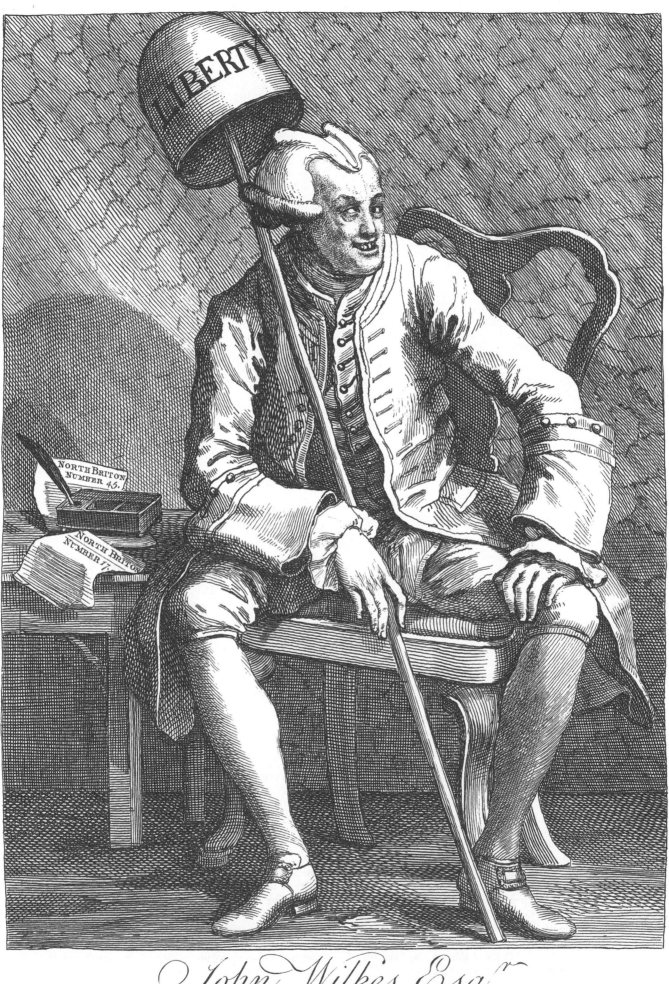

John Wilkes Esq.r

Drawn from the Life and Etch'd in Aquafortis by Will.m Hogarth.

Price 1 Shilling. Publish'd according to Act of Parliament May y.e 16. 1763.

99

THE BRUISER

ETCHED AND ENGRAVED FROM A DRAWING. SEVENTH STATE. AUGUST 1763. $13\frac{5}{16} \times 10\frac{3}{16}$

In revenge for his treatment of John Wilkes, Charles Churchill attacked Hogarth vindictively in "An Epistle to William Hogarth." The artist responded quickly by burnishing out of his self-portrait everything but the dog, the drapery, the burin and, in this state, part of the palette. In the area so provided he drew Churchill as a drunken, cumbersome bear with drooling mouth and fixed, intoxicated eyes. Wearing torn, dirty clerical bands and the ruffles of a gentleman, the ridiculous bear hugs a mug of beer and a club representing the *North Briton* ("NB") which is covered with knots reading "Lye 1," "Lye 2," "Lye 3," "Infamous Fallacy" and so on. The portrait rests on three books; the first is "Great George Street, A List of the Subscribers to the North Britons," the second "A New way to Pay old Debts, a Comedy, by Massenger." These volumes and the collection box on top of them refer to Wilkes' slender income and his well-known financial difficulties.

On the left side of the print, Hogarth's dog urinates on "An [E]pistle to W. Hogarth by C. Churchill," the poem that motivated the print. On the right side, a print (added in state six) combining both political and personal satire rests against the artist's palette. It depicts Pitt reclining on a tomb in front of a triangular monument bearing a millstone marked £3,000. Two giants, Gog and Magog, emblems of the City of London, where Pitt's source of popular support existed, flank him. Gog offers him a crown, Magog a shield and spear. With a match from one of them, Pitt nonchalantly shoots off a cannon at the dove of peace resting on the royal standard.

Below, Hogarth whips a bear (Churchill) that he has muzzled and secured and an ape (Wilkes) that uses the Liberty Staff as a hobby horse and carries the *North Briton* ("NB"). These two animals apparently perform for the faceless fiddler (Earl Temple) who stands behind them.

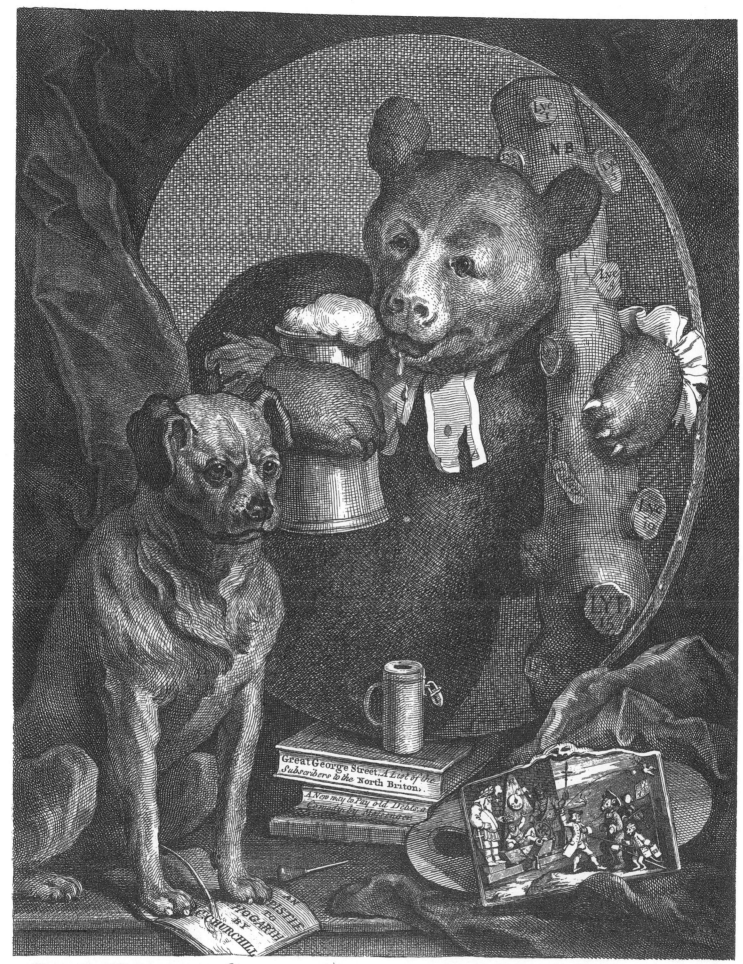

THE BRUISER, C. CHURCHILL *(once the Rev:^d) in the Character of a Russian Hercules, Regaling*
himself after having Kill'd the Monster Caricatura that so sorely Gall'd his Virtuous friend, the Heaven born WILKES!
— But he had a *Club* this Dragon to Drub, Or he had ne'er don't I warrant ye. —— *Dragon of Wantley*

Design'd and Engraved by W^m Hogarth Price 1.^s 6^d

Publish'd according to Act of Parliament August 1. 1763.

100

TAIL PIECE: THE BATHOS

ETCHED AND ENGRAVED FROM A DRAWING. APRIL 1764. $10\frac{3}{16} \times 12\frac{3}{4}$

Hogarth's last work is both a satire on dark pictures of foreign manufacture and a pessimistic statement about contemporary social and political matters. Every item detailed is involved in some kind of destruction or death. Sinking against a broken pillar, his hourglass smashed and his pipe and scythe broken, Time expires. His will, changing his executor from some unknown person to Chaos, drops from his hand: "all and every Atom thereof to Chaos whom I appoint my sole Executor. Witness Clotho. Lachesis. Atropos." Behind him stands a crumbling church tower bearing a clock without hands, a funeral yew and a skull-and-crossbones tombstone. An empty purse, a commission of bankruptcy against nature ("H. Nature Bankrupt") with a seal depicting a man on a white horse, and a book reading "Exeunt Omnes" lie near the tombstone. Close by a cobbler's waxed end is twisted round a last, and a worn brush rests beside a broken crown.

An unstrung, snapped bow and a gun without a barrel lie together.

Near a broken palette Hogarth's "The Times" is destroyed by a candle stub. A cracked church bell and a liquor bottle lie together. Above this a sign reading "The Worlds End" topples over beside its ruined inn. It shows the earth being consumed by fire. The illustration resembles the globe in "The Times," Plate I. The top of an Ionic column lies at the foot of the sign. In the distance a man hangs on a gallows. At sea, a ship sinks. In the sky Apollo lies dead in his chariot, and at least one of his horses has expired. A black moon with a solemn face in it rises on the right.

Hogarth satirizes dark paintings by burlesquing their motifs (Apollo's death) and by juxtaposing sublime and ridiculous images like the bell and bottle, the crown and brush, the bow and gun. The work is also a bitter expression of Hogarth's personal disappointment and unhappiness about the events (represented by "The Times" prints) surrounding his last political activities.

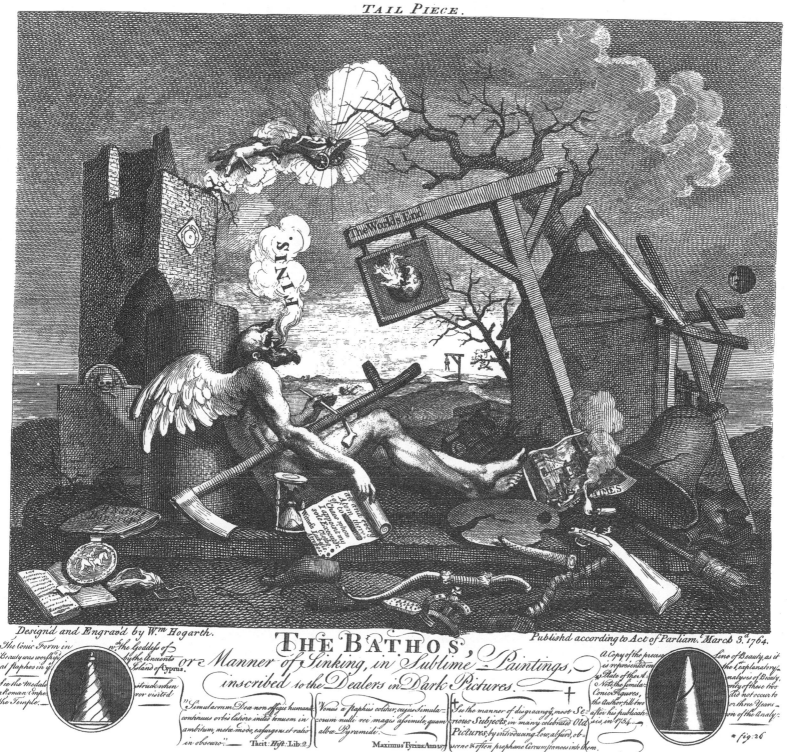

Design'd and Engrav'd by W.m Hogarth.

Publish'd according to Act of Parliam.t March 3.d 1764.

THE BATHOS,
or Manner of Sinking, in Sublime Paintings,
inscribed to the Dealers in Dark Pictures.

Index

The roman numerals refer to pages of the Introduction, the arabic numerals to plate numbers. An asterisk following a plate number indicates that the text reference is to be found in the series description located on the same page as the cited individual plate description. Thus, "42*" in the index entry for "Baron, Bernard" indicates that Baron is mentioned on the page with the description of Plate 42, but in the paragraph describing the entire series *The Four Times of the Day.* The Index does not duplicate the List of Plates.